THE
ALPHABETIC
LABYRINTH

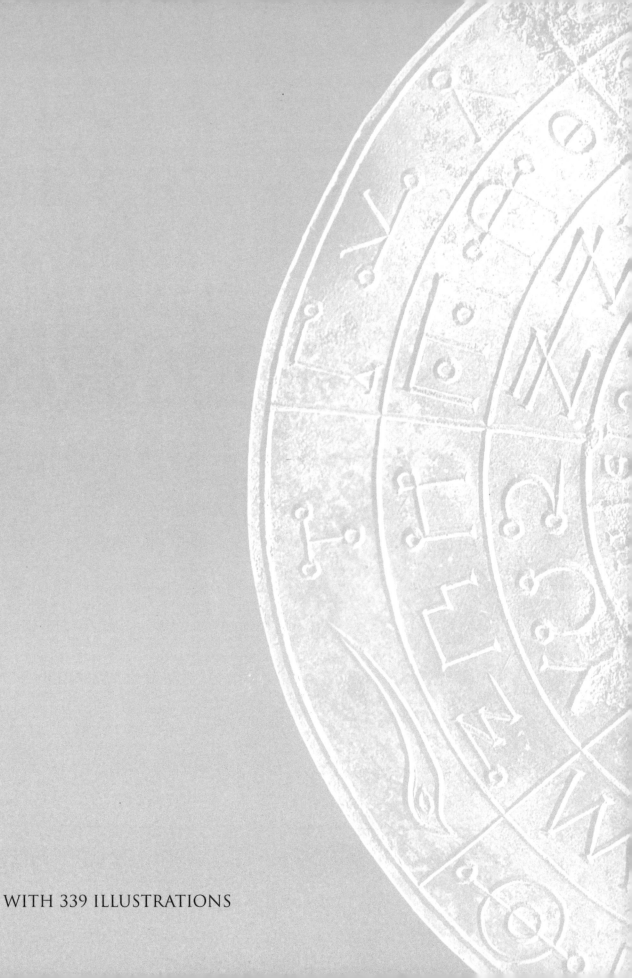

WITH 339 ILLUSTRATIONS

THE ALPHABETIC LABYRINTH

The Letters in History and Imagination

Johanna Drucker

THAMES AND HUDSON

British Library Cataloguing-in-Publication Data
A catalogue record for this book is available from the British Library.

ISBN 0-500-01608-9

Printed and bound in Slovenia

To my Father,
Boris Drucker,
who showed me that the letters were pictures,

and

to all my nieces and nephews

from:

Alex,

Annie,

Avery,

Buffy,

Christopher,

Dona,

Eliza,

Jessica,

Kieran,

Lauran,

Matthew,

Matthew,

Paul,

Teddy,

Whitney

to

Zachary

Acknowledgments:

Many thanks are due to the colleagues, friends and family who provided advice on preliminary drafts of this manuscript: Natalie Kampen, for ongoing commentary and discussion; Dirk Obbink for references in the Classical period; Andrew Gregory for translations from Latin and many details; Brad Freeman for first readings; Paula Gerson for her conscientious help on the medieval period; Gino Lee for continual counsel on the history of calligraphy and printing, as well as technical advice; Emily McVarish for interest in a much earlier proposal. Also thanks are due to Bertrand Augst and Tony Dubovsky under whose generous sponsorship and support the original research for this project was first undertaken at the University of California at Berkeley in 1980. Marc Treib provided additional support at that time. Julian Boyd provided references and advice on sections concerned with the late Renaissance, particularly the work of John Wilkins. Much appreciation to Robin Middleton, through whose machinations this book became more than a proposal. Finally, affectionate thanks to Jane and Boris Drucker for their enthusiasm and careful reading of various portions of the draft manuscript.

TABLE OF CONTENTS

The Pergamon disk

From the invention of letters the machinations of the human heart began to operate; falsity and error daily increased; litigation and prisons had their beginnings, as also specious and artful language, which causes so much confusion in the world. It was on these accounts that the shades of the departed wept at night. But, on the other hand, from the invention of letters all polite intercourse and music proceeded and reason and justice were made manifest; the relations of life were defined, and laws were fixed; governors had a lasting rule to refer to; scholars had authorities to venerate; the historian, the mathematician, the astronomer, can do nothing without letters. Were there not letters to give proof of passing events, the shades might weep at noonday as well as night and the heavens rain down blood, for tradition might affirm what she pleased, so that the letters have done much more good than evil; and as a token of the good, heaven rained down ripe grain the day that they were first invented.

Henry Noel Humphreys
The Origin and Progress of the Art of Writing, 1853

I

THE ALPHABET IN CONTEXT

In some form or other the letters we recognize as the alphabet have been in continuous use for more than three thousand years. Currently, the alphabet is more widespread than any other system of written language. A full account of its origin and development has only been pieced together during the 20th century, and the obscurity of this history through the many centuries of its use has fostered much speculation about the origin and symbolic value of the letters. Thus, in addition to serving as an efficient means of representing many spoken languages, the alphabet has also served as a set of symbols whose distinct visual characteristics have provoked a plenitude of imaginative projections. These symbolic interpretations of the visual forms of the letters of the alphabet provide a rich record of cultural history and ideas which interweave the domains of philosophy and religion, mysticism and magic, linguistics and humanistic inquiry. The investigation of alphabet symbolism forms the central focus of this study, but a few parameters and terms must be defined before proceeding with discussion of that material.

First it is important to define the term *alphabet* and understand the characteristics which distinguish the alphabet from other forms of writing. Secondly, the concept of alphabet symbolism, or the interpretation of the alphabet as a symbolic form, needs clear demarcation. Finally, a brief outline of other writing systems which are non-alphabetic in nature provides a context within which the alphabet can be appreciated.

The basic principle of alphabetic writing is to represent a single sound of a spoken language by a single letter. This phonetic writing system is at best an approximation. The orthography of English, for instance, is notoriously plagued by inconsistencies and peculiarities which generations of reformers and pedagogues have struggled to correct. But while written forms are continually changing and evolving, never more rapidly than under the influence of computers, the tenacity of the alphabet bespeaks its important place within human culture. While there are many examples of the invention of written signs used to mark ownership, record agricultural cycles, make accounts and chart astronomical events, it is the phonetic principle which is the unique characteristic of the alphabet. No other writing system has the capacity to represent the sounds of spoken language with such efficient and adaptable means.

In addition to serving as the means to record speech or ideas in writing, the letters of the alphabet also constitute a set of visual symbols. These shapes and features have played a part in the decipherment of their history and transmission and have inspired imaginative interpretations of their apparent or hidden meanings. To engage with the history of symbolic values attached to the visual form of the letters requires charting

two parallel histories: one, attitudes toward the function of language, and the other the concept of the symbol.

Language has conventionally been considered an instrument of communication. Writing is generally considered a more or less adequate means of transcribing language so that it may serve its communicative function. But throughout history, the letters of the alphabet have occasioned imaginative speculation about the possible hidden value of their visual form. In oracular and ritual practices, mystic and kabbalistic doctrine, Gnostic and humanistic beliefs, the letters have been considered as fundamental elements of the cosmos, or of divine or human knowledge. The attributes of their visual forms have been assigned values which extend far beyond their capacity to function as the orthography (mere spelling or spoken sound) and instead have allowed them to be construed as indices of the most profound mysteries of the universe. While most of the historical symbolic values attached to letter forms in these interpretations would be discounted by contemporary scholars, the history of such conceptions provides a fascinating insight into the history of ideas. The interpretation of the letter 'e' as produced by the oracle at Delphi and detailed in a record by Plutarch may have little to tell us about the concrete historical lineage of the fifth letter of our alphabet but serves to reveal much about Greek concepts of symbolic form.

As written forms, the letters of the alphabet have been used for centuries in the production of written and printed documents. Many visually inventive versions of letter forms have been produced, and as a device for the arrangement of pictorial elements, the alphabet has enjoyed the attention of calligraphic artists, type designers, and mystics. I shall not dwell extensively here on alphabet use that is purely decorative in nature, or attaches no extra meaning or value to the character of the letters, or gives no insight into intellectual thought. Instead, the focus of this study has been on the interpretation of the alphabet as a symbolic matrix whose letters are assumed to encode in their visual shape the history of their origins, of some fundamental cosmological or philosophical truth, or some mystic or ritual power. This research moves far afield from the domain of archaeological debate and linguistic inquiry, into the realm of imagination and philosophical speculation, but the framework for understanding these symbolic interpretations must be established in the history of the serious and systematic inquiry into the actual origin of the alphabet.

Fewer than a dozen instances of the invention of writing are recorded in human history. Of these, most occurred in and around the ancient Near East: cuneiform in Sumer (3100 BC – all dates given here are general), Proto-Elamite (3000 BC), Hittite hieroglyphics (1500 BC), Egyptian hieroglyphics (3000 BC), and the Cretan-Minoan pictographic and linear scripts (2000 BC, but with a considerably earlier date for the carved seals from which they are derived). Of other ancient writing systems, including the glyphs of pre-Columbian America (the earliest examples date to 300 AD), Indus valley scripts (2000 BC), Easter Island proto-writing and

other miscellaneous attempts of brief duration, only Chinese characters have survived into contemporary use.

The alphabet was probably invented between 1700 and 1500 BC by speakers of a Semitic language in the geographic area which serves as a bridge between the ancient civilizations of Mesopotamia and Egypt. The term Semitic dates from the 18th century AD, when it was derived by European scholars from the name Shem, one of the sons of Noah, to refer to the group of languages of which Arabic and Hebrew are now the best-known living examples. Contrary to popular usage, it does not describe an ethnic, racial or cultural group, but a linguistic family whose members dominated the region between the Sinai to the south, through the area known as the Levant along the coast of the Mediterranean, north through present-day Syria and Asia Minor, and east to the mouth of the Tigris and Euphrates valley. (There are exceptions, and the region was not linguistically homogenous; the Persians spoke an Indo-European language, for instance, as did the Hittites).

The people who occupied this region were known as Canaanites, after the biblical designation of ancient Palestine as the land of Canaan. The term Canaanite is rather loosely used, but conventionally includes the Phoenicians, early Hebrews, and the Semitic-speaking people of Palestine. In philological terms, Canaanite indicates one of the two main branches of the northwestern Semitic language, of which the other is Aramaic. Both branches were represented by early alphabets. The Phoenicians, who were responsible for the stabilization and spread of the alphabet, were a Canaanite group who spoke a Semitic language, occupied the coastal regions, and had extensive maritime trade routes throughout the Mediterranean between 1300 and 900 BC.

In company with Chinese characters, which made their first appearance in North China around 1700 BC, the alphabet provides the forms by which all living languages are written. Almost without exception, every existing writing system derives from one or the other of these sources. All other written forms have disappeared either under the influence of cultural exchange, colonization, assimilation, or linguistic evolution. Thus all alphabetic writing, whether Cyrillic, Devanagari, Arabic, Hebrew, Latin, Greek, Tibetan, Javanese or Bengali, or any of the many other alphabetic forms, derives from a common source in the Sinai in the second millennium BC. The non-alphabetic Chinese characters provide the written forms for the rest of the world's languages, beginning with the Tibeto-Chinese language for which they were invented.

In spite of the vast variety in contemporary visual appearance which is the result of centuries of specialized adaptation, all alphabetic forms share the same origin and possess similar structural properties: they consist of about twenty-four to thirty signs used to represent the sounds of spoken language. The record of this single point of origin, the borrowing of Egyptian characters to compose a system of notation adequate for the linguistically (and culturally) distinct peoples of the ancient Near East,

13

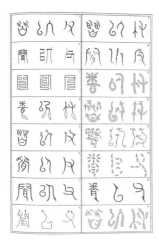

Fanciful version of the origin of Chinese characters (Karl Faulman, *Illustrirte Geschichte der Schrift*, Leipzig, 1880)

was partially preserved in biblical and classical literature, and the history of debates on the origins of the alphabet forms the subject of the following chapter.

It was in large part efficiency and economy of means which distinguished the early alphabet from non-alphabetic scripts. With a very limited number of written signs, alphabetic writing can be used to represent almost any spoken language. Languages of the Semitic language group were the first to be written in alphabetic form, particularly those in use in the Sinai peninsula, along the littoral extending up through present day Israel, Lebanon and Syria to Asia Minor, and through areas of ancient Palestine. But the alphabet proved readily adaptable to Indo-European and other languages, and contacts first brought about through the systematic invasions of the Levant by tribes from the North and East beginning in the late 13th and early 12th centuries BC promoted rapid spread of this writing system and the first adaptations of these letter forms to non-Semitic languages. The alphabet is now used to write all the many branches of Indo-European languages – Romance languages, Germanic, Balkan, Slavic, Indian and Indonesian, as well as the Finno-Hungarian languages, and can be used to transliterate unrelated linguistic groups, such as East Asian languages, as well. In many cases such adaptations were fostered by the zealous dedication of Christian missionaries – the Gothic alphabet invented in the 3rd century AD by the Bishop Wulfila being one of the first such examples — or by trade and commercial interests. The current extension of alphabetic scripts being effected by electronic media and the relative efficiency of the alphabetic keyboard is only the latest in a long series of such diffusions.

While the alphabet is phonetic in nature, this is not true of all other written language. Writing systems – to proceed to the third of my points outlined above – may also be logographic, in which case the written sign represents a single word, or ideographic, in which ideas or concepts are represented directly in the form of glyphs or characters. The Chinese language was long believed to belong to this latter category, as were Egyptian hieroglyphics, though in fact both systems combine phonetic and logographic modes, with an occasional ideographic sign. The alphabet and many of the cuneiform and pictographic scripts in use in Mesopotamia and the Mediterranean were syllabic; they made use of a single sign to represent combinations of consonant/vowel or vowel/consonant. A syllabary generally consists of many dozens of signs, and is thus more clumsy and complex than an alphabetic system. Completely ideographic scripts do not exist, though many proto-writing systems are based on ideographic principles which bypass the representation of language or linguistic structures in order to record complex thoughts in visual form. Such ideographic writings occur in cultures which have neither developed nor seemed to require a written language, though attempts to invent purely ideographic writing systems have been made. In particular, such inventions were a major passion of philosophers of the 17th century when such polymaths

Bishop John Wilkins's philo-
sophical script (John Wilkins,
*An Essay Towards a Real
Character and Philosophical
Language*, London, 1668)

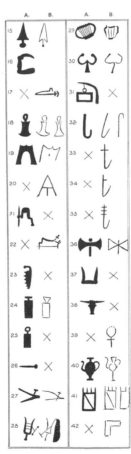

Minoan pictographs (Arthur J.
Evans, *Scripta Minoa*, Oxford,
1909) The first column shows
signs engraved on signets, the
second inscribed on clay tablets
or sealings. X indicates that
there are no examples in that
category

as the Bishop John Wilkins proposed their own idiosyncratic inventions. Wilkins's intention was to organize all human knowledge into a single logical hierarchy and then to invent a written character capable of communicating this knowledge directly to the eye. Inspired in part by a misunderstanding of the nature of hieroglyphic signs, such experiments provide considerable revelations about the concepts of symbolism and basic premises of human knowledge assumed by their designers. Contemporary designers, such as Adrian Frutiger, continue to search for such universal visual symbols.

While these basic categories – phonetic, syllabic, logographic and ideographic – describe the relations between units of writing and units of speech or language, they provide no description of the nature of the written forms used for each mode. A script may be pictographic – comprised of a set of pictorial elements whose visual form is recognizable as an image such as a standing figure, an animal, a tool or a plant which stands for the depicted object, or linear, schematic sets of arbitrary symbols. Either script may also be used to represent abstract categories such as

15

religious beliefs, legal constraints, or emotional responses, which do not lend themselves readily to direct depiction. Pictographic scripts have the disadvantage that they tend to be labor intensive and require considerable training and manual skill. This problem was ingeniously resolved by the Minoans who created punches or stamps of the almost 150 sign/images which they used when writing in wet clay or soft materials (they also used the same signs, however, when incising metal or writing with ink). Pictographic scripts have historically served as the antecedent to more simplified forms, the linear scripts whose visual elements are more reduced and schematic, more in keeping with the 'laziness of the hand' remarked on by many historians of writing in accounting for the widespread success of alphabetic forms. But there is no determining sequence according to which pictographic scripts must necessarily evolve into linear ones, or linear ones be based on pictographic originals, though the latter case is borne out by archaeological evidence in all known instances: Sumero/Babylonian/Akkadian cuneiform, Egyptian hieroglyphics and their increasingly linear cursive hieratic and demotic forms, Chinese characters and even the alphabet, all have derived their schematic forms from pictographic originals.

The primary evidence used in investigating any written script is, inevitably, its visual form. Such investigation must account, first of all, for the shapes of the letters, their orientation, the directional sequence of the writing, and the materials and media in which the writing is produced. In dating epigraphic inscriptions (on stone or other hard material) or paleographic artifacts (writing with ink on papyrus, cloth or other soft surfaces), the archaeological context provided by an excavation site may be used to determine the date of a sample as well as its function.

Of particular use in dating and distinguishing among alphabetic scripts is the manner in which they notate vowels. Ugarit cuneiform, an alphabetic script, and early examples of proto-Sinaitic alphabetic forms, notated only a few vowel sounds. Other transformations of the alphabet note almost none, and the scripts derived from the Greek adaptation have a more replete vowel notation system. Such distinctions may be used to chart the point at which an alphabetic system was transmitted or modified in adaptation from an earlier form. Additional factors to be considered in dating epigraphic evidence are the substantive content of written samples as well as the linguistic structure. While much of early non-alphabetic cuneiform in Assyria and Babylonia was used for records of trade and transactions, the early Ugaritic texts from 1400 BC record myths and legends in literary form. Cretan documents and Minoan pictographs record tax and tariff regulations while the Greek inscriptions on jugs and cups dating to the 8th century BC are poetic paeans to athletes and dancers.

Two early writing systems, the cuneiform of the ancient Near East and the hieratic form of Egyptian hieroglyphics, figure prominently in the prehistory of the alphabet. But other writing forms have vanished entirely, suffering the fate of an oblivion so deep that several of them have yet to be

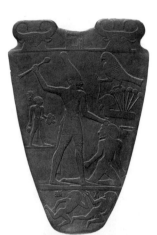

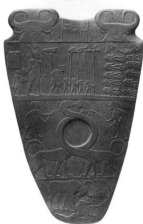

Narmer Palette, early instance of hieroglyphics (Cairo Museum)

deciphered. Before outlining in detail the history of the alphabet's develop-ment, and of the conceptual premises on which that history has been based, it seems useful to provide a context by describing the origins of other writing systems. At least one of these, the Egyptian hieroglyphics, had a history spanning nearly three thousand years', and various forms of cuneiform persisted nearly as long, so that the chronological span of their use rivals that of the alphabet.

Most of these non-alphabetic writing forms had unique origins, and in only a few cases is there evidence to indicate direct influence of idea or form for their invention. Egyptian hieroglyphics, which appear as early as 3000 BC, provide scarce evidence of their prehistory. The signs evolved into well-formed and complex elements of hieroglyphic writing, and archaeological evidence such as the well-known Narmer palette (dated at 2900 BC) provide testimony of an already-formed graphic style. The few earlier pot-scratchings and incised marks found in the region bear little relation to the pictographic elements of hieroglyphic characters, whose origin is still unknown. Egyptian hieroglyphics were used almost unchanged, at least with respect to their visual form, throughout the near-ly three thousand years of their function. But two other forms of writing, both versions of hieroglyphics modified for easier production, were also developed: the hieratic and demotic scripts. The hieratic retains, in cursive form, many of the pictorial elements of the hieroglyphs, but demotic (invented after contact with the Greeks was already considerably devel-oped) is so linear a form that its relation to hieroglyphics is structural and linguistic rather than visual. The decipherment of Egyptian hieroglyphics through the efforts of Thomas Young, Alexander Sayce and, finally, Jean-François Champollion, put to rest many centuries of mythic symbolism and esoteric knowledge attributed to the hieroglyphic characters. But the concept of the hieroglyph as an arcane and enigmatic sign continues in the popular imagination in the very use of the word as a suggestive term.

17

Cuneiform script, which competes with Egyptian hieroglyphs for the claim to be the first form of writing, was invented sometime between 3500 and 3100 BC in Sumer. The Sumerians spoke a language of uncertain ori-gin and the earliest documents produced in script were entirely picto-graphic. A more linear form of writing, the first cuneiform (wedge-shaped or 'nail-writing') developed by the Sumerians was adopted by the Babylonians and then the Assyrians, both Semitic speaking, in a system of about 750 signs (only about 300 of which were in general use) close to 2500 BC. Cuneiform remained in use into the Christian era, though employed at that time only by priests and scholars. The period of greatest use was in the Babylonian period of Hammurabi (between 1725 and 1680 BC) and at the height of the Assyrian empire in the 9th to 7th centuries BC. Writing was used in these cultures for a wide variety of purposes, and the texts are concerned with law and medicine, magic, astrology, astro-nomy, literature and many other rapidly developing fields of human knowledge.

The Hittites, who spoke an Indo-European language and had a flourishing civilization in northern Syria and Asia Minor in the 3rd through 1st millennium BC, invented a hieroglyphic writing system of their own around 1500 BC. They also borrowed the cuneiform script of the neighboring Akkadians, but their hieroglyphic system, used until their civilization was conquered and absorbed after 600 BC, comprised approximately 400 signs which were not employed by any other people.

Similarly, several script systems on the island of Crete, which may have had their original inspiration from the idea of writing observed in contact with the Egyptians, share nothing either visually or linguistically with the hieroglyphics. The earliest of these Cretan forms are two pictographic scripts which developed around the palace at Knossos in 2000 BC, apparently followed chronologically by two linear forms, A and B, which are unrelated to each other. Of these, only Linear B (first developed around 1400 BC) has been deciphered, and that relatively recently by Michael Ventris. Ventris demonstrated that the script recorded an archaic form of the Greek language but with characters whose origins seem to have been indigenous to Crete. The earlier pictographic and Linear A scripts do not record the Greek language, and they have not, as yet, been successfully deciphered. The use of Linear B for about two hundred years before the final destruction of Minoan civilization around 1100 BC (some four thousand clay tablets were preserved by their accidental firing in the blaze which destroyed the palace at Knossos) indicates that Greek administrators or rulers dominated the affairs at the Minoan capital in that period. Linear B was used mainly for keeping palace accounts of transactions, trade, and inventories. These Minoan scripts spread as far as mainland Greece and possibly Cyprus, but their influence was limited both geographically and chronologically.

The Cypriot syllabary shows the distinct visual characteristics of the Cretan scripts, and may have been brought to Cyprus around 1400 BC by the Mycenaeans. This script was used to record a non-Greek language and was clearly modified to record a different tongue.

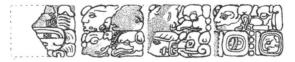

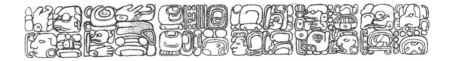

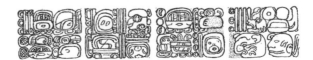

Mayan glyphs (S.G. Morley, *The Inscriptions at Copan*, Washington, D.C., 1920)

Another seemingly independent invention also occurred in the Indus valley in the period around 2500 BC. Whether created in contact with other cultures who had their own writing system or from some individual inspiration, this script also vanished without development and the documents in this language also have yet to be deciphered.

There were several other spontaneous inventions of written language: the Mayan glyphs of pre-Columbian America, which were copied and transformed by Toltec, Aztec and other peoples in that region, and the rongo-rongo script of Easter Island. This latter system has an unknown origin and linguistic function, and the earliest extant examples date from about 1000 AD. Spanish conquerors' destruction of the cultures, codices, and monuments in the region of Central America in which the pre-Columbian cultures had developed terminated any development which might have occurred subsequently in those writing forms.

But the Chinese characters, the second most widespread and persistent form of writing, were adapted to many Asian languages and cultures – some of which had as little in common with Chinese as Semitic and Indo-European civilizations had with each other. The Japanese for instance, adopted a full set of Chinese characters known as *kanji* to indicate proper nouns and concepts, then a phonetic cursive *hiragana* to indicate sounds, and finally a printed form *katakana* which could be used for transliteration. Classical Chinese characters are still used in linguistically independent cultures, such as Korea, for formal documents. Each of these writing systems has a rich lineage of symbolic interpretations attached to the traditional forms of its elements which could serve as the basis of a full-scale contribution to the history of ideas and human culture.

However, the scope of my project is necessarily limited. Even within the Western tradition in which the alphabet has succeeded in sustaining its unique place as the major writing system, there are many aspects of its form and use which will not be discussed here. For example, the entire history of Islamic calligraphy is filled with innovative visual investigations of the symbolic value of sacred and poetic texts.[1] The Arabic alphabet is very close to the Hebrew alphabet, and they have a common root in the Aramaic scripts invented in the first millennium BC. Both Hebrew and Arabic scripts have a history within the mainstream of Western European culture, with their most significant reentry into intellectual life occurring at various moments from the Middle Ages through the Renaissance and again in the 18th and 19th centuries among secular and religious scholars. The only excuse I can offer for not attending to the rich tradition of Arabic calligraphy, and its equally rich history of symbolic interpretations of letter forms and visual language, is the most banal: lack of linguistic expertise on my part and the need to set a limit, somewhere, in the scope of this research. Likewise, I have not attended to the history of the many Indian scripts, or those modified in their diffusion through Asia, Africa and other areas of the world whose script forms share a common origin with the modern European alphabet.

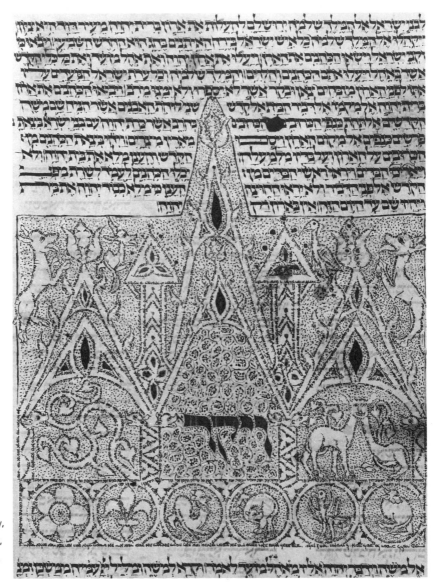

Pentateuch, Hebrew micrography,
1290 by Moses of Ebermannstadt,
Bavaria (Det Kongelige Bibliotek,
Copenhagen, Cod. Hebr. XI)

There are other traditions whose visually intriguing character make them likely candidates for inclusion which have not, again, found their place in this study. The guiding criterion I have used is to include those topics which combine the visual form with a symbolic interpretation of a mystical, imaginative, religious, historical or otherwise culturally significant character. I therefore pay less attention to those practices which are more strictly decorative in nature, or which have a more purely visual emphasis. One such tradition is that of Hebrew micrographic writing. An invention of the late Middle Ages, the technique involved the use of handwritten Hebrew letters of miniscule dimensions to weave a decorative border around an image. This micrographic writing inscribed a text, generally a portion of scripture, which was thematically complementary to the

central presentation. This technique was used into the 19th and 20th centuries in portraits and works of a more secular nature where the image involved was often composed out of micrographic writing.

Finally, I have not attempted to deal with issues of literacy, of reading, or of the impact of electronic forms of media upon the conventions of the printed document. Contemporary life is more saturated with signs, letters, language in visual form than that of any previous epoch – T-shirts, billboards, electronic marquis, neon signs, mass produced print media – all are part of the visible landscape of daily life, especially in urban Western culture. My decision was to remain involved with a textual tradition, to examine the body of literature within which the history and historiography of the alphabet has been established and transmitted, rather than to examine the role of writing in the culture more broadly considered. Ultimately, this book is concerned mainly with the symbolic attributions and interpretations attached to what may be termed the Western European alphabet. So let us turn our attention to the chronology of the discovery of its origins and development before tracing the concepts of alphabet symbolism through the course of human history and tradition.

II

ORIGINS AND HISTORIANS

A complete account of the origins of the alphabet may never be pieced together from the potsherds, fragments of stone tablets and other artifacts dating back to the Bronze Age civilizations of the ancient Middle and Near East. But the desire to understand those origins remains a compelling impetus to contemporary scholars, as it has been through the many centuries of the alphabet's existence. The texts which record that search reveal a wide range of premises on which such histories have been conceived, as well as yielding a wealth of factual or putative information about the history of the alphabet.

One of the first historians to write about the history of the *grammata* or *stoicheia*, as the letters were called in his time, was the Greek historian Herodotus. Writing in the 5th century BC about the source of the alphabet, he described a process of fairly straightforward cultural borrowing: 'The Phoenicians who came with Cadmus ... introduced into Greece, after their settlement of the country, a number of accomplishments, of which the most important was writing, an art till then, I think, unknown to the Greeks. At first they used the same characters as all the other Phoenicians, but as time went on, and they changed their language, they also changed the shape of their letters.'[1]

Plato, however, linked the Phoenician letters to an earlier source among the Egyptians, and attributed the invention to their god Thoth. Plato also recorded the legend of the Egyptian king Thamus' mixed response to the gift, which he felt might contribute as much to forgetfulness as to remembrance by allowing human memory the luxury of fallibility. The two major themes introduced by these Greek writers, that of cross-cultural borrowing and of a divine origin, dominated the history of alphabet studies up through the 19th century.[2] From the earliest period of human history the sheer variety of scripts provided ample evidence for analysis of the development and transformation of written language, but the power of writing was such that it seemed too profound an invention to have been the product of mere human effort. All early proposals for the origins of the alphabet revolved around the notion of a divine gift. In Jewish accounts, different forms of the letters were supposedly given by God to Adam in the Garden, or to Abraham when he left Chaldaea, or to Moses on Mount Sinai. In Islamic tradition, they are supposed to have been given by Allah to Adam, but denied to the angels, while in India legend ascribes the origins of writing to Ganesh, the elephant-faced god of wisdom, who broke off a tusk and used it as a pen. Such explanations are offered as late as 1799, when the exhaustive encyclopedist of alphabets and typefaces Edmund Fry recorded them in his *Pantographia* (London, 1799) with no ironic inflection whatsoever.

Chaldean alphabet (Edmund Fry, *Pantographia*, London, 1799)

On the one hand the ingenious character of the alphabet made it seem too perfect, too simple and too complete to have been invented by mere mortals, and the tendency of Western historians from biblical times onward had been to assign ultimate responsibility for all knowledge to a divine source. On the other hand, scholars intent on researching the origins of the alphabet were hampered by unsystematic archaeological evidence and lack of specialized knowledge of the evolution of languages in the ancient Near East. By the end of the 19th century, however, the conscientious chroniclers of alphabet history, Isaac Taylor and Philippe Berger both commented (with a note of regret) that the time had passed in which one could seek a single origin for the alphabet or expect to find that it had been a divine gift.

The testimony provided by classical and biblical texts remained the primary source for information about the origins of most forms of writing until the Renaissance; in the case of the alphabet, this situation remained unchanged until the 19th century. Among the Greeks, Herodotus' comments on the Phoenician Cadmus found an echo in the later writings of Diodorus Siculus, who referred to the Phoenicians as the Pelasgi, or wanderers. Pliny, in the first century AD, asserted that the use of letters was eternal, and that the antiquity of this practice extended far beyond what he called 'authentic history'. If Pliny were placing history in a relativist perspective, then he was correct, since the Egyptian system of hieroglyphic writing extended several thousand years back into antiquity to a period much beyond any memory of Greek civilization. It is far more likely that Pliny was simply falling back on a formulaic solution to a difficult problem. Plato, writing some four centuries earlier on the symbolic value of the letters of the alphabet, neither provided nor invoked real historical evidence. The dialogue in *Cratylus*, as will be evident in later discussion, is philosophical and speculative in character. Such speculations remained the norm in medieval and early Renaissance periods, when the visual evidence provided by the letters themselves was the sole source for information about their history and invention. In the Old Testament, writing is first mentioned in association with Moses. While there is no discussion of writing in Genesis, there are numerous passages in Exodus which refer to the tablets of the Ten Commandments: 'I will give thee tables of stone, a law, and commandments which I have written.' Also: 'The tables were the work of God and the writing was the writing of God.' Without contradictory evidence (or motivation) to dispute such attribution, the status of biblical texts as historical truth went unquestioned.[3]

As a visual form, the alphabet faced stiff competition from Egyptian hieroglyphics, and later, Chinese characters in their capacity to exercise fascination as visual symbols. The pictorial quality of the hieroglyphics combined with their reputedly enigmatic function to provoke all manner of imaginative interpretation. Access to their functional operation as a linguistic form was not understood until the discovery of the Rosetta Stone during French occupation resulted in the successful efforts at

23

decipherment by Jean-François Champollion in the early 19th century. (It subsequently fell into English hands.) The letters of the alphabet seemed familiar and unexciting by contrast. To some extent, however, it was such intercultural contacts which sparked the imaginative investigations which led to both the scientific investigation of the development of written forms, and also to the speculative projections which produce symbolic interpretation. It was in part Plato's contact with the priests of Ptolemaic Egypt, who had turned the early hieroglyphic writing from a system for monumental public inscriptions into an esoteric practice during the period of Greek domination, which instigated his own investigation into the character of the Greek letter forms. But in Western tradition the very term hieroglyph virtually defines the concept of a potent visual image, one whose linguistic value is far exceeded by its symbolic resonance. The concept of the hieroglyph was a central theme in the *Corpus Hermeticum*, writings produced in the 2nd and 3rd centuries of the Christian era, which combined Christian Gnosticism and arcane mysticism in a doctrine which claimed descent from the figure of Hermes Trismegistus, the Hellenized image of the Egyptian god Thoth.[4]

Such references would be irrelevant to later studies of the alphabet if it were not for the fact that in many cases these writings contained the framework through which the letters could be interpreted as visual symbols as well as instruments of linguistic use. Thus Clement of Alexandria's exegesis on symbology, *Stromates*, containing his efforts to grapple with the nature of the hieroglyphic form, outlined the structural principles by which a symbol could be related to its meaning (such as synecdoche, metaphor, and metonymy). The influence of Clement's text stretched well into the 18th century in the writings of such scholars as L.D. Nelme and Rowland Jones whose interpretations of the alphabet derive part of their intellectual structure from the 3rd-century *Stromates*. Similarly, the influential *Hieroglyphics* of Horapollo, written in the 4th or 5th century AD, and combining a distinctly Greek point of view with a smattering of knowledge of the Egyptian language and culture, became a major influence when the manuscript was discovered in the 15th century. Most important for the history of alphabet studies, Horapollo's *Hieroglyphics* was taken up by early typographers and printers, such as Geoffrey Tory and Aldus Manutius, whose extrapolation of the hieroglyphic tradition led to investigation of the symbolic properties of letters.[5] But these investigations were all concerned with symbolism, with the interpretation of visual forms as a means of gaining moral or theological knowledge, not with tracing the history of written language. The idea that the alphabet had a history, beyond that of Adam in Eden, Moses at Sinai, or Cadmus on his trade routes through the Mediterranean, is a concept which only comes to maturity in the 19th-century obsession with origins.

If hieroglyphics inspired all manner of symbolic interpretation from the point of the Greeks' first awareness of their existence, the cuneiform

Babylonian cuneiform

scripts of the ancient Near East had far less of an impact on Western thought. Neither ancient nor medieval scholars demonstrate any awareness of the cuneiform scripts of Sumer, Babylonia and Akkadia; there is no mention of the 'nail letters' (the literal meaning of cuneiform) in either classical or biblical literature. The cultures in the Tigris and Euphrates valley who had been most successful in their development of cuneiform scripts had ceased to dominate the region before the time of their contact with the Greeks, although there were cuneiform scripts in use along the northern regions of the coast on which the Phoenicians traded and in Mesopotamia as late as the 1st century AD. Even though the monumental Persian inscriptions at Persepolis and Behistun were never completely buried or destroyed it was not until 1604 that an emissary of the pope, Pietro della Valle, made preliminary drawings of the Behistun monument. This can be seen as an effective demonstration of cuneiform's inability to assert seductive power on the basis of visual mystery.[6] The 17th century, however, was a period of rapid expansion in linguistic and archaeological knowledge, as well as an era in which things charged with the exoticism of ancient or other cultures found particularly eager reception among European scholars. Cuneiform, hieroglyphics, and Chinese characters – with the latter two linked by vague and veiled connections – began to enjoy a certain vogue as objects which might provide insight into the history of human thought and ideas as well as into the foreign language of other cultures. Historians of the alphabet would later reap the benefits of this interest, since any understanding of its development would depend upon a thorough knowledge of so-called oriental languages – Persian, Coptic and Hebrew – whose study was promoted as a means to analyse hieroglyphic and cuneiform texts.

25

The Behistun monument, as first recorded by its discoverer, Sir Henry Rawlinson, in 1835

The emphasis upon visual evidence as the primary means of access to the history of writing and the alphabet shifted with the 19th century decipherment of Egyptian hieroglyphics. Once it was realized that the means of understanding these distinctly visual forms was through their connection to the sound of the ancient Egyptian language, the power of visual characters as a coded form of information declined. If that most visual of all written forms, the hieroglyph, was comprehensible only because it served to transcribe sounds or words, then the letters, mundane and unintriguing by contrast, could hardly be granted symbolic power or bear historical information through merely visual means. Visual forms could and would be used for the basis of script comparison, a practice which is still a major tool in the study of epigraphy, but the image would no longer be granted the metaphoric status of a key to unlock hidden mysteries. Certain perceptive scholars knowledgeable about the Jewish religion, such as William Warburton, whose *Divine Legation of Moses* was a major 18th-century treatise on religion, faith and the differences between Christian and Jewish teachings, pointed out in his analysis of the typologies of language and writing that Moses would have refrained from using symbolic images or modifying any pictorial forms in accord with the commandment prohibiting graven images.

The 19th-century confluence of linguistic and archaeological methods resulted in several discoveries which are pivotal to the investigation of alphabet history. One of the major obstacles to progress in establishing the history of the alphabet was that the authority of the classical texts which asserted a Phoenician source went undisputed, and yet the identity of the Phoenicians themselves remained unclear. The Phoenicians were held in high esteem in the early part of the 19th century, and were considered to be the source of culture, inventions and significant advances in the fields of technical knowledge which they had passed on to the Greeks, among others, along with the alphabet. There was no evidence whatsoever on which to link the alphabet with the Egyptian writing systems, and the operative assumption even among classical and Semitist epigraphists was that the alphabet had been invented independently of any other written form. In 1853, for instance, the *Encyclopedia Britannica* entry on the alphabet asserted that it was impossible to trace the origins of the alphabet, and that therefore 'we must ascribe it, with the Rabbins, who are prepared with authenticated copies of the characters they used, and of those of Seth, Enoch and Noah, to the first man, Adam; … or we must admit that it was not a human, but a divine invention.' This entry, cited by Isaac Taylor in his authoritative work on the alphabet, was a familiar solution to the problem of origins, but Taylor presented it as 'curiously antiquated' given the rapid changes occurring in the field.[7]

As the field of epigraphy became more firmly established with landmark publications in the first half of the 19th century, relations between the Greek alphabet and its Semitic antecedents began to be defined in judgmental terms which claimed marked superiority for the Greeks on the

26

basis of their clearly notated vowels. The two branches of epigraphic study were separated by more than the geographic specificity of the regions to which their studies assigned them; debates on methods of dating, and of the relative merits of the two versions of the alphabet began to take form. The distinctions between an alphabet with notated vowels and without, and the debates it has engendered, remain one of the more intense areas of scholarly contest in contemporary alphabet studies. By the end of the 19th century, however, alphabet scholarship had established a solid basis in philological analysis of language form and development aided by archaeological evidence. In many ways the gulf which separates Edmund Fry's 1799 publication and the comprehensive assessment of alphabet research published by Philippe Berger in 1892 is wider than any opened in the two previous millennia. There is a major conceptual distinction between Fry's eclectic gathering of typefaces, legends and mythology and Berger's cautiously circumscribed account, the result of a 19th-century approach to epigraphic research which took the natural sciences as its model.

The date of Fry's publication coincides with the discovery of the Rosetta Stone. The breakthrough in understanding the Egyptian language and the linguistic operation of the hieroglyphs had profound effects on research into the origins of the alphabet. Before the decipherment of Egyptian hieroglyphics, and their related cursive forms of hieratic and demotic, there had been no reason to look to Egyptian sources for the alphabetic letters. It had been so deeply ingrained in Western thought that the writing systems were grounded on fundamentally distinct principles, that only the clear evidence that there was a phonetic basis for at least a significant portion of the hieroglyphs provided the impetus to look for a link of some kind. Up until that point, the efforts of classicists in tracing the development of Greek writing had never reached beyond the Phoenician letters and their immediate Semitic antecedents. On the basis of both classical authorities and visual similarities, the Phoenicians were still considered the single original source for all later alphabetic development. There had been neither artifacts nor linguistic evidence on which proto-alphabetic letter forms could be traced.

Greek and Latin epigraphy and paleography were prominent scholarly fields in the early 19th century. An exhaustive attempt to publish all known examples of Greek inscriptions had been initiated by the classicist August Bockh in 1828 in Berlin (this project, now known as the *Inscriptiones Graecae* is still underway).[8] Though Greek epigraphy was firmly established, questions about the earliest origins of the pre-Greek letter forms remained unasked. Semitic epigraphy had also gained a firm foundation during the same period, largely through the efforts of Wilhelm Gesenius, who published and deciphered the full corpus of known examples of Phoenician writing in 1837. Gesenius' work remained a major source for understanding the extent of Phoenician culture and influence in the ancient Near East and West throughout most of the century, and participated in the general high estimation in which Phoenician culture was

27

Phoenician inscription (Wilhelm Gesenius, *Scripturae Linguaquae Phoeniciae Monumenta*, Leipzig, 1837)

Coins with Phoenician letters
(William Gesenius, *Scripturae
Linguaquae Phoeniciae
Monumenta*, Leipzig, 1837)

28

held as an influence on the Greeks, but his actual knowledge of the Phoenician language was fragmentary and undeveloped. These publishing projects were supplemented by new archaeological evidence of Phoenician expansion to Cyprus, Crete, the Greek islands and mainland as well as increasingly detailed understanding of the various waves of invasion and migration which changed the political geography of these regions in the same period in which alphabet diffusion had occurred. Meanwhile, scholarship in the early development of the alphabet in the Levant advanced with the investigation of ancient Semitic languages and important archaeological discoveries. The Moabite stone, or stele of King Mesha, found in Dhiban in 1868, seemed to preserve an archaic form predating the Phoenician letters. The sarcophagus of Eshmunazar, the king of Sidon, inscribed bowls from Lebanon and other objects began to provide enough evidence to suggest that the development of the alphabet had been extensive both chronologically and geographically before the Phoenicians had diffused it along their trade routes.

Chart of Phoenician letters
(William Gesenius, *Scripturae
Linguaquae Phoeniciae
Monumenta*, Leipzig, 1837)

Title page of Prisse d'Avennes,
(*Le Papyrus,* Paris, 1847)

Portrait of Prisse (Prisse
d'Avennes, *Le Papyrus,* Paris, 1847)

In his 1845 publication, *The One Primeval Language*, Charles Forster had proposed that there was a link to be found between the old Semitic writings and those of the Egyptians. While Forster's methods in part depended on his desire to unify the entire history of human culture in a single point of origin, and thus reconcile the scriptures and modern historical knowledge, he was shrewd enough to work from another more evident fact. The geographic proximity of the Semitic writings and the Egyptian culture with its well-developed hieroglyphic script suggested to him an obvious point of influence and transmission. Examining evidence from Wadi Mokatteb and Djebal Mokatteb, a valley and mountain in the Sinai, Forster promoted the idea of an ancient Semitic script. He remained puzzled, having inadequate means of dating, at what he thought was the cotemporaneous existence of two different scripts. If the Jews were using an Egyptian-influenced writing when they were wandering in the desert, then Forster was at a loss to account for the separate existence of scriptural Hebrew. Forster must have been aware of the five hundred years which separated the date of the Sinai inscriptions and the period of Moses' wanderings, since the date of the exodus is set at around 1250 BC and the period of the Hebrews' migration into Egypt is recorded in the Old Testament five centuries earlier. (In fact, the scriptural Hebrew to which Forster referred was of a later date than either of these events, but he would have had no material from which to make comparisons or draw conclusions.)

The original and much celebrated work of Emmanuel de Rougé, first read before the Academie des Inscriptions et Belles Lettres in 1859, brought solid credibility to the suggestion of an Egyptian origin for what Rougé referred to as the Phoenician alphabet. Rougé's work was first published posthumously in 1874 through the efforts of his son, who bemoaned the long delay. It seems the original manuscript of the 1859 talk had somehow disappeared in the course of being circulated among interested scholars, and though Rougé had intended to rewrite it, it was on the basis of a rough draft found in his deceased father's notes that his son brought the final publication into being.

Rougé grounded his propositions in a more thorough understanding of the relations between Egyptian writing, the sounds of the Egyptian language, and the possible application to the Semitic languages than any previous scholar. Though he was essentially speculating, he constructed a probable (but ultimately inaccurate) set of correspondences, between alphabetic letters and Egyptian hieroglyphs, and his work set the direction for subsequent research. Rougé systematically analysed the phonetic values of the hieratic cursive form of the Egyptian hieroglyphics and compared them to the phonetic values of Semitic languages. The visual samples of hieratic script from which he worked were provided through the discovery of three papyri which were written in an older form of hieratic than any known previously. The most famous of these, known as the Papyrus Prisse after its owner, was published in facsimile in 1847. This early hieratic contained barely a trace of the pictorial forms of the

Facsimile of papyrus (Prisse d'Avennes, *Le Papyrus*, Paris, 1847)

30

Part of the Egypto-Phoenician alphabet, according to Emmanuel de Rougé (De Rougé, *Memoire sur l'origine Egyptienne de l'alphabet Phoenicienne*, Paris, 1874)

hieroglyphs, and it was their distinctive schematic form from which Rougé was able to obtain the characters he suggested were the prototypes of the Semitic letters. This particular set of correspondences, mapped in a table comparing the Egyptian hieratic with Phoenician and Greek forms, was based entirely on correlations of sound values. For the sounds represented by the twenty-two characters of the Phoenician alphabet, Rougé found hieroglyphic and hieratic signs, to which the forms of the schematic Phoenician letters were supposed to bear a strong visual resemblance, thus bearing out the connection of phonetic value. In Rougé's table, the hieroglyphic picture value for the sound 'a' was indicated with an eagle, with the schematic hieratic form next to it, followed by the familiar Phoenician 'A' in its shifted orientation. Rougé's sound values may have correlated, but the visual sources he had chosen were wrong – that same 'A' would eventually be linked to the ox-head and its name 'aleph.' This absence of visual similarity between Egyptian sources and alphabetic letters was pointed out by his critics, but in general Rougé's theories met with wide acceptance. Though his specific speculations have been largely disproved, the principle on which Rouge worked and his primary assertion that the Phoenician alphabet had an Egyptian origin were both suggestive, and have been developed further by 20th-century partisans of this position. In addition, an important concept had its germination here: the idea of the pictorial origin of the schematic letter forms of the alphabet.

The introduction to Rougé's published work was addressed to François Lenormant in acknowledgment of his subsequent work in the field. Between Rougé's 1859 paper and the 1873 publication the important discovery of the Moabite stone had occurred at Dhiban. Lenormant had used this object as the means to construct what he believed was an ancient form of the Phoenician alphabet. Though the Moabite stone is now dated to the 9th century BC (and its script identified as part of an early branch of the Canaanite alphabet of which Phoenician is another) the antiquity of the alphabet had begun to be pushed back beyond the assumed point of its transmission to the Greeks in the 11th century BC. This intensified the rift between Semitist and classical epigraphers: Lenormant wrongly insisted that of the many alphabetic forms derived from the Phoenician, Greek was the oldest, while other scholars were convinced of the greater antiquity of

Moabite Stone, Louvre

scriptural Hebrew. But it was becoming apparent that to accommodate the many variations in the form of Semitic scripts a more complex model of an older proto-alphabet would have to be developed. Issues such as the direction of alphabetic writing and the sequence of letters of the alphabet were not considered by Lenormant, who simply did not have the materials on which to make such assessments. Script comparison of the external form of the letters remained the primary means of dating alphabets and tracing their relations, but the analysis of internal forms, the relations of letters to phonetic values, became an additional tool. The model of the tree diagram, with its obvious 19th-century affinity with the organic image of evolution as linear, progressive and continually divergent came to the fore. Though criticized by 20th-century scholars as reductive, such charts still provide a useful means of schematizing alphabet development.

The major figure in alphabet history in the late 19th century was Isaac Taylor. His two-volume publication on the subject in 1899 (and Philippe Berger's equally conscientious, if less exhaustive publication in 1892) summarized the considerable research on the topic. Taylor's work, to which greater consideration will be given here in acknowledgment of its greater breadth and originality, supported the image of Phoenician maritime expansion as the means of alphabet transmission, and assessed the developments in theories of the Egyptian origins. Taylor stated at the outset the clear superiority he accorded alphabetic writing over that of other scripts, whose complexity led to the 'degeneration of religion into magic, knowledge into superstition, and the increased caste separation of the learned rulers from their unlettered subjects.' By contrast, a civilization which adopted alphabetic writing was capable of unlimited progress. Taylor's language contained many metaphors of family – the early letter forms were in their 'infancy' he characterized his work as a continual search to establish the 'paternity' and 'lineage' of forms.

Taylor was evidently convinced by Rougé's arguments (he only briefly mentioned Lenormant) though he was careful to discuss the objections and criticisms which had been raised about positing relations between the sounds of Egyptian and Semitic languages. On the basis of Rougé's proposals, he constructed a chart showing what he considered to be the derivation of the modern European letter 'm'. The resulting genealogy, fictitious in its roots, and ultimately incorrect as an explanation of the transformation of this letter, was accompanied by an equally imaginative discussion in the text. Taylor took his point of departure from the Moabite stone, which was, at the time, the oldest known example of Semitic writing. Taylor unhesitatingly (and correctly) identified an early long-tailed form of 'm', or *mem*, in that inscription, which he then connected 'without difficulty' to the hieratic prototype, a schematic form of the hieroglyph *mulak*, whose visual form was the figure of an owl. He proceeded to elaborate on the visual similarities, comparing the hieroglyphic sign to the capital letter 'M', and pointing out that 'the two peaks [of the letter], which are the lineal descendants of the two ears of the owl, still

31

retain between them a not inapt representation of the beak, while the first of the vertical strokes represents the breast. In the script form 'm', the central hanger stands for the beak, on either side of which are seen the two curves which represent the ears.' Taylor's method of arriving at these detailed conclusions combined sheer daring with careful observation in accord with state-of-the-art scholarship. He fell into the major pitfall of such research: the highly schematic forms of the alphabet can be made to correspond with a nearly endless variety of more complex pictorial images, and thus, seem to be 'derived' from them. Since he had phonetic correspondences as a basis, Taylor inferred the visual correspondences. As in the case of his predecessor Rouge, this led, as much by accident as method, to his being correct for only two out of twenty-two values in his tables.

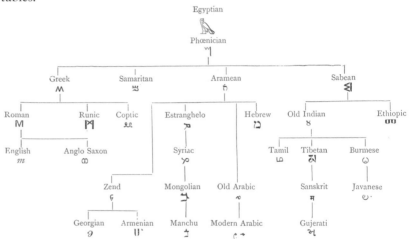

Derivation of the letter M according to Isaac Taylor (*The Alphabet*, London, 1883)

This blend of careful research and imaginative invention was characteristic of Taylor, who in keeping with his contemporary colleagues was prone to shift between biblical, classical and contemporary texts, quoted the 1st century historian Josephus alongside passages from Exodus and the work of 18th- and 19th-century historians – without any apparent change of register. Inevitably, this diverse field of sources led to mixed results. Taylor's attempt to be exhaustive produced contradictions within his text. While on the one hand he cited and endorsed Rougé's work asserting Egyptian origins, he included another chart which listed the Hebrew alphabet as if there were no connection between the two. In the second chart the names and phonetic values of the letters were juxtaposed, showing their acrophonic relation. The question of whether such names and objects were merely a mnemonic device for learning the alphabet and therefore utterly arbitrary was answered in the affirmative by Taylor, who had no reason to forge further links between the letters of the Hebrew alphabet and the objects represented by their names. It is significant that while Taylor listed the 'names' of the letters he never gave the correct visual image – the only 'forms' he placed in the chart were the square modern Hebrew letters – letters even more remote from the pictorial origins of the

IDEOGRAMS AND PHONOGRAMS.

II

alphabet than the Greek forms. To support the hypothesis of the arbitrary character of the Semitic names of the letters, he quoted a children's nursery rhyme as a parallel example. According to Taylor the relations proposed in 'A was an Archer who shot at a frog, B was a Butcher who had a great dog, etc.' were as credible as the equation 'A=aleph=oxhead'. But the techniques which had helped Rougé make such profound progress in his work also furthered Taylor's research – the systematic analysis of the sounds of the Egyptian language in phonetic terms and an investigation of the correlation between these sounds, the sounds of Semitic languages, and their representation by written signs. The alphabet was coming out of its isolation and gradually being connected to the historical context of cultural developments in the geographic region of its invention.

AFFILIATION OF EGYPTIAN AND SEMITIC ALPHABETS.

Values.	EGYPTIAN.		SEMITIC.	LATER EQUIVALENTS.			
	Hieroglyphic.	Hieratic.	Phœnician.	Greek.	Roman.	Hebrew.	
a	eagle			A	A	א	1
\bar{a}	crane			B	B	ב	2
k (g)	throne			Γ	C	ג	3
t (d)	hand			Δ	D	ד	4
h	mæander			E	E	ה	5
f	cerastes			Y	F	ו	6
z	duck			I	Z	ז	7
χ (kh)	sieve			H	H	ח	8
θ (th)	tongs			Θ	...	ט	9
i	parallels			I	I	י	10
k	bowl			K	K	כ	11
l	lioness			Λ	L	ל	12
m	owl			M	M	מ	13
n	water			N	N	נ	14
s	chairback			Ξ	X	ס	15
\dot{a}		O	O	ע	16
p	shutter			Π	P	פ	17
t' (ts)	snake			צ	18
q	angle			...	Q	ק	19
r	mouth			P	R	ר	20
\check{s} (sh)	inundated garden			Σ	S	ש	21
t	lasso			T	T	ת	22
	I.	II. III.	IV.	V.	VI.	VII.	

Affiliation of Egyptian and Semitic alphabets (Isaac Taylor, *The Alphabet*, London, 1883)

33

		Usual Notations.	Standard Alphabet.	Missionary Alphabet.	Glossic.	Palæotype.	Gesenius.	Ewald.	A. V.	Vulgate.	LXX.	Arabic.
Aleph	א	a, e, 'a	'	'	l	I	'	'	e, a	a, e, (o)	α, ε (η, ο)	ا
Beth	ב	b	β	ب
Gimel	ג	g	γ	ج
Daleth	ד	d	δ	د
He	ה	h	h	'(h)	h	н	h	h	h, a	a, (o,)	a, (o,)	ه
Vau	ו	v, w, u	u	w	v	v	v	v	o, u, v	o, u	ου, ω, ο, υ	و
Zayin	ז	z	s	z	z, (zz)	z, (sd)	ζ (σδ)	ز
Cheth	ח	ch, kh	χ	'ẖ	kh	kh	ch	ch	h, (ch)	ch(e,h,a)	χ(ε,α)	خ
Teth	ט	t, ṭ	ṯ	t, 't	't	t	t'	t'	t, tt	t	τ	ط
Yod	י	y, i, j	i	y	y	J	j	j	j, (e, i)	j, i, e	ι, η, ει	ي
Kaph	כ	k, kh (c, ch)	c,ch,(cc)	ch, c	κ, χ	ك
Lamed	ל	l	λ	ل
Mem	מ	m	μ	م
Nun	נ	n	ν	ن
Samekh	ס	s	s	ſ	s	s	s	s	s	s	σ	س
'Ayin	ע	'a	;	'h	ː	g	a	gh	a, g, e, ah (i, o, u)	g, h, a e, ee, o	γ, α, ο υ, η, η ε, ε, εε	ع
Pe	פ	p, ph	π, φ	ف
Tsade	צ	ts, ṣ, ç	ṣ	ẓ	's	s	z	ß	z, (zz, ss, t)	s, (t, ss)	σ, (τ)	ص
Qoph	ק	q, q'	q	q	'k	κ	k	q	k (c, kk)	c (ch, k)	κ	ق
Resh	ר	r	ρ	ر
Shin	ש	sh, š, s	š	s('y)	sh	sh	sch	sch	sh (s,ss)	s (ss, t)	σ (σσ,τ)	ش
Tau	ת	t, th	τ, θ	ت

34

Transliteration of Semitic letters (Isaac Taylor, *The Alphabet*, London, 1883)

There are other important historians and theorists of the alphabet renowned in the 19th century such as Philippe Berger (whose history of writing was composed as part of an 1889 exhibition of work and industry) and Henry Noel Humphreys, but the fields of research on which alphabet history drew were rapidly becoming so specialized that major synthetic works of Taylor's type ceased to be produced. The next set of important discoveries were made by archaeologists; these rapidly rendered the textual evidence of antiquity if not precisely obsolete, at least of secondary importance in alphabet studies. Noted Semitist epigraphists such as G.A. Cook and Mark Lidzbarski laid the authoritative groundwork for modern Phoenician epigraphy with their turn-of-the-century publications.

But soon the discoveries made by W.M. Flinders Petrie in 1904–5 at an archaeological site in the Sinai unearthed evidence of an Egyptian origin

of the Semitic alphabet. The site was older than the sites in which Phoenician and Hebrew inscriptions had been found, and the evidence inspired new directions in alphabet studies. Petrie was excavating an area in which turquoise and copper mines had been active around 1700 BC. He found a series of inscriptions in caves, mine entrances and temples which had obvious visible links to hieroglyphics and yet were demonstrable examples of a Semitic, not Egyptian, language. Petrie's discovery had other implications, since the number of elements contained in his signary (his term) exceeded the number contained in the alphabet used by the Phoenicians. He proposed that this signary had been diffused around the area of the Mediterranean coast and trade routes, and that it only became reduced and fixed in form at a later date. He believed, for instance, that both the Greek alphabet and the Phoenician alphabet had been formed independently from this widely used signary. The materials which resulted from Petrie's research proved more viable than his own interpretation of them and provided the basis for investigating an early source for the alphabet, one which preceded the Phoenician dissemination, and which extended the period in which both development and transmission had occurred.

A decade after Petrie's original discoveries, Alan Gardiner proposed that at least one word in the Sinai inscriptions could be read. This contradicted Petrie's notion that they were merely crude pre-alphabetic signs. Gardiner read the Semitic name of the goddess B'lat (or 'Ba'alat'), the 'mistress of turquoise' known to the Egyptians as Hathor, in a number of the artifacts found in the Sinai site. Though he could not establish with clear authority the phonetic value, or even the stable visual form of the rest of the signs in the Sinaitic inscription, Gardiner was convinced by a number of factors that this was the prototype of all the alphabets: it had historical priority, was visually related to both hieroglyphics and later alphabetic forms, and he was convinced it recorded a Semitic script. Gardiner's position was taken up by a number of other scholars. Godfrey Driver, for instance, determined that the alphabetic character of Petrie's so-called signary was well established in this early period in the Sinai. Driver found evidence that this alphabetic order was sufficiently fixed to serve as a guide for workmen in the consecutive assembly of building elements. The idea of the Sinaitic origin of the alphabet found a strong proponent in F.W. Albright, which continues to be promoted by his student Frank Cross, both of whom supported the archaeological evidence with careful linguistic research. There are challenges to this theory, however, and the geographically dispersed archaeological evidence from the Levant continues to challenge epigraphists and scholars in their search for the origins of the alphabet.

One technical point, however, should be made before going on to the outline of the history of the alphabet as it is currently understood. Changes in printing and the techniques of image reproduction have had an enormous impact on the study and publication of research in the field of

Sinai inscription (l)b'lt (British
Museum, London)

epigraphy. In his introduction Isaac Taylor bemoaned the expense of the
publication on the history of the alphabet occasioned in large part by the
unavailability of printing types to serve the purpose of representing the
many scripts he was describing. Taylor's complaints indicate just how far
epigraphic research had outstripped the commercial return to be made by
creating printing types for little-known and barely available versions of
written scripts. The major impetus to the cutting and founding of such
types had come from either colonial expansion or missionary proselytiza-
tion (or some combination of the two) and there was little to be gained in
either domain by cutting types to represent an extinct language of a long
vanished culture of the ancient Near East.

There are several sites which compete for claims to having fostered
development of the proto-alphabet in the period between 1700 and 1500
BC. The oldest and to many scholars most convincing evidence is that
from the Sinai, from the extensive materials gathered in the excavations at
Serabit El-Khadem which were the source of the inscriptions from which
Flinders Petrie composed his original signary. There are, however, both
visual and linguistic reasons to suggest that the process of alphabet forma-
tion may have occurred in several other locations at more or less the same
period and under influences besides that of Egyptian hieroglyphs. There
are four main areas in which materials have been found which indicate
early stages of alphabet formation. The furthest north of these is the area
near present-day Ras Shamra in Syria (the site of the ancient city of
Ugarit); the second is at the site of the ancient Phoenician port of Byblos,

on the coast of present-day Lebanon; the third is in ancient Palestine; and finally, the area of the mines in the Sinai peninsula. The evidence for each of these will be examined in turn, but a note about the languages of the region is a necessary preliminary.

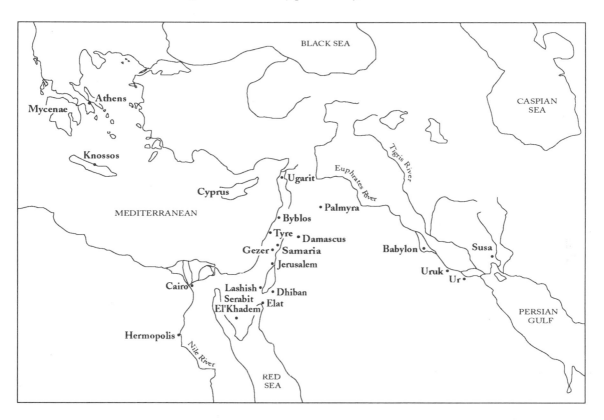

Map of region of the Mediterranean in which the alphabet was developed

The chief language type of the ancient Near East was Semitic, and represented by several major branches: Akkadian in the Mesopotamian valley, Aramaic in Syria and upper Mesopotamia, Canaanite (Phoenician), old Hebrew, Arabic (which is the main form in use in modern times), and other less dominant branches such as Amharic, the Semitic language of Ethiopia. Remnants of early Aramaic are still found in parts of Turkey and Iraq and into the Caucasus region.[9] Contemporary Hebrew is a modern revival of a branch of the Aramaic language used in the Persian empire, and has little relation to the ancient Hebrew (still preserved by the Samaritan sect as a ritualistic written language). While the alphabet was first used and modified by the Semitic speakers, it was, as most writings, adaptable to other languages. Just as the Akkadians had borrowed their cuneiform from the non-Semitic speakers of Sumer, and the Semites appropriated the written marks of the Egyptian language, so the alphabetic forms would find ready reception among the 12th to 9th century BC invaders from the north and east who spoke mainly Indo-European languages. The chief difficulty in such transmission is the notation of sounds which do not exist in the language from which the script is borrowed. The

37

most extreme example of this is perhaps the 19th-century invention of the Cherokee script by Chief Sequoyah, who merely used the alphabet as he might have any other set of written marks and arbitrarily assigned them the values of sounds in the Cherokee language. More modest adaptations have been a feature of alphabet dissemination throughout the last three thousand years, and many alphabets, such as Ethiopian, Cyrillic and the Runic *futhark* added additional letters to accommodate sounds specific to those languages. Old English incorporated at least two letters from Runic, the *thorn* and *wen*, which were later dropped as the Latin alphabet

38

ꭰ	ə	ꭱ	e	ꭲ	i	ꭳ	o	ꭴ	u
ꭶ	ga	ꭸ	ge	ꭹ	gi	ꭺ	go	ꭻ	gu
ꭽ	ha	ꭾ	he	ꭿ	hi	ꮀ	ho	ꮁ	hu
ꮃ	la	ꮄ	le	ꮅ	li	ꮆ	lo	ꮇ	lu
ꮉ	ma	ꮌ	me	ꮎ	mi	ꮏ	mo	ꮊ	mu
ꮓ	na	ꮄ	ne	ꮑ	ni	ꮓ	no	ꮔ	nu
ꮖ	gwa	ꮗ	gwe	ꮘ	gwi	ꮙ	gwo	ꮚ	gwu
ꮞ	sa	ꮞ	se	ꮟ	si	ꮠ	so	ꮡ	su
ꮣ	da	ꮥ	de	ꮧ	di	ꮩ	do	ꮪ	du
ꮭ	dla	ꮮ	dle	ꮧ	dli	ꮯ	dlo	ꮬ	dlu
ꮳ	dza	ꮴ	dze	ꮵ	dzi	ꮶ	dzo	ꮷ	dzu
ꮺ	wa	ꮻ	we	ꮼ	wi	ꮽ	wo	ꮘ	wu
ꮿ	ya	ꯀ	ye	ꮁ	yi	ꮀ	yo	ꯂ	yu
ꭵ	ö	ꭱ	gö	ꮂ	hö	ꮄ	lö	ꮎ	nö
Ɛ	gwö	ꮢ	sö	ꮩ	dö	ꭾ	dlö	ꮯ	dzö
ꮼ	wö	ꮄ	yö	ꮧ	ka	ꮪ	hna	ꭼ	nah
ꮥ	s	ꮤ	ta	ꮦ	te	ꮨ	ti	ꮭ	tla

Cherokee syllabary signs
invented by Chief Sequoyah

became the accepted standard.[10] However, all the early alphabets of the Levant were invented to record Semitic languages, and they are structurally well-suited to these languages. The terms Canaanite and proto-Canaanite are used to describe the early alphabet, with the assumption that the various transformations in the written system all derived from one basic source.

The arguments for a Sinaitic invention are supported by the age of the archaeological site and the correspondences which have been made between the visual system of letters and the sounds of the Semitic language.[11] Certainly the conditions were favorable to fostering development of a phonetic script by borrowing both the forms and concept of writing from the Egyptians. The inscriptions discovered by Flinders Petrie and subsequent scholars were hybrids of the known examples of Egyptian hieratic signs and later Semitic scripts. The language in which they were written was clearly Semitic, not Egyptian, and the people working in this region, the Seirites (known as Kenite or Midianites in the Bible) were a pre-Hebrew group whose culture gave no hint of Yahweh or of Jewish religious practices (the beginnings of which are dated much later, to the 12th or 13th century BC). The character of the inscriptions would give them an early date, even if they were not so firmly linked to the archaeological site: they do not have a fixed direction, they move from right to left and vice versa unsystematically, and the Seirite letter forms are crude, unstable, and inconsistent. The premise is that once such features became stabilized, they remained so, and since the Phoenician form of the alphabet reached relative consistency in the 11th century BC, any system in which such elements are not fixed is generally assumed to predate the Phoenician.

39

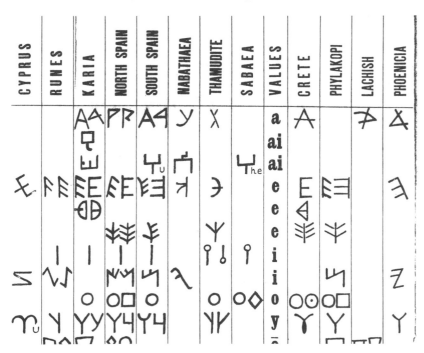

Part of the signary which served as source of the alphabet in Petrie's theory (W.M. Flinders Petrie, *The Formation of the Alphabet*)

El Khadr arrowheads with early alphabetic inscriptions (British Museum, London)

The Sinai inscriptions were ultimately determined to contain 22 symbols, and there are no notations of vowels in the writing. The practice of non-vocalic notation, as it is termed, remains common in the writing of modern Arabic and Hebrew, whose roots are consonantal in structure, and only exceptionally require vowel notation for clarity. One of the chief points of dispute with regard to the Sinai inscriptions was their readability. David Diringer, the authoritative alphabet historian, continued to state unequivocally (as late as the revised 1968 edition of his definitive work *The Alphabet*) that only the single name 'B`lat' had ever been spelled out in the Sinai inscriptions (Petrie had been more concerned about the fact that the signs were visually very crude by contrast to the Egyptian sources). Albright, however, said in 1948 that he had identified 19 out of the 25 or 27 Sinaitic signs, and that the inscriptions were a vulgar form of Canaanite. The connection between the signs and their various sounds was largely based, in Albright and Cross's work, on the fact that the name of the letters and the objects depicted could be construed as the same: the 'a=aleph=image of ox's head' concept of the pictorial origin of the alphabet. The signs are thus supposed to be the 'missing link' between Egyptian hieratic and the Canaanite alphabet, but archaeological evidence is lacking to support the progress from Sinaitic inscriptions to full-fledged alphabet. This evidence was supplied in part by the discovery of five arrowheads found in the mid-20th century at El Khadr. Dated to around 1100 BC, they show evidence of forms resembling the Sinai pictographs midway in an evolution to the schematic linear form of the Phoenician letters. According to Cross, these provide the evidence of the connection between the old Canaanite proto-alphabet of Sinai and the Phoenician system. This early system is also referred to as South Canaanite, and the system had signs for five phonemes beyond those which form the Phoenician script. The question of whether alphabets proceed from longer to shorter systems has also been a subject of debate, with the general consensus leaning toward additions over time, but not eliminations. For the Sinai/Canaanite/Phoenician theory to be fully proved, some evidence of the geographic distribution of the script up through the regions to the north in the period between 1700 and 1500 BC must be discovered. What seems more likely, given the current evidence, is that the alphabet was being developed under a number of similar linguistic and cross-cultural influences simultaneously in several regions around the Levant, and that the Sinai inscriptions provide one important contribution to the ultimate consolidation of a single writing system.

Egyptian contact with the Semitic people was not limited to the Sinai, and these inscriptions may be the 'mother-alphabet' they are considered by many scholars or only one among several instances of invention. The spread of writing as both concept and specific form throughout the region stretching north along the Mediterranean coast resulted in fairly rapid diversification. Another site of frequent and developed contact between Egyptians and the Phoenicians was at Byblos, where papyrus was imported

and timber, in short supply in the Nile valley, was exported. The Greeks also had important contact with the Phoenicians at Byblos a few centuries later, in fact the Greek name for papyrus, *biblos*, which worked its way into the language as the basis of the Greek word for book, *biblion*, was taken from the name of the Phoenician city. Working in this region in the 1930s, the French archaeologist Maurice Dunand found a number of inscriptions on bronze tablets and spatulae which are in a different form of old Canaanite script. This script is termed pseudo-hieroglyphic, but all the Phoenician letters except two have prototypes among their forms. Dunand posited the dates of these inscriptions as early (or even earlier) than the Sinai inscriptions, and suggested that they were, similarly, the product of a Semitic-speaking people inventing a writing system under the influence of the Egyptians. The arguments for this script as the prototype of the Phoenician alphabet is based on geographic proximity, the direction of writing (both read from right to left) and the fact that some documents have been found which contained both scripts. The number of signs in the pseudo-hieroglyphic script was considerably larger in number than in the Phoenician, however, and apparently constituted a syllabary. There are no other documented instances of reduction of syllabary scripts to phonetic scripts, and the structural principles on which they are based are sufficiently different to make such a transition unlikely. Again, archaeological evidence is not forthcoming to trace a continuous transition supporting this pseudo-hieroglyphic as the original alphabet, but what is quite clear is that the concept and practice of writing had developed in the region well before the Phoenician script consolidated.

A considerable number of other early Canaanite inscriptions dating as far back as the 18th century BC have been found throughout the region near Byblos, as well as Gezer and Lachish. Early, middle and late periods of this Canaanite script are distinguished in inscriptions on seals, daggers, bowls and other pottery. David Diringer pointed out that the dates defining these periods correspond, roughly, to the Age of the Patriarchs (1700 BC), the Age of Joshua (1400–1300 BC), and the Age of the Judges (13th–12th centuries BC), and that the lacuna corresponds to the period of Israelite oppression in Egypt. All of these scripts are clear antecedents to the Phoenician, and have been used to support the theory of the Sinaitic invention of the alphabet, with these Canaanite inscriptions (found throughout the region of ancient Palestine) functioning as the geographic and chronological transition between the pictographs and the linear forms. One of the problems with this suggestion is reconciling the early dates of the first of these Canaanite inscriptions – in some cases as early or earlier than their Sinai inscriptions – with a chronological development. In fact, the early Canaanite inscriptions also offer strong evidence for the simultaneous development of several independent attempts at alphabetic writing,

A sarcophagus inscription found near Byblos by Paul Montet in 1923 is debatably the oldest of a group of Northern Semitic examples of the alphabet. The text is an epitaph praising King Ahiram, and has been dated as

41

early as the 13th century BC. The North Semitic alphabet is the closest immediate antecedent to the Phoenician, and other artifacts in this script, such as the Gezer agricultural calendar are found into the first millennium BC. The direction of the writing, the form, number and sequence of the letters all correspond to the Phoenician characters, though the question of original sources remains. There is considerable contemporary debate over the dating of the Ahiram sarcophagus, and the discussion of its forms is a prominent element in the struggles between classicists and Semitist scholars over the date of transmission of the alphabet from this region to the Greeks.[12] There is strong evidence to suggest that the alphabet of this inscription provided the prototypes for the Greek script, and that the date of transmission was about this time. In that case, the Greek alphabet would be one of the several branches of original Canaanite, like Phoenician, early Hebrew, and the much earlier offshoot of South Semitic alphabets.

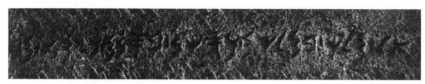

Detail of inscription on the tomb of King Ahiram, found in 1923.

Transcription of the Ahiram inscriptions

There was one other point of development of an alphabet in the Levant, and that was at Ugarit on the shores of the Mediterranean north of Byblos where an alphabetic cuneiform was developed around 1400 BC. Consisting of about thirty-two signs, including three vowels, twenty-nine consonants and one additional sign which functioned as a word separator, this alphabet, which came to be called the Ugaritic cuneiform alphabet, was another instance of adoption of an extant writing system by a Semitic-speaking people. The internal structure of the script, and its well-organized phonetic structure, suggested that it was a cuneiform script adapted to a pre-existing model of alphabetic writing. Since the only phonetic writing system in the region was the alphabet, this seems likely: all other cuneiform scripts were used for syllabaries. The Ugaritic writing had a fixed left to right direction, and was put into use as far west as Cyprus as well as throughout areas of Syria/Palestine in the 13th and 12th centuries BC. The texts of these Ugaritic tablets are tales and myths, and from the series of discoveries made there beginning in 1929, the script is known as the Ras Shamra alphabet. The key to this alphabet was the 1948 discovery of an abecedary which uses the traditional sequence of the Semitic alphabet. In 1955 a bilingual tablet of Akkadian and Ugarit cuneiform allowed the definitive decipherment of Ugarit, making absolutely clear its alphabetic character. The city of Ugarit was destroyed around 1200 BC, and the cuneiform syllabary, whose functional efficiency was limited only by the awkwardness of clay tablets, met its demise. In fact this issue of materials

is a significant one, since cuneiform could only be written with a stylus on wet clay, and its imitation in other materials was awkward and ineffective. The alphabet, by its linear and schematic form, lent itself to production in ink on papyrus as readily as in inscriptions on stone, pottery or metal.

After its earliest development, the alphabet stabilized as a writing system in Phoenicia, around 1100 BC. The South Semitic alphabets had already taken an independent direction around 1300 BC, possibly from the original Canaanite script. These alphabets long preserved a distinctive feature of the early script – its multidirectionality. From this branch developed many pre-Islamic scripts of the Arabian peninsula, and the Sabaean script which spread into North Africa and became the basis of first Ethiopic and then modern Amharic (still used in the Ethiopic Christian church). These alphabets (not to be confused with modern Arabic, which developed from a branch of the Aramaic alphabet somewhat later) fully notate their vowel sounds, typically a feature of later development, but they do so by modifying the consonantal signs with strokes added to the letter.

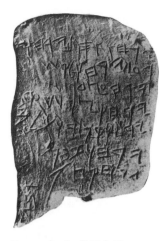

Gezer calendar (British Museum, London)

Ugarit cuneiform alphabet around 1400 BC

Ras Shamra alphabet (René Dussaud, *Les Découvertes de Ras Shamra*, Paris 1937)

No.	Sign	No.	Sign	No.	Sign
1.	ʾa	10.	ḥ	20.	ġ
2.	ʾe	11.	ḫ	21.	p
3.	ʾu	12.	ṭ	22.	ṣ
4.	b	13.	y	23.	ṣ́
5.	g	14.	k	24.	q
6.	d	15.	l	25.	r
7.	h	16.	m	26.	š
8.	w	17.	n	27.	ṱ
9.	z	18.	s	28.	t
		19.	ʿ		

43

As the Phoenician alphabet stabilized, the direction of writing became fixed in a right to left direction, and the sequence and orientation of the letters took on a permanent form. It was from this Phoenician form that the major branches of Greek and Aramaic derived, as well as the less successful old Hebrew and Punic forms. Old Hebrew developed in the 11th and 10th centuries BC during the time associated in biblical history with David and Solomon; it fell out of use after the fall of the Temple and Babylonian exile in the 6th century BC. Though preserved in the form of sect script Samaritan, old Hebrew was held in low esteem by the rabbinical Jews who adopted a chancellery script of the late Persian empire as the basis of the square Hebrew still in use today. Too little is known of the Punic forms of the Phoenician alphabet to be clear about their develop-

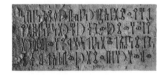

Sabaean inscription (British Museum, London)

ment, and there is ongoing research into the relations between Punic, archaic Greek, Etruscan and other alphabets which made their appearance in the Greek islands or on the Italian peninsula between 1000 and 800 BC. A particularly beautiful Etruscan abecedary is preserved from the 8th century BC, which shows a well-developed version of the linear Phoenician alphabet – though it may have had its immediate source in Greek writing.

[Facsimile page of the Pentateuch written in Samaritan script, nine lines numbered 1–9]

Page of the Pentateuch written in Samaritan (Friderico Uhlemanno, *Institutiones Linguae Sarmaratinae*, Leipzig 1837)

The major offspring of the Canaanite source were the two alphabets from which most modern systems derived: Phoenician and Aramaic. The alphabets to the east of Syria were offshoots of Aramaic, while the alphabets to the west derived from the Phoenician. Aramaic (the term refers to the writing system as well as to the language, which became the dominant language in the Near and Middle East in the latter half of the first millennium BC) developed in Syria no later than the 11th century BC but reached its greatest period of influence during the Persian empire. As the Imperial Aramaic it spread widely between the 6th century BC and the breakup of the Persian empire in 332 BC and spawned four major branches of national scripts: Syriac, Nabataean (the source of modern Arabic, Persian, and Turkish as well as Slavonic, Swahili, Malay and many other alphabets in use in Africa, Asia and parts of Europe), Palmyrene (which lasted into the 3rd century AD, when Palmyra was destroyed by the Romans), and the Jewish alphabet which led to modern Hebrew. A branch

Samaritan alphabets (Friderico
Uhlemanno, *Institutiones
Linguae Sarmaratinae*, Leipzig
1837)

Literae Samarit. vulgares.	Literae Sam. in codd. bibl.	Literae Sam. in codicibus Gothanis.	Literae Phoeniciae similes.

45

Etruscan abecedary, (Museo
Archeologico, Florence)

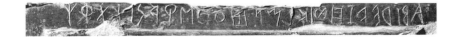

which was either early Aramaic or derived from its Canaanite prototype
spread to the non-Semitic languages of the Indian subcontinent by the 7th
century BC where it became the basis of Brahmi, Devenagari, Pali and the
scripts used throughout Burma, Tibet, and Indonesia.

,Phoenician inscriptions from 4th
century BC (British Museum,

Aramaic inscription from the
funerary stele of a priest, 7th
century BC (Louvre, Paris)

An active controversy in contemporary alphabet studies is the date
of transmission of the Greek alphabet. On this point hangs an intellectual
debate which has at its base an opposition between dating methods
of classical and Semitist scholars, some of whom would like to disclaim
the Semitic origin of the Greek alphabet. This debate took its most
extreme form in the work of A.E. Waddell, who in 1927 published a work
in which he claimed an Aryan origin for the alphabet. To do this he rede-
fined the racial and ethnic character of the Phoenicians as Aryans, rather
than Semites, and fueled his discussion with a rabid anti-Semitism. Most
of the controversy around Greek acquisition does not have this blatant
racist slant to it, though a persistent subtext is the concept of a Greek
superiority in the field of writing, as well as in its cultural application and
use, which has persisted in the classical tradition in Western Europe.

Since there is little archaeological evidence in Greece for the period
between the disappearance of the writing systems of Minoan Crete and

Mycenae, and its reappearance on the mainland between 750 and 700 BC, the problem shifts to the dating of Semitic inscriptions whose relation to the Greek prototypes of the 8th or early 9th century BC is largely assessed through script comparison. A long-standing component of this argument, still supported by many classicists, is the concept of a Greek Dark Age of illiteracy in the three hundred years following the destruction of Minoan and Mycenaean centers.[13] Writing in these early cultures was largely used for accounting purposes, and though the Linear B script of the latest Minoan era recorded a Greek language, the earlier scripts have no relation to Greek whatsoever. Tablets and records of taxes and transactions abound, but there are no instances of the literary writing which is a feature of the first classical inscriptions.

The supposed superiority of the Greek alphabet has traditionally been asserted on the basis of the full notation of vowels through independent letter forms. As evidence in the Ugarit alphabet and certain Canaanite inscriptions has revealed the presence of various vowel notations in the Semitic scripts, the hard and fast distinction between the Greek form and Semitic sources has blurred. The Greek alphabet derived directly from the Phoenician, as is evident by the comparison of letters, whose similarity leaves little doubt on this point (in contrast to, for instance, the Etruscan, which sometimes seems closer to the Greek forms than to the Phoenician originals). Early Greek inscriptions do not have a fixed direction, they can be written right to left, or left to right, or in a regularly alternating sequence known as *boustrophedon* after the pattern made by a plowing ox. This point, combined with the visual force of script comparison, suggests an early date of transmission – one closer to 1100–1050 BC than the 9th or 8th century BC date traditionally assigned – since after this period the Phoenician inscriptions do not have the variability of direction seen in the Greek inscriptions. The lack of evidence from excavations for any writing in the Greek mainland between the destruction of Mycenaean civilization and its syllabary in the 12th century BC and the appearance of jug and bowl inscriptions in the 8th or possibly 9th century BC has left ample room for debate. Of these latter, two striking examples are the Dipylon jug dated to around 740 BC and the so-called Nestor's cup, also dated to the 8th century BC. These two objects, deemed among the oldest examples of Greek epigraphy, though close in visual form to the Phoenician prototypes, inscribe verse-texts of praise to an athlete and a dancer in a style which is perfectly consistent with the heroic classical tradition.

Through the work of Martin Bernal, Joseph Naveh and P. Kyle McCarter, as well as a host of other archaeologists and linguists, the gap between early Greek classical inscriptions, archaic evidence, and the history of Semitic scripts in the Levant has been closing. It was the Western Greek (Chalcidian) alphabet which spread through Cumae in Italy and thus to Europe, becoming the basis of all modern European scripts, including those used for modern English. Later inventions, such as the

Dipylon vase showing Greek inscription dated to 8th century BC

47

Cyrillic, Glagolitic, Wallachian, German, Runic and Roman hands all trace their origins back to the Greek. In the contemporary world there are several hundred alphabets currently in use, all of which are derivations of the Canaanite scripts of the old Semitic language. The Greeks adopted the Semitic names of the letters, though the words have no value in their Greek form: *alpha*, *beta*, and *delta* for instance merely denote the letters.

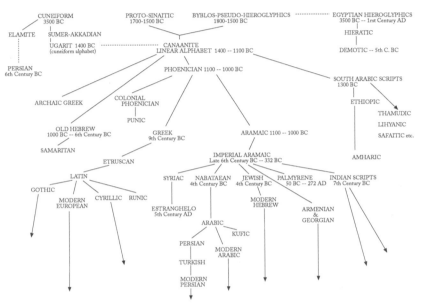

Schematic chart showing basic lines of alphabet development

Thus the Phoenician alphabet is the direct antecedent of the alphabets of Western Europe. Its transmission to the Italian peninsula remains an obscure, and possibly an independent event. But the development of most modern offshoots, of which the main branches are the Italic, Coptic, Gothic, Armenian and Georgian, and Slavic, are well documented. The precise development of the alphabetic systems of Runes and the Ogham script used for early Irish texts are less clearly understood.

The persistence, longevity and standardization of the alphabetic script is as remarkable as the fact of its diversity and adaptability, and the variety of visual forms which are invented to inscribe the alphabet has yet to be exhausted by human imagination. The historiography of alphabet research charts a course of increasing complexity with respect to the considerations necessarily taken into account in evaluating the history of alphabetic writing. As archaeological evidence and linguistic knowledge expand the understanding of ancient cultures, this research will continue to be refined. But the focus of this present study, while it relies on the same intellectual history in which research into the origins and development of the alphabet has flourished, is on a counter tradition, one in which speculation on the value of the visual symbols of the letters was essentially unfettered by allegiance to archaeological or linguistic evidence, and was instead an expression of the human search for meaning in symbolic form.

III

THE ALPHABET IN CLASSICAL HISTORY, PHILOSOPHY AND DIVINATION

Transmission and modification of the alphabet

In the classical period, the Greek attitude toward the alphabet contained elements of historical consciousness, mythical belief, linguistic analysis and symbolic thought. This array of positions is evidenced in the many classical texts which attempt to describe the origins, value, or function of the alphabet. Both the Greeks and the Romans had explicit faith in the performative efficacy of written forms, and in later antiquity the blend of mythical and magical practices expanded to include Jewish, Egyptian and Christianizing influences as well (as will be seen in the next chapter). The alphabet was involved in a wide range of cultural activities between the 5th century BC and the first centuries AD, but the legacy of classicism extends into the 20th century. Later writers making use of classical mythology did not always ground their work in the texts of this earlier period and often granted themselves considerable latitude in interpreting the classical tradition. This chapter focuses on the discussion of the alphabet and its history as it was manifest in antiquity, with some indications of classical themes taken up in later history and symbolism.

Current debates about the precise historical moment at which the alphabet was transmitted to the Greek islands and mainland leave many issues unresolved. Research into the effects of the alphabet upon Greek culture has been extensive. The claims for the superiority of the Greek modifications of alphabetic writing have been symptomatic of the European tendency to privilege all aspects of Greek culture over that of the much older civilizations of Africa and the ancient Near East. The Greeks themselves made few such claims though their discussions of history and symbolism in connection with writing are embedded in a complex of concerns about their own history, identity, and culture.

Arguments for the superiority of the Greek alphabet, as mentioned earlier, centered on the importance of vowel notation and on the impact of alphabetic literacy on Greek culture in general. The distinctions between the mechanics of the Semitic alphabet, particularly the Phoenician proto-type from which the Greek alphabet was derived, and that of the Greek were amplified by 19th- and especially 20th-century classicists for whom the literary significance of the Homeric epics eclipses that of all previous literary works in scope and quality. These scholars reduce the law books of Ur (around 2100 BC), the Code of Hammurabi (about 1750 BC), the

Epic of Gilgamesh and the Old Testament (the books of Deuteronomy and story of creation are dated to about 600 BC) to the status of minor productions of essentially preliterate societies. The bias of such a position is sufficiently obvious to need little elaboration, but the features which distinguish the Greek writing system and the various changes which the Greeks found efficacious in adopting the alphabet to their own linguistic needs deserve descriptive attention.

| | SEMITIC ALPHABETS. | | | GREEK ALPHABETS. | | | | | | |
	Phonetic Values.	Modern Square Hebrew.	Primitive Semitic.	First Epoch. r. to l.	Second Epoch. l. to r.	Third Epoch. Eastern.	Third Epoch. Western.	Fourth Epoch. Greek.	Fourth Epoch. Latin.	Phonetic Values.
1	'a	א	𐤀	A	A	A	A	A	A	a
2	b	ב	𐤁	S ꟗ	Β	B	B	B	B	b
3	g	ג	𐤂	⌐	ſ	Γ	⟨	Γ	C G	c, g
4	d	ד	𐤃	Δ	Δ	Δ	▷	Δ	D	d
5	h	ה	𐤄	⅀	⅀	E	⅀	E	E	e
6	v	ו	𐤅	Y	Ʋ	Y V	F Y V	V Y	F V	f, v, u
7	z	ז	𐤆	I	I	I	I	Z	...	z
8	ch	ח	𐤇	ᗷ	ᗷ	H	H	H	H	ē, h
9	ṭ	ט	𐤈	⊗	⊗	⊗ ⏀	⊕	Θ Ϲ ϕ	...	th, ph
10	y	י	𐤉	⌇	⌇	I	I	I	I	i
11	k	כ	𐤊	⋋	⋉	K X	K	K X	...	k, kh
12	l	ל	𐤋	∨ ⌐⌐	L Λ	Λ	L	Λ	L	l
13	m	מ	𐤌	⋎ꟷ	ᙢ	M	M	M	M	m
14	n	נ	𐤍	ᛉ	N	N	N	N	N	n
15	s	ס	𐤎	ⲭ	ⲭ	Ξ	+	Ξ	X	x
16	'a	ע	𐤏	o	o	O Ω	O	O Ω	O	o
17	p	פ	𐤐	⌐	Γ	Γ	Γ	Π	P	p
18	ts	צ	𐤑	ᚹ	M	..	M	s
19	q	ק	𐤒	φ	Ϙ	...	Ϙ	...	Q	q
20	r	ר	𐤓	◁	P	P	R	P	R	r
21	sh	ש	𐤔	ꟗ	⟨	Σ	⟨	Σ	S	s
22	t	ת	𐤕	T	T	T	T	T	T	t
		I.	II.	III.	IV.	V.	VI.	VII.	VIII.	

Transmission of Semitic forms (Isaac Taylor, *The Alphabet*, London, 1883)

The linguistic structure of Semitic languages is centered on word roots, or morphemes, which have a consonantal structure. In such a language a

50

sequence of syllables such as t-r-n are sufficient, in context, to indicate a semantic value, such as 'torn', rather than being modified by its vocalic notation (as in the case of English and other Indo-European languages) to have a range of values such as: *tern*, *turn*, or *torn*. When the Indo-European speaking Greeks adopted the alphabet from the Phoenicians, an event which archaeologists place between 1000 and 800 BC, the Greeks transformed several of the consonants in the Phoenician alphabet into letters used to notate the vowels which performed an essential, rather than supplementary, function in their linguistic system. Vocalic notation did exist even in Semitic precedents, however, with a form of writing known as *plene* or *full* writing, which might have been known to Greeks through the same contacts with the Phoenician settlements from which they acquired their alphabet.

That the Phoenicians were the source of the letters of the Greek alphabet is undisputed. The sequence of the letters, their graphic forms, and their names (which have no semantic value in Greek and are strictly Greek pronunciations of the Phoenician letter names) are the same in the two systems. In fact, the Greeks recorded this origin in semi-mythic form, to be discussed below, invoking the figure of Cadmus, the Phoenician, as the source of their alphabet. Archaeological evidence for contact has been found throughout the entire region which stretches from the Phoenician cities of Tyre and Sidon west to Cyprus, from Phrygia in western Asia Minor along the islands of Lesbos, Samos, throughout the Cycladic islands and onto the mainland areas of Boeotia, Euboia and the Peloponnese. But whether it was the presence of Phoenicians in these regions or the travels of Greeks to Phoenician trade centers which was responsible for the contact between the cultures is unclear. One spot recently proposed as the point of alphabet transmission is inland at Al Mina on the northernmost edge of what was ancient Phoenicia.[1] Even if the concept of writing in classical culture may have been given impetus from other sources such as contacts with Egypt, or the Near Eastern users of cuneiform writing, the Phoenicians were the immediate source for both Greek and Latin alphabets.

51

The adaptive transformations of the letters, though linguistically complex, may be sketched out in relatively simple terms. *Aleph*, *he*, *yod*, *ain* which had had consonantal values in Phoenician, became the vowels *alpha*, *epsilon*, *iota* and *omicron* in Greek.[2] The Phoenician *wau*, which kept its name in Greek, became two letters. One stayed in the sixth place in alphabetical order, but was represented by a new visual sign, known as the *digamma* (a letter which resembles a Roman 'F') while the original vocalic function of 'u' came to be represented by the Greek *upsilon* which was placed at the end of the alphabetic sequence. The additional distinction between long and short vowels led to the creation of a variant on the *omicron*, the *omega*, which even in its visual form displays the common origin, and to an additional sign for the long 'e' to distinguish it from the *epsilon*. The large number of signs used for sibilants in Semitic languages

	Ionia.	Ægean.	Corinth and Corinthian Colonies.	Argos.	Athens.	Euboea and Chalcidian Colonies.	Bœotia.	Peloponnese.	Achæan Colonies.
α	A A	A A	A	AA	A A	A A A	A A Ͷ A	A A A	A A
β	B	Ɔ C	⌐ Ꮇ B	B	ᛒ B	ᛒ B	ᛒ B	ᛒ	B
γ	Γ	Γ Λ	⟨ C	↑	Λ Λ	↑ Λ C	Λ Γ	⟨ Γ	∣
δ	Δ	Δ	Δ ▷	D	D Δ	▷ Δ D	▷ D Δ	▷ D Δ	▷ D Δ
ε	Ɛ E	Ɛ E	ᛒ B E	Ɛ E	ᛕ E	Ɛ Ɛ	Ɛ Ɛ E	Ɛ E	Ɛ F E
ϝ			F Ⅼ	F		F	F Ⅼ	F F	F Ⅼ
ζ	I			I	I	I	I	I	
η	H	H	⊟	⊟	Ⅎ H	⊟ H	⊟ H	⊟	H
θ	⊘ ⊕ ⊙	⊕ ⊙	⊗ ⊕	⊗	⊕ ⊙	⊗ ⊙	⊕ ⊞ ⊙	⊗ ⊕	◈ ◇ ⊙
ι	I	I	Ƨ I	I	I	I	I	I	Ƨ ካ I
κ	Ϟ K	Ϟ K	K	K	K	K	K	K	K
λ	Λ	↑ Λ Λ	↑ Λ	↑ ↑	Ʌ	Ʌ	Ʌ	Λ Λ	Λ Λ
μ	M M	ᛙ M	Λ M	M	M	ᛙ M	M M	M	M
ν	N ᴎ	ᴎ N	ᴎ	ᴎ N	N	ᴎ N	ᴎ N	ᴎ N	ᴎ
ξ	Ξ		Ξ	⋈		+ X	+	+ X	+
ο	O	O Ⅽ Ω	O	O O	O	O	O O	O	O
π	Γ Π	Γ	Γ Γ	Γ	Γ	Γ Π	Γ	⊓	Γ Λ
ϙ		Ϙ	Ϙ	Ϙ	Ϙ	Ϙ		Ϙ	Ϙ
ρ	P	Ρ P R	Ρ P R	Ρ P	P R	P R R	Ρ P R R	Ρ P R R	Ρ P
σ	Ϛ Σ	Ϛ ᛙ M	M Σ	M Ϛ	Ϛ	Ϛ Ϩ Σ	Ϛ Ϛ	Ϛ Ξ Ϛ	M
τ	T	T	T	T	T	T	T	T	T
υ	Υ V	Υ V	Υ V	Υ	Υ	Υ V	Ρ V	Υ V	Ρ Υ V
φ	Φ Φ Φ	Φ Φ	Φ Φ Φ	Φ	Φ Φ	Φ Φ	Φ Φ	Φ	Φ
χ	X	X	X +	X	X	Ψ V	Ψ V	V	V ↓
ψ	Ψ V								
ω	Ω	O ⊙							
	I.	II.	III.	IV.	V.	VI.	VII.	VIII.	IX.

52

Geographical distribution of Greek alphabets (Isaac Taylor, *The Alphabet*, London, 1883)

(there were four in Phoenician: *zayin, semkh, sade/tsade* and *sin/shin*) led to curious crossovers in notation as these came to perform in Greek as *zeta, xi, san* and *sigma* – of which the last two are not distinguished vocally. The so-called 'supplementals' were aspirated consonants not present in Semitic language. These letters were the newly invented Greek *phi, khi, psi*, added between *upsilon* and *omega* at the end of the alphabet. These transformations are generally considered to have occurred around 800 to 750 BC, since the earliest abecedaria of the Greek alphabet, dated to about 700–650 BC, show all of these letters in place and in fairly standardized visual form. The linguistic and archaeological evidence for the addition of letters and transformation of older models is highly technical, but the

essential point is that the requirements for the *meaningful* notation of the Greek language were distinctly different from those of their Semitic neighbors.[3] Further, the mutations effected upon the borrowed writing system clearly reflect an understanding of the relations between written form and phonetic analysis of the elements of speech.

The adaptation of the Phoenician alphabet to Greek language was also accompanied by changes in the graphic form of the letters. In some cases this was merely a change in orientation – the Greek *alpha* is merely the Semitic *aleph* turned 90 degrees to the position we think of as upright. A glance at Taylor's charts will show the graphic modifications which result in the Greek alphabet. While the major adaptations were uniform among local Greek scripts showing at least a common point of origin, there is evidence of slight variation of both individual letter forms and for the selection of letters included within the alphabet depending on the archaeological source. The *digamma*, for instance, does not appear in the Ionian alphabet, one of the two main branches of the early Greek alphabets, of which Chalcidian was the other. This latter Chalcidian or western branch is credited as the prototype of Etruscan and hence Latin scripts. The Ionian alphabet was adopted as the standard, official form by a decree in 403 BC in Athens. The *san* and *qoppa* were not included in this script, thus the total number of letters in the official Ionian alphabet was twenty-two. There was a range of graphic forms of writing, with the quadrate form of Greek majuscules finally becoming standardized around the 3rd century BC, existing side by side with graffiti forms and less formal scripts. But while some rounded forms or uncials can be found in inscriptions after the 3rd century BC, a genuine miniscule letter was not invented until the 7th or early 8th century AD, and the classical Greek alphabet, in spite of local variations, consisted chiefly of twenty-two standard forms (as opposed to, for instance, the fifty-two forms used in notating English).

53

Very early Greek inscriptions, classed as 'Cadmean' from Formello and Caere; the first inscription is an abecedarium which shows four Greek letters added in sequence after the *tau* (Isaac Taylor, *The Alphabet*, London, 1883)

Greek inscription from Egyptian site of Abu Simbel, dated to between 7th and 6th centuries BC. (Isaac Taylor, *The Alphabet*, London, 1883)

To understand the significance of alphabetic writing in classical culture it is necessary to link the formal innovations with the functional applications to which the new script was put. Writing in the ancient Near East

Pompeiian graffiti (Harold Johnston, *Latin Manuscripts*, Chicago, 1897)

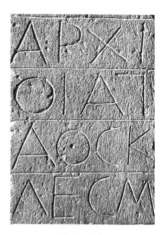

Writing materials used in Pompeii as depicted in wall paintings (Harold Johnston, *Latin Manuscripts*, Chicago, 1897)

54

Monumental Greek letters showing typical quadrate form of thin linear inscription, 6th century BC (Staatliches Museen, Berlin)

had been used for a variety of purposes: public monuments, declarations of military successes, codes of law, and, on the smaller scale it had been used to record prayers and economic documents connected with property transfer, ownership or accounting. One of the points on which the supposed superiority of Greek alphabetic writing is defended is its use for recording poetic verse. Many of the earliest archaeological fragments are inscribed with fragments of hexametrical poetry. But very early instances of Greek alphabetic writing also occur as graffiti, such as that found on the Cycladic island of Thera. There the informal inscriptions are accounts of homosexual erotic exploits which are vernacular rather than literary in their tone, and their social significance is not linked to poetic verse but to the complex relations between writing, space, and ritualized interactions. Graffiti inscriptions are found throughout the ancient world, in areas of the Greek islands, mainland, and the Italic peninsula – with some of the most famous preserved in Pompeii.

There are many claims made for the effects wrought on Greek culture by what Eric Havelock termed the 'literate revolution.' These show a marked contrast in tone from that of the classical sources concerned with the alphabet which evidence an awareness of the connections between writing, history, and cultural identity in relativistic rather than hierarchical terms. Before attending to these original sources, however, a brief assessment of the assertions made by classicists is in order.

As we have seen in Chapter 2, scholarship concerned with both the origins of language and the invention of writing was largely dominated through the 19th-century by the belief in an original primeval language linked either to Adam, Noah or other biblical figures within the Old Testament. This original language and original writing were generally assumed to be some form of Hebrew, or Semitic dialect, which had been lost in the confusion of tongues at Babel or in the diffusion of the sons of Noah in resettling the earth after the flood. The invention of classical Greece as the ideal and superior progenitor of Western European culture was largely a 19th-century invention, one which fostered the 20th-century version of this image. Not least among the arguments used to support this notion is that the Greek transformation of the alphabet made for a distinctly different, and necessarily better, literate culture than that which existed in Egypt, Palestine, and throughout the Near East. A scholar like Havelock asserts that the Greeks should be credited with having 'invented literacy and the literate basis of modern thought.' Literacy was widespread among free males in 5th-century Athenian society, but literacy cannot be considered a universal condition in classical Greece. It was clearly implicated in structures of administrative power, social hierarchy, and politics. Havelock claimed that the alphabet rendered the Greek society literate *by virtue* of its literal phonetic character, and thus 'converted the Greek spoken tongue into an artifact.' In so doing, it allowed for language to become an 'object for inspection, reflection and analysis.' The Greeks were thus able, his argument continued, to surpass the 'limitations

of prealphabetic scripts' whose content could never reach 'that standard of sophistication characteristic of Greek and post-Greek literatures.' The ethnocentrism of such stances has been challenged by recent reconsiderations of the origins of Greek culture, which has been shown to be highly synthetic, with extensive borrowings from the Egyptians in areas of medicine and mythology, from Babylonians in astrology, geometry and astronomy, and in later antiquity, from the hybrid blending of rituals, cult practices and religious beliefs which were prevalent throughout the Near East and Mediterranean.[4] But the high esteem in which Greeks held literacy is the background against which the more esoteric aspects of alphabet mythology gain their value.

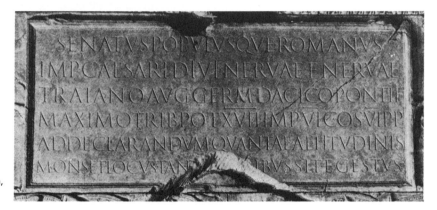

Monumental Roman capitals from the base of Trajan's Column, Rome

A B C
G H I
N O P
T V W

Renaissance form of Roman majuscules, inspired by classical models, by Serlio, 16th century (Lewis F. Day, *Alphabets Old and New*, 1910)

Papyrus scrolls, wax tablets, lead, gold and silver foil were all materials used for written documents in addition to which inscriptions were frequently scratched through, or painted onto, pottery glazes. Monumental stone engravings increased in scale and number throughout antiquity, with a high degree of aesthetic achievement in both the Greek and Roman period. The Latin alphabet, as has been mentioned, was not a direct descendant of the Ionian alphabet of the Greeks, but a development with a common early antecedent. The alphabet eventually adopted by the Romans came from the Etruscans, through settlements in and around the city of Cumae on the ancient Italian peninsula. Some of these settlers had come from Boeotia and Euboia on the eastern side of the Greek mainland, and some from the island of Pithekoussai. The Romans made their own modifications. They were responsible for the superbly designed monumental capitals which are still copied by calligraphers and stone carvers in contemporary lettering. But they also saw the need for additional letters. In 44 AD the emperor Claudius introduced three new symbols, a vertical *digamma* for 'V,' an *anti-sigma* for the *ps* and *bs* sound, and another symbol to represent the long 'u' sound. Distinctions between 'V,' 'U,' and 'W' as well as between 'I' and 'J' did not enter the alphabet until the medieval period. The alphabet used by the Romans is the direct progenitor of the alphabet used for English, though elements of an Anglo-Saxon script were in use up through the 15th century when, largely due to the standardization effected

55

by the spread of printing, they were eliminated. Attempts to revive local scripts have occurred throughout the succeeding centuries, most especially in the efforts of spelling reformers who cited the inadequacy of the Latin alphabet for notating the sounds of the English language. These and other developments, such as the Renaissance reinvention of what they believed to be classical forms, will be touched on in later chapters.

Classical conceptions of the character and origins of the alphabet

The Greek word for the alphabet, *stoicheia*, also carries the meaning *elements* with all the cosmological associations of that term. For the Greeks the letters had an atomistic and elemental character. The letters were indecomposable: there were no smaller, more significant, or more basic elements of the cosmic order. It was from these units that the material form of the universe, and the natural world, was constructed. In addition, the essence of the letters was equivalent to their value as numbers, for numbers were considered the purest form of energy or matter. This fundamental concept, which finds its first articulation in the thinking of the Pythagoreans, weaves through all of classical symbolism.

The notion that the letters were a finite set of elements capable of infinite combinations was frequently commented on by classical writers. The Roman philosopher Lucretius, for instance, noted that if all the letters in the Homeric epics were set free from their literary form, jumbled in a sack, and then poured out, they would reconstruct the universe. Several centuries earlier, Aristotle had pointed out that both Tragedy and Comedy were written with the same letters. But in spite of this cosmological conception of the elemental character of letters, the Greek authors had a definite sense of the human history in which their writing system had evolved as well as of its mythic significance. The accounts used to describe these two are often in contradiction, but are no less indicative of Greek attitudes for that fact.

Classical authors linked the alphabet to both Phoenician or Egyptian sources – to the figures of either the semi-mythic Cadmus, a figure whose name means person 'from the East,' or Thoth, the Egyptian god who is associated with the Greek Hermes. The Greek sources agreed that Cadmus was Phoenician, but they placed the period of his arrival in Greece in the middle Bronze Age, around 1600 BC, more than half a millennium earlier than current archaeological dating permits. The historical record preserved in these accounts was sometimes embellished to give a mythic character to the story. Among the 5th-century historians, Nonnos described Cadmus's gift to the Greeks as a 'divine art,' while Kritias stated in rather more pedestrian terms that it was the Phoenicians who had 'discovered the word-guarding scratchings.' But the most elaborate version of the legend of Cadmus is in the writing of Herodotus, who also attempted to corroborate the tale with all the archaeological sources at his disposal.

Herodotus combines history and mythology in his story of Cadmus, whose sister Europa had been carried off by Zeus after the god appeared to her in the form of a very mild bull. He had carried her off on his back to Crete where the bull-worshiping cult of Poseidon flourished. Cadmus pursued her in company with his mother, first to Crete and thence to Thrace and Samothrace. His mother died on these journeys and he took her body to be buried near Delphi where also he consulted the oracle for information about his sister. The oracle advised him to stop searching for her and instead keep travelling until he encountered a cow, at which point he was to found a city. The cow in this part of the story has also been associated with a degraded form of the bull central to the cult of Poseidon.[5] Following these instructions, Cadmus founded the city of Thebes as a Phoenician colony in Boeotia. Zeus rewarded Cadmus with a wife, Harmony, the daughter of Aphrodite and Ares. But Cadmus was chased from Thebes and went to Euchelians, where his descendant Oedipus founded the Cadmean dynasty, thus forging ever more complicated links between Phoenician forebears and Greek mythology.

Hathor/Isis image in 18th century illustration (Charles Davy, *Observations upon Alphabetic Writing*, London, 1772)

In the course of his later travels, Cadmus had yet another encounter with a figure linked in later accounts to the origins of writing, the nymph Io (spelled with an *omega*). He supposedly gave her the gift of the alphabet which 'permitted the human voice to be arrested in figures of writing and letters.' Io was also pursued by Zeus, turned into a heifer to conceal her from the jealous Hera, and as she wandered the footprints of her hooves marked out the tracks of the two letters which form her name. Io was then put under the surveillance of Argus, with his hundred eyes, and was only freed when Hermes was sent by Zeus. With the aid of his flute with seven holes, Hermes put Argus to sleep long enough for Io to return to her original form. This myth will recur as an account of alphabet origin among writers of the 18th century, but here it manages to embed the historical facts of migration, settlement, and invention into the adventures of mythical figures. The image of the flute of Hermes will also recur in later symbolism, with its seven holes – each associated with the vowels and the seven elements of cosmic musical harmony. The tangle of associations which links the bull, the heifer, and the symbolic history of writing extends to include links to the goddess Isis who is identified with the bovine form (through association with the goddess Hathor) as well being assigned a role in the history of writing.

Isis writing her mysteries (Pitois Christian, *L'Histoire de la magie*, Paris, 1870)

57

The three pieces of evidence Herodotus uses to back up his account include, first, an inscription found at Thebes in the temple of Apollo Ismenios where ancient writing was scratched on three tripods. Secondly, he pointed out that the word *phoenikeia*, or *phoenician things* had been used by earlier writers as a term to indicate writing. And finally, Herodotus stated that one had only to look at Phoenician writing to see the striking similarities with that of the Greeks; he himself had reputedly travelled in Phoenician regions and seen originals. The thrust of Herodotus' account has in common with those writers attributing the

Image of Thoth as scribe from Egyptian papyrus and from the title page of an early 20th century publication (Frederick Portal, *A Comparison*, New York, 1904)

invention to the Egyptians a recognition of the preexistence of cultures more developed and more literate than their own. The Greek notion that culture itself had come from the east, and that writing therefore must have come to them from that direction, is echoed throughout the texts of classical antiquity.

Herodotus, Diodorus Siculus, Plutarch, Lucian, Tacitus and Pliny were among the classical writers who believed in a Phoenician precedent for the Greek alphabet, but they were often divided on its origin. For instance, Epigenes (4th century BC) stated that the art of writing had been known among the Assyrians seven hundred and twenty thousand years before his time, an exaggeration, though not wholly inaccurate. Pliny, in the 1st century AD, had asserted that the Assyrians had had writing for all eternity. Other writers claimed that the first writing had been among the Syrians, and that the Phoenicians had merely modified it. Tacitus, in his *Annals* gives credit for the invention to the Egyptians and states that the Phoenicians were only responsible for its dissemination.[6]

Among those who traced writing's origin to Egypt was the late 6th-century BC writer Hekatios. He stated that it was the daughters of Danaos who had brought it when they fled from Egypt with their father. The king, Aegyptacus, had wanted them to marry his sons. Danaos had refused, and took flight to Argos, only to be followed by the suitors. Finally Danaos agreed to the marriages, but only on the secret condition that his daughters murder their husbands on their wedding night, which all but one reportedly did. This rather dire tale is cited in passing by a number of authorities, but mainly provides evidence of the perceived link between Egyptian and other writing.

The more widespread myth states that Thoth (Hermes) was considered the 'scribe of the gods' and the 'lord of writing.' In a variant, he is named as the vizier of Osiris and the teacher of Cadmus. But more generally Thoth was depicted as the protector of Osiris, Isis and their son Horus through the power of language rather than by physical might. Isis is sometimes mentioned as having been instructed by Thoth to invent different writing for each of the nations with different languages in order to keep them from confusion.[7] Written words attributed to Isis were also used in amulets, particularly as an aid in cases of snakebite, while Thoth is frequently depicted in Egyptian images as the figure who reports the result of the weighing of the heart in the moment of the final judgment.[8]

Philostratus (b. 170 AD) gave another account of the alphabet which concentrated on its transformation in the hands of Palamedes, said to have been born in Boeotia, where in fact, archaeological evidence indicates early instances of Greek writing. Palamedes supposedly added eleven new letters to the existing seven (*tau*, and the first six vowels). The Roman writer Caius Julius Hyginus (33 BC–14 AD) extended this in his version, stating that a certain Simonides had added four more to Palamedes' system to which Epikharmus of Sicily added two, bringing the total to standard twenty-four.[9] Both Plutarch and Pliny recorded this account as well,

though their arithmetic is slightly different, since they claim the original number of the Phoenician letters was sixteen and that Palamedes added only *zeta*, *upsilon*, *phi* and *xi*.[10] The consistent point in these accounts is the conscious recognition of both the Eastern source of the alphabet and the processes of transformation necessary to adapt it to Greek use.

Classical writers were not overly concerned with the date of these events. Josephus, writing in the 1st century AD, stated that at the time of the Trojan War the Greeks knew nothing at all of writing, but at the same time he mentions the famous letter of Bellerophon which features in the sixth book of the *Iliad*. In this story the 'baneful signs' which are 'scratchings on a folded tablet' were instructions carried by Bellerophon from Proitos to his wife's father, the king of the Lykians. The tablet told the king that he was to kill Bellerophon on reading the message which the unwitting (and presumably illiterate) messenger carried. (This concept of the 'fatal letter' has an Old Testament parallel in the story of David and Uriah in the King of Samuel.)[11]

What is compelling in all of these accounts is an interest in both historical perspective and cultural relativism. The very fact that the Greeks did not perceive their writing as something divine or natural, but as something associated with both human history and cultural exchange, seemed to cause them to reflect philosophically upon both its character and its development. While there are a few other instances of purely mythic or legendary attribution among the classical texts, they are vastly outnumbered by these historical accounts. For instance, there is a somewhat farfetched legend which recounts that Hermes was apparently inspired by the sight of cranes in flight, their angular, schematic forms suggesting signs which he considered might serve to represent the sounds of writing.[12] Another authority states that the letters merely 'fell down from the heavens for the benefit of humankind.'[13] Reportedly the spot at which they fell was called Phoenix (a word meaning *Phoenician*), and located near the city of Ephesus. A monument inscribed with alphabetic letters at Ephesus enters later records as part of divinatory practices. The *Ephesis grammata* were letters incised on the base of a cult statue of Artemis used in rituals, but the texts produced in this process are unintelligible to later writers.[14] Finally, there is the significant mythic figure of Prometheus, whose transgressive acts against the gods, dramatized in the work of Aeschylus, include giving both fire and writing to humankind. The power ascribed to the written word in such an association would be evident even were it not underscored by the gruesome punishment meted out to Prometheus for his behavior.

59

Philosophy and linguistics

The classical text which provides the most extensive discussion of the alphabet is that of the *Cratylus* of Plato.[15] It is a philosophical text which

examines the nature of language as a form of representation, and poses a number of questions about the mimetic or imitative character of writing. Plato had had personal contact with Egyptian culture and writing. Plato's attitude towards his own writing system seems to have been enhanced by his contrast of the alphabet with the other, more visually striking forms of hieroglyphics since he questions the value of the Greek letters in symbolic terms. Plato's work, however, reveals the phonological bias of the Greeks; he clearly understands the letters in their relation to the sounds of language first and foremost, rather than as visual elements in their own right.

Plato believed that writing had been invented in Egypt, and he attributed the origin to the god Thoth, or Theuth. In the *Phaedrus* Plato states that Thoth had come to Thamus, the King of Egypt, to show him many inventions including writing. Thoth claimed that the letters would 'make the Egyptians wiser and give them better memories.' Thamus was not convinced. He argued that the discovery would 'create forgetfulness' because his people would no longer rely on memory but would 'trust to the external written characters and remember of themselves.' Writing, therefore, was not to be 'an aid to memory, but to reminiscence.'

According to the basic tenets of Platonic idealism visual signs – images, letters, glyphs – were inferior to the transcendent Ideal. Plato held all visual images in low esteem and he even banished painters from his imaginary Republic. For if apparent reality were a mere shadow of the Ideal, then any image imitating reality was at best yet another degree removed from the Ideal. The mark or letter, like any image, served a merely mechanical function and could not in any sense serve the highest function of human knowledge, to reveal Truth. But as a thing in itself, a letter might contain an essence. Plato attempted to reconcile both this Idealist disregard for signs of signs and the typically Greek atomistic understanding of cosmic structure in the dialogue he stages in the *Cratylus*. On the one hand, the text shows a concern with analysing language as a system of formal logic, an approach which is anti-Idealistic. On the other, it struggles with origins and first causes, looking for Truth in every letter or sign. To give full play to the conflicted opinions, Plato situated the figure of Socrates between two speakers who articulate opposing positions within the dialogue of the *Cratylus*. The first of these, Hermogenes, argues for a conventional, socially determined link between language and meaning, letters and their values, linguistic forms and sense. He puts forth the concept that language is an arbitrary system which produces meaning through formal rules and logical propositions. By contrast to this conventionalist position, the figure of Cratylus espouses a naturalist (i.e. atomistic) attitude, stating that the letters are elements which contain an essence. From this it follows that meaning in language is built up out of these smaller units. If the value of these elemental units could be divined, then the meaning of words could be calculated in terms of the combination of letters used in their production. The philosophical issues at stake

here are complex, since they involve a distinction between the concept of a mutable universe and that of a stable, permanent fixed order of essences, such as Aristotle would assume as the basis for his analysis of the natural world.

Leaving such issues aside, the particulars of the analysis of the alphabet which emerge from Cratylus' propositions and Socrates' interrogation revolve, ultimately, on the discussion of the function of the letters in the production of linguistic meaning. This in turn raises the central issue of whether or not an Idea is equivalent to the material form of its expression, such as its expression in language. Cratylus argues that a word must be either the perfect expression of a thing or mere, arbitrary, inarticulate sound: it cannot be anything else. He further claims that language and writing were invented by an Imitator who understood the essence of things and encoded this into their names. Hermogenes, however, counters by stating that all words are conventional names for things, used and agreed upon through social contract and invented by a Legislator. Socrates introduces confusion by pointing out that the letters themselves are not the same as their names. A word such as 'alpha' or 'beta' contains many letters not contained in the letter itself, and this introduces a conflict of identity into language at the very elemental level of the letters. Socrates suggests that this may be the result of mutation over time and that the original names have been lost, buried, in this process. In looking for these original names, Socrates makes an analogy between the letters as elements of language and colors as elements of a painting, stating that just as a painter composes an image by combining a percentage of purple, white or other pigment, so a word may be understood in terms of its component parts, the letters.

Cratylus and Socrates assess the values of particular letters by examining groups of words in which the same letter appears to indicate a common theme. For instance, they conclude that *rho* is a sign of motion because it is found in words such as *tremor, tremble, strike, crush, bruise, crumble* and *whirl*.[16] The cause of this association of letter and meaning was not merely incidental, it was linked to the physical activity of pronunciation. According to Socrates, the tongue was 'most agitated and least at rest in the pronunciation of this letter' and therefore the original imitating inventor used it 'in order to express motion.' By the same principle, he goes on to say, *iota* was used to 'express the subtle elements which pass through all things.' In fact, the principle by which the *iota* might express this capacity is linked to its graphic character, not its pronunciation. As the smallest letter it was capable of fitting into spaces – both between other letters and other things – with the very least amount of difficulty. The rest of the analysis of selective, specific letters emphasizes the physical act of pronunciation: *phi, psi* and *sigma* require 'great expenditure of breath' and are used 'in imitation of such notions as shivering, seething, shock and shaking' or anything else 'which is windy.' *Lamda* with its liquid smoothness, produced by the slipping of the tongue, expresses this

61

smoothness in such words as *level*, *slip* and *sleek*. The 'heavier sound of *gamma*,' in which the tongue is detained combines with *lamda* to express the notion of stickiness, as in the words *glutinous* and *glucous*. Their analysis is incomplete, irregular, and unsystematic. But it makes clear that there was an attempt to examine both the philosophical and physiological underpinnings of language through analysis of its smallest elements, the letters of the alphabet. The struggle to find links between idea and expression concentrated on these atomic forms. In addition, it shows the kernels of the phonological analysis of the language still used in phonetics today: into categories identified by the mechanics of pronunciation such as gutterals, labials, dentals and so forth. Plato had Socrates apply these principles to an analysis of his name in the *Thaetetus*, only to have him meet with frustration. He is unable to find any atomistic analysis which accounts for the relation between his identity and his name given that it is used to designate other individuals as well. But he continues to assert that the letters are 'the primeval elements out of which you and I and all things are compounded here.'[17]

Plato was not the only Greek author to understand the phonetic structure of the language: Dionysius of Halicarnassus, writing in *On Literary Composition* (approximately 20–10 BC) gave another such analysis of the letters.[18] He linked the atomic character of the letters to their capacity to represent speech, saying that 'every sound made by the voice originates in these and is resolvable into them.' He understood the distinction between the function of vowels and that of the consonants and was more thorough in his description of the physical acts of pronunciation. In place of Plato's impressionistic terms – *slipperiness* or *stickiness* – Dionysius states that the *lamda* pronounced by 'the tongue rising to the palate and by the windpipe helping the sound.' Like his predecessor, he does not extend his analysis into a visual realm, and the graphic character of the letters remains unnoticed in his work. It is worth pointing out that most linguists and classicists are in agreement upon the suitability of the early Greek alphabet to adequately notate the sounds of the Greek language. In a situation such as the current English language use of the Latin alphabet, the mismatch between the forty or so phonemes of speech and the twenty-six graphemes used for notation would never support a cosmological analysis of language into *letters* (rather than sounds) as its fundamental parts.

Pythagoreanism and Number Symbolism

No aspect of the conflation of the concepts of *stoicheia* (elements) and letters carried more weight in the classical period than that associated with the cosmological system of number symbolism. The notion that the order of the universe was fundamentally mathematical, and that all structures, beings, and forms could be expressed in terms of number was central to the tradition known as Pythagoreanism.[19]

Pythagoras himself presumably lived in the 6th century BC. His image as a legendary figure, which developed on the basis of his writings and his supposedly exemplary life, waxes and wanes in popularity throughout the classical period. Much of the symbolic quality ascribed to his work was in fact the work of his followers, and the Neo-Pythagoreanism which arose in the early centuries of the Christian era has as much in common with Gnosticism, Hermeticism, Neoplatonism and other contemporary systems of belief as with its authentic forbear. The writings of Nicomachus of Gerasa, and others, will therefore be considered in the following chapter, and strains of Neo-Pythagoreanism will continue to weave through this study up through the Renaissance.

In early Pythagoreanism, however, numbers were considered *to be things*, and things numbers. Things could not therefore be derived from numbers, by Pythagorean logic, since a thing could not be derived from, or different from, itself. But by the time that Pythagoreanism became popular in the work of 5th- and 4th-century BC writers such as Speusippus and Aristoxenus, the prevailing concept was that sensible things were in fact derivatives of the higher order of numbers. Thus the notion of the symbolic content of numbers, and in particular, of such correlative systems as alphabetic letters with their numerical equivalents, belongs to this later period. In orthodox Pythagorean tradition, the numbers were living beings, older than the bodies of the material world, and more powerful.[20]

In the 3rd century BC the fully developed concept of number symbolism known as *gematria* developed. Gematria is premised on the belief that numerical equivalents for letters may be used to decode and calculate the concealed meanings of scripture or text.[21] In this system the first ten letters were assigned a value correlating to the first ten numbers, with each letter after this obtaining value as a multiple of ten in accord with its place in a regular sequence.

In gematrial calculations the number values are used to compute correspondences and associations. For example, the number equivalent of the word for cosmos (*kosmos*) is 600, equivalent to the number for the godhead (*o theotes*) while the word for cosmos preceded by a definite article reaches the sum of 670, placing it in proximity to the concept of paradise (*paradeisos*) which has the value 671. For believers, the number of secret connections revealed in this process are limitless and may involve long sequences of calculation. In one such calculation the god Pan, the symbol of wholeness, equals the number 131 which, when linked to that of the serpent (*drakon*) stands for Eros. When this is in turn added to the value for creation, the sum equals the gematrial value of the word Zeus, and so forth through a cycle which leads through Apollo, Artemis, Selene and the number for conscious will (*nous*) to result, finally, in the number for death (*thanatos*).[22] For the cosmologically disposed, these gematrial calculations provide a key to the secret structure of the universe.

Later developments show elaborate theories of harmony (the literal exploration of the music of the spheres) and other manifestations of

63

mathematics as a fundamental structure. One symbolic element from this tradition which shows up repeatedly in the historiography of the alphabet is the so-called Pythagorean 'Y.' This letter will feature in studies of Renaissance symbolism, but the ritual it condenses as a visual sign can be traced to classical texts where it is linked with initiation into Pythagorean studies. An initiate presented with two options for a life to lead is asked to choose between them. On the one hand is a life of austerity, discipline, and difficulty in which ideas and intellectual pursuits are the chief reward. On the other is a life of material comfort, even indulgence, sexual, and sensual satisfaction. The initiate's position is considered equivalent to that of the juncture of the two branches of the 'Y,' and the choice will determine whether the path of Pythagorean rigor or of worldly comfort is taken. When this symbol is loaded with Christian values, the two branches become stigmatized as choices between vice and virtue, distorting of their earlier representation of worldly vs intellectual pursuits.

Number symbolism was widespread in antiquity, not all of it strictly Pythagorean in character. A striking example is the analysis of the value of the letter offered in Plutarch's *Essay on the Letter E at Delphi*.[23] Though considered a minor text in Plutarch's work, it reveals the mechanics of number symbolism at work. Not strictly speaking associated with divinatory practices, the letter was nonetheless found at the Oracle at Delphi inscribed in various materials such as gold (linked with Caesar's wife Livia), bronze or wood (the 'E' of certain wise men).[24] In a commonly acknowledged equivalent, Plutarch associates the seven vowels with the seven astrological planets. In this system the 'E' is in the second position, aligning it with the Sun, and thus, with the god Apollo himself associated with Delphi and the Oracle. The numerical equivalent assigned to the letter 'E,' however, was five. Plutarch enumerates seven explanations for the dedication of this letter to Apollo's Oracle.

First of all, Plutarch begins, the letter was to be understood in terms of its pronounced form or 'Ei' which had been the cry of protest offered by the wise men against interlopers. They stated unequivocally that they were five in number, not seven, thus precluding claims by imposters to be included among them. Second, by its place as the second vowel, it was, as noted above, associated with Apollo. Third, when pronounced aloud it meant 'if' and was thus the means by which people might inquire of the oracle 'if this' or 'if that.' Fourth, it was to be used as 'if' in prayers or wishes expressed to the god in supplications beginning 'If only ...' Fifth, 'if' was indispensable because of its value in syllogisms and logic. Sixth, the number 'five' was considered the most important number in mathematics, philosophy and music. Seven, as an utterance it also meant, 'Thou art,' by which was indicated the eternal existence of the god Apollo.

Some of these values, particularly those associated with the symbolic value of the number, Plutarch associates with the teachings of the Pythagoreans. Stating his allegiance to the 'theory of numbers,' Plutarch articulates a series of meanings for the number. Five had the value of

marriage' because it produced by the addition of two, the first male number, and three, the first female number (the number one was preserved within Pythagoreanism as the symbol of unity, cosmic wholeness, and carried no gender). Five in calculation produced nothing strange, only multiples which ended in itself or in some combination of ten, the perfect whole. Five was also the number of chords in music and the elements of melody were five (the quarter tone, half tone, tone, tone plus a half tone and double tone). Plato had stated there were five worlds altogether (earth, water, fire, air and the quintessence) and also that there were five first principles: Being, Identity, Divergence, Motion and Rest. He had also stated that there were five forms of all living things: gods, demigods, heroes, humans and animals and five divinations of the soul – nutritive, perceptive, appetitive, spiritual and reasoning. Finally, also from Plato, Plutarch notes that the Good existed in five categories: moderation, due proportion, mind, sciences and arts, and pleasure which is pure and unallied with pain.

There are very few such texts from the classical period which form associations of meaning and the alphabetic symbols and Plutarch's essay is an exception. His synthetic appropriation from a variety of sources and his disregard for any of the visual aspects of the letter form to which he assigns such symbolic potency are, however, characteristic of the interpretations granted to letters in the later classical period and into the early centuries AD.

Magic practices involving alphabetic writing

Delphic sibyl in 17th century depiction (Servatis Gallaei, *Dissertationes de Sibyllis*, Amsterdam, 1688)

Magic in its many forms was an exceedingly common element of religious practice among both Greeks and Romans. The materials in this section are drawn from sources traced to Greece, Hellenistic Egypt and the far flung reaches of the Roman empire. The written word was believed to have very definite and real power throughout this period – the power to curse, to heal, to empower and to constrain. Whether such oracles as the famous ones at Cumae, Delphi and Dodona made extensive use of writing is difficult to determine. There are no remaining written documents and there is only sporadic mention of the use of writing in the oracles' activities. It is clear that answers to inquiries were sometimes given in writing, and both the visual augury of entrails and divination by lots were common practice. But oracles depended largely on forms of ecstatic speech trance and there are few, if any, recorded instances of actual oracular pronouncement involving alphabetic letters as symbols.[25] Later depictions of the Cumaean Sibyl, of the Delphic Pythia, or other less renowned oracles, are frequently depicted with inscribed messages on scrolls in long cryptic lines. But in classical times the use of writing was far more common in the form of amulets and curse tablets and various kinds of imprecations protecting everything from city or field to private property from violation.

65

Cumaean sibyl (Servatis Gallaei, *Dissertationes de Sibyllis*, Amsterdam, 1688)

Persian sibyl (Servatis Gallaei, *Dissertationes de Sibyllis*, Amsterdam, 1688)

Customs varied locally, Greeks in their homeland, for instance, were less involved with burial imprecations than were Greeks in Anatolia and Asia Minor.[26] These were activities which were known as early as the 5th century BC and extended almost five centuries into the Christian era.

Various kinds of curses and tablets are associated with burial rituals in antiquity. These range from curses applied to newly dead enemies, curses against those who would violate a tomb, and phylacteries designed to aid or protect the dead. For example, curse tablets were commonly buried near the site of a fresh tomb in order to punish a deceased enemy by giving the spirits of the dead greater power over the victim. Funerary imprecations were inscribed on tombs or inserted into them on tablets in order to protect them from material or spiritual violation. Such imprecations were often worded to prescribe the price to be paid in both spiritual and economic terms should such a violation occur: 'The man who acts against these prohibitions will be a wrongdoer towards the gods of the underworld, and he will pay a fine of 1,5000 denarii to the most sacred [imperial] treasury.'[27]

Spells also linked the concept of the written word as efficacious to matters related to love, wealth, power or victory in athletic or military contest. Most of these practices have precedents within Egyptian and Near Eastern rituals.[28] One category of written spells is known as *defixiones*. These were written on lead tablets, folded, and then buried either with a corpse of the 'untimely dead' or put in holy areas reserved for funerary rites.[29] These so-called 'binding' curses were used in a wide variety of situations. When used in agonistic contests, they were inscribed with requests for restraint of the enemy, a binding or limitation of his resources. Binding curses against athletic rivals were highly specific, asking that the hands, arms, shoulders or other body part be limited or rendered powerless. They often involved an analogy to the situation of the corpse, as in 'Just as you, Theonnastos [the dead person with whom the tablet was buried] are powerless in the movement of your hands, your feet your body … so too may Zoilos be powerless …'[30] In romantic situations, such tablets were used to either restrain a rival or induce passion in the object of one's affections. 'All seeing one, IOPE, make her … lie awake for me through all eternity.'[31] Or more strongly, 'Make NN, daughter of NN, have insomnia, feel flighty, be hungry and thirsty, get no sleep, and lust for me, NN, son of NN, with a gut-deep lust until she comes and makes her female genitals adhere to my male genitals.'[32]

Early medical practices often involved incantations, though the first record of an actual amulet is in the *Charmides* of Plato. Here Socrates describes a cure for headaches which involves using a medicinal leaf in combination with a written charm. The amulet must contain both elements – without the written spell the leaf would have no power.[33] Many *magic amulets* contained only scrolls and inscriptions, no herbal or other potion. These small strips of lead, gold, silver or papyrus were tightly rolled and encased in a small cylinder which was suspended around the

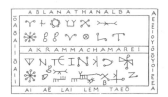

Amulet (Hans Betz, *Greek Magical Papyri*, Chicago, 1986)

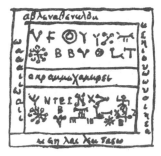

Amulet from 4th or 5th century (E. Wallis Budge, *Amulets*, Oxford, 1930)

Amulet (Hans Betz, *Greek Magical Papyri*, Chicago, 1986)

A
E E
H H H
I I I I
O O O O O
Υ Υ Υ Υ Υ Υ
Ω Ω Ω Ω Ω Ω Ω

Magical arrangement of Greek vowels (E. Wallis Budge, *Amulets*, Oxford, 1930)

neck. While there are few extant amulets from the classical period, there are an abundance of them in the Roman period where the magical *lamellae*, or spells written on tiny strips of foil, were commonly used for amulet inscriptions.

These texts were largely formulaic and of the 'Flee Gout, Perseus is chasing you!' variety. A written epistle containing a prayer for cure and laid on the body was considered a medical treatment. In the Christian era letters written by a saint or holy figure were of course deemed most valuable and most powerful. Extensive documentation on incantations and spells of all varieties, used for every imaginable purpose, have been preserved in the Greek magical papyri from Graeco-Roman Egypt. Those designed for medical use range from specific recipes for poultices to the simple writing out of magic names on deerskin or metal or other specified material to be bound to the afflicted area of the patient's body.

Burial rituals involving phylacteries (the word itself derives from the Greek root meaning 'to protect') are traced to the 4th century BC. In these practices the body of a corpse had a scroll unrolled upon it to protect it from the terrors of the afterlife.[34] Another tradition used the gold leaves of Orphic rituals to inscribe passports for the dead, with prayers and supplications to the gods and shades.

The vowels, in sequence, and in set configurations, were commonly used in spells. The cosmic power granted these elements has, again, links to the Pythagorean tradition. Each of the seven vowels was associated with one of the planetary gods: Apollo (the Sun), Mercury, Jupiter, Saturn, Venus, Mars and the Moon. The very first instance of a magical spell cited in Hans Dieter Betz's exhaustive compendium of magical papyri uses a vowel inscription to call up a demon. The ritual involved is complex, requiring first the deification of a falcon, two fingernails, and hair from one's head in a mixture of milk and honey. After all the particulars of the ritual are performed a strip of papyrus is to be inscribed with a spell written out in myrrh. This spell is the double figure of two pyramids of vowels, side by side. The first is structured with a single 'A' at the top, followed by two 'E's and so forth until the final row of seven long 'O's.' The second pyramid inverts this order, placing the long 'O's at the top and diminishing to the point of the 'A.' This vowel sequence would in turn be incorporated into the actual prayer to invoke the aid of the demon helpmate.[35] Vowel combinations such as these were often combined with other nonsense utterances in a manner which prefigures the Gnostic and Kabbalistic use of such combinations, but metrical phrases were also frequently used. A charm used to restrain oneself against anger, for instance, places various patterns and combinations of vowels on the borders of a small *lamella* in the center areas of which are more arcane characters and nonsense combinations.

Kleromancy, or divination by lots, was also a common practice which sometimes involved alphabetic writing. In certain lot systems, twenty-four self-contained oracular lines, each of which begins with a different letter

67

of the alphabet, were used. When a lot was drawn, the line which bore the letter corresponding to the lot would be read as the response to the inquiry.[36] Written tablets from which a choice would be made were frequently inscribed in advance and produced as part of a prepared response. The letters themselves were not granted particular symbolic value, but the alphabet as a stable structure enabled the process of the oracle.

At least one form of divination involved direct use of the alphabet, and Iamblichus, a late 3rd- early 4th-century AD follower of Pythagoras, is credited with its invention. This form of divination is known as alectryomancy – or divination by means of a fowl. To use this method one scratched the letters of the alphabet out around a circle in the sand and then sprinkled grain over them. The fowl was released and the pattern of its pecking was recorded. The sequence of letters was studied for hidden meanings or messages.

One very famous, but unique, instance of divinatory activity is recorded by the Roman writer Ammianus Marcellinus who dated the events he recorded to the year 371 AD. His story describes a seance in which the participants have a metal disk inscribed with the letters of the Greek alphabet. A ring suspended over the disk by means of a wooden tripod swung toward the edges of the disk to pick out the letters of the message. The questions being asked by the group were 'When will our emperor die? And who will be the next emperor?' After indicating the number '7' the ring began to spell out a name. '*Theta*, *epsilon*, *omicron* –' the participants in this process eagerly concluded the full name was 'Theodorus.' Such inquiries were considered traitorous and when the authorities learned of these events the participants in the seance were arrested, as well as the unsuspecting Theodorus who claimed to have no knowledge of the event. All were summarily executed.[37] In another version, it was the fowl method of Iamblichus which was employed in this fatal divination. Iamblichus was supposedly included among the hapless victims though himself not present at the seance. In both cases, as the story goes, after a period of seven years it came to pass that the emperor died and was succeeded by *Theo*dosius.

While there is no concrete evidence that such metal disks – classical prototypes of the Ouija board – were ever produced in antiquity, there is one unique and peculiar artifact which has some striking resemblance to the object described in these stories. This is the Pergamon disk, a shallow metal bowl inscribed with several rings of characters. Dated to the 2nd century AD it contains an inner circle and three outer concentric rings. The inner circle is divided into seven areas and inscribed with characters associated with the seven planets while the outer rings are cut into eight divisions each and associated with one of the twenty-four letters of the Greek alphabet. The precise use of this object and the meaning of the characters are not clear; but it is unique among artifacts of this period.

One final image which bespeaks the powers assigned to writing comes from Cicero's *De Divinatione*. He tells the story of one Numerius

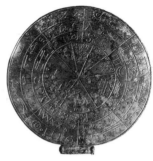

Pergamon disk (Staatliche Museen, Berlin)

Suffustius who had a dream that sacred tablets were concealed within a group of rocks. Waking, he sought out the spot, cracked the rocks open and found the concealed tablets which were inscribed with an ancient script. Though he did not know the source or meaning of the tablets, he had a wooden chest made to preserve them. These were placed in the temple of Fortuna at Praeneste and honey supposedly then flowed out from them mysteriously.[38]

Roman notae, numerals and signs

The Romans added a number of features to the classical uses of alphabetic writing. Among these were the extensive use of abbreviations on monuments, coins and in other instances of written language. These were known as *sigla*, and have been extensively documented. Lists of *sigla* can be found in most standard texts on Latin paleaography, and in themselves they are not particularly mysterious. However, the fact that there was so extensive a system of these abbreviations does demonstrate a high degree of consensus and shared context among literates in the culture, since a single letter might bear a variety of values. The letter 'A,' for example, was used in senate votes to indicate a lot cast in favor of acquittal, standing for '*absolvo*.' It was also used in the Roman *comitia* to indicate that the voter rejected the proposed change. 'B' could be used independently to indicate *beneficiarius* or *bonus* and 'C' on its own stood for *cedit*, *centurio*, *circus*, *civis*, *clarrisimus* and *Caesar*. In addition to standing independently, abbreviations consisting of two or more letters were extremely common. For example: 'BBVV' for *boni viri* (good men), 'BD' for *bona dea*, 'BF' for *bona fortuna* and 'BV' for *bene vale*. Literally hundreds, even thousands, of these were in use in Roman times, depending on common linguistic and cultural references for their comprehension.

69

Another Roman invention was a form of shorthand attributed to Cicero's freed slave, Tiro. Cicero is reported to have used such a shorthand during the trial of the Catilinian conspirators, especially for recording the famous speech of Cato in 'signs which in small, brief characters comprehended the force of many letters.' *Notarii*, or shorthand writers, were distinguished from other types of scribes, and the function they performed was specialized. Shorthand became widely used in Roman times for both recording of public lectures and among students taking down material from a master's speech. Much of this writing remained illegible in spite of the rediscovery of extensive paleographic evidence. It was not until the 1747 publication of Dom. P. Carpentier's first systematic attempt to unravel the mysteries of this highly cursive and very condensed writing that any insight into the textual substance of these pieces was made. By the end of the 19th century, authoritative keys for deciphering had been compiled, but difficulties of translation were compounded by the problem of legibility – after all, this form of writing is termed tachygraphy because it was

written at great speed. The system depended upon a set of *radicals*, generally the initial capital letter of a word. This might stand alone, especially in the case of a frequently employed term. But more elaborate radicals existed to indicate certain invariable words: adverbs, prepositions, conjunctions, certain nominative forms and even certain third person singular forms of a verb in the indicative. This in turn could be modified by a *termination* which, while swiftly notated, permitted inflection or other modification of the word. These were not idiosyncratic systems unique to individuals, but well established alternative writing systems which were institutionalized in teaching and widespread habits of use.

Tironian notes (Karl Faulman, *Illustrirte Geschichte der Schrift*, Leipzig, 1880)

A high degree of specialization was thus introduced among the Romans to both standardize and diversify the field of writing practice with the specialized graphic forms serving very different purposes within the body politic. Not least of these was the adaptation of letter forms to represent number values. The graphic symbolism of these Roman numerals often partakes of the obvious, as in the case of the strokes of the 'I' used to indicate a sequence of values increasing unit by unit like the extended

fingers of a counting hand. The 'V' has been linked to the space between thumb and forefinger on an open hand, while the 'X' is supposed to invoke the angle of two hands linked together. This latter stretches visual credibility while the former observations are quite banal, and the 'X' contains the character of a double 'V' readily enough without comparing it to manual contortions. The numerals 'C,' 'M,' and 'L' presumably derived from older Chalcidian symbols, the circle with a horizontal line modified to 'C' had been used to represent '100,' just as a similar circle split by a vertical line had been used by the Etruscans for the value of '1000.' 'D' is evidently simply the graphic equivalent of half of this latter sign. The source of 'L' for fifty remains vague, linking it to a form of the Chalcidian 'X.' The conventions which brought these forms into conformity with letters within the Latin alphabet were the effect of convenience, rather than necessity, and other signs would have functioned equally well – even better since they would have stood less chance of confusion.

Classical inspirations and later authors

The classical tradition has been a source of inspiration throughout Western European history and in this regard the history of the alphabet is no different from that of any other tradition within the history of ideas. Certain elements discussed here will recur throughout the following chapters in passing or in substantial discussion. The Pythagorean tradition of number symbolism, the practices of gematria, and most particularly, the image of the Pythagorean 'Y' are elements which provide a recurring motif in alphabet historiography. The myth of Io, in which her hoofprints spell out her name in two fundamental elements, the 'I' and the 'O,' returns particularly in the writings of 17th- and 18th-century historians who analysed the graphic structure of the alphabet in terms of these two primary forms. And finally, there are inventions of a *classicism* which have little relation to actual precedent within classical texts, yet draw heavily upon the structures derived from classical mythology. One of these is the remarkable *Divination de l'Alphabet Latin*, a work by the 20th-century writer François Haab, who demonstrated the elaborate symbolical relations among the letters as evidence of their connections to specific personages within the pantheon of Roman gods and goddesses, but which will be described in a later chapter.

GNOSTICISM, HERMETICISM, NEO-PLATONISM AND NEO-PYTHAGOREANISM: ALPHABET IN THE EARLY CHRISTIAN ERAS

The symbolic interpretations of the alphabet which emerge in the early centuries of the Christian era manifest the full range of cultural influences typical of the largely secular and cosmopolitan Hellenistic culture. They combine religious and cult practices from Egypt, Babylon, Persia, Syria and Palestine with the teachings of Greek philosophy. A remarkable diversity of belief systems vied for political and spiritual domination in the 1st and 2nd centuries AD, including many syncretistic hybrids peculiarly characteristic of the period. The reasons for this are evident from the history of the Mediterranean region at the close of the classical era, as the Greek influence established under the political and military triumphs of Alexander the Great in the 3rd century BC began to be challenged by cultural factors such as the marked reemergence of ritual practices in the East, including Christianity and the increasing significance of Rome. The late Hellenic period and the early centuries of the Roman empire were characterized by considerable religious tolerance and diversity. The focus of this chapter will be on materials from the period spanning the close of the classical era through to the consolidation of the Church and the Roman Empire. The works to be examined here were mainly written in Greek, some in Latin, and all participate in one of the several religious or philosophical systems which proliferated throughout the Mediterranean region. Many of these sources are concerned with the alphabet as a vehicle for symbolic meaning, but before attending to these, it seems useful to provide a brief overview of the role of writing in the restructuring of power between classical and Christian eras, and to the many transformations in the visual forms of the alphabet in this period.

The Alphabet and Politics

The historian Hans Jonas stated that from the Greeks' perspective the area from Egypt through the ancient Near East to the borders of India had been the 'East.' But with the emergence of Rome as an Imperial power, the division of Eastern and Western domains became redefined. The Christianizing of the Roman Empire under Constantine and the establishment of the New Rome at Constantinople further emphasized the bipolarization of the Church in which Greece – and the Greek language and alphabet – would come to be characterized as Eastern. The political strug-

Quadrate Greek letters from a
stele at Athens (Lewis F. Day,
Alphabets Old and New,
London, 1910)

Trajan imperial majuscules as
redrawn by Edward Catich, 1961

gles of these changes were marked in the transformations in script forms. *The Politics of Script*, by the historian of paleography and typography, Stanley Morison, remains an unsurpassed study of the role played by written forms in reinforcing and marking the boundaries of political identity and control during the period from the 6th century BC through to the medieval era.[1] Morison's work does not deal with the alphabet as a symbolic form *per se*, but establishes a foundation for understanding the cultural history of the late Hellenic and early Christian eras in relationship to the role of writing.

Morison's study begins by identifying formal distinctions between the monumental capitals used in Greek inscriptions as early as the 6th century BC and those which became the regularized and consistent form of Latin majuscules. Greek and Latin monumental capitals had in common a *quadrate*, or essentially square, form, but were clearly differentiated in most other respects. The Greek letters were made of thin, consistent, unserifed, strokes while the Latin capitals of the 3rd century BC were characterized by thick major strokes, thin substrokes, and elaborate serifs. By the 1st century AD, Morison points out, 'Rome brought its influence to bear on Greek as written by the scribes of the subject people' and Greek lettering began to show evidence of the Latin forms.[2] The 'geometrical and mechanical' model of the Latin capitals became identified with the authority of Imperial Rome. In such inscriptions as those of the Trajan column these letters took the visual form in which this identity was standardized and promulgated. Various hands developed for purposes other than monumental inscriptions, for instance for legal and business documents which required all range of formal, informal and rapid writing. In addition, such documents were written on materials other than stone, such as on the surfaces of papyrus and vellum. Letters drawn in ink were adapted to accommodate the movements of the scribe's hand rather than the stonecutter's chisel.

73

By the early 2nd century AD a form of Latin lettering known as Rustic emerged which was more condensed and less square than the earlier Imperial majuscules. It was used both in carved inscriptions and in writing on papyrus. Though still essentially a set of majuscule forms, it had a character and visual identity which were perceived to be more specifically Latin than even the Imperial capitals. One bit of evidence of this identity was the application of the rustic hand – in preference to the Imperial letters – to the manuscript publication of 4th-century codex editions of Virgil, the quintessential Latin poet.

The next major change in alphabetic writing occurred in relation to Constantine's rise to power and establishment in 313 AD of Christianity as the official religion of the Roman Empire. In 312, conquering Rome, Constantine reputedly had a vision in which he saw the Cross shining in the sky along with the *alpha* and *omega* and the words 'With this sign, Chrisomon is triumphant.' In his vision the form of the Greek *alpha* was forked, a style which would come to be clearly associated with the

	ROLLS FROM HERCULANEUM.	CAPITALS FROM CODICES.	ANCIENT CURSIVES.	UNCIALS.
a				
b				
c				
d				
e				
f				
g				
h				
i				
k				
l				
m				
n				
o				
p				
q				
r				
s				
t				
u				
x				
y				
z				

Chart showing majuscule and cursive forms of Roman alphabet in use in early Christian era (Harold Johnston, *Latin Manuscripts*, Chicago, 1897)

74

Byzantine style of alphabetic lettering. More immediately, Constantine's conversion and dedication to the rebuilding of libraries of Christian texts combined with a desire to establish a form of writing which would be distinct from that of the Latin emperors whose imperial majuscules were now

4th century manuscript of Virgil, showing Rustic characters (Deutsches Staatsbibliothek, Berlin)

Christian catacomb inscriptions with curved 'E' and *Omega* (De Rossi, *Roma sotterranea*)

associated with the persecution of Christians and the destruction of earlier Christian libraries under the edicts of Diocletian. The older Latin scripts also carried strong associations with the writings of the classical pagan dramatists, poets and historians, in addition to which the majority of texts by the Evangelists and Church Fathers had been originally written in Greek. Synthesizing an alphabet which would have visual elements of familiarity for both Greek and Latin readers, and which would also have the virtue of distinguishing itself from Latin precedents, Constantine established a new Christian script to symbolize what he called '… a world rising triumphant to the stars under the leadership of Christ.'[3] The script which developed had the advantage of being more efficient to write and more economical in terms of space than the monumental capitals or even Rustic forms of earlier scripts. The uncial form became regularized largely through its efficacy as a means for reconstructing Christian libraries from the 4th century onward.

Book hands, chancery hands, letter forms for monumental inscriptions, official documents and imperial decrees proliferated in the next centuries. It was not until the Carolingian miniscule was adopted by official

75

Crypt containing early Christian inscriptions, 3rd century AD (Henri de L'Epinois, *Les Catacombs de Rome*, Paris 1896)

Image of Latin scribe in early Christian era (Codex Amiatinus, Biblioteca Laurenziana, Florence)

decree in the 8th century as a means of unifying the empire of Charlemagne that any successful attempt at uniformity was effected. In the interim, peculiar syntheses of Greek and Latin letter forms continued to produce odd hybrid styles. Morison calls particular attention to the writing on the Cross presented by Justin II, Emperor of Constantinople, to the pontif of Rome. Produced in the metal workshops attached to the Hagia Sophia sometime between 565 and 578 AD, the piece displays a peculiar and distinctly non-Roman monumental lettering. As the Cross was believed to contain a piece of the True Cross, and intended to serve as a symbol of the links between the New Rome and Old, the use of the strange combination of uncial, capitals, and as Morison says, 'what-not,' must be understood as intentional and significant. The redesign of the old Latin letter forms was intended to reflect the new Imperial authority at Constantinople. One visual element in particular points out the significance of the new forms – the forked 'A' which had also appeared in Constantine's vision. By its new form, this letter signified the Greek and Eastern influence which had integrated into the letter forms of the old Roman empire.

77

Justin's cross, 6th century; note the forked 'A' form (Vatican Museum)

The Concept of the Logos

Christian dogma has in common with certain other Western religious and philosophical belief systems a faith in the concept of the Word. In Christianity, this concept is associated not only with the notion of a Divine Truth (itself rooted in earlier belief systems – such as Platonic philosophy with its hierarchical structure of Truth as an Ideal) but also with a notion of embodiment of that Truth. Christ, as Prophet and Saviour, not only delivers the Word, but states that he in effect is the Word as well. The concept of *logos* thus carries with it a meaning far beyond the mere signalling of the existence and authority of a sacred text. In

Christian terms, the *logos* is the metaphysical condition of being, the very essence of God as the full extension of the universe – transcendent, absolute, and ultimate. Both Jewish and Islamic dogma share this concept, though in modified form. In Jewish culture the Word is the Divine Word, and is to be found in the Scriptures. Preservation, interpretation, and transmission of these sacred texts is at the heart of Jewish belief and Jewish law and the mystical potency of the Word is the basis of the kabbalistic tradition. In the Islamic community, the text of the Koran is similarly revered as Divine, and honoring and disseminating its wisdom and beliefs are one of the major tasks of the believer. Belief in the sacred character of the Word, in all of three of these religious systems, includes a reverence for its visual form, and a respect for scrupulously accurate reproduction of the text of the Scriptures.

The implications of these belief systems for Western culture more generally are that they establish a foundation for belief in the transcendent power of language and the Word, or *logos*, more generally. Along with this belief comes a faith in the authority of language when it is the embodiment of Law, or Faith. This belief raises the validity posited in language to the level of Truth, again in a metaphysical and transcendent sense. In much of Western culture, the very concept of Truth itself is linked to the activity of language, and its capacity to present itself as the embodiment of an authoritative power. These notions permeate early Christian Gnosticism, as they also permeate the Jewish Kabbalah. They have a more banal, but no less effective, legacy in the traditions of textual interpretation which appear in literary studies, historical studies and the like. These latter, and the belief systems underlying them which are characterized as *logocentric* in character, have been systematically critiqued in the work of recent critics, the most prominent among whom is Jacques Derrida, the French philosopher responsible in large part for the development of deconstructionist criticism which begins with an investigation of the logocentric basis of Western metaphysics.[4]

Christian monograms (X. Barbier de Montault, *Iconographie Chretienne*, Paris 1890)

78

Gnosticism – Syncretic Beliefs and Symbolic Knowledge

Like other syncretic religious practices which originated in Egypt, Gnosticism exhibits the various influences present in Alexandria at the close of the Hellenistic era, borrowing from Greek, Coptic, Mandaean and Jewish sources. Gnosticism was based on the belief that the revelation of divine knowledge which culminated in Christ could be found in the faith of many peoples, but was also a significant attempt to integrate the beliefs of the ancient world with the new teachings of Christianity. The cosmology of Gnosticism is characterized by a belief in dualism borrowed from Zoroastrianism and Persian Mazdaism and combined with Babylonian astrological fatalism and the transcendent monotheism of the Jewish faith.

Gnosticism is based on the concept of emanation of the Divine Light through the debased form of the material world. In Gnostic cosmology, God is not one with the universe, and the material world is no evidence of God's existence. Instead, God is considered alien to the material universe, which is base and crude. This dualism, which is termed *anti-cosmological* because it not only distinguishes the Divine power from the world but even pits the two against each other, was contrary to the teachings of the early Christian Fathers. Thus, in spite of certain Christian features, Gnosticism was considered a heretical doctrine. Outlawed by decree in the 3rd and 4th centuries, it virtually disappeared by the 6th century AD. Its Christian aspects notwithstanding, Gnosticism should be understood as a spiritual counterattack of the Eastern sensibility against the domination of Western culture.[5] Gnosticism is mystical and symbolic in character rather than based on the abstract rational logic associated with Greek culture.

The beliefs of Gnostics ranged from a mystical eroticism (associated with the bridal chamber imagery of a text known as the *Pistis Sophia*) to far more abstract cosmological structures and to considerations which are almost fully reconcilable with standard early Christianity. Valentinus, in Egypt, was the most famous of the Alexandrian Gnostics (d.161 AD) but Simon Magus, a Syrian magician who became the prototype of later Western magicians, was responsible for a dualistic form of Gnostic practice which he later renounced for more orthodox Christianity. Few original Gnostic texts remain, and many doctrinal beliefs, such as those of Marcos, a student of Valentinus, are largely passed on to posterity through the work of other writers. In this case, it is through the Christian writer Irenaeus, whose *Adversus Haereses* recorded Marcos' cosmology in great detail in order to thoroughly denounce it.

Before considering Marcos, however, one unique artifact containing an early Gnostic text will be discussed. This is an amulet similar to those discussed in the previous chapter, a small, foil *lamella* originally rolled and suspended around the neck, which was discovered in Beirut in 1925 by the scholar Charles Virolleaud. Though eventually lost in transit between Paris and Oxford, the piece was thoroughly studied and documented by

79

A. Dupont-Sommer, who published his research on it in 1946. Surprised at the strikingly Christian content of the amulet, which made it unique among the other he had studied from this period, Sommer translated the nineteen lines inscribed on the tiny metal scrap (approximately 10 by 6 centimeters). The text began with the sign of the cross and the single word 'Waw.' It continued, 'son of God, the Great, /the strong, the Holy God. / Three powers exist in him/ the grand virtue of the Ocean,/ and the Archontes, the water and / the World.' The rest of the short text includes two incantations, one for divine inspiration, one for malediction. Sommer compares the use of the *Waw* in this context to the privileged status accorded the *upsilon* in Pythagorean symbolism. Though the invocation of the Son of God is obviously Christian, Sommer terms it unusual in Gnostic texts. In the *lamella* the *Waw* comes to be interchangeable with the term Christ, the Ocean referred to is the mythic Abyss, while the Archontes are the supernatural beings which are the intermediaries between God and the world in Gnostic cosmology. In Gnostic systems with close links to astrology, the Archontes are associated with the seven planets.

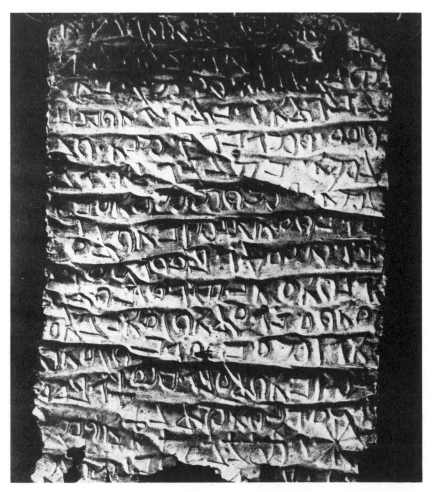

Aramaean *lamelle*, now lost, rephotographed after Dupont-Sommer (Paris, 1946)

Sommer situates his interpretation of the amulet in the intersection of Neo-Platonic, Neo-Pythagorean and Christian symbolism. He points out that the use of the *waw* as a symbol has parallels to other letter mysticism, such as that of the Neo-Platonist Porphyry, who produced a similar discussion of the values assigned to the Greek *omega*. Such letter mysticism was prevalent in the Hellenistic world in which the term *stoicheia* retained its cosmological significance, invoking both the letters and their role as fundamental elements of the universe. St Paul, for instance, in his Epistle to the Galatians in 55 AD, discussed the cult of the *stoicheia*, cautioning against it: 'When we were young we were instructed in the elements of the world (*stoicheia*) which, by their nature, were not gods. How can you go back to their pathetic and feeble elements which you consented to use once again? You observe the days, the months, the seasons and the years.' Paul associates these practices with childhood instruction in the learning of the alphabet, but the calendrical observations were also considered pagan practices, associated with astrology, rather than with the Christian calendar. A few years later Paul admonished another group, the Colossians, for their continued allegiance to the philosophy of the *stoicheia*. The identification between these alphabetic cosmologies and pagan beliefs was clearly made.

While the *lamella* participates in the widespread practice of letter symbolism, the specific thematics of this text show the particular hybrid character of Gnosticism. Although both the initial cross and the association of the *waw* with the phrase the 'son of god' are distinctly Christian, the immediate imbrication of these opening statements with a text concerned with the cosmological hierarchy of the Ocean and Archontes betrays the influence of Eastern cults. The powers of Ocean, Air and Water lose this animate energy as spiritual forces in the anti-pagan disposition of the early Church. Similarly, the distinctly Greek and mythological astrological associations, which are so easily assimilated in this short text to reinforce the symbolic structure of the cosmological system, were also considered, as in the passages of St Paul above, anathema to early theologians. Such synthetic combinations of belief systems, and the attempt to reconcile their apparent contradictions through a universal symbology, would have parallels in the work of later thinkers, particularly Raymond Llull, the medieval Catalan logician and mystic, and in the polymath philosophers of the early Renaissance. But in a period when even Christianity was as yet not fully institutionalized, the Gnostic sensibility as evidenced in this *lamella* threatened the kind of clear identity in political and spiritual realms which the early Church so definitely sought.

Of the Gnostics, Marcos (who was active in the second half of the 2nd century AD) is the one for whom we have the most evidence of interest in letter mysticism. Marcos's work integrates the Greek faith in the mysticism of letters, the *stoicheia* with the full apparatus of Gnostic cosmology. According to Marcos the letters compose the basic Plerome with its elements: the Archontes, the Eons, Words and Angels which are the Roots

81

and Sources of all which exists below. In Marcos's text a divine figure known as the supreme Tetrad appears in a female form. In this vision the letters of the alphabet are all assigned to parts of this divinity's body, as Marcos describes: 'First was her head, the *alpha* and *omega*, her neck, the *beta* and *psi*, her shoulder and her hands, the *gamma* and *khi*, her chest the *delta* and the *phi*, her diaphragm the *epsilon* and the *ypsilon*, her stomach *zeta* and *tau*, her sexual parts *eta* and *sigma*, her thighs *theta* and *rho*, her knees *iota* and *pi*, her legs *kappa* and *omicron*, her ankles *lambda* and *ksi*, and her feet *lambda* (again) and *nu*. With the exception of the deviant last pair, all of these associations proceed from the first and last letters of the alphabet toward the middle, clearly using its systemic entirety as a metaphor for the wholeness of the soul in the body. As the vision continues, the woman insists that Marcos understand the significance of the statement that Jesus is an *episemon onoma*, a highly symbolic name. The word *episemon* carries an additional value in this context because it is associated with the antique *digamma*, the letter which had held sixth place in the archaic Greek alphabet. Because it had fallen out of use by Marcos's time, the *digamma*, was granted special significance. Since it had been used to designate a sound similar to the *waw* (also the sixth letter), there were several links between the *episemon/digamma*, the *waw* of Marcos's text. The value related to the transformations in the alphabet and the symbolism of the sixth letter as the secret name of Jesus, will be touched on again in discussing other non-Gnostic Christian texts.

As Marcos's vision continues, the ineffable name of Christ is calculated by spelling out the names of the letters which compose the Greek *Xreistos*, the numerical total of thirty (three for *Xei*, two for *rho*, etc.) is itself granted symbolic value: it equals the combined value of six, the number of letters in the name Christ, and twenty-four, the number of letters of the alphabet. Such calculations, highly reminiscent of the symbolism of the Pythagoreans and the gematrial calculations of later Kabbalists, allow for almost endless recycling of symbolism through the name of Christ. The twenty-four letters of the alphabet are also granted other Christian symbolism in Marcos's discussion, by virtue of belonging to three classes of phonetic value. There are nine mutes which are the Paths and Truth, eight semi-vowels which are the Logos and the Life, and seven vowels which represent Man and the Church. The inequality of these classes in the 9/8/7 sequence requires that one letter leave the first class and migrate to the third to re-establish the perfection of the 888, another numerical equivalent of Jesus's name (and also, of course, equal to the 3 x 8 equation of the alphabet, or twenty-four). The letter which is designated the *episemon*, the Insigne, which thereby becomes the sign of Jesus through a complex chain of associations and transformations.

According to the alphabetological drama, the significance of these numbers is derived from a biblical tale in which Jesus becomes the 'sixth' number (i.e. the *episemon* and the *waw*) when he goes up the mountain with Peter, John and James and is joined by Elijah and Moses; he comes

down from the mountain on the sixth day and enters the Hebdomade (the domain of seven) in a redemptive descent which mirrors the movement of the aberrant ninth vowel in the first class to become the eighth member of the third class. While the number eight figures prominently in the numerical analysis of Jesus's name, it is with the relations between the symbolic values of six and seven that Marcos and Gnosticism are largely concerned.

The number six had carried the symbolic value of Creation from the Old Testament account of God's six days' labor in creating the universe. In addition there is a link which Marcos establishes between Adam, made on the sixth day, and Jesus since in the story of the Passion, the sixth hour of the sixth day is the time associated with the nailing of Christ to the Cross. In Marcos's text it is stated that 'the perfect Intellect, knowing that the number six possesses the power of creation and regeneration, manifest to the Sun the light and power exercised by the appearance of the Insigne ...'[6] Marcos's text forges other associations with the Pythagorean six, the number of regeneration, and the rebirth of Christ. Such synthetic blendings of Old and New Testament imagery, of Pythagorean influenced number symbolism and the hierarchical structure of the Cosmos show the syncretic tendencies which marked the Gnostic spiritual project.

The Christian philosopher, Clement of Alexandria, writing in his work *Stromates* in the late 3rd century, took up this Gnostic theme and reiterated the point that the Insigne, *episemon*, or *waw* is linked to Jesus because it is the letter which is hidden in the alphabet (in other words, the old *digamma*) as His divinity is Hidden – first in the world, then in his Ineffable Name. For Clement the *disappearance* of the letter from the alphabet was crucial since it signalled the movement of resurrection and redemption. Thus the process by which the seven letters of Christ's name (the Greek *Kreistos*) became six (the number of intervals between the letters) and so forth allowed an interchange of symbolic values between six, seven and eight. As a 3rd-century Alexandrian, Clement was well aware of the Gnostic precedents and sources for his work, the aspects of his writings which would exert a more long lasting influence resided in other portions of the *Stromates*. While Marcos's discussion contains the most detailed exegesis of the letter *waw* that has come down to the present day, the doctrine attached to the letter is probably much older than Marcos. The discussion of the Three Powers (the Incorruptible Light, the Water, and the Earth) in the *lamella* analyzed by Sommer can be traced into 1st century Syrian sects, though without the same explicit Christian symbolism. Some degree of symbolism was also attached to the visual form of the *waw*, connecting it to the image of the serpent which some Gnostics believed was inscribed in its very design. According to one source, the serpent was recognized as the most eminent symbol, possibly even that imposed on the head of Cain to prevent his being killed. Whatever these early sources may have contributed to the symbolism of the *waw*, they are fully absorbed into Marcos's interpretation, where they have been absorbed into the Gnostic Christian imagery of the *episemon*.

Another Gnostic text, *Pistis Sophia* (the title literally means *Faith-Wisdom* in Greek) makes use of both the full alphabet and the symbolism of the vowels common to classical culture in its structure. Considered a late work, and an expression of an already degraded form of Gnosticism, the *Pistis Sophia* nonetheless presents a clear image of the cosmological structure of Gnostic thought.[7] The world, again distinct from the realm of Divine Light which is the antithesis of the Darkness of the universe, is governed by Archons. These are the lower powers who rule the material world, a prison whose innermost dungeon is the earth. There are seven spheres of the Archons, each ruled by a figure whose name recalls the names of God from Jewish texts; Sabaoth, Adonai, Eloheim and so forth. *Pistis Sophia* describes a world of twenty-four aeons and twenty-four mysteries, and indicates the existence (if not the clear significance) of the five marks, seven vowels, five trees and seven amens.[8] These are the twenty-four elements, knowledge of which was required for the passage toward salvation. In the book the soul is put to the test of travelling through the aeons which structure the cosmos. The female character of Pistis Sophia is found by Christ, stuck in the thirteenth aeon, and is led by her through the necessary stages toward enlightenment. As in the case of earlier religious practices, the work manifests a strong belief in the mystical power of letters, numbers and magic formulae. At the end of the book Jesus utters an incantation which repeats the Greek vowels in a manner precisely duplicating their use in many Greek magical papyri. The passage describing this activity places particular importance on the combination of 'I A U' (the last letter indicates the Greek long 'O', *omega*, the final vowel in the traditional sequence 'A E H I O Y U'), a combination which carries complex symbolic value in Greek, Arabic, Hebrew and Sanskrit linguistic contexts.[9] Standing at an altar, dressed in linen garments signifying purity, Jesus turns to all four corners of the world repeating 'I A O,' 'I A O.' One interpretation offered is that *Iota*, the universe, came out of *Alpha* which offers renewal before return to *Omega*, the 'completion of all completions,' while another interpretation of the statement reads, 'I' (Jesus) 'am the A (*alpha*) and the O (*omega*). The *alpha* and *omega* were continually identified with principles of manifestation and reintegration. The scene described is similar to that prescribed as a ritual practice in the Greek magical papyri (which are of the same chronological period) in which the sequence of seven vowels is pronounced turning first to the four cardinal points and then to the Earth, to the Air and finally to the Heavens.[10]

Other magic words, letters, combinations are found among the Gnostics, some of which become standard features of later magic practices. The word ABRAXAS, for instance, is one in which the seven letters are intended to signify the seven creative powers, each, again, associated with one of the seven vowels, planetary angels. The numerical significance of the word ABRAXAS was calculated at three hundred and sixty-five, corresponding to the number of 'aeons or emanations from the first cause' and the 'aeons,' were further considered the 'Spirits of the Days.'[11]

ABRAXAS gem (E. Wallis Budge, *Egyptian Magic*, London, 1901)

Neo-Pythagoreanism and Neo-Platonism – the Non-Christian Greek Tradition

Elements of Pythagorean number symbolism show up in almost every aspect of early Christian letter mysticism, but they are subsumed in such practices to the overriding concern with the central image of Christ and of salvation. There were, however, strongholds of the non-Christian Greek tradition. Most significant among these were Neo-Platonism, a reinterpretation of the teachings of Plato promoted most significantly in the writings of Plotinus in the 3rd century[12]. As defined in Plotinus's *Enneades*, Neo-Platonism promoted a mystical discipline leading to salvation through union with the One. Asserting that this teaching could be found in the work of the classical philosophers, particularly Plato, Neo-Platonism was a distinctly anti-Christian movement, a rival for power in the spiritual domain, an attempt to build a stronghold of faith grounded in Greek tradition capable of withstanding the increasing power of Christianity. The movement found strong proponents in the 3rd and 4th century writers Porphyry (a student of Plotinus) and Iamblichus, and continued to have a significant following into the 6th century. It would experience a revival with the Renaissance publication of Marsilio Ficino's Latin translation of Plotinus's text as part of the Renaissance attempt to reconcile classical tradition with Christian beliefs.

Because of the link with Greek tradition, both Neo-Platonism and Neo-Pythagoreanism made use of the theories of cosmological structure, harmony and symbolism which had emerged in the classical period. They also were both theurgical practices, combining contemplation, ritual magic, disciplined habits, and good works in the formation of a route to divine salvation. The mystical tenor of Neo-Platonism was reinforced by its use of the *Chaldean Oracles* and various poems ascribed to Orpheus as its response to the power wielded by the Christians through the force of their 'divine book.' A collection of cryptic statements rather than a systematic statement of belief, the *Oracles* nonetheless pointed to the synthetic character of Neo-Platonism, and its capacity to draw on the old Babylonian astrological cosmology as well as the tenets of Greek philosophy in its attempts to establish a powerful spiritual belief system. In the 2nd century Julianus the Theurge used the *Chaldean Oracles* to attack Christianity, and by the reign of Constantinus, son of Constantine, such beliefs were still so prevalent (and so persuasive) that all divinatory practices were outlawed by decree in 357 AD in an attempt to control the influence of non-Christian religion.

Letter mysticism enters the tradition of Neo-Platonism only marginally. Since the goal of Neo-Platonism was a mystical union with the One, the structure of the cosmos formed a metaphoric framework for structuring the hierarchical relations of levels of consciousness. The links between Pythagoreanism and Neo-Platonism in this period are complex, but certain figures, such as Nicomachus of Gerasa, made elaborate use of number symbolism which was in turn appropriated by the Neo-Platonists. In Neo-

85

Pythagorean cosmology a general sympathy connected all parts of the spheres of the cosmos, the so-called harmony of the spheres. The structure of these harmonic relations was of course mathematical, and as the order of the material universe had emerged, in Pythagorean belief systems, from the One, the understanding of this cosmic harmony was a means of studying and accessing the One. Such notions were readily assimilated into a Neo-Platonist belief that goodness and order were to be found in form and harmony, measure and limit – rather than in the dualistic struggles of Zoroastrianism, Gnosticism, and Christianity.

The Neo-Pythagorean theory of harmony of the spheres was specifically connected to the doctrine of the seven planetary vowels. This doctrine was elaborated by Nicomachus of Gerasa in his influential text *Theological Arithmetic*, written around 150 AD. The distances of the planets from the earth were converted to the values of the chords in the heptachord which served as the basis of Greek musical harmony. As Nicomachus explained, the elements of the musical scale were therefore not based on the force of vibrations of individual sounds, but on the respective proportions of the cavities in wind instruments necessary to produce them. Chords and notes were both indicated by letters of the alphabet, with the vowels holding privileged place: 'All those who have made use of the symphony of seven sounds as if it were simply natural borrowed from this source in order to know not only the spheres but also the sounds which are the only ones among the letters which we call vowels and musical sounds.'[13]

Such a cosmological structure was even adapted by Marcos the Gnostic who linked phonemetric and astral cosmology in the following description: 'The first sphere of heaven makes the sound *alpha*, the second, *epsilon*, the third *eta*, the fourth which forms the middle of the heavens expresses the virtue of the sound *iota*, the fifth the sound *omicron*, the sixth *upsilon*, and the seventh sphere, which is the fourth from the middle, is *omega*.' While this passage is so mechanical as to provide little spiritual inspiration, it does indicate the kind of intellectual cross fertilization which permitted similar source materials to be put to different religious ends. For Nicomachus, however, the spiritual value of the vowels was more explicit: 'If the inexpressible things (vowels) are combined with expressible things (consonants) just as the soul is bound to the body and harmony to the strings, they create animate beings, those of the stories and songs, those of active faculties, production of divine things.'[14] When arranged in graphic form, the vowels formed a triangle with *alpha* at the top and a row of seven *omegas* forming the base. When given the perfect form of the isosceles triangle, this formula was understood as a spiritual stairway of 'the name' in the form of a heart.

One final synthetic text will be mentioned here, which was by Zosimus, a Hellenistic alchemist and writer. It contains a paean to the Omega with typically Neo-Pythagorean imagery, but bearing traces of Gnostic cosmology as well, particularly the image of the Ocean: 'The

Amulets (based on Charles W. King *The Gnostics and their Remains*, London, 1864)

Letter Omega, the round, the double, corresponds to the seventh zone of heaven, that of Kronos, according to material language – in spiritual language it is something else, ineffable, which only Nicotheos knows secretly – so, as I said, according to the material language Omega is that which one calls Ocean – origin and source, of all the gods, all as one says, of the monarchs of material meaning. Thus, the said Omega, grand and venerable, includes all the powers of the divine water, etc.'[15]

The theory of the significance of the seven vowels and their continued association with the planets, as well as with theories of cosmic harmony, would show up again in the Renaissance, as part of the revival of classical knowledge. Other strains of Neo-Pythagorean thought would inform medieval Kabbalistic work, the *ars combinatoria*, and cosmological propositions through the Renaissance which involved theory of harmony and structure in the ordering of the universe. These would increasingly come to be understood in relation to the notion of the Book of Nature as a work of the Divine order, spirit or mind, but the strength of the Pythagorean systems perpetuated their use even into much later Christian and scientific attempts at ascribing symbolic significance to the structure of the universe.

Christian symbolism

Indisputably, the most famous early Christian statement using the symbolic imagery of the alphabet comes from the Apocalypse of St John, in which Jesus speaks the following words, 'I am the alpha and the omega, the first and the last, the beginning and the end.' Almost exactly the same formula is repeated elsewhere as 'I am the alpha and the omega, that which is and which has been, and will be – the all powerful.' The use of the alphabet as a sign of cosmological totality is inextricably bound up with the Greek concept of the *stoicheia*, but in the Christian world it loses this atomistic meaning and serves as a sign of the wholeness of the Divine world of Christian faith. In a passage of his work, *Stromates*, Clement of Alexandria expanded on this symbolism, '... the sensible forms are vowels, which explains why the Lord was known as the Alpha and Omega, the beginning and the end. The sign AO is easily associated with Christ when one discovers a numerical equivalence with the name of the dove, another well known Christian symbol.' Clement is only one of the many early Church Fathers to take up this symbolism, which recurred throughout the medieval period.

Aside from the refrain of this text, one document which provides evidence of early readings of the alphabet through Christian symbology is in a letter written by St Jerome to St Paula. Known as the XXXth Epistle, this text is also much cited in later literature.

The passages in St Jerome, written about 384 AD, focus on the 118th Psalm which is composed according to the order of the Hebrew alphabet, though using Greek letters.[16] The first verses all begin with *alpha* and each

87

succeeding set of verses with the succeeding letter until ending with those beginning with *tau*. Jerome assigns a value to each letter and then groups them into phrases, all the while keeping in mind his ultimate aim, to explain to St Paula that the alphabet contains spiritual knowledge in symbolic form.

In the first group are the following letters are equivalents: *Aleph = doctrine, Beth = house, Gimel = plenitude, Daleth = the tablets, He = this here*. The meaning of this string of elements is at first construed literally by St Jerome as 'doctrine house plenitude these tablets here.' But then he expands, filling in the gaps, and arrives at the explanation that the first four letters read together mean that 'the doctrine of the church, which is the house of God, is to be found in the plenitude of divine books.'

The second group of letters are: *Va, Zai*, and *Heth* which mean 'and this life.' And what life, Jerome asks, is possible besides that one described in the Scriptures 'thanks to which one knows Christ himself, and which is the life of believers.' *Teth* and *Iod*, the third set of letters, mean 'good principle' and signify that 'In effect, even if we know the all the Scriptures, still our knowledge is partial and our prophecy is partial and we see only by means of mirror and enigma. But when we will have been worthy of being with Christ, when we resemble the angels, then we will have no more need of the the teaching of books.' The fourth group, *kaph* and *lamed*, stand for 'hand of the art or discipline,' in which the hand implies action, the heart and discipline make clear that 'we can do nothing if we don't know what to do.' *Mem, Nun, Samech* mean that 'from which comes the eternal salvation' which, Jerome says, 'has no need of explication – it is more clear than day, by the holy books we are furnished with eternal aid.' The elements of the sixth group, *ain, phe, sade*, are the 'source' or 'eye of the mouth of justice'. Jerome instructs Paula to interpret these as in the case of the third group, to mean 'good principle.' Finally, the seventh set of letters, *koph, res, shin, tau*, carries the somewhat cryptic sense of the 'call or appeal of the head of the teeth signs.' Stretching to include the literal sense of the letters' symbolic value, Jerome explains that 'the teeth permit the voice to be articulated and heard and by these signs one arrives at the head of things – which is Christ.' Not surprisingly, Jerome then invokes the symbolism of the number seven, associating this last group with Christ as the ultimate, the end of all things.

Perhaps the most interesting feature of St Jerome's exercise from the perspective of alphabet historiography is his use of the names of the Hebrew letters in a symbolic interpretation, the first such recorded instance of this practice. The values assigned to the letters as symbols in this manner were never fully standardized, not even in the peak vogue of such associations in the 19th century, and Jerome's interpretation has a number of idiosyncratic aspects. In fact, with the exception of the assignment of the value *house* to *beth*, the only letters which have values which are cited elsewhere as the *names* of letters are those which name body parts: *caph/hand, ain/eye, phe/mouth, res/head*, and *shin/teeth*. While

aleph is often assigned the value of *doctrine*, *covenant* or *faith* by virtue of
its position as first letter, the rest of the spiritual values which Jerome
ascribes are not features of much later interpretations; they do, however,
feature in another manuscript dated to this period and fully twelve of the
twenty-four values are the same in the two texts.

Adolphe Hebbelynck: images of
the Greek alphabet, (redrawn
after *Les Mystères des Lettres
Grèques*, Paris, 1902) Left to
right, top to bottom, the
sequence of these letters follows
that of the manuscript, rather
than the traditional alphabetic
order

pi: the foundation of the Church
and the mystery of Christ in the
figure of the temple
delta: heaven and earth
gamma: earth before it emerges
from the waters

beta: with a blackened bowl,
the white part represents
waters, the shadows below are
the abyss
alpha: in circle, the space above
is air and wind, below are
waters
eta: split of light and shadows,
the middle line makes the
separation

zeta: separating the superior
and inferior water
iota: plants with grains or seeds
kappa: fruit trees

aleph is often assigned the value of *doctrine*, *covenant* or *faith* by virtue of
its position as first letter, the rest of the spiritual values which Jerome
ascribes are not features of much later interpretations; they do, however,
feature in another manuscript dated to this period and fully twelve of the
twenty-four values are the same in the two texts.

This second document is a Coptic-Arabic text assigned to the 5th or
6th century and referred to as 'The Mystery of the Greek Letters.' The
actual manuscript (dated to the 14th century) is assumed to be the work of
a Palestinian monk known as Saba, and had been the object of extensive
study in the 19th and early 20th centuries by Emile Galtier, Adolphe
Hebbelynck, M. Amelineau and others.[17]

On the basis of linguistic evidence, the original of the text studied by
Hebbelynck seems to have been in Greek and from the early Christian era,
though the Coptic manuscript from which he worked was dated to the
11th century. The work has vivid themes of creation and redemption but
lacks the cosmological symbolism of Gnostic texts, and is more purely
Christian in its tone.

The underlying premise comes, again from the statement made by
Christ to John in the Book of Revelation, 'I am the alpha and omega.'
Hebbelynck's author (henceforth to be referred to as Saba) takes this to
mean that there is 'a mystery in the letters of the alphabet of His revela-
tion of the promulgation of divine law and the origin of the world.' The
author is at pains to distinguish his interpretation from the Greek theory
of the *stoicheia*, stating that the alphabetical letters are symbolical ele-
ments only, in whose 'form is figured the form of the elements of the cre-
ated world' rather than being literally atomistic elements of the cosmos.
The text begins with an alphabetological encoding of the acts of Creation.

'One of these letters embodies the earth and the heavens, another is
written to represent the earth and the water, another to represent the
abysses and the shadows, another to represent the wind and the water,
another symbolizes light, another shows the firmament of heaven, another
depicts the separation of the waters above and the waters below, another
shows the formation of the earth and its immersion into the waters.
Another, again, is the image of the plants, another of the fruit bearing
trees, another shows the light of the stars, and in another one finds the sign
of the sun and the moon, another shows their place in in the heavens.'[18]

Before detailing the symbolic value of each of these in company with
drawings to illustrate his points, the author digresses on the theme of the
episemon. This letter, again identified as the *digamma*, is not present in
the alphabet. Thus the *episemon* is hidden, and signifies the descent of the
Word of God from Heaven to the Earth as well as His Coming to found
His Church. To these themes, familiar from the discussion of Gnosticism,
Saba adds schematic elaboration of the value of the number 22, stressing
that it is the Greek alphabet which foretells the coming of Christ, though
he is not loathe to move freely back to the Hebrew letters when high
authority and antiquity support his arguments.

lamda: light rays from heaven to earth

mu: night separated from day

nu: the paths of the sun and the moon

omicron: the two faces of the sun and the moon

pi: the mystery of the new testament, the Church of Christ, and access to Christ

rho: heaven above with a line of light illuminating earth

summa: the incomplete circle is the image of the world, opening is the light in the world

tau: a divine ray and also the cross

vau: lines tracing the decent of Christ to hell and then his ascent

phi: the figure of the earth, the grand mystery of the ascension of Christ

chi: the four angles are the four evangelists as well as the four stages of the light of day

omega: consummation of the world and the knowledge that Christ does not perish

In addition to the twenty-two works produced in Creation (as noted in the above citation) Saba lists twenty-two miraculous works of Christ: 1) sending Gabriel to the Virgin, 2) the arrival of God as Word from Heaven, 3) the descent of the Word into the Virgin, 4) the nine months of pregnancy, 5) a childhood of purity, 6) the belief in the reincarnation of God, 7) legal circumcision, 8) glorious baptism, 9) the testimony of the Heavenly Father that 'this is my son,' 10) the descent of the incorporeal Holy Ghost, 11) the struggle against the devil in the desert, 12) the transcendent miracles, 13) the transfiguration into immutability, 14) the suffering on the cross, 15) the mortal death, 16) being put into the tomb, 17) the descent to hell to free saints' souls, 18) the delivery from hell, 19) the resurrection, 20) the ascension to heaven, 21) the place at the side of God, and finally 22) the second coming. This is the most clearly Christian of the passages in the manuscript, unclouded by any Gnostic, Pythagorean or astrological symbolism. However, the monk Saba is at pains to render his interpretation of the alphabet as replete as possible, and so begins to synthesize from other sources.

First he makes the division between seven vowels and fifteen consonants, associating the vowels with the seven creatures to whom God gave voice: angels, the soul of reason, the corporeal voice of humankind, birds, animals, reptiles and wild beasts. Of these, two are rational and indivisible, the voices of the angels and of the soul of reason, and they, in turn, Saba associates with the invisible Father and the immaterial Holy Ghost. The fifteen non-vowels he associates with the works of creation which had no voice, such as the heavens above, the firmament, the earth below and so forth through to the sun, the moon, the fish, and the cetaceous creatures in the seas. Once again the absence of dualism and the full integration into a Christian cosmology are evident, and distinguished the text from that of Gnostic and Pythagorean writers.

Saba sketches out the sum of this cosmology, first by making a division of the alphabet into six equal parts (one for each day of Creation) and then mapping these divisions onto a schematic Delta which shows the full structure of the universe. The Delta is the image of the Trinity which encloses within its upper realms three parts: the holy heaven at the top, then the waters above, and then our heaven. Below this are three divisions of the inhabited earth: our earth, the waters below, and the hidden, subterranean earth. Following this schematic diagram of the Universe are the drawings of the individual letters and the discussion of their symbolic values. The unique element of this manuscript is its use of the graphic form of the letters as a means of exegetical analysis. The visual form is considered a true embodiment of value, not merely a surrogate or convenient symbol because of its place in the alphabetical order. The letters carry value in Saba's cosmological scheme through their forms as images.

In his final section, Saba discusses the origins of the alphabet, asserting that the first letters were Syrian or Chaldean and that they were traced on a stone by the finger of God, found by Cadmus 'after the cataclysm.'

Before Moses, he adds, knowledge was not possible, just as *aleph* could not literally have been the first day since there were no days at the start of creation. The author's difficulty arises when he attempts to interpret the names of the Syrian letters as cosmologically significant and almost immediately gives up the project. He then switches to an interpretation of the Hebrew letter names, closely following the symbolism of St Jerome. While Saba's discussion of the origin of writing is not without precedent in the classical era, the tone of this passage contains elements of historical analysis which is not typical of writers from the early Christian era whose interests tended to be more strictly concerned with religious faith than secular history.

Hermeticism

No discussion of symbolism in this period would be complete without at least some mention of the Hermetic tradition. Also Egyptian in origin, the cult of Hermes Trismegistus (the name means thrice-Hermes or three-times powerful Hermes) was also a development of the Hellenistic period. Though Hermeticism, like Neo-Platonism, will resurface with consequences for the structure of schemes of symbolic interpretation in the Renaissance, the tradition is relatively unimportant for alphabet historiography, largely because it is linked to the mythic tradition of the hieroglyphic as a symbol in western imagination. Still, the *Cyranides*, first book of the lengthy *Corpus Hermeticum* (an amalgam of texts ascribed to Hermes, granted great antiquity, and in fact collected in the 2nd and 3rd centuries AD) does make use of the Greek alphabet as its structural basis. The *Cyranides* is a magico-medical treatise in which the curative (and magical) properties of plants, animals, birds, and stones are described. The alphabetic structure comes into play because the elements of each section are selected on the basis that they begin with the same letter, thus each of the twenty-four chapters, contains a linked analysis of the symbolic value of a plant, a stone, a fish, a bird which have in common only their initial letter. The sympathetic forces of nature are expressed in this link of the letter, which is not, however, ascribed powers in its own right.

More significantly for the intellectual history of written forms, is the conviction expressed by Hermeticism that the universe was a rebus. This assignment of arcane, esoteric and mystical value to visual symbols, particularly within a hieroglyphic context, was typical of the late Hellenistic period in which Egyptian priests were intent on mystifying their Greek rulers and concealing Egyptian beliefs in occult practices. The antiquity attributed to the Hermetic texts participates in this sensibility, shrouding the Egyptian culture in a veil of mystery which had not been part of its earlier actual history.[19]

The force of Hermeticism was largely felt through the *Corpus Hermeticum*, but the work of Clement of Alexandria, also evidently

91

formulated in an Egyptian context, became a conduit through Clement's propositions for the interpretation of symbols. In his work the *Stromates*, Clement outlined a methodology which would form the conceptual basis of visual symbology well into the Renaissance. While Clement thought of Hermes as the author of black magic, a figure only to be condemned, the symbological tradition of Hermeticism informed his thinking, most especially this notion of the universe as a rebus and the idea that the 'hieroglyphic sensibility' as key to reading it, though as a Christian, Clement saturated his cosmology with the idea that every entity in the natural world linked to the Divine Being.

Clement had divided hieroglyphic writing into the curiologic (the spelt) and the symbolic. The latter category he further divided into three: the Imitative (an object represents itself), the Figurative (an object stands for one of its qualities) and the Allegorical (an object is linked through enigmatic conceptual processes). In fact, these categories describe relations between visual forms and their meaning. A visual form may be mimetic or imitative, directly copying features of the object it represents; it may be associative, suggesting attributes which are not visually present such as abstract properties incapable of literal depiction; and finally, it may be symbolic, meaningful only when decoded according to conventions or systems of knowledge which, though not inherently visual, are communicated through visual means. Clement's structure shows up in direct citation in works as late as the 18th-century historian President De Brosses and William Warburton whose books were concerned with symbolism and writing as historical forms. Clement's conceptual outline may even be perceived in the work of Charles Peirce, the American logician and semiotician, whose fundamental categories of representation are based on similar relations between signs and their meanings. More directly, the symbological traditions of Freemasons, the Christian Kabbalists, allegorical alphabets, and the emblem books of the 16th century all borrow from Clement and also from the Hermetic tradition in Renaissance Neo-Platonism and mysticism. Clement's contribution to Christian dogma was significant, but his lasting influence was through this structure of symbolic interpretation.

Features of the various belief systems which surfaced in the syncretic tenets of Gnosticism, Neo-Platonism, Neo-Pythagoreanism and the Early Christian symbolic interpretations of the alphabet were bequeathed as an intellectual legacy to the medieval and Renaissance periods. Certain of these features were modified in accordance with the changed contexts in which they resurfaced while others were imported or rediscovered with less modification, as will become evident. Other features of the symbolical analysis of this period, such as the arcane cosmological features of Gnosticism, were, however, all but lost in the thousand years which followed this period, one in which biblical and classical imagery was associated with the alphabet in a variety of new and different ways.

V

CALLIGRAPHY, ALCHEMY, AND ARS COMBINATORIA IN THE MEDIEVAL PERIOD

Calligraphy: Manuscripts and Book Hands

The millennium which stretched from the decline of the Roman Empire to the invention of printing in the mid-15th century witnessed the development of writing into both a decorative art and an effective medium for communication. Fostered largely within the context of Church activities, especially in monasteries, calligraphy also flourished as a feature of shifting political influences in the domain of secular power. This is the period in which various scripts acquired distinct graphic identity as well as that in which highly stylized forms of illumination transformed the shapes of initial letters into visual ornaments of almost infinite variety.

However individualized, script forms in Europe in the Middle Ages all derived from some form of Roman source modified by local and foreign influences. The decoration of initial letters, however, often showed greater evidence of older influences, particularly that which distinguished the metalwork of tribes who had migrated into Northern Europe before the Christian era. As local styles of both script and decoration developed, their distribution followed the movements of individuals or political forces within the networks of medieval literate society. Since both the scripts and the illuminated letters of medieval manuscripts participate in these stylistic differences and distributions, both will be examined here, but separately, in keeping with most of scholarship in the field.

As the Roman Empire declined the role of the scribe passed to the monk: monastic scriptoria became the major sites for the production of writing throughout the Middle Ages. Writing would become an element of secular life with the development of universities from the 12th century onward, but until that time, the copying and illumination of manuscripts took place largely under the auspices of Christian religious orders; between 400 and 900 AD the development of distinct writing forms can be linked to particular scriptoria in the British Isles and throughout the European continent.[1]

In the 4th century monasteries were established throughout Italy and Southern France, and Roman scripts such as the uncial and half-uncial flourished. Of particular influence in fostering manuscript production were those missions established under the order of St Benedict, such as those founded at Subiaco and Montecassino in the early 6th century under an edict that each member of the community set aside some part of the day for reading. Meanwhile, the monasteries which would be the source of the distinctive Celtic traditions came into being in 5th-century Ireland,

spreading to mainland Britain in the 6th and 7th centuries where they encountered Anglo-Saxon influences, including that of the Runic characters brought by Scandinavians. By the beginning of the 7th century the scriptoria which would later be renowned for their individual manuscript traditions had already been established at Luxeuil, Bobbio, St Gallen and many other sites in Northern Europe. Scriptoria were an essential part of these monasteries, often set into tower rooms or off interior courtyards to afford them greater invulnerability in the event of attack. The value accorded books was correspondingly high, and stealing a manuscript was considered a serious crime. Scribes often intoned against any prospective thief with invectives reminiscent of the curse tablet verses of an earlier period: 'If anyone take away this book, let him die the death, let him be fried in a pan, let the falling sickness and fever seize him, let him be broken on the wheel and hanged. Amen.'[2]

Changes occurred in the function and place of writing within the social order in the centuries following the decline of the Roman Empire. The activity of writing shifted emphasis – from the carving of monumental inscriptions, writing of classical poetry, and recording of legal and historical texts – to the copying of religious and classical texts within the province of religious communities. These transformations had been preceded by certain technical changes: vellum replaced papyrus as a material support for writing and the codex (sheets bound into books) replaced the scroll. The monumental capitals which had been produced for and in stone inscriptions were replaced by graphic forms originating from the use of the pen, rather than the chisel, stylus or brush. Finally, the division of elements within the text came to be visually marked so that titles, beginnings, endings, and commentaries came to be organized spatially and indicated by distinctions of size and design to a far more complex and nuanced degree than was practical within monumental inscriptions.

The terms *script* and *hand* are often used interchangeably, but in fact, the former indicates a model of letter forms while the latter designates the actual production on the page of such a model through a particular scribe's work. Both scripts and hands vary considerably, but given the non-mechanical nature of manuscript production the continuity and uniformity of form is as remarkable as the range of invention.

Three important writing forms were the legacy of the Roman Empire: the square capital, which adapted poorly in the transformation from inscription to penned form; the rustic capital whose precedent had been in brush forms which were more readily suited to modification by the pen; and the uncial form which appropriated elements of the Greek alphabet (see Chapter 3). The term uncial was derived from a derogatory statement made by St Jerome in the 4th century when he condemned the use of excessively large, inch-high, letters in the writing of manuscripts, claiming it made them clumsy and unfit for use. From the Latin term for 'inch' came the term uncial. There were, in addition, a number of cursive scripts whose designs emerged in part from the swift strokes of pen production.

Insular script termed 'artificial uncial,' early 8th century: note interwoven gloss in Anglo-Saxon miniscule from late 9th century (British Library, London Ms. Cotton Vespasian, AI, folio 55, verso)

This Roman cursive, like later chancery hands and other rapidly produced pen scripts, was often used in official, legal documents which did not require the monumental character of inscriptional letter forms. By the 4th century a modified form known as the half-uncial also appeared within southern Europe, particularly in Italy and France, and quickly gained popularity. This was the first script to have a regularized minuscule and became the functional script for paperwork, correspondence and other Church business throughout Europe.[3]

As the Roman Empire fell apart in the West in the 4th and 5th centuries, migratory tribes on the edges of the Empire gained prominence and in the clash of mix of cultures small, isolated political units evolved. The resulting lack of coherent cultural unity in Europe exacerbated the differentiation in script forms so that it is necessary to discuss the writing of particular localities, peoples and historical periods rather than tracing a single line of continuous evolution. An exhaustive treatment of the many scripts which developed in medieval calligraphy is outside the scope of this work. But the major areas of activity, movement and influence in Northern Europe and the British Isles will be broadly sketched here. It should be kept in mind, given the Eurocentric focus of this study, that simultaneous developments were occurring throughout this period in areas of Asia, the Near and Middle East, Africa, and, by the early centuries AD, in the Central American peninsula as well.

While Roman uncial and half-uncial flourished in the Italian states, it was in the British Isles that these forms developed a unique character and aesthetic sophistication unsurpassed in medieval writing. The Roman letter forms were brought back to Britain in the late 6th century with the missions of St Augustine, as all earlier traces of Roman influence on writing had vanished after the Romans left the British Isles in the 5th century. It should also be noted that Ireland had never been a part of the Roman Empire and therefore all Latin scripts entered this region through the

95

influence of Christian missionaries. St Augustine's monks used a form of uncial script which is called 'artificial uncial,' a more labor intensive and elaborate version of the earlier uncial letter.

Hiberno-Saxon script form, example from the *Book of Kells*, late 8th or early 9th century. (Trinity College, Dublin, Book of Kells, Ms.58 A.1.6, folio 146 recto)

96

Latin writing was carried to Ireland through the missionary work of the legendary (but real) figure, St Patrick. A Christian Briton (born 389), he had been captured at the age of sixteen by raiding Irish tribes and taken to Ireland. When he made his escape he sought extensive Christian training with the express intention of returning to Ireland to promote Christianity. After three decades of efforts he finally succeeded in gaining permission from Church leaders to establish a mission among the Irish. The script he brought with him was the common half-uncial, which became the basis of the Hibernian script, a far more formal and stylized letter than its original source. Between the 6th and the 9th centuries, the Hibernian (Irish) scribes worked in relative isolation from Continental (or even British) influences and evolved the script into what became known as the Insular majuscule. This script is considered to have reached its high

point of development in the Book of Kells, produced around 800 AD. Though unique as an artifact, this work embodies characteristic elements of the Hibernian style. As a script form, Hibernian made extensive use of linked forms of letters, or ligatures, as well as having a distinctive visual format with heavy, almost triangular serifs and a fluid, animate grace. The flexibility of the scribes' attitudes towards letter forms permitted them to change the appearance of individual letters or words as well as to accommodate the spatial constraints of a particular page.[4] Unfettered by a formulaic adherence to linear sequence, for instance, the scribes often invented imaginative graphic solutions to textual treatment. In addition to the complex visual solutions posed in the writing of the text, the pages of the *Book of Kells* contain some of the most elaborate instances of illuminated letters ever produced.

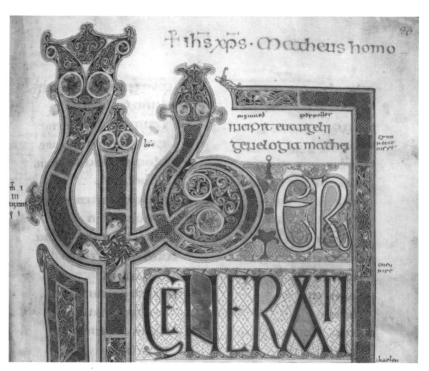

Page from Lindisfarne Gospels, around 698, showing zoomorphic interlaced decoration, graduated sizes of lettering, and a variety of uncial hands and capitals. (British Library, London)

97

The Irish in turn established missions in the British Isles disseminating the Hibernian style throughout the 6th and 7th centuries. Such monasteries as those at Iona and Lindisfarne became centers famous for their scribal productions, and the Anglo-Saxon minuscule of the Lindisfarne Gospels has both its own unique features and many elements which reveal its Celtic sources, as do the decorative elements of that particular work. The Anglo-Saxon capitals were studied extensively by later historians, like Henry Shaw, who reproduced them in deluxe editions of drawings in the late 18th and early 19th centuries. Roman missions were re-established in southern England in this period, and thus the Latin hand which had mutated through the Irish monasteries into the Insular majuscule gradual-

ABCDEF
GbJKLM
NOPQRS
TUVWXYZ

19th century redrawing of
Anglo-Saxon majuscules (F.
Lewis Day, *Alphabets Old and
New*, London, 1910)

ly migrated southward only to meet and coexist with forms of the Roman half-uncial moving north from the missions in the south. The visual blending of these two resulted in hybrid manuscripts employing both hands side by side, and the 7th century, a period of great scribal activity in the British Isles, is marked by Roman and Hibernian influences in vying with each other for visual perfection. Another modified form of minuscule developed in the 9th century under the influence of Carolingian scripts. By the 11th century this had become part of the vocabulary of written letter forms which Anglo-Saxon scribes used in combination with other, earlier forms. Through the work of St Boniface and others, the mixed forms of Hibernian and Anglo-Saxon writing were subsequently carried into Germany where they became an important influence on developments in Continental monasteries.

Meanwhile, the development of local scripts in Europe in the 5th and 6th centuries reflected the continual redistribution of power and waves of invasions and changed cultural composition of different regions. It is possible to chart shifting territorial boundaries of political influence and periods of relative cultural stability through the development of national hands. Individual monarchs established courts whose chancery hands recorded their activities while various monasteries resisted devastation from invading tribes or raiding parties long enough to foster development of a manuscript style. In a period of continual change, therefore, the history of a particular script often serves as the means of tracing the political or military successes of an individual leader or group of people. Throughout the 6th century, for instance, the influence of such groups as the Lombards in Northern Italy, Visigoths in Spain and Merovingian Franks along the Rhine were all reflected in script forms while Roman influence continued in the south of Italy, especially in the book hands which were produced in Subiaco and Montecassino.[5]

At the end of the 5th century the first Frankish king, Clovis, consolidated the tribes and territories along the Rhine into the Merovingian kingdom. The Merovingian book script which emerged in these territories used to be considered by scholars the national French book hand. But it is now considered to have had a more circumscribed, localized impact, taking its place alongside the popular cursive forms such as those developed in Burgundy and in the monastery at Luxeuil. The Merovingian hand was highly developed, very distinct in its exaggerated verticality, loopy quality, and thin, spidery lines. One historian of letter forms, Nicolete Gray, characterized it as 'a torturous script with a fascinating complicated rhythm which seems to suggest the involved and violent terror of life in Merovingian France as portrayed by the *History* of Gregory of Tours, written between 573 and 594.'[6] While such a dramatic description lends glamour to the script, the bright, vital designs of initial letters which also make their appearance in Merovingian manuscripts belie this dark vision. One point to note in examining the unfamiliar forms of these samples is that while they were more legible at the time that they were current, they

were nonetheless often filled with copying errors which contributed to difficulty in reading. This was not intentional, but the result of copying by scribes whose knowledge of Latin was minimal, and whose method of reproduction was based on purely visual observation. Some of the most difficult to read scripts of this period were charter hands or court hands. These, in fact, were often rendered nearly illegible on purpose, to baffle, awe or impress the reader with ornate and complex flourishes and forms.

Anglo-Saxon, early 11th century, probably from Luxeuil. Note hybrid combination of squarish majuscules, uncial, and minuscule. (Bodleian Library, Oxford, Ms. Auct. F1.15f.5)

The next period of relative unity in Northern European writing came in the late 8th century, with the consolidation provided by Charlemagne, whose dynasty replaced that of the weakened Merovingians. Charlemagne established extensive administrative order in political and cultural domains after taking power in the 770s (he was crowned King of the Franks in 768 and Emperor of the West in 800). In 789, the Carolingian minuscule was instituted by official decree and flourished as both the instrument and sign of this political order. It remained the dominant script in Europe until about the year 1000 and was the only one with substantive claims to international status. The Carolingian script was developed by the Anglo-Saxon monk Alcuin, who standardized its forms and supervised its use in the vast publishing projects Charlemagne initiated. The minuscule showed conspicuous traces of Roman influence, particularly the older

half-uncial forms which were consciously promoted by Charlemagne to demonstrate the continuity of his rule with that of the old Roman order.[7] This visual continuity was further emphasized by employment of Roman inscriptional capitals as the basis of titling forms in Carolingian manuscripts. Under Alcuin's direction the vertical proportions of the letter forms, which had become exaggerated by extremely elongated ascenders and descenders, had their proportions fixed. A set of four lines at designated intervals was used to contain the strokes and the result was a letter which had a direct influence on Italian calligraphers of the 15th and 16th century such as Palatino and Arrighi, who were attracted by the clarity, legibility and elegance of these forms and also by their 'classical' associations. The models of these early Renaissance calligraphers in turn influenced the designs of Italian printing types. Through this lineage the Carolingian minuscule had a fundamental influence on type designs still in use today.

Merovingian minuscule, early 8th century; *Homilies of Caesarius of Arles* probably from Luxeuil. Note the constructed bowl of the 'h'. (Bibliothèque Nationale, Paris, Ms.Lat. 9427 f.180v)

Carolingian miniscule. Note the finely adjusted proportions of ascenders and descenders as well as the open spaces within the letters; 9th century (British Library, London, Add.ms.10546)

By the end of the 9th century, Charlemagne's empire was in its turn disintegrating due to internal conflicts among his descendants. Aggressive inroads of new groups of invading tribes – Vikings in the North, Magyars from Central Asia in the East, and the increasing presence of Arabs throughout the Southern Mediterranean, Palestine, and Spain also created chaos in Europe. The effects of Viking invasions were particularly devastating in the British Isles, where many Anglo-Saxon monasteries were destroyed. Though the Carolingian hand had persisted briefly as an aftereffect of Charlemagne's influence by the 11th century variety was once again the order of the day in written forms. In the 12th century, the dominant influence of monasteries was much modified by the emergence of the lay scribe and the formation of workshops in centers close to the emerging universities and related publishing industry. Evidence of this commercial activity also shows up in the existence of sample sheets posted by writing masters to encourage business, a precursor to the virtuoso displays of penmanship which existed in the period after the invention of printing in the Renaissance. The scant evidence of the existence of earlier pattern books suggests that they had circulated among scribes, rather than serving as public advertisement.

The variety of faces which developed in the 11th to 15th centuries constituted the last phase of invention in the period preceding the standardization effected by the casting of printing types – though both calligraphic production of manuscripts and the development of penmanship as a fine art were features of the post-Gutenberg era. The proliferation of hands can be roughly divided into the so-called Gothic forms, the Rotunda and

Bastarda forms. The term Gothic was first used by Italian scholars in the Renaissance for earlier medieval art forms. They found the various blackletter and *textura* forms of the Northern scribes aesthetically unappealing. In general, all of the blackletter and *textura* hands tended to be sturdier, more condensed, and more efficiently produced than the elaborately formed uncial and minuscule hands from earlier medieval periods. The so-called Gothic *littera bastarda* was one of the most prolific and varied of these later hands. A further development in this script was the addition of elaborate flourished capitals termed *cadels* for the French word *cadeau* or gift used to describe the extra elements which in some cases became so extravagant that they overwhelmed the page with decorative activity. When printing types were designed in the middle of the 15th century, these various local hands would provide models beginning with the blackletter Fraktur forms in Germany which served as the basis of Gutenberg's designs.

Sample sheet for commercial advertisement of scripts, around 1400. Note names of scripts: Textus, Rotundus, and also the varying style of initial capitals (Staatsbibliothek zu Berlin Preussischer Kulturbesitz, Ms. Lat 2o, folio 384)

A sample of a *bastarda* hand from the latter part of the 15th century (Bodleian Library, Oxford, Ms. Ashmole 789, folio 4, verso)

The beginning of the Gospel of St. John: *In Principio Erat Verbum*. Note the flexibility of form, with letters interweaving without regard for fixed linear sequence or discreteness of character. (Municipal Library, Aix en Provence, ms. 7)

In summary, then, letter forms are examined in their role as elements of cultural diffusion and influence as well as for their visual characteristics. While the geographical distribution of different script forms permits individual practitioners and missionaries' movements to be mapped in the active dissemination of style, the role of such style in the demarcation of domains of power becomes evident as well – for example in the case of the Carolingian minuscule. In addition, of course, the distinctions made by types of writing as they identify different types of written documents – religious and sacred, secular and profane – also permits writing to participate in maintaining the boundaries of power within the medieval social order. For instance, in some instances 11th-century charter scripts (or court hands) were deliberately rendered in a visually complex style which, though not illegible to practitioners, was far more difficult for the non-professional to read than graphically simpler faces. Specialized hands such as the *Litterae Celestiae* (used exclusively for the imperial documents of Rome for a brief period beginning just after 367) carried meaning and ideological value through their form as well as through the substance of the documents they were used to inscribe.

The inventiveness of scribes, and their marked presence as individual writers through remarks and commentary on manuscripts as well as through their personal styles, imparted a highly individual quality to their works. Scribes also indulged in certain word games, one of which was the

103

production of abecedarian sentences designed to contain every letter in the alphabet. A few instances of these sentences have been preserved, though their function is unclear. They may have been used as warm-up exercises, displays of virtuosity, or merely to establish and write out a full set of visual forms before embarking on the labor of writing. These sentences are distinguished by their linguistic invention, rather than solid sense, as is obvious in these two examples cited by Marc Drogin: 'Te canit adcelebratque polus rex gazifer hymnis.' (The Hymn, of treasure-bearing king, sings of you, and the north pole also honors you.) And: 'Trans zephyrique globum scandunt tua facta per axem.' (Your achievements rise across the earth and throughout the region of the zephyr.)[8] Another conceit of scribes of the late Middle Ages was the invention of a patron demon, Titivillus. Originally conceived of as a devil responsible for causing errors through the sin of inattentiveness, Titivillus was gradually transformed into the patron saint who could be blamed in order to absolve scribes of responsibility for such errors.[9]

The visual aspects which distinguish manuscript writing from either monumental inscriptions or print are its elasticity of form, adaptability of size, and mutability of spatial arrangement and spacing – all features which would become considerably more fixed and rigid within the technology of printing. Nowhere was the freedom of formal invention more striking than in the development of illuminated letters.

Decorated Letters

The geographic distribution of decorative Insular, Merovingian, Carolingian and other lettering followed that of the book hands of the same name, but the design considerations raised by these ornate letters are very different. While the bookscripts are stylistically distinct, they have in common that they are all essentially finite sets of repeatable alphabetic elements which are legible to a familiar eye. Initial letters, however, are treated with such freedom in decoration that they often lose all identity as recognizable forms or come to serve a purpose utterly different from that of an alphabetic letter. Since books in the Middle Ages were used for manifestation – that is, laid upon the altar for view and display as well as reading – such decoration played a considerable part in seducing the eye into contemplative engagement with the page.

The origin of the decorated letter is generally traced to the 4th century manuscript of Virgil known as the *Vergil Augusteus* whose rustic capitals were discussed in the previous chapter.[10] Cited as an early instance of manuscript production intended for consumption by bibliophiles (rather than a unique legal document or monumental inscription), this manuscript included oversized drawn initials in ink which contrasted with that of the main text. While only a few leaves of this work are still extant, they all follow the same design formula and have the first letter of the first word

of each sheet illuminated in this modest manner. The transformation of letters through decorative design which can be seen in its most embryonic form in this manuscript would become full blown in medieval practice, though the period of greatest achievement in letter decoration is generally considered that which extends from the 7th to 12th centuries. According to the medieval art historian Jonathan Alexander, work later than this has less variety or creative inventiveness. He in part attributes this change to the specialization of tasks among lay craftsmen whose involvement in manuscript production was motivated by commercial rather than spiritual gain.[11] Nicolete Gray suggests that the emergence of full blown images in the form of miniature illumination gave these works more the pictorial emphasis and shifted them away from interest in using letters as a vehicle for decoration.

The beginning of St. Mark's Gospel (*Initium*) from the Lindisfarne Gospels (British Library, London, MS Nero D IV, f95). Insular decorative work, highly organic. The interlace of the fill in the 'IN' bears striking visual resemblance to pre-Christian Celtic metalwork designs

The authoritative scholar Carl Nordenfalk described three categories of letter ornament: filling, adding, and substitution. These simplest categories describe the transformations of letters through coloration, or pattern, through the use of decorative devices, images and flourishes, and through the use of elements (botanical, zoomorphic, anthropomorphic) to actually make the letter forms. Alexander introduces another element into this analysis, drawing a distinction between classicizing and medieval tendencies. The first of these tendencies characterizes the Carolingian Renaissance with its emphasis on rational virtues such as clarity of structure and simplicity of form, while the anti-classicizing sensibility of the Insular scripts or Romanesque traditions is characterized by elaborate decoration, visual complexity and variation of design. These two tendencies are aesthetic poles between which the scribal work of medieval decorators can be assessed, though such an oppositional framework is inadequate to describe the range of visual invention. Another set of tensions, among the formal logic of the letter, the complexities of surface design, and the spatial illusion of a pictorial image can be used to describe the more distinctly visual issues in decoration.

Insular interlace pattern in capital showing some recognition of spatial illusion in the overlapping; from the Bosworth Psalter, 980 (British Library, London, Add ms. 37517)

The Insular style which developed in Ireland and the British Isles from the 7th century was characterized by dynamic interlacing of patterns,

largely abstract, which weave around the basic structure of the letter. Increasingly, these initial letters lost their clear identity and became the maze of interlocking pattern rather than a separate support for it. Zoomorphic forms, animal heads, eyes, twisted torsos and feet came to be part of the visual catalogue of elements in the Insular style which in its first few centuries remained a matter of surface pattern rather than illusionary space. The establishment of scriptoria on the continent under the influence of monks trained in the British Isles spread this style into Europe in the 8th century, for example, to St Gallen, where Insular style decoration became particularly well entrenched.

8th century Merovingian majuscules, with flat areas of geometric shaped colour creating jewel-like facets (Bibliothèque Nationale, Paris, Ms. Lat. 11627)

In Insular manuscripts, as in most illuminated or decorative codices, the most elaborate designs were saved for openings of books or chapters where the texts were so familiar that legibility was not an important requirement. The first time the name of Christ appears in the *Book of Kells*, for instance, it announces the significance of the event in visual terms which overwhelm the textual character of the page. Such practices bespeak a faith in visuality which escapes the need for a textual reference: the image of the letter functions in its own right to communicate effectively. Another characteristic element of this style, as seen in the *Book of Kells*, the *Bosworth Psalter* and the *Lindisfarne Gospel* was the tendency to gradate the size of letters as they moved from these large initials into the text, forming a visual bridge. As a result of such a treatment the page works as an organic whole rather than an arrangement of discrete elements and the swarming movement of the Insular style conveys an image of animate form as the vision of a universe suffused with life and spirit.

Around 800, also Merovingian, with birds and fish as the basis of the letters (Oxford, Douce Ms. 176, fol. Madan 21 21750)

By the 10th century, Insular decorative devices took on a three-dimensional quality, and spatial articulation became an additional feature of animate forms and flourishes. The elaborate interlocking of pattern was painted to give the illusion of elements wrapping around each other, and

patterns of foliage were added to the vocabulary which had previously included mainly animal forms or human figures. Such foliated patterns were common on the Continent, in the monasteries at Metz and St Gallen and independent styles were distinguished by the degree of flattening, gilding, or naturalistic illusion in the work.

Script from Carolingian period using classical forms of Roman capitals, from Alcuin's version of the Vulgate, Tours, 834-843

Merovingian decoration in the 7th and 8th centuries, though not as elaborate as that of the monasteries of the British Isles, gained its distinction from the combination of constructed elements and substituted forms. The use of the compass as a tool in letter design had classical precedents, but the simplicity with which this process is displayed in certain Merovingian designs reveals a pleasure in basic form which is skillfully complemented by suggestively animate additive elements. Some of the most imaginative instances of Merovingian decoration involve the creation of letters entirely from the forms of birds and fish.

Within the classicizing sensibility of the Carolingian scripts in the 9th century, however, decoration was often more minimal, with elegant solutions posed by the use of the Roman majuscule forms as the basis of decorated designs. The sense of the structure of the letter is generally evident in

Gothic versal with flourishes, 14th century redrawn in 19th century (From Henry Shaw, *Alphabets and Numerals of the Middle Ages,* 1853)

Carolingian examples, though a Franco-Saxon school in the late 9th century blends Insular and Continental tendencies into novel innovations. The forms of bookscripts and the forms of initial, majuscule or titling letters had different origins: the former in the medium of pen and writing the latter in the stone inscriptions from which the basic forms of Roman capitals are derived.[12] While initial letters could, in principle, be the enlarged or elaborated form of uncial, half-uncial or other scripts, they were frequently based upon Roman capitals, especially (though not exclusively) in Carolingian manuscripts. This convention seems rooted in the importance which such capitals added to initial letters, but the graphic stability of these forms, generally quadrate in nature and uncomplicated in their basic structure, can also be granted some of the credit from a design perspective.

It is always difficult to establish causal links between stylistic changes in visual arts and historical circumstances, but by end of the 9th century the culture of Europe and the British Isles was fragmented into small pockets of local activity. The Roman empire had completely disintegrated and its final vestiges preserved in Charlemagne's rule had vanished. Major changes came into the structure of trade, commerce, industry and government in the 11th century. Contemporary with these social transformations was the appearance of decorative letters which have more pictorial unity and organization, especially with respect to the articulation of spatial relations, than had existed even in the well-achieved designs of early centuries.

Historiated letters: two versions of Jonah and the Whale from late 13th century, Evesham Psalter (British Library, London, Add. ms, 444874, f.93) and Oscott Psalter (British Library, London, Add. ms. 50000 f.101r.)

By the 11th century centers of activity reemerged in Germany, England and Spain. This revitalization gave rise to styles later designated by historians with the terms Ottonian, Romanesque and Gothic. These new styles contained dramatic new elements such as versals and the fully developed form known as the historiated initial. A wide range of themes were depicted in these historiated letters. Early instances were filled with biblical imagery as well as themes of aggression, scenes of combat and struggle whose meaning was not always explicit, though they suggested a generalized conflict between good and evil, civilized and bestial aspects of human nature.[13] By the 13th century, hunting themes were also prevalent, but

humor played a visible role in many of the specific treatments. Narrative scenes gradually entered the pictorial vocabulary of decorators, and the images took on the character of tiny illuminations, independent pictorial elements within the page, rather than remaining as fully integrated into its woof and warp as in the decorative patterns of earlier styles. In the Gothic period, capitals were created out of uncial forms which were thickened and enlarged. Their strong graphic definition allowed them to read clearly as letter forms even when decorated with the elaborate pen flourishes which became a favorite exercise of late medieval scribes. Historiated initials, though not without earlier precedents, reached new levels of complexity in this period, making use of the spaces suggested by the structure of the letters and integrating them into a narrative image.

Decorated letter with complex internal pictorial organization, 11th century (Bodleian Library, ms. 717, Oxford, f.2.)

III

In historiated letters the counters, or open spaces defined by the shape of the capital form, were often used as pictorial opportunities. In the 11th century the figures existed in the shallow proscenium space, as in a flattened framed area of image without elaborate depth or complexity. In some cases the elements of the letter – crossbars or the swirling division of upper and lower loops of the 'S' – were integrated into the narrative depiction. In other examples, the letter itself was sometimes articulated as a set of figures which participate in a central action which they frame, and the possibility of variation is as unlimited in these devices as it was in the geometric or abstract patterns of other forms of illumination. Elaborate figure alphabets achieved a degree of development in the Romanesque and Gothic period which were unprecedented. A 14th century example, the famous Bergamo alphabet attributed to Giovannino dei Grassi (approximately 1390) grants the figures so much autonomy that the letter forms

are barely perceptible as organizing structures. This alphabet was much imitated, either directly through copying or as an idea, and even served as the basis of a number of Renaissance and Mannerist printed letters.

Decorated initial from Pliny, *Natural History* from the 1460s (Victoria and Albert Museum, London, Ms A1 1504-1896, fol 485v)

The Bergamo alphabet of Giovannino dei Grassi, around 1390 (Biblioteca Civica, Bergamo)

Imitation of the Bergamo alphabet from a copper engraving about 1460 (Bibliothèque Nationale, Paris)

A final transformation occurred as the interwoven space identified with the Romanesque period was gradually replaced by the 'transparent' Gothic space whose visual structure showed glimmers of perspectival illusion, pictorial conventions approaching those instituted in the Renaissance. In these Gothic works, the layered space was highly organized into foreground, middle and background elements of the scene and various levels of framing devices. Accompanying this rationalization of space was the increasing division between visual and textual elements and a decreased emphasis on the role of illuminated letters in portraying the narrative or moral meaning of the text. But it should be pointed out that the spatial complexity of forms was not limited to the activity of the figurative elements. Complex three-dimensional illusions of carving or decoration also made their appearance which were very distinct from the earlier play of elements as a surface pattern. In many cases the letters become autonomous, representational objects, fully formed illusions on the page, rather than aspects of its surface.

The activity of decoration in manuscripts did not develop uninterrupted or unquestioned. Aside from the shifts toward or away from more elaborate designs, such as the effect of Charlemagne's classicizing repression of any decoration which might obscure the letter form, there were from time to time specific attacks on the very activity of the scribe's decorative labor. One such was the strong criticism mounted by the ascetic Cistercian St Bernard in the 12th century against what he considered to be the excesses

Early 12th century letter from Winchester Bible with developed image of dimensional illusion (Bodleian Library, Oxford, Winchester Bible, ms. Auct.E., inf. fol. 51)

of the Romanesque style. He attacked decorated letters as frivolous, claiming that they were without meaning or value and further stated that they were a waste of scribes' time. A subtext emerges from his attack in which the Word has a transcendent value not to be interfered with or confused with its material form. The theological and moral implications of St Bernard's criticism thus far exceed a mere scolding of monks for indulging in frivolous labor and reveal a deprecation of the function of visual elements in the production of verbal meaning which is a recurring theme in Western thought.

Early 12th century, note the way the body of the bird makes the bowl of the 'P' in a substitution, rather than merely wrapping around it as decoration (Walters Art Gallery, Baltimore, MD, Ms. 10.18, folio 175)

Another interesting late development was the production of pattern books for decorated letters. These came into existence by the 12th century and included elaborate images of birds, animals and interlacing which served as models for monastic and lay scribes.[14] The idea of decoration as repeatable, as based on models to be replicated rather than conceived as an exercise of contemplative invention, signals a marked change in attitude toward the work of writing as productive labor comparable to other forms of production. Writing could now be a form of piece work rather than an exercise of faith, an instrument for publication and commercial production rather than an end in itself. This shift in sensibility participates in a rationalization of production which will also characterize certain Renaissance designs of letter forms in which alphabets embody a code of humanistic values based on mathematically constructed designs. Elaborate decorative and pictorial forms were much simplified by the requirements of printing technology. The more finely detailed designs were confined to title pages where they were instances of the engraver's skill rather than elements of the printed page *per se*, and the hand work of painting could not be readily replicated in print until the 19th century when lithography served as the vehicle for reinvention of the illuminator's art.[15]

An early example of a pattern book from the 12th century (Fitzwilliam Museum, Cambridge, England)

114

Interlaced initials redrawn by Henry Shaw (*Alphabets and Numerals of the Middle Ages*, London, 1845)

Runes and Ogham

While the Latin alphabet spread throughout Northern Europe and into the British Isles under the influence of both earlier Roman occupations and subsequent Christian missions, two forms of writing whose origins are still not entirely clear developed in these regions as well. These are Runes and Ogham, both of which have a rather fantastic history in cult literature which developed long after their use as functional writing systems had been eclipsed. Since they do show up in this later literature, particularly in 18th century works which make use of myths of origin as a basis for claims for partisan national identity, it seems useful to mention their actual development within the historical phase at which they appear as functional writing systems.

Runes (the word actually refers to the written inscriptions, rather than to the individual letters) bear strong resemblance, both in their visual form and in the sound equivalents they represent, to the early forms of Etruscan and Latin alphabets. Scholarship on their actual origin is divided, and archaeological evidence points to an adaptation and modification of an Italic script by migrating Goths in the Alpine region around the 3rd century BC. Isaac Taylor suggests that the characteristic form of the Runes (and Ogham) was determined by their having been adapted for inscription in wood, and the addition of new letters to fit the requirements of the Goths' language. Archaeological material adequate for tracing the development and geographic spread of this script is lacking, however, though parallels between the names, sequence and sound values (powers) of the letters sustain this hypothesis. The earliest datable inscriptions are in the late 2nd and 3rd centuries in the northern Germanic areas of Europe, including Denmark, Sweden and parts of present day England around the Isle of Man and Northumbria. In England the use of Runes persisted up through the 9th century as a means of recording the vernacular and it served a similar purpose for several centuries longer in Scandinavia. English scribes of the 8th century often used letters from the Runic alphabet as a means of indicating sounds which were not readily notated in the Latin script, and spelling reformers in England in later centuries continually struggled to revive such letters as the *thorn* and *wen* because of their usefulness in indicating the Anglo-Saxon aspects of the language.

Throughout its use, the Runic alphabet, or *futhark* (so-named from the initial letters of the system according to the same principle as the word *alphabet*), had both the role of a functional writing system and was also associated with magical and cult activities.[16] Many of the early Runic inscriptions express Christian sentiments, prayers or devotion, though earlier instances intoning pagan deities or demons abound. Divinatory practices using Runes were common in England (and Scandinavia) in the Roman period: Tacitus and Julius Caesar both make note of these activities in their writings. As late as the 7th century, Runes inscribed to protect, promote or defend an individual in matters of war, love, illness, fertility

and weather were widely used. By the 9th century such practices had faded to the margins of English culture in spite of the presence of certain Runic letters in the Anglo-Saxon book hands. The inflation of the magical properties of Runes developed after their demise as a common writing system and was sustained by earlier mentions in medieval manuscripts suggesting such occult values.[17] The names of Runes, for instance, have been analyzed as a cosmology of gods, demons and natural powers in an elaborate articulation of fertility cult symbolism and other sacred beliefs, some of which was invoked in 18th-century literature.[18]

116

NAMES.	VALUES.	RUNES. I. GOTHIC.	II. ANGLIAN.	III. SCANDINAVIAN.	IV. ALPHABET OF ULPHILAS.	
fech, feh, fe	f					φ
ur, hur	u					ου
thorn	*th*					δ
asc, æsc, os	*a, æ, o*					α
rad, rat	r					ρ
cen, kaun	*c, k*					κ
gebo, giſu	g					γ
wen	*v, w*					v, hv
hegl, hagal	h					h
nyd, nod	n					ν
is	i					ι
ger, yr, ar	*y, ge, j, a*					j
hic, ih, eoh	*ih, i, eo*					ζ
peorth, perc	p					π
ilix, calc	*a, i, k, x*					q
sigil	s					σ
tir	t					τ
berc, berith	b					β
hæc, ech, eh	e					η
man	m					μ
lagu	l					λ
ing	*ng*					χ
dag, dæg	d					θ
othil	*o, œ*					ω

Runic characters, from Isaac Taylor, *The Alphabet*, New York, 1899

But if the graphic and phonetic properties of Runes permit their evolution to be linked to other alphabetic systems, the origin of Ogham cannot be so readily assessed. Ogham inscriptions are found in some areas of the British Isles where there were Scandinavian settlements (especially Wales) but in none of the areas where Runic inscriptions have been found. As with the Runic characters, Ogham is composed of straight lines, but while the Runes have the quality of alphabetic forms which have been modified to suit their rendition in wood, hard stone or metal (thus the elimination of curved shapes) Ogham elements are a unique alphabetic code of simplified lines and branches. Scholars have suggested that the Ogham script developed from the system of notching sticks as a form of record-keeping common among shepherds. The names assigned to the Ogham characters correspond to trees common in the British Isles, and much is made of this, and other so-called 'tree alphabets' by later writers seeking cult values for these early writing systems. Ogham never reached the same degree of development as a communicative script as Runes did, and both fell out of use by the end of the medieval period.

Ogham notation system, from Isaac Taylor, *The Alphabet*, New York, 1899.

117

Missionary and Slavic Alphabets

In the 4th century an alphabet was invented by a Christian monk determined to carry out the missionary activity of converting pagan tribes to his faith. This alphabet was an early instance of what would be a recurring pattern of such missionary inventions, and though considered an artificial and shortlived contrivance, it deserves mention here as a precedent

for later such inventions. The invention was that of the Bishop Ulfilas or Wulfila (318–388) who spent forty years among the Visigoths of Moesia and invented an alphabet to use in transcribing holy texts into the language of these tribes. To do this he adapted the common Byzantine uncials of the 4th century, adding letters for sounds unique to the language of the Goths, some of which had Greek equivalents and some from the Runic *futhorc* or *futhark*.

Names	Values	Glagolitic	Cyrillic	Wallachian Ruthenian	Russian	Names	Values	Glagolitic	Cyrillic	Wallachian Ruthenian	Russian
Az	a		л	Ⰰ	А а	Uk	u		оу 8	ОУ	У у
Buki	b		Б	Б	Б б	Fert	f		ф	Ф	Ф ф
Vedi	v		в	Б	В в	Kher	χ		χ	Х	Х х
Glagol	g		г	Г	Г г	O	ō		ѡ	Ꙍ	Ꙍ
Dobro	d		д	Д	Д д	Sha	sh, š		ш	Ш	Ш ш
Est	e		є	Ɛ̑	Е е	Shta	sht, št		щ	Щ	Щ щ
Zhivête	zh		ж	Ж	Ж ж	Tsi	ts		ц	Ц	Ц ц
Zêlo	dz		Ѕ	Ѕ		Tsherv	tsh, č		ч	Ц Ч	Ч ч
Zemlya	z		з	З	З з	Djerv	dj		ћ		
Izhe	ê, i		н	И	И и	Yet	ye		ѣ	Ѣ	Ѣ ѣ
I	i, y		ї	I	I i	Yu	yu		ю	Ю	Ю ю
Kako	k		к	К	К к	Yer	o/e		ъ	Ъ	Ъ ъ
Lyudi	l		л	Л	Л л	Yery	y		ъі	Ы	Ы ы
Muislite	m		м	М	М м	Yerek	e/i		ь	Ь	Ь ь
Nash	n		н	Н	П п	Ęs	eng		ѧ	Ѧ	
On	o		о	О	О о	Yęs	yeng		ѩ	ҥ	
Pokoy	p		п	П	П п	As	ong		ѫ	Ꙗ	
Reci	r		р	Р	Р р	Yąs	yong		ѭ	ҥ	
Slovo	s		с	С	С с	Thita	θ		ѳ	ѳ	Ѳ θ
Tverdo	t		т	Т	Т т	Yzica	ü		ѵ	Ц	Ѵ ѵ
		I.	II.	III.	IV.			I.	II.	III.	IV.

Glagolitic and Cyrillic alphabets, from Isaac Taylor, *The Alphabet*, New York, 1899

A more successful 'invention' was the ecclesiastical script created in the late 9th century by Cyril and Methodius, missionaries to the Slavic

118

Moravians and Bulgarians. Used for Cyril's translations of the Psalms and Gospels into Old Bulgarian, the alphabet originally had thirty-eight letters, twenty-four of which were identical with the Greek uncials. The new characters were in part appropriated from Glagolitic, another liturgical alphabet of complex origin, sometimes mythically attributed to St Jerome. Some of the features of this older alphabet persisted in Cyrillic which in turn became one of the major alphabets of the world, along with the Latin, Arabic, and other Asian offshoots whose developments are equally complex in terms of both their formal transformations and historical circumstances. Other missionary impulses would result in the production of all manner of bizarre notation systems in subsequent centuries. These would ultimately motivate the production of the International Phonetic Alphabet in the 19th century as an outgrowth of the linguistic struggles of missionaries in non-Indo-European speaking regions to cope with the task of establishing a foundation for the transmission of Christian faith and European culture.

Hrabanus Maurus, the 9th century Archbishop of Fulda, composed one of the first known compendia of alphabets in his work *De inventione linguarum* (*On the Invention of Languages*).[19] Maurus recorded only five alphabets, to each of which he assigned a particular, if brief history. While Hrabanus's work was not, strictly speaking, produced as part of a missionary project, his writing reflected the interest of churchmen in preserving information about alphabetic scripts and putting it into a record.

Alphabets recorded by Hrabanus Maurus

119

In almost every case, the tradition on which Hrabanus based his assessments of these scripts was fairly clear, though the sources for his visual materials were less obvious. First, he discussed the Hebrew alphabet, invented by Moses, and revived by the figure Esdra after the captivity of the Jews. There were twenty-two letters in this alphabet, which corresponded with the number of the Hebrew alphabet, but Hrabanus's forms

were somewhat peculiar adaptations of the unfamiliar script. The second alphabet he discussed was the Greek alphabet, which he associated with the Phoenician Cadmus, following the tradition of classical antiquity. He noted that letters had been added to this script 'to make numbers more manageable' and brought the total to twenty-four. There was some confusion on this point, and Hrabanus added three other characters on the grounds that they were needed for their numerical capabilities since they permitted calculations to extend up to figures including the number for one thousand. His account of the invention of Latin was unique: he attributed it to the nymph Carmentis, the mother of Evander. His majuscule script had a peculiar rounded 'E' and, normal for the period, no 'J' or 'W.' Next Hrabanus included a most peculiar script and attribution: the letters of 'Aethicus the philosopher and cosmographer in the Scythian nation.' He stated that he had himself obtained letters through texts of St Jerome, but they resembled alchemical scripts more closely than any alphabet in practical use in his period.

Finally Hrabanus recorded a version of the Runes, which he called letters used by 'the Marcomanni' or Normans. The term Marcomanni has been associated with tribes north of the Danube, and Hrabanus claimed they spoke a ' Theodiscan' language. He stated that the people were pagans, and that they used this script to record 'their songs, incantations or predictions.' These were certainly the conditions in which Runes were perceived to operate in the 9th century in Germanic regions, and Hrabanus's observations were accurate as a record of the impressions of his time.

What seems most compelling about Hrabanus's record of these scripts was his historiographic sensibility. There were other instances of this kind of attempt to come to terms with the history of the alphabet and its early mutations, but Hrabanus's record had some unique features in terms of its mythological theories and attributions. But even more, his brief account contained the seeds of a reflective sensibility, one concerned with the actual history of the alphabet as itself valuable, not merely its value as symbolic form.

Alchemical Alphabets

There are two aspects to the engagement between the alphabet and alchemical practices. The first is the use of the alphabet as a code to order elements in alchemical operations and the second is the design of cipher alphabets used to conceal the knowledge of secret processes in an unreadable and arcane form. Some of these secret signs pass into use in the cult rituals and iconography of the Rosicrucians beginning in the late Renaissance, much removed from their earlier role as elements of a scientific inquiry, while other elements form the basis of the chemical symbols used in laboratories as a universal notation.

ABCDEFGHIKLMN
OPQRSTUXY

ABCDEFGHIKLMN
OPQRSTU

ABCDEFGHIKLMN
OPQRSTUVYZ

Alchemical alphabets (C.J.S. Thompson, *The Lure and Romance of Alchemy*, London, 1932)

Alchemist in his study with acrostic formula and alchemical apparatus (Pitois Christian, *L'Histoire de Magie*, Paris, 1870)

The origins of alchemical symbols reach back into antiquity, with the appropriation of planetary signs from Chaldean astrology and astronomy into the Greek system, and the subsequent association of certain metals with these planetary elements.[20] In this system, gold came to be associated with the sun, silver with the moon, and so forth, so that the sign of the sun or moon might function to represent the metal in a formula. Alchemy proper is a later development, and belongs to the period of Arab influence in southern Europe. The word alchemy is in fact a combination of the Greek word *chemya* with the Arabic prefix *al* attached. The concerns of alchemy, though much distorted in later romanticization and obfuscation through occult associations, were quite simply to understand the nature of metals and the processes by which they might be transmuted into other forms, particularly gold – which was considered to have transcendent spiritual value. It was in the first centuries of the Christian era that the fusion of Egyptian metallurgy and Christian Gnostic and Neo-Platonic sensibilities lent a metaphysical aura to alchemy, but the medieval practitioners were frequently serious scientists inquiring into the structure of the natural world. Alchemical symbols served as a shorthand to record experiments and procedures, but quickly came to serve the function of secrecy as well. Traces of early alchemical manuscripts show up as references in the treatises of the Middle Ages, authored by such mythic figures as Hermes and Cleopatra and the more historically authenticated Mary the Jewess and Zosimus. But actual manuscripts used in alchemical practice are evidence of Arab domination of the art between the 7th and 13th centuries.

The Arabs were at first loath to make widespread use of Greek symbols, considering them the legacy of a pagan people and hence unfit for their purposes. Developed alchemy made its way into Western Europe in beginning in the 12th century by means of Latin translations of Arabic texts, around the same period as the consolidation of the Kabbalah. At this point the use of elaborate symbols based on Greek and other complex visual signs, many of which seem to have been the product of an individual author's visual imagination, came into common use. Eventually whole elaborate systems of 'hieroglyphics' were pressed into service to encode the alchemical processes and keep them from the uninitiated. Anagrams, acrostics and other enigmatic figures were used extensively. The lettering in alchemical texts cannot be properly called an alphabet, but there are obvious links between existing writing systems and the symbols transformed for use by alchemists.

The great Magus figures of the late Middle Ages and Renaissance, such as Albertus Magnus, Roger Bacon, Basil Valentine and the Michael Maier provided encyclopedic records of earlier and contemporary alchemical practices. But by the 15th and 16th centuries, when extensively illustrated volumes of alchemical knowledge were published in the form of elaborate allegorical images and deliberately obfuscating texts, alchemy had become a pseudo-science, rapidly being displaced by the formation of a new scientific understanding of the structure of the physical world. From that point

121

on, alchemy took its place among the arcane areas of human thought, and was channelled into occult practices where its obscure language and deliberately complex symbology found a receptive following well into the 19th century.

One intriguing example of the use of a cryptic alphabet in an alchemical manuscript is the so-called cipher document attributed to Roger Bacon (1214–1292). Identified as a 13th century English manuscript, it is written entirely in an unknown alphabet. Bacon, in *Letter on the Secret Works of Art and the Nullity of Magic*, had strongly advocated use of ciphers: 'The man is insane who writes a secret in any other way than one which will conceal it from the vulgar and make it intelligible only with difficulty even to scientific men and earnest students.'[21] He proposed seven modes of concealment in this work, including the use of magic figures, spells, and mysteriously symbolic words. One method of secret writing was to use only consonants, as in the case of the Semitic languages, another was 'effected by commingling letters of various kinds' or through inventing an idiosyncratic alphabet, or, finally, through use of shorthand. At least one scholar who studied the cipher manuscript assumed it was written in just such a shorthand. This was William Newbold, Professor of Philosophy at the University of Pennsylvania, who came into contact with the manuscript (known by its owner's name as the Voynich manuscript) in Philadelphia in the 1910s.

Newbold set about to decipher the work, and finding no key by which the 'apparent' letters of the script could be decoded, decided that each of these letters was in fact an accumulation of micrographic shorthand script. According to Newbold, this shorthand was itself a code, and by linking the notational marks with their Latin letter counterparts, deciphering those in turn into complex anagrams, which he subsequently unscrambled, the manuscript would yield its supposed secrets. Newbold's method and conclusions seem farfetched to a degree which stretches credibility. He was able to unravel only a few words and phrases within the text by application of his torturous method, and had he applied it systematically to the entire manuscript (upwards of two hundred pages) the result would have been to read the text of 300,000 characters as if it were in fact closer to 3 million signifying elements. Newbold was unable to decipher even enough of the text to give a sense of its content, for which he remained dependent on the iconography of its images. These depicted a peculiar version of the process of egg fertilization in humans, with human sperm migrating through successive levels of a structure, which was as much cosmological as biological, towards their goal.

While there was a tradition of micrographia among Hebrew calligraphers in the Middle Ages, even their most complex designs would not rival the complexity which Newbold ascribes to the cipher manuscript. Newbold also suggested that the last line of this manuscript contained a key which referred in turn to the several 'gates' by which the secrets could be accessed. Newbold took this term to refer to the gates of the Kabbalah,

Cipher alphabet in manuscript attributed to Roger Bacon; William Newbold's analysis of the letters into an elaborate shorthand (University of Pennsylvania Press, Philadelphia)

the combinations and permutations of letters which formed a basic aspect of that mystical practice. What was remarkable about Newbold's work was his conviction that the alchemical character of the treatise justified such an interpretation. Subsequent scholarship decoding the manuscript has laid Newbold's obsessive scheme to rest when the code in which the text was written was deciphered in the 1940s by Joseph Martin Feely. Feely was inconclusive in determining the attribution and his interpretation was in keeping with the alchemical mysteries of the manuscript's imagery.[22]

Ancient and Celestial Alphabets

A unique tradition for investigating the origins of the alphabet existed among Arabic scholars around the 10th century. This tradition will be examined here through a text supposedly composed by Ahmad Bin Abubekr Bin Wahshih in the the year 225 of the Hegira (around 840 AD).[23] It is one of the few such texts which exists in published and translated form, though there are mentions of other such works in secondary literature, such as the *Book of Frenzied Devotee to Learn About the Ancient Scripts* by Abu Bakir Ahmad (composed around 855 AD) and *The Book of Secret Alphabets* by Abu Abd Al-Kahil written a century earlier.[24] Mystical alphabets and codes, some of which had magical connotations, became a sophisticated art among Arabs in the Middle Ages and were connected with alchemy and religious practices. One example was the Davidian alphabet or *Dambudi*, which was considered the invention of King David whom some Arabs thought of as a great magician.

Joseph Hammer Purgstall, an authority on the history of Persia and the ancient Near East, presented Wahshih's text in a book entitled *Ancient Alphabets and Hieroglyphic Characters Explained* (1806). Purgstall stated that its author had lived a thousand years earlier and that he had been a Chaldean, Nabataean or Syrian by birth and had translated a work treating hieroglyphics and secrets of Hermes from his mother-tongue, the Nabataean, into Arabic.[25] Although it does contain some information on hieroglyphics, the bulk of the manuscript is concerned with all manner of ancient and secret alphabets such as the *tree alphabet*, the *mimshim*, antediluvian, or primeval alphabet, and the so-called *Hermesian* alphabet used by the ancient king of the Egyptians to keep 'all things secret.' Ibn Wahshih's text is divided into eight chapters and an appendix. Each of these contains a set of alphabets grouped thematically, and all are visually striking. While some have visual precedents in either functional models (Hebrew, Chaldean, Greek and so forth) or symbolic systems such as the alchemical signs, some appear to be *sui generis*. It is these which will be detailed here.

The first chapter contains three 'usual Oriental alphabets' (Cufic, Maghrabin and Indian); the second 'the seven most celebrated old alphabets,' but the chapters which follow depart from this orthodoxy into

Ancient alphabets from Joseph Hammer Purgstall's translation of Ibn Wahshih's 9th century manuscript (Butler Rare Books and Manuscripts, Columbia University, NY)

123

discussion of the 'long desired knowledge of occult alphabets.' Chapter III, for instance, contains seven alphabets attributed to the 'most celebrated Philosophers and Learned Men' who include Socrates, Plato, Aristotle, and Pythagoras – each of whom is credited with their invention. The following chapter refers to the four and twenty alphabets (or cyphers) that were used by other Philosophers, such as that of Costoudjis, who 'wrote in this alphabet three hundred and sixty books on divinity, talismans, astrology, magic, influence of planets and fixed stars, and on the conjuration of spirits.' A tree alphabet attributed to Doscorides is clearly an Ogham script, and the issue of contact and knowledge of such a script, fully developed in the 8th century but geographically restricted, raises some questions about the actual date of the supposed manuscript – or at least the spectre of later additions.

The alphabets of the seven planets (Chapter V) and of the twelve constellations (Chapter VI) are more in keeping with the scholarly traditions of the Middle Ages, with the same synthesis of Greek, Egyptian, Babylonian and Persian astrology and science which characterizes Arabic alchemical practices in this period. The fact that Chapter VII presents the alphabets of the ancient kings of Syria, Egypt, Canaanites, Curds, Persians and other peoples of the ancient Near East reinforces this contextual link. Ibn Wahshih states that 'every one of these kings invented, according to his own genius and understanding, a particular alphabet in order that none should know them but the sons of wisdom.' These were not a simple 'a b c, but alphabets in which they expressed all they knew and understood of the secrets of nature' as in the Hermesian or hieroglyphic alphabets which formed the substance of the final chapter.

In the Appendix to his work, Ibn Wahshih listed some of the most fascinating alphabets of all – those which he considered to be antediluvian. These were no more than three in number, the *shishim*, which was inspired by divine revelation and then used by the Hermesians (Egyptians), Nabataeans, Sabeans and Chaldeans, the *Syrian*, and then the original form of the antediluvian alphabet 'in which Adam wrote his books.' The use of the term 'Hermesians' is a particularly strong argument for the composition of this work between the 9th and 13th centuries. This is the period in which the association of Egypt with Hermes has become an established concept, one which originated in the early Christian era with the composition of the Hermetic corpus but became fully institutionalized as an aspect of the medieval alchemical tradition. The other striking feature of this work is its complete lack of Christian symbolism or referents; all the figures are either Greek and Alexandrian philosophers or Old Testament kings, and not a hint of Gnosticism or religious philosophy is present. It purports to be a magical and historical work, not concerned with faith, but with knowledge as encoded in these alphabets and their traditions.

A similar sensibility pervades the tradition of celestial alphabets, though many of these are presented in texts without the accompanying

gloss which renders the Hammer presentation and that of the Ibn Wahshih so richly rewarding. Cornelius Agrippa von Nettesheim, the occult encyclopedist, and Athanasius Kircher, the Renaissance polymath, both include so-called celestial alphabets in their compendia. The graphic similarities between some of these and the alphabets in Ibn Wahshih's text and in other alchemical symbol systems is noticeable, and celestial alphabets are also a feature of certain Kabbalistic treatises from the late Middle Ages.

The concept of the celestial alphabet is simple: the forms of the letters are supposedly derived from observation of configurations of stars in the heavens which can be 'read' as a form of sacred writing. These alphabets are visually recognizable by the use of nodal points to indicate the stars at the intersection of the bars or lines in their forms, the empty spots in the ink lines signalling the bright point of light in the dark sky. Such alphabets still feature in works at the end of the 18th century, such as the *Pantographia* of Edmund Fry, who includes them quite nonchalantly alongside Chaldean, Aramaic, Hebrew and other scripts.

Ars Combinatoria

A compelling and unique formation of medieval thought was produced by the Catalan philosopher and theologian Raymond Llull in the 13th century. Llull devised a system for demonstrating the interrelated structures of all the elements of the universe as an example of the perfection of God's work (and as manifestation of his 'dignities' or attributes). The *Ars* (or Art) was supposedly revealed to Llull in a vision on Mount Randa. Mythic accounts of this event include the description of the miraculous appearance of inscriptions on the leaves of a nearby lenticus bush in every alphabet in which Llull's *Ars* would eventually be translated.[26] This system was set forth in a number of major works, *Ars Demonstrativa* (after 1282) and the later, more condensed, *Ars Brevis* (around 1308). Both of these systems made elaborate use of the alphabet for structural and procedural operations, and the overall concept which Llull articulated in these works became the inspiration for later cosmological and philosophical systems in the work of such writers as Pico della Mirandola, Giordano Bruno, Athanasius Kircher, and Gottfried Leibnitz.

While the details of Llull's system were exceedingly complex, the basic concepts of his exhaustive *Ars Demonstrativa* are relatively simple. The purpose of the *Ars* was to show the Christian mysteries which are the very structure of the universe which, through symbolic computation, could serve to both find and demonstrate universal Truth. Llull designed the *Ars* to be a system (or *techne* as he termed it) rather than as a logic or a metaphysics, and it was intended to be a comprehensive 'science of sciences' and a 'key to the exact and rational ordering of all knowledge.'[27] The *Ars* was represented in diagrams using an Alphabet and Figure which served

Diagrams from Raymond Llull's work, a thirteenth or early fourteenth century manuscript of *Ars Demonstrativa* (Biblioteca Marciana, Venice)

to facilitate the operation of the *Ars*. The Alphabet was in part a notational shorthand while the Figures visualized the relations among the elements so 'that the senses can help the imagination and the imagination the intellect.'

The full set of figures for the *Ars Demonstrativa* consisted of twelve diagrams. The first seven of these are designated by A, S, T, V, X, Y, and Z. The other five are identified as Theology, Philosophy, Law, the Elemental Figure and the Demonstrative Figure. The letters which designated these first figures, while not of symbolic value in an inherent sense, come to function as substantive symbols within their operation in the *Ars*. They carry meaning, and these meanings are in turn linked with the elements of the cosmology Llull is intent upon disclosing. For instance, the letter A designates God in a figure whose circular rim contains all of God's dignities or attributes: goodness, greatness, eternity, power, wisdom, will and so forth. The V figure is similarly inscribed with the seven Virtues (in blue ink): Faith, Hope, Charity, Fortitude and so forth, and seven Vices (in red): Gluttony, Lust, Avarice, etc. The X figure contains sixteen elements of opposing concepts such as Free Will/Predestination, Perfection/Imperfection. The figures Y and Z represent the single concepts of truth and falsehood. A fine network of lines interconnects all attributes in each of the figures, showing all the possible relations and combinations among the elements. In the next set of drawings, the figures designated as Principles contain the basic elements of each of the areas of Theology (Essence, Life, Dignities etc.), Philosophy (Motion, Matter, Form, Intellect) and Law. The Demonstrative figure 'represents a mechanism for combining all the other figures' while the Elemental figure is connected to Llull's earlier work *The Principles of Medicine*.[28] These figures comprise the essential components of Llull's Art, while the figures of S and T function to create interrelations among the elements.

Since the Ars was meant to be comprehensive, a true *universalist* system, it contained a great deal of information in the codes of these diagrams. Two of these, the 'T' and the 'S,' had specialized functions. The 'T' worked to interrelate all the internal elements of the Ars, the 'data' contained in the other figures. By contrast, the S figure provided a link between the system of the Art and the Artist, or person who made use of the Art. The S was the figure which connected the Ars to the outside world, and made it applicable. Anthony Bonner, Llull's translator, compared Llull's system to a computer: 'if A, V, X, Y, Z the Elemental Figure, and the three Figures of Theology, Philosophy and Law contain the basic data, Figure T provides the processing unit, and Figure S constitutes the terminal or control unit assuring correct access to the data and processing.'[29]

Llull's work was arcane, and the values he assigned to the twenty-three letters of the medieval alphabet (I and J were represented by one character, and the same was true for U and V; W was ignored – all of which were common conventions in 13th-century Latin) were unique to his

system. But it was an alphabetical symbolism of a high degree of development, and the qualities which were designated by the letters B through R which were internal elements of the S figure (that which provides access to the Artist) came to be embodied in the letters themselves. For Llull the K, the L, the G and others were not substitutions, but abstract entities possessing set characteristics and capacities. The letters of the Alphabet were active agents of the Art, not mere representations. Thus G 'considers that Y accords with majority' or F 'remembers Y in things past' and 'if F did not remember in present time, then G could not consider,' while A, the letter which designated God, 'is its own truth, immeasurably and eternally.'

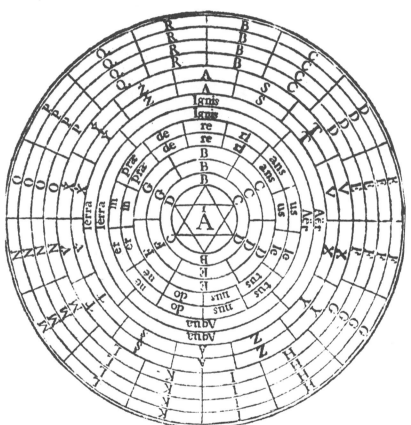

Figure from a printed version of
Ars Brevis, Mainz, early 1700s

In the later *Ars Brevis* the Alphabet was reduced to nine letters with A and T as the major figures. The letters in the *Ars Brevis*, though they carried value in symbolic terms similar to that of the earlier *Ars Demonstrativa*, functioned much more as mechanical elements for manipulation and combination. The letters were defined more by their function than as entities, though their character was no less distinct for that. Llull's significance in part resides in the way his Art became a founding instance of what was later termed *Ars Combinatoria*. This concept was defined as a systematization of systems so that they functioned as an abstract network of knowledge and process. It was a structure of internally related elements

and of relations to both a user and a set of references in the world. In one of his works, Llull demonstrated the application of his *Ars* to profound theological questions which occupied medieval thinkers such as 'Could Adam and Eve have cohabited before they ate their first food?' or 'How do angels speak to each other?' and 'Can God make matter without form?'

While Renaissance constructions of a universal or philosophical alphabet had very different premises from those of Llull, attempts to design an abstract mathematical logic to demonstrate the universal structure of human knowledge and divine order, such as that of Leibnitz in the 17th century, borrowed much from Llull's earlier example. Llullian diagrams showed up in manuscripts and books throughout the Renaissance and Kircher's monumental presentation of systematic knowledge, *Ars magna sciendi sive combinatoria* (1669) was largely based on Llull's work. Some of these later philosophical languages used the Latin alphabet, assigning cosmological value to the letters, while other proposals were dependent on original inventions of new symbol systems.

VI

THE KABBALAH

The term Kabbalah, which simply means *tradition* in Hebrew, is used to refer to the mystical aspects of Jewish exegetical literature, specifically denoting the ecstatic religious practices developed in 12th-and 13th-century Jewish communities in and around Castille. Medieval Kabbalistic literature cultivated an atmosphere of mystery and artificial antiquity but the popular image of the Kabbalah as a cult practice of arcane incantations and magic was a 19th-century invention which has obscured the scholarly origins of the movement.

The most fundamental tenet of the Kabbalah is a belief in the ineffable character of Divine energy and the sacredness and religious significance of the Hebrew language as an instrument of Divine power. In the Kabbalah the contemplation and manipulation of the letters is considered a means of approaching God through meditation and esoteric interpretation; the alphabet is granted a high degree of sanctity since the twenty-two letters are considered to be the very elements by which God brings the world into being. For the kabbalist, God's writing is the world. The doctrines and interpretations of the Kabbalah derive in large part from three primary works, the *Sefir Yetzirah* (*The Book of Creation*), *Bahir* (*The Light*) and the *Zohar* (*The Splendour*). Kabbalistic spiritual exercises are intended to contribute to the collective religious enlightenment of the Jewish people through the study of the holy scriptures. The Kabbalah is intimately bound to the interpretation of the Old Testament, particularly the Torah, but represents the mystical, rather than rational, aspect of Jewish religious and interpretation.

There are scholars who trace the origins of the Kabbalah to mystical beliefs existing in biblical times, but the consensus is that the practices began to take more definite shape in the first centuries of what is termed the Common Era.[1] Most of these early kabbalistic activities are legendary, such as the story of Rabbi Akiva, a 1st or 2nd century devout, who experienced ecstatic visions and survived on account of his humility though his three companions were struck down by the intensity of their revelations.

The history of the Kabbalah parallels the history of the Jewish people both in Palestine and throughout the Diaspora.[2] There is little concrete evidence of kabbalistic activity until the destruction of the Second Temple in 70 AD, but closed mystical societies became a feature of Jewish culture after this date. As the Jews dispersed throughout the Mediterranean region and Western Europe during the early Christian era, kabbalistic practices began to become distinct and well-developed. An apocalyptic literature sprang up among such Jewish sects as the Pharisees and Essenes. Revelations dealing with the terrors awaiting humankind at the end of time appeared in company with ecstatic texts investigating the hidden

world around the Throne of Glory and its unseen occupant. This branch of the Kabbalah is known as Merkabah mysticism (*merkabah* means 'throne') and took the biblical passages in which Ezekiel described his vision of the Chariot as a point of departure. The elaboration on the structure and dynamics of this image form one strain of kabbalistic literature, but it is not intimately involved with the use of the alphabet.

Though inextricably bound up with the rabbinic traditions of Judaism, the Kabbalah was formed in the context of extensive contact with Greek and early Christian religious cult practices in and around Palestine. The oldest kabbalistic doctrines exhibit the influence of Christian Gnosticism, as well as sometimes contradictory impulses borrowed from the 3rd century Greek Neo-Platonist, Plotinus and Pythagorean number symbolism. The dating of kabbalistic texts is in part facilitated by the thematic connections between these intellectual developments and the tenets of kabbalistic practice.

Kabbalah shares with Christian Gnosticism a fundamental search for knowledge, a belief that the Divine Being can only be known through the manifestation of Wisdom, and also exhibits features of Gnostic dualism in the balanced structure of many of its schematic designs. However, the Kabbalah betrays its Jewish origins by the fact that kabbalistic knowledge is always knowledge of the Book. Traces of Neo-Platonism are evident in the kabbalistic belief in a fundamental unity of divine energy, conviction that the material world is its emanation, and its strong hierarchical organization. The Neo-Platonic concept of Logos as Truth parallels the kabbalistic doctrine of the Divine Name. In its attitude toward evil, which is generally not a concern of Judaic tradition, the Kabbalah borrowed from Gnosticism a conviction that evil was located in the reality of this world and combined this with the Neo-Platonic idea of evil as an entity without metaphysical reality. The origins of the Kabbalah can thus be located geographically in the region stretching from Jerusalem to Alexandria and chronologically in a period in which Jewish, Christian and Greek religious cults were in a ferment of continual exchange without clear differentiation from each other.

The term Kabbalah does not refer to a single doctrine or text, but to a variety of practices which can be roughly divided between those which are primarily theoretical and meditative and those which are practical and magical in their focus.[3] These range from speculative intellectual inquiry about the dynamic structure of the spiritual realm, to ecstatic meditative disciplines based on the permutations of the elements of Divine Names, to applied practices which attempt to channel spiritual energy through incantations or manipulation of signs. All share a devotion to the sacredness of the biblical texts and Hebrew letters as instruments of Divine revelation, though the symbolism of the alphabet comprises only one aspect of Kabbalah, whose larger, overarching purpose is conceived as the apprehension of God through understanding of His Wisdom.

In addition to the Merkabah mystics, there was a second major group

Devout Rabbi (Henri Serouya, *La Kabbale*, Paris, 1947)

of kabbalists, the Bereshit, whose thematic focus was on the Work of Creation through a specialized interpretation of Genesis. Specific references to the concept of the Hebrew letters as the instrument of creation began to surface in their 3rd- and 4th-century texts, but a developed kabbalistic doctrine does not emerge until the 9th-century in Italy, and even then it is rudimentary in form. The seeds of these practices spread west and south and by the 10th-century centers of Jewish learning and Kabbalah existed in Sicily and in Narbonne in southern France. But the Kabbalah took its first mature form in 12th- and 13th-century Spain at Gerona and Salamanca as well as in the Near East where an especially strong community developed at Safed, on the edge of the Sea of Galilee.

Because of its dependence upon a thorough knowledge of the Hebrew language and alphabet, the Kabbalah remained almost exclusively within the boundaries of the Jewish community throughout the Middle Ages. The Hebrew language was almost unknown within Christian Europe in this period and in addition many Rabbinic groups were adamant about preserving the sanctity of the Kabbalah. Its study was reserved for an elect few who were rigorously screened to ascertain whether they met the prerequisite requirements: they must be in mid-life, of stable disposition, dispossessed of worldly concerns, and humbly devout in advance of their initiation. Other scholars and religious leaders were more lenient, and worked to popularize and render available the basic teachings, making them more widespread within the Jewish community, and ultimately, beyond its borders.

Texts and Authors

Of the texts which form the core of the Kabbalah, one of the oldest is the book *Sefer ha-Bahir* or *Book of Light*. This work makes its first appearance as a text in southern France in the 12th century, and was thus attributed to one of the earliest historically verifiable figures in kabbalistic study, Isaac the Blind. More recent scholarship demonstrates that its literary character and religious substance differ greatly from other works by this author and that like many kabbalistic texts it is an amalgam of earlier writings and cross currents blending Gnostic and mystical tendencies. The work was well known among 13th-century Spanish kabbalists, who believed it was an ancient document 'composed by the mystic sages of the Talmud' from fragments, scrolls and other sources.[4] Though unsystematic and miscellaneous, the text of this work is considered important by scholars of Kabbalah, particularly Gershem Scholem, largely because of what he characterizes as its use of symbolic language and its concern with 'events in the divine realm,' as opposed to descriptions of the sequence of human events which follow creation. A paradigmatic of Kabbalah, this text has little interest in individual humankind from psychological, historical or spiritual perspectives and concentrates upon the study of Divine energy.

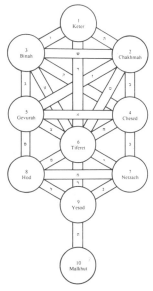

Sephirotic tree (Paulus Ricci,
Gates of Light, 16th century)

Sephirotic tree (Aryeh Kaplan,
Sefir Yetzirah, 1990)

The central image in these texts, which was later to become the founda-
tion of all later kabbalistic study, is the structure of the Tree of Life.
Composed of ten Sephirot, or emanations, this form is considered the first
manifestation of Divine power. One complex theological problem con-
fronting kabbalists was to explain the formation of a finite, material world
from an infinite, all encompassing source, the *Ain-Soph*, thus an elaborate
configuration of emanations, fixed in the form of the Sephirotic tree,
became the basis both of intellectual understanding of the structure of the
celestial sphere and the basis of ecstatic, meditative practices for ascending
its levels towards enlightenment. In the heterogenous amalgam of Aramaic
and Hebrew texts which comprise the *Bahir*, the Sephirot became defined
first as emanations, then as divine principles or powers, and finally as
supernal lights. The term derives from the Hebrew word meaning sapphire
and is thus intended to refer to divine radiance. The Sephirot existed in a
realm between the material world, which was represented by the elemental
forms of the alphabet through which it was created, and the ineffable
height of the Divine. Further elaborations on the structure of the Sephirotic
tree introduced paths between the Sephirot each governed by a letter of the
alphabet which encoded elaborate symbolic elements into this system.

Portions of the *Bahir* depend upon the *Sefir Yetzirah*, whose origins are
even more shrouded in historical obscurity. Traditionally attributed to the
Jewish patriarch Abraham, this text is generally considered to have origi-
nated in the early centuries of the Common Era. As in the case of the
Bahir, its obvious use of Gnostic and Neo-Platonic concepts dates the ear-
liest sections of the *Sefir Yetzirah* to the 3rd century with other portions
added as late as the 9th century. The earliest extant manuscript versions of
the work, however, belong to the same period in medieval Spain as the
Bahir and *Zohar*, and the work is not referred to in written commentary
before this time. The reasons for this are germane to both the text itself
and the Jewish tradition from which it springs, since like many sacred
Jewish texts it probably had an extensive existence in oral form. Once
written, it was the object of many interpretive commentaries which
became woven into the main body of the text.

In the first portion of this brief text, the Sephirot are described primar-
ily as a system of symbolic numbers; following this are five chapters which
introduce the basic premises of alphabet symbolism on which all further
kabbalistic study of the letters is grounded. The work was an integral and
fundamental part of the medieval literature of the Kabbalah, and its
description of the Sephirot forms the basis of the doctrine of emanations
in the work of Isaac the Blind (d. 1235), of letter symbolism in the writing
of Eleazar of Worms (active around 1220), and other major Kabbalists of
the 12th and 13th centuries. Chief among these was Abraham ben Samuel
Abulafia (1240–1292) whose synthesis of existing concepts of the
Kabbalah helped to define its philosophical and mystical emphasis within
the Spanish community, by contrast to the theosophical and Gnostic ten-
dencies stressed in the German Hassidic centers which limited themselves

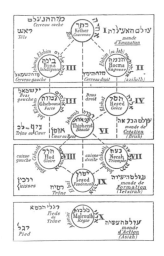

Sephirotic tree showing attributes and parts of the body (Henri Serouya, *La Kabbale*, Paris, 1947)

to more restrained intellectual analysis of texts. Abulafia strongly defended combinatory mediations based on the Tetragrammaton of the Divine Name, moving toward prophecy and mystical experience and away from other more philosophical tendencies within the Kabbalah. The *Sefir Yetzirah* remains the primary source for understanding the symbolic value of the Hebrew alphabet within the Kabbalah.

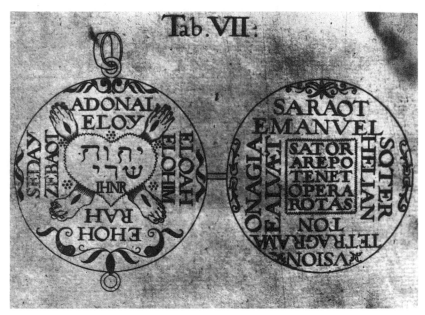

Renaissance Kabbalistic diagrams (Reicheltius 1676)

Abulafia's widespread influence had a strong effect upon the way in which the Kabbalah was appropriated by the Christian humanists of the Renaissance two centuries later, partly through the work of his most renowned student, Joseph ben Abraham Gikatilla. Produced at the very end of the 13th century, Gikatilla's texts attempted a lucid synthesis of all the known tenets of the Kabbalah into a single system, linking the ineffable concept of the Divine Ain-Soph with the structures of the ten Sephirot. Gikatilla's writings served as the basis of at least one major Christian kabbalist, Johann Reuchlin, but in addition, Gikatilla's correspondence and exchanges with Moses ben Shem Tov de Leon, contributed to that writer's work on the major kabbalistic text, the *Zohar*.

The *Zohar* is the most extensive and developed of the many so-called pseudepigraphic texts which were produced in medieval Spain. A vast literature arose in this period among kabbalists who asserted the antiquity of their writing by concealing the authorship of their own texts behind the name of a biblical figure. The *Zohar*, which is believed to have been written (or, more accurately, compiled and unified) by Shem Tov de Leon between 1280 and 1286, was a compendium of miscellaneous work from various sources, many of which bear evidence of the influence of much earlier texts and ideas. Shem Tov de Leon claimed that the manuscript had been passed to him through family connections and that it had been

חל תאחר איננו כי יסנו וכאשר תחכה מימיוך לשמאלך
תונא עשרה ותראה כ יבכתר בית לבלן ומקור כלן

Perspective diagram of ten Sephirot as embodied in initial letters of the names of the Sephirot (Moses Cordovero, *Pardes Rimmonim*, Krakow, 1592)

produced in the 3rd century by Simeon ben Yohai, a mystic who had supposedly secluded himself for twenty years to compose it. The language and sensibility of the work are predominantly medieval, according to Gershom Scholem, and though there is an eclectic range of sources the work has a general unity which bespeaks a single authorship. While the *Zohar* is considered the most important kabbalistic text, its wide range of concerns moves far afield from the concentrated examination of the symbolism of the alphabet, and so its content will not feature prominently in this study, which will draw more extensively upon the *Sefir Yetzirah*.

The Jewish authors and texts whose production and eventual publication follow in the next few centuries build upon these three primary books. It was in this period before and shortly after the expulsion of the Jews from Spain in 1492 that major features of the Kabbalah were consolidated. A systematic analysis of the relations among the Sephirot was developed by Moses Cordovero (d. 1570) in *Pardes Rimmonim* (*Garden of Pomegranates*), and then Kabbalistic doctrine was transformed in the teachings of Isaac Luria (1534–72), a Spanish Jew who eventually settled in Safed after a brief period as Cordovero's student in Jerusalem. Though he wrote only one known work early in his life, Luria exerted tremendous influence as a teacher, and the kabbalistic system he expounded was recorded and studied in the writings of his many students and disciples.

In the history of the Jewish Kabbalah, Luria's works are used as a demarcation point. Kabbalistic writings which predate Luria were based on the assumption that there was a single, expansive process of Formation in which emanations from the Origin moved outward in a creative construction of the divine and then material realms. Luria inverted this premise and interpreted the process of Formation as a regressive cycle of contraction (*zimzum*), breaking apart (*shevirah hakelim*), and mending (*tikkum*). Post-Lurianic methods are distinguished by an increased attention to demonology and dark aspects of the fundamental structures of the Kabbalah, but more profoundly, by this inversion of the cosmological dynamic. Subsequent generations of Kabbalists were influenced more by Luria's work than by that of any other figure – with the possible exception of Abulafia. His teachings have been interpreted by 20th-century critical writers such as Harold Bloom, who saw in them a Myth of Exile which emphasized a final phase of restitution and restoration.[5]

With the expulsion of the Jews from Spain and Sicily, the practitioners of Kabbalah migrated to Italy and Palestine, where the community of Safed became a major center of Jewish kabbalistic studies from the early 16th century onward. The Kabbalah also became considerably more public in this period, and there were even those among the ranks of kabbalistic scholars who inveighed against exclusivity and in favor of democratizing the doctrine. In Italy, the immigration of Spanish Jews sparked contact with Renaissance humanist scholars whose interest in acquiring a knowledge of Hebrew was in part motivated by a desire to understand the Kabbalah and reconcile its mystical hierarchy with their Christian models

of the cosmos. The Christian Kabbalah reached its peak in the publications of the 16th and 17th centuries, while the Jewish tradition which had come into full flower in the Middle Ages continued to flourish and continues in modified form to the present day. The most visible manifestation of the Christian Kabbalah in modern times was in its idiosyncratic adaptation by the Rosicrucians, but as part of the Jewish tradition of scriptural exegesis through meditation, contemplation and revelation its practices have been largely subsumed in the study of intellectual history.

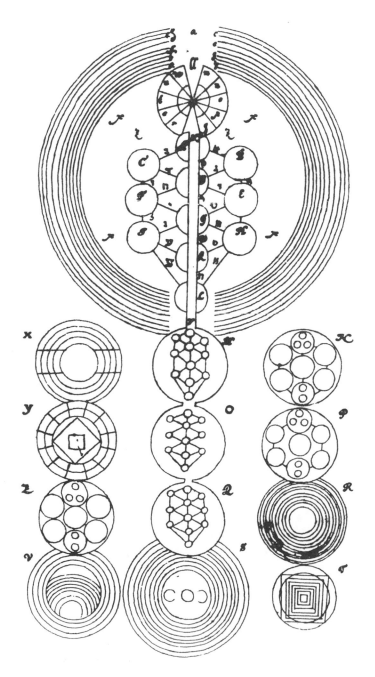

Isaac Luria's system of the formation of the Sephirot (Knorr von Rosenroth, *Kabbalah Denudata*, 1678)

Christian Kabbalah

Three Renaissance figures are responsible for the introduction of Kabbalah to the Christian community from the very end of the 15th century into the 16th: Giovanni Pico della Mirandola, Johann Reuchlin, and Cornelius Agrippa.[6] Because of the sacred character of the Kabbalah it was considered a divine revelation and Christian humanists considered its teachings essential for knowledge of the Bible while classical humanists saw it as a key element in their attempt to reconcile ancient texts and Christian tradition.

Pico della Mirandola (d. 1494) came into possession of a major kabbalistic manuscript two years before his death, most likely from one of the many Jewish scholars who had migrated into Italy from Spain. Pico's interest in the Kabbalah and in the Hebrew language brought charges of heresy on him, and his life was only spared by the clemency of the Pope. Pico became one of the first Christian scholars of Jewish intellectual tradition not merely to defend the teachings of the Talmud and Kabbalah, but to promote the study of Hebrew and tolerance toward the Jews themselves. Though Pico is considered the point of entry of Kabbalah into Christian humanism, it was his disciple Johann Reuchlin who gave a definitive form to the Christian Kabbalah. Working primarily from the late 13th century writings of Joseph Gikatilla, Reuchlin published two major works: *De verbo mirifico* (1494) and *De arte cabalistica* (1517). It is interesting to note that these publication dates precede the earliest edition of the *Sefir Yetzirah*, which only appeared in print in 1592. Reuchlin's later work makes use of a fictive conversation among three characters, Simon, a Jew, Philolaus, a Pythagorean philosopher, and Marranus, a Moslem, to discuss the teachings of the Kabbalah and tease out from them the three concerns of interest to Christian humanists: the image of the Messiah, Pythagorean number symbolism, and the practical aspects of Kabbalah. By the latter is meant the mediations on and manipulations of the letters of the Divine name which were believed to have magical powers.

Like other Jewish texts, the Kabbalah promised the coming of a messiah and this provided the grounds on which Christians reconciled their tenets with those of the kabbalists. The messianic promise which wove through the Kabbalah was recast in a Christian interpretation by conflating the symbolic figure of Adam Kadmon, a primordial man created in God's image, with Jesus on the basis of the conviction that the messiah had already appeared. Adam Kadmon was described in Jewish texts as 'the cosmic reflection of the body of God,' but became the figure of Christ in Christian interpretations.[7] He was depicted diagrammatically and pictorially in Christian texts as a figure whose limbs and trunk were configured in correspondence with the structure of the Sephirotic tree. In another Christianizing transformation, the Tetragrammaton YWVH was expanded so that the term *Yahweh* became *Yasueh* or Jesus (YWSVH). These new combinations were inserted into the elaborate acrostics and

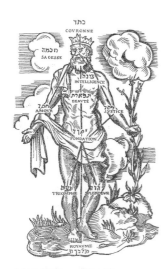

Adam Kadmon (Henri Serouya, *La Kabbale*, Paris, 1947)

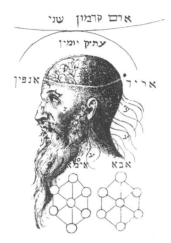

Adam Kadmon (Knorr von
Rosenroth, *Kabbalah Denudata*,
1678)

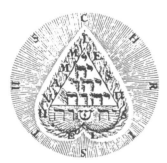

Christian Kabbalistic diagram
(Jakob Boehme, *Libri
Apologetici*, 1730)

Celestial alphabets (Julius
Bartolozzi, *Bibliotheca magna
rabbinica*, 1675)

charts of letter permutations central to kabbalistic practice and subsequently used to demonstrate the inevitable Christian outcome of early Jewish beliefs.

Agrippa's extensive investigation of the knowledge of magic available in the Renaissance was published in his three-volume work, *De occulta philosophia* (published in 1531). Agrippa dealt extensively with the Kabbalah, describing the Sephirot and asserting the superiority of the Hebrew letters over all others 'because they have the greatest similarity with the celestials and the world.' The patterns of celestial alphabets, traced from constellations and star clusters, appeared in Agrippa's work and in their several forms these alphabetic variations were published throughout the Renaissance as part of the proof of the sacred character of the Hebrew alphabet and evidence of its antiquity as the original writing. An interesting feature of Agrippa's work was its conspicuous attention to the feminine aspects of kabbalistic teaching. In part this was due to his courting of favor with the Princess Margaret, for whom he extolled the superior virtues of *Shekhinah*, the female counterpart of God, while also asserting that Eve was closer than Adam to the perfection of the Divine being represented by the Tetragrammaton.

137

Other important figures in the history of the Christian Kabbalah include Agrippa's successor in the anthologizing of occult knowledge, Paracelsus; Guillaume Postel who translated the *Sefir Yetzirah* into Latin, thus making it widely available to European scholars; Athanasius Kircher, who Christianized the Sephirot beyond all recognition; and the English scholar Robert Fludd (1574–1637), who managed a place for the Kabbalah within his cosmological integration of Aristotelian and Platonic philosophy. Christianizing transformations of kabbalistic doctrine continued to weave a heterogenous symbology: in the mid-16th century, Anton Reuchlin interpreted the letters of the Tetragrammaton with Christian equivalents in which *Yod* was the Father, *He* the Son, and *Vaw* the Holy Ghost, while a schematic rendering by Heinrich Khunrath (1609) conflated the *Ain-Soph* with the Savior who was in turn placed on the figure of a phoenix to symbolize the resurrection. One of the most enduring of these texts was Knorr von Rosenroth's (1677 and 1684) *Kabbala Denuda* (*Kabbalah Unveiled*) in which the entirety of the Kabbalah was shown to be Christian revelation.

138

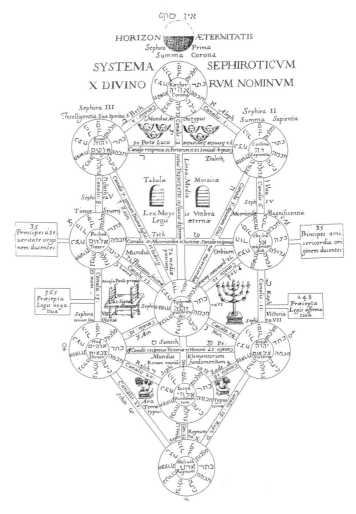

Sephirotic tree without Christian iconography (Athanasius Kircher, *Oedipus Aegyptiacus*, 1652)

At its peak in the 16th century the Kabbalah was known throughout Christian Europe, in Italy through Pico, in Germany through Reuchlin and Paul Ricci, in England through the figure of John Colet and later, Fludd, and in Holland, where Erasmus knew only enough of the Kabbalah to denounce it. Interest in the Kabbalah in Christian intellectual communities waned with the passing of the Renaissance, and drifted to the margins with other occult practices, only appearing in debased form as a supposedly magical practice devoid of serious scholarly or religious content.

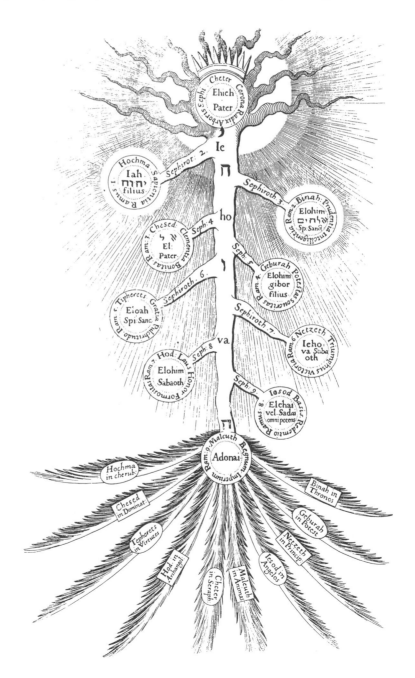

Sephirotic diagram (Robert Fludd, 1621)

Diagram showing the soul's
progress towards Divine God
from the center, marked with
tau , to the outer rim of *aleph*
(Robert Fludd, 1621)

140

Sefir Yetzirah: The Book of Creation and Alphabet Symbolism

The *Sefir Yetzirah* or *The Book of Creation* is a brief text (in its short form not more than 1200 words) which is the main source for alphabet symbolism within the Kabbalah.[8] It is divided into six short chapters, the first of which describes the ten Sephirot and the latter five the attributes and activities of the alphabet. The *Sefir Yetzirah* is both the primary instruction manual for meditative practices using the alphabet and the basic account of the structure of the material world in terms of alphabet symbolism. Within its systems, the letters do not simply have independent values, but are significant in relation to each other through an elaborate system of correspondences, first and foremost with the passages in the *Torah*, and secondarily with the elements of physical space, human attrib-

utes, yearly cycles, astronomical charts and so forth. Because of the long history of commentaries these schemes of attributed correspondence proliferate almost without limit, and only the most basic of these will be outlined here. For the kabbalist, the paths to understanding are necessarily infinite, reflecting the boundless and infinite character of Divine energy. Because the means of access to this understanding resided in the analysis of the scripture as a set of hidden relations, concealed meanings, and esoteric knowledge – all of which are revealed through the calculation of correspondences – these expand continually within the history of Kabbalah.

Alchemical diagram with Kabbalistic imagery (Steffan Michelspacher, *Cabala*, 1616)

The first line of the *Sefir Yetzirah* states that there are thirty-two mystical paths of wisdom. This number refers to the ten Sephirot and the twenty-two letters (consonants) of the Hebrew alphabet, each of which corresponds, initially, to a particular phrase in Genesis, and is corroborated by the fact that one of the names of God, Eloheim, appears in thirty-two places in the description of the Creation. In twenty of these instances

it is associated either with the phrase 'he said,' or with the phrases 'he made' or 'he saw.' The first of these appears ten times, corresponding to the Sephirot, the second three times, corresponding to the three letters of the alphabet known as the 'mothers' and the third seven times, corresponding with the letters known as 'doubles.' The remaining twelve instances of 'Eloheim' correspond to the twelve 'simple' letters. It is on such bases that the symbolism of the alphabet emerges in the Kabbalah, and each layer of correlation and analogy weaves the texture of interpretation into a more complex web of symbolic value.

142 Theater of knowledge, kabbalistic diagram with Christ at the center (Heinrich Khunrath, *Amphiteatrum Sapientiae*, Leipzig, 1602)

All understanding of kabbalistic systems begins with the premise that it is impossible for the limited consciousness of the human being to speculate on or contemplate God; one can only approach God through an examination of his relation to creation. Similarly, the name of God is unpronounceable because of his ineffable quality and so he is referred to as the *Ain-Soph*, which is an adjectival Hebrew phrase meaning in-itself, infinite and boundless, through the four letters of the Tetragrammaton '*YHVH*', and through other letter combinations which stand in for the Divine Name. The process of formation is the central theme in the *Sefir Yetzirah* and the first elements of the spiritual world, all of which exist as emanations from the Divine, are the ten Sephirot, or celestial energy

spheres. These ten luminous emanations are configured into a diagram, the Tree of Life. With *Kefer*, the Crown, at the top, flanked below to the right side by Intelligence (*Binah*) and the left side by Wisdom (*Chakhmah*), the Tree descends through the ten centers which are also considered gates to enlightenment. The right and left branches of the Tree are associated with the masculine and feminine principles. Commentaries do not always agree on the character of each of these Sephirot, but generally, they have the following values: Greatness (*Hesed*), Power (*Gevurah*), Beauty (*Tifert*), Endurance (*Nezach*), Majesty, (*Hod*), Foundation (*Yesod*) and finally the Kingdom (*Malkhut*) at the base. The Sephirot are in turn connected through a series of pathways, numbering twenty-two, each of which is inhabited by a letter of the alphabet whose position is symbolically significant. The letters have another important role below this realm of emanations as the fundamental elements of the material world, but much of the symbolism of the lower realm is encoded in the role played within the Sephirotic tree by the individual letters.

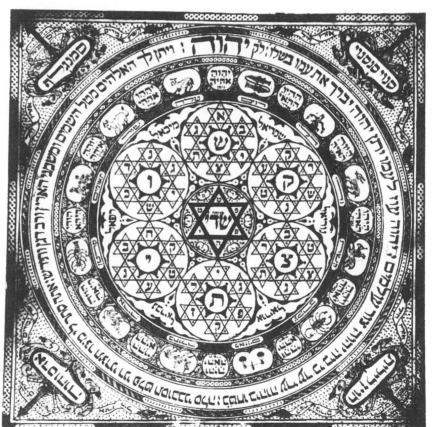

Italian 17th century Kabbalistic drawing showing astrological signs interspersed with permutations of the Tetragrammaton

The Sephirot are considered the Transformers, the first appearance and delimitation of the infinite energy of the *Ain-Soph*, while the twenty-two letters, also known as the Autiot, are the 'Workmen' who function to create the material realm. The Autiot are always linked to real, material

structures and cycles, never to mere speculation or abstraction. The *Sefir Yetzirah* states that with the letters: 'He depicted all that was formed and all that would be formed.'

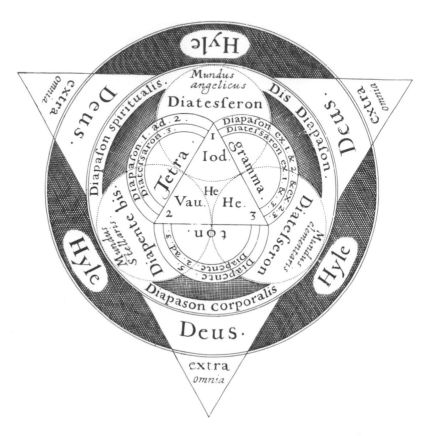

Tetragrammaton as Trinity
(Robert Fludd, 1619)

144

The creation of the letters themselves is described at the outset of the second chapter of the *Sefir Yetzirah* where it states that God first 'engraved' then 'carved,' 'permuted,' 'weighed,' and finally 'transformed' them. Commentaries interpret this sequence to mean that the letters are first transformed from divine energy by being engraved in the spirit and then carved to fill the consciousness of one's mind. The three other activities of permutation, numerical valuation (weighing) and decoding as ciphers (transformation) became the basis of the manipulative aspect of meditative practices. The *Sefir Yetzirah* divides the alphabet into three groups: the three Mothers, the seven Doubles and the twelve Singles. Each of these is examined in a single chapter devoted to its analysis and the whole of the text is intended as a description of the process of formation by which the structures and cycles of the material world are brought into being. The descriptions which follow include both the values assigned to the letters within the *Sefir Yetzirah* and those culled from later commentaries.

The three Mothers, or matrices, are considered first: Aleph, Mem, and Shin. Initially these are configured as a scale, with Aleph as a center balance and the Shin and Mem as two pans, as in a balance or scale, of liability and

Nineteenth century occult diagram of Sephirotic tree (Gerard Encausse, *La Cabbale*, Paris, 1891)

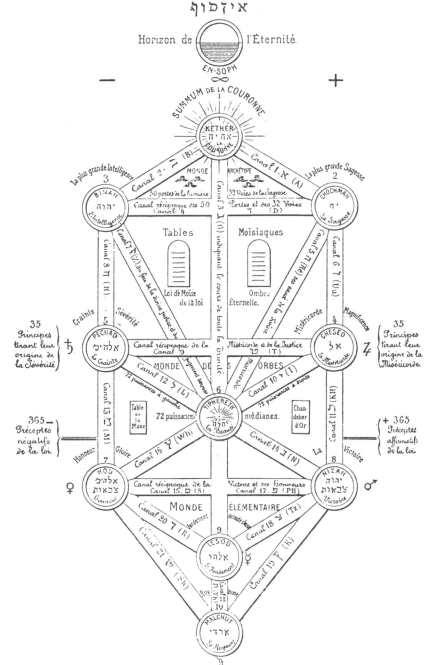

Four cardinal points (Henri Serouya, *La Kabbale*, Paris, 1947)

Holy name with crowns of flame (Athanasius Kircher, *Oedipus Aegyptiacus*, 1652)

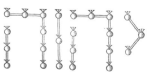

Aleph with letters of the Tetragrammaton (Athanasius Kircher, *Oedipus Aegyptiacus*, 1652)

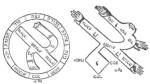

145

merit. Mem is described as humming, Shin as hissing and Aleph as the breath between them. As the first letter of the alphabet, Aleph is granted certain unique roles, particularly within the thesis, antithesis and synthesis sequence of relations among the Mothers. In their existence as a set of three, the Mothers are associated with the seasons of the year (which

number three in both Greek and Hellenistic systems), with the three major parts of the body (head, torso, stomach) and with the three elements (air, water, fire). These are the most fundamental elements of material existence, and contain within themselves the potential of all the others; such hierarchies are essential to kabbalistic cosmology. In later commentaries esoteric values for the letters are accompanied by the more common, exoteric meanings – such as the value of an oxhead for the Aleph, but within the *Sefir Yetzirah* only esoteric values are considered.[9] The following values synthesize work from a number of writers, including Aryeh Kaplan, Perle Epstein, Johann Reuchlin and Carlo Suares.

Aleph is considered a silent letter, as 'undetectable as invisible air.' Aleph serves as a mediator between the two oppositionally defined values of the other two mothers providing a space for their interaction. In its capacity as air, Aleph is associated with the chest or torso. It also governs the spring and autumn equinoxes. Aleph is also granted the identity of the King over breath, and as the first letter is considered a primary manifestation of the Father; thus, its neutral role in mediating between the other Mothers is significant. In its most profound cosmological sense, Aleph is one, a unity, the abstract principle on which all material existence of everything is conceptualized. Johann Reuchlin also mentioned the Great Aleph, whose numerical value is 1000, which 'desires to come out and be seen as the cause of all things' (by contrast to Beth, which is conceived as the *doer* of all things).

In its visual form Aleph divides the worlds above and below through the dynamic diagonal of its central line; this line breaks through static symmetry with 'a life engendering movement.' It is a sign which is charged with life, the dynamism of coming into being, and in this respect Aleph functions as a microcosm of all the aspects of the alphabet.[10]

Mem, the second Mother, is associated with water, and figures prominently in the Hebrew word for that element, *mayim*. Mem is thus considered the fluid ink of matter. It is associated with the stomach and is closed and contained in its visual form while also representing the flux and flow of liquid. From this latter quality it comes to be associated with the astrological interpretation of the course of human destiny. Finally, Mem is cold and therefore brings forth wintertime.

Shin, the third Mother, represents fire. It is associated with the head, and intellect. Its three rising arms end in flames and its hissing pronunciation mimics their sound. These same elements are also interpreted as teeth – which can remain as the last traces of physical being but can also be lost while the body lives. On this account the letter is associated with transformation and seen as an esoteric sign of divine fire which makes changes while consuming. As heat Shin is responsible for bringing forth the summertime. In the Christian Kabbalah, Shin has another special significance because it is the letter which added into YHVH transforms it into YHSVH, thus bringing the Messiah (Yeshus) into being through God (YHWH).

Together these three symbolize the form of the masculine and feminine principles. In the sequence Aleph/Mem/Shin they stand for the male, whose fire and passion are visible on the outside, and in the sequence Aleph/Shin/Mem they signify the female who keeps her passion hidden, interior and concealed. In this configuration the three Mothers were also used in determining the gender of that mythic creature, the golem (see discussion below), by using the appropriate sequence. Also, when used in the pattern Shin/Mem/Aleph, the three Mothers had the power to destroy a golem.

When placed within the Sephirotic tree, each of the Mothers governs one of the horizontal paths which link the masculine left branch with the feminine right branch. These two branches change their identity when counted as members of the three vertical columns, in which case they represent the three Fathers (Yod, He, and Vau) which are the three letters of the Tetragrammaton. In meditative practices, the contemplation of the three Mothers is used to create a receptive state in the kabbalist, which may then be transformed into a creative mode through meditation on the three Fathers: this in turn would generate spiritual descendants.

The seven Doubles are letters which were traditionally pronounced with either a harsh or soft sound (though there is no instance of one of the Doubles, Resh, as a letter with this dual pronunciation in either historical or modern Hebrew). The harsh pronunciation was indicated either by a dot, Dagesh, or by a line, the Rafeh. In the *Bahir*, where the consonants (the letters of the Hebrew alphabet) are defined as the body and the unwritten vowels as the soul, these two marks are granted a status in-between. The two poles of the Doubles are associated with harsh and lenient judgement which is indicated by the pairing of values for each letter. In their capacity as seven, they represent the seven planets, seven heavens, seven days of the week and seven orifices of the head. But first and foremost, they define the coordinates of three-dimensional space and the six days it took to make them. Beth, on Sunday, made the space above and Gimel on Monday the space below. Following this the four cardinal directions came into being: Daleth on Tuesday the East, Kaph on Wednesday the West, Pe on Thursday the North and Resh on Friday the South. It remained for Tau, on Saturday, the Sabbath, to hold them all together at the very center, thus stabilizing the existence of the space of material creation. Beyond this, each Double signifies a pair of traits which are linked through a principle of transformation so that they are not simply opposed to each other, but derived each from the other in its basic definition.

Beth signifies wisdom and folly, as well as the moon and the right eye. From its exoteric meaning as house, it signifies ownership, continuity, community and ancestral property, but also functions more basically as the mark of enclosing space. This translates in esoteric terms into activities of building, bounding, covering so that Beth is considered basis of support in the physical realm.

Gimel signifies wealth and poverty, Mars and the right ear, and microcosmically indicates the role of the Doubles in the creation of the spatial directions. As it also means camel, it comes to stand for the ability to survive austerity, paralleling the camel's capacity to go without water. Gimel thus acquires the meaning of a natural system which regulates itself. As the third letter of the alphabetic sequence, it also marks the impact of the activity of Aleph on the stability of Beth and is seen as the first descendant.

Daleth signifies knowledge and ignorance in the form of the open and closed door; but is also interpreted as seed and desolation. It is associated with the sun, the right nostril, and the role of the Doubles to represent the planets. Esoterically, Daleth is the letter associated with access to wisdom and insight through its symbolic function as the doorway.

Kaph signifies life and death and is associated with Venus and the left eye, as well as the Doubles' representation of the days. In its literal and exoteric meaning it is associated with the palm of the hand, and in Christian Kabbalah it is associated with two of the wounds of Jesus. In a broader symbolic sense it can also mean a force such as the energy which radiates from the palm of the hand.

Pe signifies dominance and subjugation, and is linked with Mercury, the left ear, and the Doubles' role in signifying the gates of the soul. Because it is associated with the Hebrew word for mouth it comes to symbolize speech and the immortality of one's utterance or 'word.'

Resh signifies peace and war, and is associated with Saturn, the left nostril, and the Doubles' links to the angels. It also represents the head and is thus associated with activity of recognition according to features of face.

Tau signifies grace and ugliness, Jupiter and the mouth. In Christian Kabbalah it is the sign of the cross, but also, a phallus. In its cosmological sense, as the final letter of the alphabet Tau signifies the endpoint and completion of God's creative work.

The Doubles were also used to calculate a weekly cycle in which each successively governed times of the day. These cycles could be used to determine auspicious times for particular activities, but only in a limited capacity, since any activity resembling fortune telling met with disapproval in the rabbinic community. These guides were more frequently used to select prayers appropriate to a particular hour of the day. When placed within the structure of the Sephirotic Tree the Doubles were assigned a place within the seven vertical lines and thus became the ladders leading upward from seven Sephirot. The kabbalist could climb with hard sound of each Double and descend with the soft.

The twelve Simples form the remainder of the alphabet, and they are associated with the twelve months, twelve zodiacal signs, twelve limbs and twelve tribes. Within the chapter addressing their activity, there is a discussion of all of the letters of the alphabet divided according to their phonetic identity as gutterals, labials, velars, dentals and sibilants. This phonetic analysis is accurate and curiously appears only once in the text and

nowhere else within either the *Sefir Yetzirah* or other kabbalistic texts. The passage is interesting, but anomalous, and was probably an instance of a late insertion from a unique source which improved on the above cited sequence in which God engraved and carved the letters by adding the statement that God also 'placed them in positions in the mouth.'

He, the first Simple, is associated with Aries, speech, the right foot, Life, and the tribe of Reuben; He is a window which lets in light, but doesn't provide human entry and thus provides a link between the inner and outer world. He symbolically represents religion which establishes links among people and but also between humans and the divine, universal life.

Vau is associated with Taurus, with thought, the right kidney, property, and the tribe of Simeon. Exoterically, Vau represents a nail, which reflects the light from its polished head. Nailheads were used as a system of divination in which the figures made in these reflections of light were interpreted. Vau can also signify a doorknob, thus a means of opening a door of understanding or insight. In its visual form it resembles an impregnating, fertilizing agent.

Zayin is linked with Gemini, with motion, with the left foot, with the activity of attraction, and the tribe of Levi. Exoterically it means a staff or a sword at rest, and is therefore given the esoteric value of forgiveness. In the Christian Kabbalah, Zayin is linked with the symbolism of the sword. In sequence, following Vau, Zayin represents the conclusion of the act of impregnation and the open field of possibilities.

Cheth is associated with Cancer, sight, the right hand, the human relation to ancestors, and the tribe of Judah. Cheth represents a fence or gate which serves as a barrier or demarcation of ownership. By marking the inside and outside of property Cheth comes to represent the capacity to discriminate between that which is worthwhile and worthless. Cheth also signifies the power to distinguish the living from the dead. More generally, Cheth symbolizes the very activity of distributing energy and is the means for storage of substance which is still unstructured or not very evolved.

149

Teth is linked to Leo, to hearing, the left kidney, the activity of descendants, and the tribe of Issachar. Teth is also identified with primeval female energy, though as the symbol of the serpent Teth symbolizes organic unity and the quality of prudence. Certain interpretations associate Teth the serpent with the staff of Moses which turns into a serpent, or with Mercury's staff.

Yod is associated with Virgo, is the sign for action, the left hand, health, and the tribe of Zebulon (these first six tribes were headed by the sons of Leah). As the sign of the hand Yod means fullness, but also the means to transform ideas into realities.

Lamed is associated with Libra, intercourse, the gall bladder, the human activity of coition, and with the tribe of Benjamin (Rachel's son). As the image of a goad or prod, Lamed is the sign used to prompt action. It therefore symbolizes directed energy which requires sacrifice and gains the esoteric value of the sacrifice necessary to accomplish any action.

Nun is linked to Scorpio; the sense of smell, the intestine, the activity of death, and the tribe of Dan. As the sign of a fish, Nun symbolizes the fish's capacity to survive in an environment hostile to humans and therefore acquires the esoteric value of the trait of reversibility.

Samekh is linked to Sagittarius; to sleep, to the organ of the kivah (which may be the pancreas, though it is generally associated with rennet gland in cows and not usually used to refer to human organs), to the activity of travel, and the tribe of Naftali (these last two are the sons of Rachel's handmaid, Bilhah). As the sign of a prop or support Samekh signifies elements which help or assist and thus comes to stand for the activity of interdependence.

Ayin is associated with Capricorn, with anger, the liver, human government, and the tribe of Gad. As the image of the eye, Ayin is associated with perception and the power of metaphysical vision which provides foresight into the operations and concealed workings of events.

Tsade is linked to Aquarius, to taste, the korkeban (which is the gizzard in fowl and can be interpreted as the stomach in humans, though rarely used in this sense), to friends, and to the tribe of Asher (with Gad these are the two the sons of Leah's handmaid Zilpah). As the fish hook, Tsade represents the means by which one world can penetrate another to take something from it.

Qoph represents Pisces, laughter, the spleen, human enemies, and the tribe of Joseph (the other son of Rachel, Joseph is out of sequence in the symbolism of the Singles because he had been sent to Egypt). Since Qoph literally means the back of the head from which one cannot see it becomes the sign of inner sight, rather than the vision of those things which can be grasped directly.

While the letters have very distinct functions within the three divisions they also have a logical relation in the sequence of the alphabet. In one such analysis, Johann Reuchlin unsystematically blends the exoteric values indicated by the letters' names (such as beth=house) with other esoteric meanings. In Reuchlin's interpretation Aleph is the letter, or Rule, and Beth is the house but Gimel takes on the value of retribution in a cycle of initiatory, stable and then reversed energy. Reuchlin uses the traditional value for Daleth, which is the door, and interprets He as the exclamation Behold, a value close to the sound of its pronunciation, but without semantic substance. Since He has no word value, this was a common enough interpretation, but by emphasizing its place in the sequence with Daleth, it becomes related to the idea of a passage through a door or gate. For Vau and Zayin, Reuchlin used the conventional values associated with their names – a bent hook or nail and a weapon. Though Vau has little impact on the narrative of sequence Reuchlin spells out, Zayin anticipates Cheth, which becomes terror in his system. Teth and Yod are causally related: Teth represents a slipping downward from which one can be rescued by Yod in a confession of praise. Kaph is interpreted, again

conventionally, as the palm of a hand but Lamed Reuchlin transforms into the sign of teaching, without connecting it to the surrounding values. Mem has the standard value of water but Nun is the son, more broadly interpreted as the category of filial position. This suggests a Christian association, since the conventional interpretation of Nun is as both the word for and the image of the fish with Christ the Son. To Samekh he granted an abstract value, that of placing or positioning, without elaborating on the significance of this either sequentially or symbolically. Ayin retains its value as an eye, Pe as a mouth, though Tsade acquires the enigmatic and oblique value of the sign for the sides of things. Qoph is a turning, or circuit, while Resh is the image of neediness. Here Shin has its value as a tooth or teeth, and Tau, quite prosaically, is the sign for a sign. What is peculiar in Reuchlin's analysis is both its idiosyncrasy and its interweaving of abstract and concrete values. The letters whose names carried strong semantic value were not even interpreted metaphorically, be allowed to stay within the web of abstract interpretation. It is as though Reuchlin were stretching the interpretive parameters as far as possible, but was constrained by conventions attached to the vocabulary for which he could not manage a metaphoric valuation. The interpretation does not succeed in producing either narrative or symbolic unity, and displays the difficulty of attempting an innovative version of a highly traditional system.[11]

While such values and systemic relations are spelled out briefly in the *Sefir Yetzirah* the aspects of the Kabbalah which pertain to alphabet symbolism are not in any way exhausted by these listings. There remains the entire complex realm of alphabetic manipulation first through the elaborate patterns of letter permutations and then through the three activities of *gematria*, *notarikon*, and *temurah* – or, weighing or calculating, ciphering by taking a word as an acrostic, and transforming or substituting the sequence of letters. Precise formulae for these activities as well as a description of the conditions for their application were described in detail by Abulafia in the 12th century and Isaac Luria in the 16th; their methods were used by kabbalists from that point onward, often with little alteration.

The most sacred permutations were those which employed the letters of the Divine Name, *YHWH*, but there were many other formulae as well. Abulafia associated each letter of the alphabet with a part of the body and instructed that both should be meditated on simultaneously since rearrangement would have bad effects on the health. The kabbalist was cautioned not to meditate too soon after intellectual study and to clear the mind through ritual bathing, fasting and abstinence. Abulafia also prepared the novice for the effects which would be brought on by the meditations: 'After much movement and concentration on the letters the hair on your head will stand on end ... your blood will begin to vibrate ... and all your body will begin to tremble, and a shuddering will fall on all your limbs, and ... you will feel an additional spirit within your body ... like fragrant oil, anointing you from head to foot.'[12]

Prescribing specific patterns for the permutation of the letters of the alphabet, especially in combination with the letters of the Tetragrammaton, Abulafia's was one of the first of many such formula books. The fundamental system of permutation in all of these involved the 231 gates, or pairs of letters of the Hebrew alphabet.[13] The patterns of permutation increased in difficulty as one ascended the Gates to achieve a perfect coordination in which the body, mind and flesh would correspond to the spirit of the letters and one would in fact become the Torah itself. Abulafia described the activity of 'gazing into the Chariot' by which he meant the letters of God's name arranged in the shape of the chariot or throne which had been a central image of Mekabah mysticism. The most important aspect of meditation was to 'surrender the sense' of a passage in the Torah; this could be achieved by repetition, or through permutation of the letters in the passage through systematic combinations. Another meditation involved permuting the Tetragrammaton with the five vocalic sounds while envisioning a movement through the centers of the body: the head fire, the belly water, the chest or heart the center of air. Abulafia also cautioned that the student would encounter difficulties and obstacles; there were figures called 'withholders' which could interfere with concentration; each student had to learn to recognize these and overcome them.

The *Autiot*

א	ב	ג	ד	ה	ו	ז	ח	ט
Aleph	Bayt Vayt	Ghimel	Dallet	Hay	Vav or Waw	Zayn	Hhayt	Tayt
1	2	3	4	5	6	7	8	9
י	כ	ל	מ	נ	ס	ע	פ	צ
Yod	Kaf Khaf	Lammed	Mem	Noun	Sammekh	Ayn	Pay Phay	Tsadde
10	20	30	40	50	60	70	80	90
ק	ר	ש	ת	ך	ם	ן	ף	ץ
Qof	Raysh	Seen Sheen	Tav	final Khaf	final Mem	final Noun	final Phay	final Tsadde
100	200	300	400	500	600	700	800	900

Chart showing gematrial values of the Hebrew letters (Aryeh Kaplan, *Sefir Yetzirah*)

Some of the particulars recommended by Abulafia contributed to the aura of magic surrounding Kabbalah: the best hour for meditative permutations (known as *tzeruf*) was midnight. The meditator was to light many candles, wear phylacteries and a prayer shawl, and write out the permutations of the alphabet with ever increasing speed. The resulting ecstatic state accompanied by the desire of the soul to leave the body could be so powerful that there was even the possibility of death. At the peak of ecstatic experience there would be a rush of unintelligible language and the

Twelve zodiacal houses and the spheres from earth to heaven, from *The Book of Raziel* composed in the 14th century

kabbalist had to envision a surrounding circle of angels who could help to decipher the divine message. It was the sheer force of the letters themselves which brought forth the meaning, since the only link between the Sephirot of non-verbal Wisdom and verbal Intelligence was through the letters of the alphabet.

In addition to the rituals of permutation, the methods of notarikon, gematria and temurah were systematically applied. An example of such practice is the kabbalistic analysis of the Torah as the symbol of the heart of creation. This symbol is derived in two stages, first from the fact that since Beth is the first letter of the first word of Genesis ('Bereshit') and Lamed the final letter of the last word in Deuteronomy ('Yisrael'), they form the beginning and endpoint of the Torah. Second the letters Lamed and Beth were combined independently (LV) to spell the word for heart. Such cipher readings were common – as were gematrial calculations.

The bases of *gematria* were the numerical values of the letters assigned to the alphabet according to their sequence. The letters from Aleph to Teth had values from one to nine, Yod to Tsade ten to ninety, and Qoph to the end of a sequence which added the alternate forms of Hebrew letters Kaph, Mem, Nun, Pe and Tau had values from one hundred to nine hundred. Adding the values of individual letters produced the value of any individual word or phrase. There are several relations established by the gematrial values of the opening and closing words of the Torah: Bereshit also has the gematrial value of 913, equivalent to the value of the phrase 'He created the law,' granting it a double meaning. The gematrial value of Yisrael is 541, which, added to 913 equals 1454. The value of the name Adam Kadmon tallied to one more than this (1455) thus showing that he encompassed all scriptural knowledge within his supernal body.[14]

Preoccupation with the frequency and pattern of letters in the Torah, and in specific passages, was an inexhaustible source of kabbalistic interpretation. Baal Shem Tov, an early Hassidic Rabbi, stated that the quantity of each letter in the Torah had been set in advance, existing at first in a state of chaos, which God had put into an order which granted them one sense. However, the original quantities could be calculated and interpreted in studying the Torah as a means of understanding the fixed and essential character of God. The letters of the Torah could also be interpreted as a continual sexual embrace between the masculine energy of God and the feminine Shekhinah so that the entire text was granted an erotic charge.

Celestial alphabet from *The Book of Raziel*

In another example of gematrial analysis a passage from Genesis was interpreted as the foretelling of the coming of the Messiah. The passage reads, 'The sceptre shall not depart from Judah, nor a lawgiver from between his feet, until Shiloh come;' the last phrase (in Hebrew IBA ShILH) translates in Gematria into the number 358; the number 358 is also the Gematria equivalent of the word Messiah (when spelled in Hebrew as MShICh). This same number was associated with the serpent of Moses (NChSh) and thus Christian kabbalists were able to link the staff of Moses, transformed into a serpent and back, into the image of Christ on the cross (which was signified by the letter Tau, linked to the staff) since they interpreted the Hebrew word for Messiah to mean Christ.[15] In one very simple example of a notarikon acrostic reading cited by Reuchlin, a book written about the commutation of letters as a kabbalistic practice was given the title *The Garden*, which in Hebrew is spelled with *GNTh* – the three letters which denote Gematria, Notarikon, and Themurah, the three methods of alphabet manipulation.[16]

Finally, each letter of the Hebrew alphabet was considered to be connected to an angel. Each time the letter was used the angel was invoked and the group of letters in a word would call up a corresponding group. The angels inhabited a celestial sphere in a space between the realm of the Sephirot and that of the Alphabet which was also referred to as the realm of speech. The stars in this realm formed a link between the realm of the Throne above, the intermediate Sephirot, and the realm of Creation below and were visible in the stars. Since there was a prohibition against the production of graven images in Judaic culture, it was not permitted to make pictures of the constellations or of the angels and their configurations. Only schematic tracing in diagrams of the connections between stars was allowed, and thus the study of angelology results in the production of the celestial alphabets which correspond in turn to the letters of the Hebrew alphabet.

Kabbalistic meditations flourished between the 13th and 16th centuries, but by the 18th these had largely disappeared either through fear, lack of interest or discreditation. The force of more rational interpretive practices imposed themselves on mainstream rabbinic culture, and the process of scriptural analysis opposed the ecstatic meditation on the Name which had been essential to the Kabbalah.

Nonetheless, the kabbalistic tradition continues to have its adherents, even if the structure of the meditative practices has modified, losing some of its quality of medieval incantation to more somber spiritual investigation. Contemporary believers are profoundly devout. Some, like Rabbi Yitzchak Ginsburg, follow the teachings of the founder of the Hassidic sect, Rabbi Yisrael Ba'al Shem Tov, in a serious investigation of Jewish thought as embodied in the letters. Others, like Ben Shahn, have reworked Kabbalistic symbolism as a fundamental mythic structure of Jewish tradition.

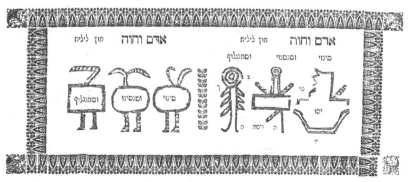

מיכ״אל גבריאל רפ״אל צוריאל קדומיאל מלכיאל צדקיאל פדיא״ל חזמי״אל צוריאל קחדיאל רמ״אל יופיאל סטורי : מרי״אל ודרי״אל להרי״אל חזקי״אל
רחמי״אל קשטיאל שבני״אל ברקיאל אחיאל חניאל חייאל להא״ל מלכיאל רחסיאל שבניאל קדמיאל רומיאל קדמיאל חכמיאל רמאל קדשיאל עויאל עזריאל חכמיאל
מהני״אל גיאל גדיאל צורנק עופני״אל רחמי״אל · סמסיס ודרנויס רסמיאל רומיאל מיאל יעוריאל אהריאל נריה סמפיאל עינאל הסוריה רגאל צורה
פסוסיס עזריאל סמכיאל מתני סיס ירואל טטרוסיס חוניאל זבדיאל ועריאל דיאל בריאל גדיאל עזריאל אהניאל ·

בשם אהיה והא ההא אא בב או מאב אאא

Kabbalistic figures from *The Book of Raziel*

אשבעית עליך מוז ראשונה בשם סטוח יורך ובשם שלשת מלאכים ששלח יורך בשניך ומלאך בחיי כיס ונשבעת להם במקום שממלא שמוחס שלא
חזיק אתה ולא אחת ממחמותיך ומשרתיך ולא כל מי ששש שמומס לכן בשמוחו ובחתומס כתובים כס אני משביעך ואת מחמותיך ומשרתיך שלא
חזיקו את יולדת פלונית בת פלונית ולסילד שעילד לס לא ביום ולא בלילה לא במאכלם ולא במשחה לא בריאתס ולא בלבם ולא בשני מאות ארבעים
ושמונה אבריהס ולא בשלם מאות ושש ומשה גידיהס בכת השמות והחתומות האלה אלו אני משביעך ואת מחמומיך ואת משרתיך :

Rabbi Ginsburg's work, *The Alef-Bait*, expresses the awe and wonder which all believers experience in the presence of the letters. He cites a famous text by Ba'al Shem Tov, who exhorts the practicing Jew to make of daily life a continual practice of devotion, one in which 'Your way shall ever be in the presence of G-d.' In such a condition, each of the letters which pass one's lips are ascendant and unite with each other, carrying with them the full glory of their three powers: the power of World, of Souls and of Divinity. The letters live their own independent existence, connecting to become words and then joining 'in true unification with the Divinity.' Thus every attempt should be made to join one's soul to the letters at every utterance so that it too might rise to join with the Divine God. Through such practices, one could intensify one's awareness of the power of God and Divine presence in every moment of thought, speech or action, and thus increase one's wisdom through faith and spiritual practice.

More specifically, the Hassidim identify three creative powers for each letter of the alphabet: energy, life and light. The letters are thus building blocks in both a cosmic and almost literal, physical sense of all reality. They are, as Ginsburg says, 'the inner life-pulse permeating the universe as a whole and each of its individual creatures ("pulsing" every created being, instantaneously, into and out of existence); and as the channels which direct the influx of Divine revelation into created consciousness.'[17] Letters form words, but are above all, Light, the very state and condition of joining with the Divine as emanation from and return to that source. The Hassidim stress that the word for letter in Hebrew 'also means "sign" or "wonder." ' And that the term 'wonder' must always be granted the value of Divine light, than which nothing is greater. As a cosmological system, belief in the letters as the fundamental elements allows that the most mundane transactions of quotidian existence are themselves permeated with

sublime value in each and every instance of utterance or writing because the alphabet is inextricably bound to the Divine Being as its expression and its essence.

One of the most vividly mythic versions of kabbalistic imagery is told by Ben Shahn in his version of *The Alphabet of Creation, an Ancient Legend from the Zohar*, first published in 1954.[18] Shahn's tale anthropomorphizes the letters, giving each an individual character and role to play. He begins by stating that all twenty-two letters originated in the crown of God, where they were engraved with a pen of flowing fire. There were twenty-two generations before the creation of the world, one for each of the letters. And each one begged that the world be brought into being through its power and symbolic value. In Shahn's account, the letters appear in reverse order, as if each one's rejection paves the way for the appearance of the next. Thus *tau* appears first, asking, as each letter after does, that the world be brought into being through him. God refuses, saying that *tau* would later serve as a sign of death upon the foreheads of men. As each letter appeared, it gave its reasons for believing in its appropriateness as the foundation for creation while God gave the reason for refusing to use it as the basis of creation: *shin* argued that it was the first letter of one of the names of the lord, *shaddi*, but God countered that it was also the first letter of the word for falsehood in Hebrew; *resh* stated that the word *rahum* meant 'merciful,' but God pointed out that it was initiated the word for evil; *koph* began the word for *kodesh*, or Holy One, but also for a curse and so on through the entire alphabet. As God reached the end, which was in fact the beginning of the alphabet, he came to *gimel* which was the first letter of both the words for 'great' and 'retribution,' and then passed on to *beth*. *Beth* had no negative attributes, *beth* was associated with *baruch* the first word in prayer meaning 'blessed is the lord,' and *bereshit*, meaning 'in the beginning,' again, the first words of Genesis. But the Lord passed over *beth*, in spite of the many virtues of the letter, and instead put *aleph* in its place because *aleph* made no claims at all for virtue or goodness or strength, and thus by modesty and humility won first place in both the Decalogue and the alphabet.

For both Shahn and Ginsburgh the alphabet is real and symbolic, a mystical essence and a material means of access to the structure of Divine light, power and wisdom.

The Kabbalistic Creation of a Golem

The concept of the golem evolved directly out of the teachings of the *Sefir Yetzirah*. The word means 'shapeless matter,' but specifically indicates a human figure formed from clay and brought to life through the incantation of magical, kabbalistic permutations. Interpretations of the literal or symbolic value of the golem vary, with many authorities willing

Mikolas Ales, *Rabbi Loew and the Golem*, 1899

only to lend credibility to the creation of a spiritual figure, not an actual living being. The earliest mentions of the golem – in passing in the Old Testament and then more frequently in 5th- and 6th-century writings – sometimes confound the figure with the stage of creation in which a human being exists but does not yet possess a soul. At one time, the myth of the golem was taken so seriously that it was debated whether or not golems could be included in a *minyan*, the minimum number of men considered necessary for certain Jewish rituals to be performed, such as a burial. Myths of the golem flourished particularly in Northern European kabbalistic tradition up to their peak in the 16th century and resurfaced in early 20th-century German expressionist films and plays.[19]

The myth of the golem had an early practitioner in the 13th-century scholar Rabbi Eliezar Rokeach, or Eleazar of Worms. In his book *The Depths of the King*, Eleazar provided several techniques for the construction of a golem. First of all, the novice must never attempt to make a golem alone, but should work with one or two colleagues, all of whom must purify themselves before starting. Together they must dig virgin soil and mix it with pure spring water taken directly from ground, since placing the water in a vessel of any kind would cause it to lose its purity and thus its power. Once the clay was mixed, it should be formed in the shape of a human figure, and over this figure a sequence of letter combinations must be pronounced. Any errors in pronunciation would result in failure of the project, but if the sequences were pronounced correctly, the golem would come to life. Eleazar stated that combinations of letters in the first half of the alphabet would animate the golem, while those from the latter half would deactivate it. In another place, Eleazar suggested that the clay could merely be spread out and that the form of the golem would emerge on its own, as a result of the permutations. One other passage suggests that engraving the letters 'Emet,' or 'Truth' on the forehead of the golem would bring it to life, with the advantage that effacing the first letter transformed the word into 'Met' or 'Dead' which would deactivate the golem. In keeping with the kabbalistic tradition, it was believed that recitation of the letters of the alphabet would bring about a direct infusion of wisdom into the figure formed in the clay.

The golem concept flourished in France, and then in select areas of Western Europe, rather than in the Spanish regions from which the central kabbalistic tradition had sprung. By the late 15th century, the texts describing the creation of a golem had been translated into Latin, rendering them available to Christian kabbalists. The most renowned and remarkable tales of the invention of a golem were those associated with 16th-century Prague in the figures of Rabbi Eliahu Chelem and Rabbi Judah Loew. The source for tales of the former come from a text by two Christians, but the accounts of Rabbi Loew's successful experiments were told by Chayim Bloch in the early part of the 20th century.[20] These stories recount explicit details of the golem's invention, limitations, and usefulness in combating the attempts of the Christian community to persecute

157

Star of David with letters of the Tetragrammaton, (Henri Serouya, *La Kabbale*, Paris, 1947)

the Jews through false accusations or deceptive misdeeds: the powers of the golem are carefully subordinated to the aim of preserving the Jewish community.

Most kabbalists, even one as involved with ecstatic practice as Abulafia, refrained from endorsing belief in the golem as a literal creation. The practices he described were more clearly focused on the kabbalist's own body, and on forming a clear mental image of a body which existed as a spiritual double and was created through a meditation on the sequence of the alphabet which replayed the process of creation. Though he also provided recipes for the making of a creature, Abulafia considered the golem a symbolic creation which was the culmination of meditative experience. In the making of a golem, as in all kabbalistic practices, the fundamental role of the alphabet was as a proof of the existence of God.

VII

RATIONALIZING THE ALPHABET: CONSTRUCTION, REAL CHARACTER AND PHILOSOPHICAL LANGUAGES IN THE RENAISSANCE

The invention of printing in the middle of the 15th century had profound effects on both the visual appearance of written forms and on the social functions which differentiated applications of writing. But the attitudes towards the alphabet which emerged between the first publications of Johann Gutenberg around 1454 and the establishment of the French and British Academies in the 1660s prefiguring the Enlightenment are not limited to the effects of printing.

In the 15th century, the publication of the Hermetic corpus had reinforced the authority of alchemy, grounding it in the supposed antiquity of these works. The additional influences of the kabbalistic doctrine of emanation and the Neo-Platonist concept of transcendence, all combined in the early Renaissance to produce a cosmological view of the world. Highly structured, rigidly hierarchical, and considered the manifestation of divine mystery and power, the cosmological model was modified considerably in the 16th and 17th centuries. By the early 1600s the *Corpus Hermeticum* had been reevaluated and its origins dated to the 3rd and 4th centuries of the Christian era. The historical perspective provided by this realization was in turn part of a larger set of intellectual changes prefiguring the end of the Renaissance era: events in human history began to be placed within a chronologically linear framework and the disciplines of science and theology in their more modern form displaced the cosmological and alchemical models which had held sway earlier. By the late 17th century, the conceptual basis of knowledge had been transformed from the Aristotelian logic which had prevailed among medieval scholastics to a methodology grounded in an unquestioned faith in human reason. Though traces of Hermeticism, kabbalistic thought and mysticism persisted they no longer determined the mainstream of intellectual or religious activity.

Johann Gutenberg, a line from the 42-line bible, Mainz, 1454

Alphabetic writing participated in many aspects of Renaissance thought, and in areas as diverse as philosophy, linguistics, and occult sciences as well as in penmanship, printing and design, the alphabet functioned as an index to the various changes in intellectual currents which occurred in the Renaissance.

The Rationalization of the Alphabet

The conventional wisdom that the invention of printing brought about the standardization of alphabetic writing is essentially true, though it must be qualified by the recognition that writing continued to diversify in

Ehrhardt Ratdolt specimen
sheet, Venice, 1485

Leonardo da Vinci and Fra Luca de Pacioli's constructed alphabet, about 1500 (*Les Plus Beaux Types des Lettres*, Paris)

Palatino's constructed alphabet, *Libro Nuovo*, 1540 (*Les Plus Beaux Types des Lettres*, Paris)

Albrecht Dürer's construction of majuscules 1525, Nuremberg

form as its functions became specialized. The printed word was only one area of the wider spectrum of written forms produced in the Renaissance period. Just as in the Middle Ages the traditions of inscriptional letters based on stone carving had persisted alongside the development of highly differentiated hands for the production of manuscript texts, or for use in written documents within the arena of secular activity, so in the Renaissance these traditions were reinterpreted according to the needs of the various areas of human activity served by written language.

Generally speaking, the production of books through the new process of printing displaced the activity of manuscript copying and the first typefaces designed for this purpose were, by and large, based on scripts developed in manuscript form. The long tradition of reinterpreting the Roman square capitals from Imperial inscriptions was also given a unique revival in the Renaissance mania for constructed alphabets, the submission of alphabetic form to elaborately systematic rationalization. These designs sometimes returned to the medium of the stone carver and sometimes serving as the basis of printing types or decorative initial blocks. Meanwhile, the activity of handwriting *per se* became the specialized domain of writing masters whose virtuosity was displayed in published manuals advertising the skills required for production of charters, court documents, legal, financial and business records – all of which were produced by hand well into the 19th century.

Typefaces based on late medieval script forms were cut in the first fifty years of printing's existence in Germany, France, Italy and England, the period known as the *incunabula* era of print. Some of these first efforts in the new medium became the basis of typeforms still in use in the late 20th century, though modified to suit later technologies such as photomechanical reproduction or electronic typesetting. The blackletter designs cut by Gutenberg, for instance, were employed until the 19th century in Germany. But other early typefaces reflected a late medieval sensibility which subsequently fell from fashion and there are several early type styles which are as remote and unfamiliar to modern eyes as are the manuscript letters on which they were based. For instance William Caxton's types, the first cut in England, were based on an English blackletter which had a cruder visual form than the humanistic book scripts which ultimately determined the aesthetic standards of printing types. The difficulty and laboriousness of producing typefaces worked against the proliferation of a wide variety of sizes and styles, though as the number of trained punchcutters, printers and designers grew the range of available faces multiplied in proportion to their numbers. It is estimated that between 8 and 10 million volumes were produced by 1500, less than fifty years after the first use of moveable type to print a book.[1]

The first types were designed in Mainz, Germany, by Johann Gutenberg and used in his initial publication, referred to as the 42-line bible, which was completed around 1456. In point of fact, Gutenberg's 'invention' consisted in large part of the design of a device for casting indi-

161

Albrecht Dürer's black letter and construction, 1925, Nuremberg

162

Geoffrey Tory's constructed majuscules, *Champfleury*, 1529 (Edward I. Strange, *A Manual of Lettering*, London, 1898)

vidual letters in variable sized metal units which could in turn be recombined in an infinite array of sequences – the mechanical basis of printing. The actual concept of printing letters from a relief surface had been in existence for centuries in both China and the West, though in Europe the applications of this technology had largely been confined to the production of stamped bindings for books. Gutenberg's radical breakthrough in production methods netted him very little gain: he was bankrupted through a complex of circumstances and though celebrated by posterity, suffered considerably in his lifetime from poor business choices and unfortunate partnerships.

Printing spread rapidly in Europe with the technology disseminating from the German center, at first through individuals and then through the emergence of a full-blown profession. Conrad Sweynheym and Arnold Pannartz, for instance, two itinerant printers who had gained their expertise from Gutenberg, helped spread the invention, modifying both the forms and the substance of printed books to meet the needs of various communities. Establishing themselves near Subiaco in Italy, Sweynheym and Pannartz designed a typeface based on the humanistic script which had been developed in the scriptorium of the monastery there. By the end of the 15th century not only had a significant number of books been produced, but various genres had become established: the pocket-sized edition, the illustrated book, the vernacular text and so forth.

The proliferation of type styles which accompanied the spread of printing reflected both local styles and tastes and the desire of the new profession to serve a varied clientèle. The specimen sheets of the German printer Ehrhardt Ratdolt produced in 1486 – some thirty years after Gutenberg's first publication – provide some sense of the range of types available in a single printer's establishment, though it should be kept in mind that Ratdolt was printing in Venice, a major center of typographic activity and calligraphic tradition. While the persistence of the writing styles from earlier manuscript traditions are clear in the adaptations to printing types, the page designs became more insistently linear and regularized owing to the mechanical demands of the print medium. It took nearly a century and a half before the designers of text fonts used in printing conceptualized their designs independently of the manuscript tradition which had offered such striking models to the first generations of printers, while the increased variety in titling and decorative faces, largely used for advertising, was a development of the 19th century.

In the realm of titling types, majuscules or capitals this history is distinctly different. While text types took their visual form from manuscript faces, the development of capital letters returned to the tradition of Roman capitals. But rather than literally copying the forms which at that mid-15th century period existed about them in great numbers on the classical monuments scattered throughout Western Europe, the Renaissance theorists of letter design reconceptualized the forms of these letters through a process of elaborate, highly rationalized construction. The basis

Geoffrey Tory's constructed 'A' with compass image, *Champfleury*, 1529

Geoffrey Tory's constructed 'T' and 'K' based on human proportions; *Champfleury*, 1529

Geoffrey Tory's constructed 'O' based on human proportions; *Champfleury*, 1529

of all of these constructions was the mistaken notion that the Roman forms had resulted from a mechanical production based on the circle and the square, the two geometric figures considered to be most harmoniously proportioned (barring the golden mean, which, oddly enough, was never pressed into service as the basis of letter forms). On the basis of this misconception designers, geometers, artists and printers designed versions of the Roman capitals throughout the period of the high Renaissance which were based on elaborate theoretical models.

The first known treatise on constructed letters is the work of Felice Feliciano (at least one treatise on constructed Gothic initials exists, but its dates are unclear, and it may well have been a treatment from this later period), but the first printed version of a constructed alphabet was produced in 1480. Authored by Damiano da Moyle of Parma, this work had fallen into obscurity until its rediscovery and publication by Stanley Morison in the 1920s. Feliciano and da Moyle both exhibit the features which were conspicuous elements of constructed alphabets through the end of the 16th century: the use of the compass and square, the establishment of a set of proportions for the width of the major strokes, and the careful discussion of the process by which letters should be derived through application of their method. Each designer had an individual opinion on a whole number of points: the relative sturdiness or delicacy of the basis strokes, of the amount of subtlety to be invested in the construction of the tail of the 'R' or the 'Q,' and the axis of emphasis on which thin and thick variations of line in the 'O' should be oriented from the perpendicular and so forth. Peculiar exaggerations of letter forms resulted from an insistence on the theoretical propositions: in the work of Feliciano, for example, the 'Z' and 'D' become extremely wide in order to fill out the proportions of a perfect square.

Constructed alphabets were designed by such figures as the well-known and much admired geometer, Fra Luca de Pacioli, whose designs, possibly developed in consultation with Leonardo da Vinci, were published in 1509, and a whole raft of other mathematicians, writing masters, and printers. Foremost among these were Albrecht Dürer and Geoffrey Tory, whose major treatises on letter formation were published within the same decade. The widely contrasting sensibilities of the two men are immediately apparent in the contrast of their systematization of letter design. Dürer's 1535 *On the Just Shaping of Letters* is a mechanical treatise with a rigorous aesthetic purpose while Tory's *Champfleury* combines cosmological and mystical insights with his humanistically tempered diagrams.

Dürer's work is remarkable for its use of method for its own sake. The letter forms he designed, like the diagrams he created through his own peculiar adaptation of Italian theories of perspective, were idiosyncratic. What he had grasped in his visits to Italy in the 1490s and early 1500s was that method was a conceptual tool, but the clear understanding of its mechanics never formed a solid basis for his work. His use of circles, grids,

163

Geoffrey Tory, Combination of 'I' and 'O,' *Champfleury,* 1529

LHOMME LETRE

Geoffrey Tory, 'L'homme lettré,' *Champfleury,* 1529

Geoffrey Tory's 'QU' the affectionate pair, *Champfleury,* 1529

or proportional systems often seems arbitrary – as was often the case within the works of Italian designers of constructed letters. In many instances the schematic lines seem to have been added *after* the drawn construction rather than having used it to actually generate the letters. But Dürer's application of method shared the infatuation with the production of form through rational method of his Italian contemporaries. But the proof of his engagement with method for its own sake was in his peculiar application of the theories of construction to the design of a blackletter face based on the penned forms of a manuscript hand. The forms of these letters, generated from the gestures of a scribe's writing movements, had no relation whatsoever to the mechanical principles ascribed to the invention of Roman capitals. Yet Dürer obligingly created a *constructed* form of this blackletter alphabet in accord with precisely these same mechanical principles.

The work of Geoffrey Tory, the preeminent French printer of the early 16th century, incorporated the cosmological synthesis particular to early Renaissance scholars. Tory used his studies of the letters as the means to integrate classical and mystical knowledge, drawing on Neo-Pythagorean and Neo-Platonic symbolism. For instance, Tory used a theory of proportions derived from the human figure as the basis of his designs, mapping the body of a man into the grid on which he based his majuscules – a quintessentially humanistic, early Renaissance idea. But then he linked his structuring grid of proportions to systems of mythology and the Muses. Insisting that all the capital letters could be constructed from a combination of the 'I' and the 'O' (the straight line and the circle) Tory assigned to each of the ten units in his grid a different Muse, adding Apollo's as the tenth name to complete the set. These proportions also corresponded to the openings and intervals on the mythic flute of Virgil, themselves each governed by a Muse, while the mouth and shaft of the flute signified the 'I' and the 'O.' Inscribed within this system, the letters were inherently aesthetic and symbolic. Tory termed these Attic letters and the sum total of twenty-three letters could be projected onto the human anatomy to show the perfection of its organization in relation to the system of the alphabet as seen in his image of *L'homme lettré.*

Tory made particular assessments of the characters of each of the letters as well, though his method was not systematic. He characterized the 'A' for instance as 'a symbol of the voice coming forth between two parts of the palate,' an image which he felt was evident in its form. But he also asserted that the letter A was composed visually from images of the compass and straight edge, the fundamental tools of the geometer's discipline. Tory's imagination extended to explain such anomalies as the disproportionate size of the letter Q, the only majuscule which did not fit within the space of the square. 'Q,' Tory explained, was unwilling to be parted from his 'trusty comrade and brother U' (or 'V' in Tory's vocabulary, the U/V distinction still unmarked in this era) and therefore he 'embraces him with his tail from below.'[2] Finally, Tory was a repository of certain classical

Geoffrey Tory's Pythagorean 'Y',
Champfleury, 1529

traditions in new Renaissance form: the symbol of the 'Y' long associated with Pythagoreanism, appeared in two forms in Tory's work. In both cases the symbolic opposition of good and evil, virtue versus temptation, were visually projected onto the letter – at first emblematically through a set of symbols tied to the branches of the letter, making it into an emblematic image, and in the other case by using it as the basis of a visual narrative. Tory's collection of information on letters did not end here; in the final section of the *Champfleury* he published various alphabets: a set of letters used for Papal documents, a utopian alphabet he attributed to Thomas More and Chaldean, Persian and Greek letters among others. Compendia including the fantastic and the historical systems on equal terms featured in the works of both earlier and later historians, though Tory's visual presentation was more elegant than most.

165

Geoffrey Tory, Pontifical capitals, *Champfleury*, 1529 (Edward I. Strange, *A Manual of Lettering*, London, 1898)

Decorative initial used in printing from Hans Holbein's *Dance of Death* designs

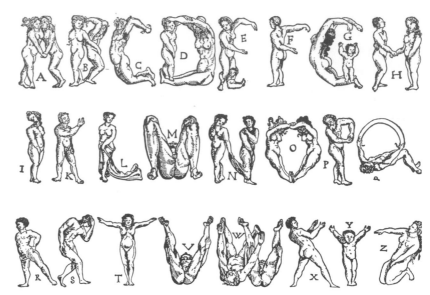

Alphabet of nude figures, Martin Weygel, Munich, 1560

Italian woodcut initial used in printing, by Paulini, 1570

Though the conviction that rational design was the best design would persist, especially in France, well into the 18th century and serve as a conspicuous influence on the development of the so-called modern typefaces of Bodoni, Grandjean, Le Bé and others, Giovanni Cresci, who served as the official Vatican scribe between 1566 and 1572, rejected the myth of the circle and square, straight edge and compass, as the basic elements and instruments of letter design. Cresci had a sensitive eye, and his observation of the inscribed forms on the Roman monuments around him led to a far more nuanced production than that of his more rigorously theory-bound predecessors in the field of letter design. Though less mystical and cosmological than Tory's work, Cresci's subtle combination of hand and eye with systematic method seems, in retrospect, more fully humanistic than the earlier application of systematic rationalization to the alphabet.

Penmanship: Writing Masters and Manuals

Woodcut initial used in printing, Italian, early 16th century

While printing became the prevalent method by which books were produced by the end of the 15th century, the documents used in business, legal and financial transactions continued to be handwritten. The historian of calligraphy Donald Anderson has noted that as the medieval scribe disappeared, the writing master and manual of penmanship emerged as if to fill the void.[3] While the letters of the alphabet were not accorded symbolic value within these written displays of virtuoso skill, these documents occupied a distinct social niche by virtue of their visual form. The first writing manuals (as opposed to pattern books or specimen sheets) were published in the early 16th century, with Ludovico Vicentino degli Arrighi's work of 1522 quickly followed by that of Giovannantonio Tagliente in 1524 and Giovambattista Palatino in 1540. These three are

Woodcut initial used in printing, Lucas Kilian, *ABC Buchlein*, 1632 edition engraved by Regina Hertlerin

Theodor de Bry, 1595, Woodcut Initials with Adam and Eve motif in the 'A' and Tetragrammaton in the 'B'

considered the great penmen of the Renaissance and each is associated with a distinctly individual style of chancery cursive hand, but distinguished writing masters emerged throughout Europe in the 16th century: Juan d'Yciar in Spain, Johann Neudorffer and Wolfgang Fugger in Germany, Daniel Smith in England, among others, and each was renowned for particular stylistic features.

One of the most articulate paeans to the virtue of scribal activity was producéd at the dawn of the 16th century by Johannes Trithemius. A Benedictine monk, Trithemius defended manuscript production in his work *In Praise of Scribes*, arguing that parchment lasted longer than paper, that copied works looked better than printed ones, that copying was both educational and uplifting to the spirit, and that printing had in no way displaced the need for such individual productions. He himself wrote a clear humanistic hand and made copies of many manuscripts as well as acquiring a significant collection for his monastery. But he permitted his works, including *In Praise of Scribes*, to be printed arguing that they thus reached a wider audience.

To advertise their skills, writing masters published their works, first through the laborious process of wood engraving. The complex flourishes and the grace of regular rhythmic design had to be translated into a rigid wood form which copied the writing master's model. The success of these productions bespeaks the technical skill of engravers of the 16th century, but the task of publication was further aided by the invention of intaglio printing around 1570. The use of a burin, or sharp carving tool, to inscribe the surface of a metal plate was well suited to the reproduction of elaborate curves and decorative forms. In many cases, these published works bear the names of both the printer and the engraver, testimony to the part played by both in the production. The best of the work of these writing masters was in turn incorporated into designs of type, as in the case of Arrighi and Palatino and the types which bear their names. The use of these master works for design also carried over into initial letters, with the work of Juan d'Yciar, for instance, repeatedly translated from drawn form to carved blocks for reproduction. The designs of decorated letters proliferated in the Renaissance, mainly for use in the printing industry, but often derived from the complex drawings of artists. Hans Holbein's initial capitals in the *Dance of Death*, with their explicit depictions of elements of this narrative, are one example of such production. Holbein's letters, like those of many other famous designs, were recut and reproduced in many editions with varying degrees of accuracy and precision.

Manuals by distinguished writing masters served to publicize their work, to guarantee their reputations, and as the basis of exercises for students of the art who continue to copy the models of Palatino, Arrighi, Tagliente and others up to the present day. Such works as *A Booke Containing Divers Sortes of Hands* (1570) by John Baildon and John de Beauchesne, the first writing manual published in England, or Daniel

167

Palatino's first published book
on penmanship, *Libro Nuovo*,
1540

Italian mercantile hand from
Palatino's *Libro Nuovo*, 1540

168

Smith's *Copybook* (1651) from almost a century later, were straightforward compendia of script styles with only modest amounts of decorative display. Styles in writing changed with styles in other visual and decorative arts however, and the regular, rhythm of chancery hands which predominated in the 15th and 16th centuries gave way to the play of 'contradictory movements' in the Mannerist period.[4]

By the 18th century, the work of writing masters was so elaborately decorative that its main motivation seemed to be to indulge in complex demonstrations of dazzling and almost illegible skill. Many historians consider this the period of decay, rather than the supreme achievement, of the writing masters, whose technical abilities combined with the achievements of the engravers to render their work mechanical and inhuman rather than the epitome of sensitive touch which some considered the basis of calligraphic perfection. On the more mundane level, however, the most practical of manuals still served as the source and standard for legible hands considered essential for business and legal transactions. Thus, into the 18th century, a work like Richard Ware's *The Young Clerk's Assistant* (1733) displayed its modest goals in its title as well as in its models of basic scripts.

Juan d'Yciar, riband letter
design (Henry Shaw, *Alphabets*)

Juan d'Yciar woodcut letter
designs (Henry Shaw, *Alphabets*)

Jean de Beauchesne and John
Baildon, *A Booke Containing
Divers Sortes of Hands*, 1571

R. Gething, *Calligraphotechnica*,
1619

169

Flourish capitals typical of late
Renaissance German penman-
ship

170

Christopher Weyle, German,
early 18th century virtuoso pen-
manship (redrawn by Shaw)

Renaissance scribe at work, (*Les
Plus Beaux Types des Lettres*,
Paris)

Cryptography: the Swift Secret Messenger

Cryptographic methods had been well known since antiquity. A process of letter substitution attributed to Caesar was the most common form of message coding practiced before the Renaissance. Invented symbols and strange corrupt forms of foreign alphabets had also been used in medieval codes, mainly in the practice of secret diplomacy. A number of esoteric alphabets were even considered the invention of Charlemagne, though the scholarship which supports this supposition is hardly substantial enough to contradict the fact of his illiteracy. In the 13th century, Roger Bacon had included suggestions for no less than seven methods of producing secret writing in his works, such as using letters from long dead languages, invented characters and signs to make clandestine codes. But in the Renaissance cryptography received a major impetus from the work of Johannes Trithemius whose publications provided the foundation for proliferation of cryptographic works through the next two centuries.

Secret alphabet attributed to
Charlemagne

Alphabetum frontale.

	A	B	C	D	E	F	G	H	I	K	L	M	N	O	P	Q	R	S	T	V	X	Y	Z	W
A	1	2	3	4	5	6	7	8	9	10	11	12	13	14	15	16	17	18	19	20	21	22	23	24
B	2	3	4	5	6	7	8	9	10	11	12	13	14	15	16	17	18	19	20	21	22	23	24	1
C	3	4	5	6	7	8	9	10	11	12	13	14	15	16	17	18	19	20	21	22	23	24	1	2
D	4	5	6	7	8	9	10	11	12	13	14	15	16	17	18	19	20	21	22	23	24	1	2	3
E	5	6	7	8	9	10	11	12	13	14	15	16	17	18	19	20	21	22	23	24	1	2	3	4
F	6	7	8	9	10	11	12	13	14	15	16	17	18	19	20	21	22	23	24	1	2	3	4	5
G	7	8	9	10	11	12	13	14	15	16	17	18	19	20	21	22	23	24	1	2	3	4	5	6
H	8	9	10	11	12	13	14	15	16	17	18	19	20	21	22	23	24	1	2	3	4	5	6	7
I	9	10	11	12	13	14	15	16	17	18	19	20	21	22	23	24	1	2	3	4	5	6	7	8
K	10	11	12	13	14	15	16	17	18	19	20	21	22	23	24	1	2	3	4	5	6	7	8	9
L	11	12	13	14	15	16	17	18	19	20	21	22	23	24	1	2	3	4	5	6	7	8	9	10
M	12	13	14	15	16	17	18	19	20	21	22	23	24	1	2	3	4	5	6	7	8	9	10	11
N	13	14	15	16	17	18	19	20	21	22	23	24	1	2	3	4	5	6	7	8	9	10	11	12
O	14	15	16	17	18	19	20	21	22	23	24	1	2	3	4	5	6	7	8	9	10	11	12	13
P	15	16	17	18	19	20	21	22	23	24	1	2	3	4	5	6	7	8	9	10	11	12	13	14
Q	16	17	18	19	20	21	22	23	24	1	2	3	4	5	6	7	8	9	10	11	12	13	14	15
R	17	18	19	20	21	22	23	24	1	2	3	4	5	6	7	8	9	10	11	12	13	14	15	16
S	18	19	20	21	22	23	24	1	2	3	4	5	6	7	8	9	10	11	12	13	14	15	16	17
T	19	20	21	22	23	24	1	2	3	4	5	6	7	8	9	10	11	12	13	14	15	16	17	18
V	20	21	22	23	24	1	2	3	4	5	6	7	8	9	10	11	12	13	14	15	16	17	18	19
X	21	22	23	24	1	2	3	4	5	6	7	8	9	10	11	12	13	14	15	16	17	18	19	20
Y	22	23	24	1	2	3	4	5	6	7	8	9	10	11	12	13	14	15	16	17	18	19	20	21
Z	23	24	1	2	3	4	5	6	7	8	9	10	11	12	13	14	15	16	17	18	19	20	21	22
W	24	1	2	3	4	5	6	7	8	9	10	11	12	13	14	15	16	17	18	19	20	21	22	23

Alphabetum laterale.

171

Grid used to produce alphabetic
code, Trithemius's version,
Steganographia, 1499 (1721
edition, Nuremberg)

168 *STEGANOGRAPHIÆ*

Cum has vel quaslibet alias acceperit literas princeps aut alter, cui mittuntur, in arte peritus figno Dorothielis cognito fe vertat ad Chorum (ubi ipfe fpiritus cum ducibus & fervitoribus fuis moratur) faciens omnia & fingula quæ ars ipfa requirit. Deinde fpiritum voce fubmiffa facilè vocet ut novit.

Conjuratio 2.

Dorothiel onear chameron vlyfeor madufyn peony oriel nayr drufe mouayr Pamerfon etro dumefon da-voricaho. Casmiel hayrno fabelronthon.

Clavis & Senfus.

oNeArVlYfEoRpEoNyNaYrMoVaYrEtRoDaVo RiCaHoHaYrNo. *Senfus.* Na vieren nim vier durch hin.

Completo carmine ifto fi moram fecerit fpiritus in veniendo; iterum legat usque tertio : & fine omni dubio vifibilis apparebit,& re-velabit ad aurem commiffa.

Tenor arcani.

Ich biden uwer Gnade wolle mime Bruder Jacob das Altar geben.

172

While no systematic study of the relations between diplomacy, cryptography and specific political circumstances exists, there is sufficient evidence to suggest that the major role of secret writing was in the realm of struggles over power, military manoevers or behind the scenes political intrigues and conspiracies.[5] These works have a very different aim and sensibility from those of the alchemical texts which used ciphers to protect arcane knowledge from the vulgar and uninitiated. The cryptographic texts universally function as guides to the production and use of secret writing, though, as in the case of Trithemius's work, they are sometimes so coded themselves that they require unravelling before providing useful tools for the novice.

Trithemius's major works on cryptography were the peculiar and much misunderstood *Steganographia*, which first appeared in print in 1499, and *Polygraphia*, a more straightforward manual published in 1506. In the first work Trithemius stated that messages to be transmitted secretly could be carried by spirits which had themselves to be called upon by means of unintelligible conjurations. He then provided an exhaustive record of the various spells to be used to bring forth spirits – who had names which resembled those of the Hebrew angels. One such phrase read: 'Parmersiel Anoyr Madrisel Ebrasothean Abrulges Itrasbiel Nadres Ormenu Itules Rablon Hamorphiel.' These invocations are themselves in code: taking every other letter results in the production of a German phrase instructing the reader to 'take the first letter of every word.' This process was then to be applied to the sentences which followed to reveal the substantive message. The messages Trithemius used for his examples were generally suited to military situations and involve calls to arms, assignations for flight and struggle.

Scriptum iam superiori exemplo literarum numerum in quartam partem deducemus hoc modo: erunt ergo triginta characteres.

Addimus praeterea etiam his posse singulis sex literas praefigurari, vltra praedictis quatuor addere duo.

Primas has figurando, postea praedictas hoc modo.

Giambattistai Porta, *De furtivis literarum*, 1563

173

Thus the many 'angels' invoked in *Steganographia* were in fact messengers, but in the metaphoric sense that the spells for their conjuration were keys containing prescriptions of different codes. Trithemius's formulas involved such sophisticated patterns of substitution – some required a continual mutation of the coding process so that the reader was to 'take' the letters in varying patterns and sequences – that his prescriptions were considered the bases even for modern cipher work. His language however was

completely obfuscating, and the phrases invoking spirits led to his being accused of conjuring and trafficking with demons. Somewhat chastened by harsh criticism, Trithemius's *Polygraphia* presented the procedures for coding in less arcane language, but his image as a conjurer persisted for generations.[6] Many of his contemporaries actually refused to read *Steganographia* for fear of its maleficent influence and copies of the book were burnt by church officials leading the Spanish inquisition.

Cipher disk attributed to Giambattista Porta, late 16th century

John Wilkins's 'double' alphabets, a code distinguished by using two types of letters in the same message; *The Secret and Swift Messenger*, 1642

The Secret and Swift Messenger. 37

Aa. Bb. Cc. Dd. Ee. Ff. gg. ʃ h Ji. Kk. Ll. Mm. Nn. Oo. Pp. qq. Rr. Sʃs. Tt. Vuv. Ww. Xx. Yy. Zz.

the second Alphabet.

Aa. Bb. Cc. Dd. Ee. ff. Gg. Hk Ji. Kk. Ll. Mm. Xn. Oo. Pp. Qg. Rr. Sʃs. Tʒ. Vuv. Ww. Xx. Yy. Zz.

Other cryptographers were more visually imaginative than Trithemius, who limited himself to alphabetic substitutions, though not more sophisticated in the actual mechanics of code production. Of the many texts produced on cryptography in the 16th and 17th centuries, those of Giambattista della Porta and Gustavus Selenus are among the most renowned. Porta's publication of 1563, *De furtivis literarum notis vulgo zypheris libri quinque* (*Five Books on Secret Letter Signs – in the Vernacular, Ciphers*) contained several novel innovations. Among these were ciphers which substituted an arbitrary but systematic set of symbols for the letters of the alphabet. Messages produced in this code had the bizarre form of unknown writing, and obviously the recipient had to have the key to the code to facilitate decipherment. *De furtivis* also contained codes made by a process of dislocating the letters in a message from their linear sequence, so that the spatial attributes of a grid participated in the code, sometimes through such elaborate distributions that both encipherment and decipherment were fraught with errors even in Porta's examples. Porta made use of other inventions, among them a cipher disk whose rotating wheels could be used to determine the substitutions of letters or for efficient deciphering. *Cryptomenytices et Cryptographiae* published in

1624 by Selenus (pen name of Duke August of Braunschweig and Lunenberg) presented a summary of knowledge on cryptography based on the holdings in the Duke's own extensive collection. Porta and Selenus acknowledged their debt to Trithemius as did Blaise de Vigenere, author of *Traicté des Chiffres* (1586), John Wilkins in *Mercury: the Swift and Secret Messenger* (1642), and Gaspar Schott in *Schola steganographica* (1655).

While these works all contained various prescriptions for codes or ciphers, none surpassed Trithemius in his fundamental grasp of the conceptual basis of cryptography. Descriptive imagination was not lacking, however: Schott suggested that images and messages could be carried in the air in the same way images are carried in a mirror; these in turn could be impressed on a recipient within a 24 hour period, after which they would, presumably, fade. These later scholars were not without insight into Trithemius's limitations. Schott criticized one of his predecessor's schemes which proposed the use of two magnetized needles, each within a circular frame with the alphabet on its rim, whose movements could supposedly be coordinated with each other across a physical distance so that a message spelled on one could be read in the movements of the other. Schott pointed out that this procedure would never work in actuality since the magnets could not be linked in this way.

The works of these authors often combined their cryptographic studies with other aspects of the function or history of written language. Trithemius, for instance, included a brief history of written forms in his *Polygraphia*, tracing its invention from the age of Mercury and reproducing supposedly secret alphabets attributed to the Normans, ancient Franks and a monk, Otfrid, of Weissenberg.[7] Many proposals for schemes of cryptographic writing hardly, if ever, led to production of actual documents.

Wilkins, for instance, suggested using the musical notes and staff lines as an alphabetic code and laid out the particulars in his work, but no instance of its use has ever surfaced in written form. Wilkins was particularly thorough as well as inventive: he anthologized instances of the use of smoke signals, sign language and cryptograms using string, knots, sticks and even geometric figures whose coordinates could be mapped onto an alphabetic grid to produce sense. Published in 1641, Wilkins's ideas and suggestions seem to have been pressed into actual service in the secret communications used in diplomatic circles during Oliver Cromwell's political struggles.[8]

Perhaps the most interesting aspect of the Renaissance fascination with cryptography was not the novelty of inventions for ciphers or codes but the realization that language was susceptible to abstract manipulation as information. While the earliest codes were, in point of fact, *literal*, that is, they made use of a transposition and exchange of letters, later systems of code began to evolve an epistemological structure in which the relations between human knowledge and language were explored. In the work of

175

By Mathematical Figures.

By Points, Lines, and Figures mixed together.

Method of translating alphabetic sequence into points as the basis of diagrams in code; John Wilkins, *The Secret and Swift Messenger*, 1642

Wilkins, the realm of cryptographic studies verged on the linguistic investigation which in turn inspired the production of several schemes for a universal language.

All of these involved codes in the transformation of linguistic information into a schematic structure, but the enterprise was conceived on starkly different intellectual premises than were the cryptographic methods used to construct secret messages.

Common Writing, Real Character, and the Arca Glottotactica

Attitudes towards language evolved in the Renaissance from the conviction that language could be analysed for its perfection, as evidence of divine inspiration, to a realization that languages were embedded in human history, were inconsistent, imperfect, and subject to change. The boundaries of cultural experience expanded with increased exploration and trade increasing exposure to an array of foreign languages which appeared exotic to Europeans whose own languages were put into perspective by contrast. The universal language schemes which emerged in this period, particularly in the 17th century, were motivated by one or more of the following desires: to recover the lost perfection assumed to be embodied in the original language spoken by Adam; to find a system of polyglot translation capable of breaking down the barriers between peoples which were embodied in linguistic differences; and to construct a system in which linguistic categories would designate logical categories in a more perfect relation of language and knowledge. It was written language, rather than spoken language, which lent itself to these proposals, in part because the concrete quality of its visual form lent itself to more ready manipulation within descriptive systems.

Of these many systems, the simplest were the proposals for translation systems, which were basically mechanical means to provide a universal lexical key. Alexander Top's *The Olive Leaf*, first published in 1603, was the one of the first of such suggestions for a 'Universall Alphabet.' Top's book contains an exhortation to his readers to recall that the one and only original alphabet, invented by God, consisted of the twenty-two uncorrupted letters of the Hebrew tongue. All diverse written languages therefore had one source and could, through Top's analysis, be linked to each other in a universally readable code. The full title of Top's work was *The Olive Leaf or Universall Alphabet: Wherein is set forth the Creation, Descent, and Authoritie of Letters – together with the Estimation, Profit, Affirmation or Declination of Them for the familiar use of all students, teachers and learners of what Chirography soever most necessary.* The peculiarity of Top's work was that he resolved to translate one language into another by means of a chart of letters, without regard for vocabulary or syntax. But as every letter was believed to imprint some aspect of the Lord's creation, it was important to return the diversity of tongues to their

original unity by demonstrating the similarity of letters in all alphabets.

While Top's proposal was not workable as a means of translation it contained certain elements which featured in early proposals for a universal language. Among these was the conviction that there had been an original language which had been confused and multiplied at Babel. It was believed that if recovered this single tongue would be found to have been based on a *natural* relation between words and things. The notion of a book of the world in which elements were letters to be read as God's work became one of the prevailing metaphors by which this concept was represented, though in the course of the 17th century, the mystical and cosmological tendency became distinguished from philosophical and theological discussions. There were two aspects of these assertions about an original language: that in its original form writing could represent knowledge in a natural relation between word and thing and that language could embody knowledge directly. In such a proposition, language is presumed to be capable of containing its own referents, or of being meaningful directly rather than serving as a sign to represent something.

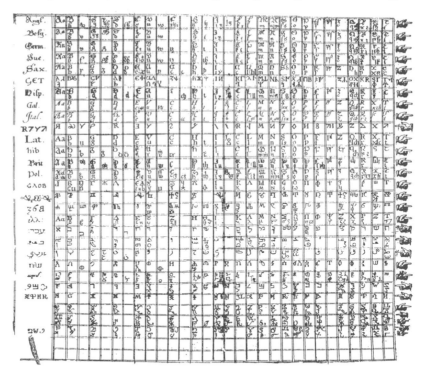

Alexander Top, *The Olive Leaf*, 1603

177

The concept of a natural language led Renaissance scholars to a search for a set of visual signs which would serve to embody the system of human knowledge (conceived of as the apprehension of a divine order) and also into attempts to produce a universal language which would transcend the limitations of existing languages. These limitations were that existing languages could be understood only by trained or native speakers, rather than apprehended directly by any individual, and they were all highly

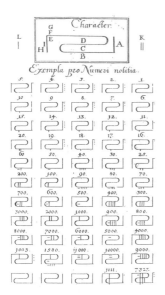

Johannes Becher, *Pro Notitia Linguarum Universali*, 1661

imperfect with respect to embodying the structure of knowledge. Most of the authors of these schemes from Top to Wilkins to Dalgarno contained an exhortation to put into place a single language that would help to resolve international conflicts. This unifying sensibility contrasted sharply with the emergence of strong nationalistic identities in the 18th century.

The various projects which arose from these several observations were not always clearly differentiated from each other – or from the various efforts to recover the original language. But almost all of the schemes for a philosophical or universal language contained a proposal for a new writing. These writing schemes varied in accord with the conceptual premises they were invented to facilitate, but the thread which united them came from the Renaissance fascination with hieroglyphics and the deeply rooted misconception that these written forms could 'signify directly to the eye.'

The force of this hieroglyphic imagination was intensified by the conviction that knowledge could be schematized in a single philosophical system. The attempts to realize such a system culminated in the work of George Dalgarno and John Wilkins in the 1660s. Their work represented a clear break with the systems of Aristotelian scholasticism. This change had originated in large part from the impetus of Petrus Ramus (1515-1572), who rejected the rigid teaching techniques and fixed categorization of forms which had characterized medieval pedagogy and philosophy and replaced them with a descriptive structure determined from observation. The work of Ramus, along with the work of Francis Bacon, heralded the onset of the empirical method on which modern science is based. Strains of Hermetic philosophy and Neo-Platonic thought still interwove their arcane symbology through these universalizing systems, and the representation of knowledge in the form of complex visual emblems or signs often combined the Renaissance fascination with what was considered ancient wisdom and a rational structure for the presentation of universal knowledge.

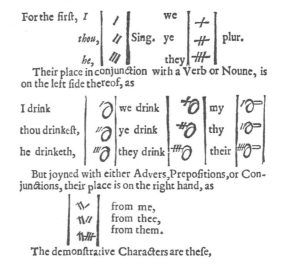

178

(31)

Here under follow all the Radical Characters of Verbs and Nounes, made use of in this Work.

Ƹ	to be
ℬ	to make
Ϩ	to ſpeake
Ƭ	to driɴke
ℓ	to love
Ƙ	to kleanſe
Ƙ	to come
Ʊ	to begin
Ϲ	to create
Ƅ	to light
Ƅ	to ſhine
Ɗ	to live
℗	to darkeɴ
Ɯ	tocomprehend
Ƨ	to ſend
Ƥ	to ɴame

THE END.

Francis Lodwick, *A Common Writing*, 1647

An early discussion of the possible basis on which a universal language could be constructed emerged in an exchange of correspondence between the philosopher and mathematician, René Descartes and the mechanist Marin Mersenne in the 1630s. Mersenne's publication of *Harmonie Universelle* (1636) contained a proposition: 'To determine if the sounds of the voice can have a relation to things signified such that one may form a universal language.' Working from the idea that if the letters could signify naturally, that is, without relying on conventions, then meaning would be immediately apparent, Mersenne went on to say that there were in fact certain meanings inherent in letters. By letters Mersenne meant sounds: thus the 'a' and 'o' indicated things which were large and broad, the 'e' was a sign of subtlety and sadness, the 'i' signalled elements which were small and penetrating, like rain, the 'u' things which were obscure and hidden, the 'm' was associated with whatever was great (as in *monstrous* and *magnum*), the 'f' indicated *fire* and *wind*, as did 's' and 'x,' while 'l' was liquid and humble, 'n' negative and hidden and so forth. Clearly this is all associative and suggestive, but Mersenne proposed that such assessments might provide the basis of an abstract algebraic language. In his response to these propositions, Descartes suggested that a language merely based on elemental units (letters or sounds) would not suffice since these were obviously impure and unsystematic. Instead, he proposed a reduced and simple grammar which could be rendered in numbers, the basis of the numbers would be a universal dictionary in which each cipher would stand for a basic or 'primitive' term. There was a fundamental distinction between Mersenne's system of inherent values and Descartes' concept of an abstract system of values translated into a symbolic code governed by mathematical or other rule-bound conventions. Descartes' desire for a system of correspondences and calculations was actually related to Raymond Llull's earlier concept of a combinatory art, and the philosopher Gottfried Leibniz combined these two sources in his *De Arte Combinatoria*, published in 1666. The distinguishing feature of these systems was their abstraction: language was transformed into logical relations, words into numerical values, and the substance or meaning of language into quantifiable terms. While the mathematical sophistication of these systems permitted them to function as the basis of logical science, the structure of the key or lexicon contained the more substantive information about the concept of the structure of knowledge. The conception of the universal language, however, had already evolved from one which was literal and elemental to one which took into account an overall system and rule-bound relations.

Another persistent strain, however, was the simple conceit of inventing a notation system which corresponded to a polyglot dictionary, generally including the common vernacular languages of Europe (English, German, French, Italian, Spanish, plus Latin and sometimes others). This was used as the basis of two elaborately titled works: Francis Lodwick's *A Common Writing Whereby Two, Although Not Understanding One the Other's*

Language, Yet by the Helpe thereof may Communicate their Minds One to Another (1647) and Cave Beck's *The Universal Character, By which all the Nations in the World may Understand One Another's Conceptions, Reading out of the Common Writing Their Own Mother Tongue* (1657). The idea of a 'common writing' was simply that of a code into which vocabulary could be translated so that *mother/madre/mater/mère/mutter* were all given the same numerical value. One might readily 'translate' through such a system on a word by word basis, a primitive approach to language grounded an assumption that words were elements of meaning independent of syntax or idiomatic subtlety. The forms of the 'common writing' attempted to use a very simple visual code. In another such system designed by the chemist Johannes Becher, for instance, the addition of a line, dot, or hooked curve modified the basic term with respect to gender, number, person, tense, voice or other grammatical category, depending on where it was placed (above, below, left or right and so forth). Beck used existing letters and numbers recombined according to his lexical code (nouns were represented by the letters 'p' 'q' 'r' and 'x' while the infinitives of verbs were represented by numbers, with tenses indicated by other letters). All of these systems required either prolific photographic memory on the part of the user or depended on the availability of the handbook as perpetual guide – certainly guaranteeing a market for author's publication should the system catch the public imagination.

Another version of these lexicon based system was Athanasius Kircher's *Polygraphia Nova et Universalis* published in 1663. Kircher's system included one unique feature, his *Arca Glottotactica*, which functioned as a primitive computer for the processing of linguistic information in coded form. Kircher was the great polymath of the Renaissance, though his conceptual frame of reference was much grounded in late medieval thinking. A powerful leader in the Jesuit community in Rome, Kircher had travelled extensively and had published significant tomes across the full spectrum of human knowledge. His works included studies of the structure of the subterranean world of underground rivers, volcanic lava flow and caves, an exhaustive text on all extant devices for producing light, illuminations and projected images, vast compendia of information on China, Egypt and every conceivable area of science, history and culture. Among these works the *Polygraphia* is an almost inconsequential contribution, and certainly it had none of the widespread influence of his *China Illustrata* or *Oedipus Aegyptiacus*, works which were cited by historians of language and writing well into the 19th century. In many ways Kircher was a collector rather than a conceptual thinker, his works were more frequently exhaustive amalgamations of information than the bases for a new episteme or theoretical model of thought. He had the advantage of great resources and tremendous intellectual reach, excellent printers and illustrators, who rendered the elaborate schemes he described with articulate and detailed clarity. Amid the pages of his works on Egypt was a table of alphabetic characters from ancient languages, including celestial

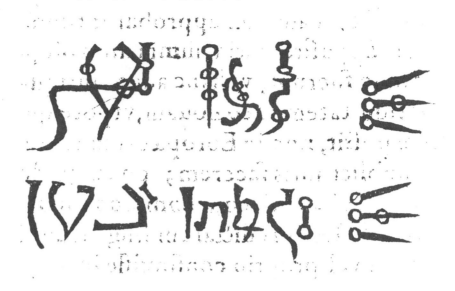

Inscriptionis Chaldaicæ antiquæ.

Da qui è il fine,
occupando le
lettere tutto il
doßo della pic-
tra.

Da qui è il
principio della
schiena della
pietra.

Typus inscri-
ptionis Si-
naicæ.

Hic incipit la-
pidis dorsum.

Hic finitur dor-
sum lapidis, &
litteræ totum
dorsum occu-
pant.

P. Thomæ Obecini Nouariensis authenticum huius
scripturæ testimonium.

Athanasius Kircher's Chaldean
letters and interpretation,
Oedipus Aegyptiacus, Rome,
1652

alphabets. He did a detailed analysis of a Chaldean inscription which he considered of antediluvian date, translating it into Hebrew then Syriac then Latin to arrive at the deciphered text: 'faciet concipere Virginem Deus' which he expanded to mean 'God will cause the Virgin to conceive, and thus the Son will be born.' The sheer volume of his work, even if he only served to supervise his Jesuit brethren in these productions, is overwhelming. Yet in the history of language Kircher has lost the primacy of place he occupied in his lifetime, the long shadow of his idiosyncratic theories on the decipherment of Egyptian hieroglyphics which lasted until the 19th century decipherments having been the most lasting aspect of his influence.

Modernus character Samaritanus.	Character Syriacus modernus.	Literæ Phœnicum.	Literæ Coptæ modernæ.	Græcæ modernæ.	Latinæ modernæ.	Literæ Arabicæ modernæ.
				A α	A a	
				B β	B b	
				Γ γ	G g	
				Δ δ	D d	
					H h	
					V u	
				z ζ	Z z	
				x χ	Ch	
				Θ θ	Th	
				I ι	I i	
				K κ	K k	
				Λ λ	L l	
				M μ	M m	
				N ν	N n	
				Σ σ	S s	
				Π ϖ π	P p	
				z ζ	L	
				K κ	Q q	
				P ϱ	R r	
				Σ σ	S ſ	
				T τ	T t	
VII	VIII	IX	X	XI	XII	XIII

Athanasius Kircher's compendium of alphabets, *Oedipus Aegyptiacus*, Rome, 1652

CLASS. II. GRAMMATICA. 105

Tabula, in qua ex probatiſſimis Authoribus, primæuorum charaƈterum formæ, & reliquorum omnium charaƈterum qui ab ijs originem ſumpſerunt ſucceſſiua temporum propagatione, exhibentur. Ex quibus apodiƈtice oſtenditur differentia vnius ab altero, omneſq́; neſcio quæ rudimenta primorum charaƈterum in ſe pſis continent; verum & vnicum originis ſuæ argumentum.

Interpretatio.	Character duplex mysticus ab Angelis traditus.	Character temp. tran. situs flum. R. Abr. Bal.	Characterum variæ formæ ex numis & Blancutio extractæ.	Floridus character post transitum fluminis quem & Hebreum siue Samaritanum diximus.	Character Mosaicus Legis ex inscript: & Rabbinorum monumentis.	Assyrius siue Esdræus.
A						א
B						ב
G						ג
D						ד
H						ה
V						ו
Z						ז
Ch						ח
T						ט
I						'
C						כך
L						ל
M						מם
N						נן
S						ס
Ngh						ע
P						פף
Tí						צץ
Qí						ק
R						ר
Sch						ש
Th						ת

I II III IV V VI

O 2 Mo-

Athanasius Kircher's compendium of alphabets, *Oedipus Aegyptiacus*, Rome, 1652

The mechanics of the *Arca Glottotactica* were relatively simple. The system proposed the use of physical structure 'whereby tablets various languages ought to be set in order for the purpose of composing letters.' Rather than relying on the usual lexicon in book form, Kircher's system permitted placement of markers in a physical place to indicate the use of a word or phrase. The wooden ark, sketched out in an illustrative plate, was divided into boxes, each of which corresponded to a particular category of terms used in correspondence, the *epistoliographia pentaglossa*. By using strips placed into the requisite boxes of the ark's grid (each identified by

an alphabet code), a message could be spelled out in any tongue through this distribution; the recipient of the message could 'read' it in retrieval by reversing the process, linking the box to the category in whatever language was native to the reader. While essentially a lexical system, the *Arca Glottotactica* was distinguished by its use of a physical structure to process the information in abstract form, and because the categories used to structure the ark were a primitive step towards organizing knowledge as abstract information, rather than by reducing the existing structures of language to a simplified form. While he claimed that 'The Box is valid for writing documents throughout the world,' the languages to which Kircher granted a place included only French, Italian, German, Spanish and Latin.

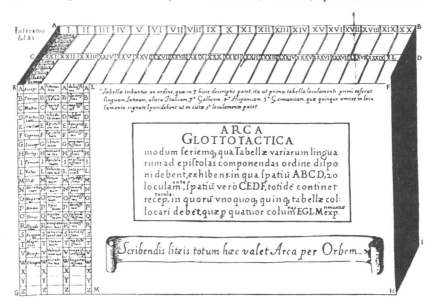

Athanasius Kircher's *Arca Glottotactica* from *Polygraphia Nova et Universalis*, Rome, 1663

Becher, Beck and even Kircher stopped short of making a thorough conceptual classification of knowledge as the basis of their polygraphic or common writing systems, but the proposals of John Wilkins and George Dalgarno each articulated a complete Aristotelian analysis as the basis of a new system which they termed a rational grammar or philosophical language. These writers made the most substantial contributions to universal language schemes in the 17th century synthesizing threads from diverse fields of intellectual investigation. They also made use of the medieval *ars combinatoria* of Raymond Llull, with its universalizing mechanical structures and combined these with Ramus insights into a method grounding human knowledge on empirical observation and the rational analysis of sign systems which prefigured John Locke's theory of knowledge.[9] These works therefore made a highly significant contribution to the development of the history of ideas, especially with respect to the theorization of relations between knowledge and representation.

Both Wilkins and Dalgarno succeeded in accomplishing the intellectual task of describing the world through a natural philosophy capable of

being outlined in a single comprehensive system. Dalgarno and Wilkins were well acquainted with each other and even worked collaboratively; the exhaustive tables which Wilkins eventually included in his *An Essay Towards a Real Character and Philosophical Language* (1668), had originally been composed to assist Dalgarno in designing his *Ars Signorum* (1659).[10] Both men were intent upon constructing a language system in which structure of knowledge (posed as the structure of the world itself) could be accurately represented. Two separate activities were required for this: first the systematic outlining of this structure and secondly a visual code for its representation. Wilkins in particular was fascinated with the possibility of a writing which communicated directly to the eye while Dalgarno was interested in constructing a language with a visual base to provide a means of communication for the deaf and dumb (which he published in 1680 under the title *Didascalocophus*).

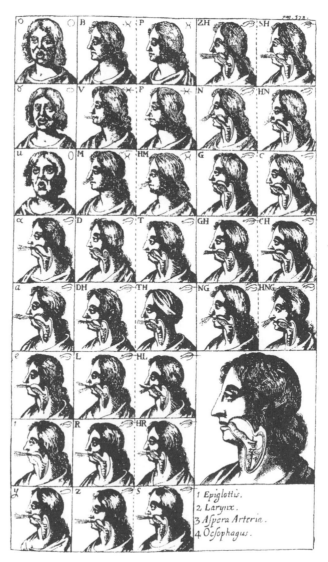

John Wilkins, *An Essay towards a Real Character and Philosophical Language*, London, 1668

The *Ars Signorum* began with an analysis of the art of signs, which Dalgarno termed *sematology*, a precursor to later semiotics. He proposed three categories of signs: the supernatural (such as the communications by God which use extraordinary means such as dreams or visions), the natural (expression of emotions by means of weeping, sighs or laughter) and the institutional or conventional (the use of images which have no relation to the things they represent). Alphabetical characters fell into this final category, and Dalgarno bemoaned the fact that no combination of such characters 'making up a word should have any affinity to or resemblance to the thing for which it is substituted.' He suggested that a 'real character, on the other hand, would teach much knowledge as it would be suited to the nature of things.' Dalgarno refused to construct such a character, adhering to a set of alphabetic codes to represent his categorical system. He even went so far as to criticize John Wilkins's attempts at a 'real character' as too far-reaching and ambitious for his purposes. By relying on existing letters, Dalgarno could reduce the entire of his schematic outline of knowledge to a set of notations: the letter 'M' for instance, was meant to indicate all geometric forms, with 'mab' standing for circle, 'mmb' for sphere, 'mib' for cube and so forth. Dalgarno even gave a hint of kabbalistic influence in his work as a justification for retaining the existing alphabet, stating that the letters acted as radical elements of a cosmic order. In keeping with this tradition, he assigned the consonants to represent the gross and material parts of human activity while the vowels were reserved for aspects of the soul.

Dalgarno's outline of the structure of universal knowledge was laid out in elaborate tables labelled the 'Grammatico-Philosophical Lexicon or Table of Things and of All Simple and General Concepts Both Artificial and Natural Including Reasons and More Common Aspects Arranged by a Practical Method.' These were the proof of his belief that it was possible to include 'every conceivable object, process, quality, state of being and idea'[11] and give it a place within a system which was itself the basis of a philosophical language. Equating language directly with knowledge was a major conceptual leap from the mechanical projects of either *ars combinatoria* or the common writing. In the process, language was made more scientifically rational and more spiritually perfect, encoding the divine structure of the universe within an epistemological system. In Dalgarno's hierarchy the seven fundamental categories (represented by the vowels) began with the highest possible abstraction, termed *Thing* or *Being* (i.e. God or the transcendent Divine Spirit) occupied the first place, with *Substance*, *Accident*, and *Concretion* as the next four categories; these were followed in turn by the material categories *Body* (without spirit), *Spirit* (without body) and *Composition* (the perfect combination of the two into the human being).

John Wilkins's *Essay* reiterates these ideas, and makes use of the same schematic outline of universal knowledge (of which, after all, he was apparently either full or part author). But Wilkins's unique contribution

was his invention of a real character, which he developed in part after his critique of all existing forms of writing. Displaying considerable acquaintance with the letters of the Hebrew, Arabic, Syriac, Illyrian, Georgian, Gothic, Aetheopic, Coptic and other alphabets, he dismissed all of them as inadequate to his purposes. He declared (and with good reason) that the letters were in confused order and did not express things directly, they were unsystematic in their correspondence between form and sound, and certainly did not encode a system of knowledge. While admitting that the alphabet may have been of divine origin, Wilkins indicated little interest in the project of recovering an original language or alphabet. In fact Wilkins asserted that language was arbitrary in its forms – a considerable break with the mystical traditions which considered language as the most fundamental Divine manifestation. Since it was arbitrary, Wilkins stated, all people should 'agree on the same expression as they agree on the same notion,' in a language comprehensible by all nations. The philosophical language would reflect that structure of the world in its own form, and the 'real' character was a written code in which each 'word' would be defined by its place in the overall system. Meaning and position in the hierarchy would be the same, and by reading the character, learning the language, one would be absorbing the universal structure of knowledge. There were several elements in this writing system: *radicals* and *distinctions*, or fundamental elements and their conditional modifications. The atomic and schematic nature of this language again removed it from vernacular traditions and idiomatic expression, rendering it a far more rational and philosophical system than one embedded in human exchange or lived circumstances, but also more perfect.

187

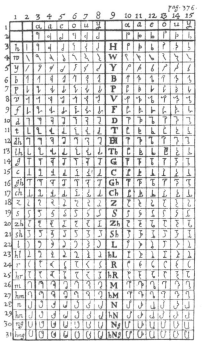

John Wilkins's *Visible Speech, An Essay towards a Real Character and Philosophical Language*, London, 1668

In the distinctions between the systems of Kircher, Wilkins and Dalgarno, there is an evident contrast between a schematic medieval hierarchicization and a rationalized system of philosophical analysis. With the publication of John Locke's *An Essay on Human Understanding* in 1679, philosophers shifted their investigations of language into an analysis of the mental activity of thought, and away from the relations between language and cosmic or universal order. The concept of the hieroglyphic (mistakenly and frequently linked historically and conceptually to Chinese characters) persisted for another century, though it had more influence on the composition and interpretation of visual forms, such as emblems and devices, than on the analysis of the alphabet. The idea of a universal language would recur, particularly in the late 19th and early 20th centuries as a possible solution to the nationalistic tendencies which inflamed world politics into war; but the philosophical aspects of their undertaking lapsed from favor.

Phonetics and Shorthand

Other interesting developments in writing in the Renaissance took place in the areas of phonetic notation and shorthand. Phonetic notation was linked to spelling reform, and with increasing realization of the discrepancies between the letters of the Latin alphabet and the sounds of, in particular, the English language, the impetus toward reform gained momentum. Phonetic notation was more clearly the domain of the specialist, while projects for a changed spelling were frequently proposed by frustrated pedagogues at their wits end with the difficulties of teaching illogical orthography. These difficulties increased as vernacular languages evolved; by the 19th century there was hardly a nation in Europe or America not beset with such problems or plagued by proposals for their resolution. Certain minor reforms eventually crept into modern languages, though few nations adopted the radical changes which characterized the transformation of old Russian to new in the early 20th century. But the beginnings of these reform projects was in the 16th century, when one John Hart published *A Methode or Comfortable Beginning* (1569). Hart went to the trouble and expense of having new printing types cut to fit his proposed method with the goal of reducing the duplicate symbols for similar sounds and inventing suitable ones for the sounds not adequately represented. A host of other such proposals were published in England in the 16th century including Thomas Smith's *De Recta et Emmendata* (1568) and William Bullokar's *Short Introduction or Guiding* (1580), but none had the visual inventiveness of Hart's. In general, the suggestions for new symbols were modest, often depending on letters modified by an additional strike through with a line, or other change readily achieved within the existing resources of the compositor's case.

John Hart's spelling reform proposal, *A Methode*, London, 1569

189

Spelling reform and suggestions for a changed orthography proceeded largely from an an assessment of the relations between the sounds of language and the signs for its notation: such methods analyze the acoustic aspects of language. Phonetic notation, on the other hand, tended to emphasize the articulatory process and was frequently initiated by an analysis of the organs of speech. Robert Robertson's 1617 publication *On Pronuntiation* is considered to be the first such analysis. Robertson

mapped the ten positions taken by the tongue in relation to the roof of the mouth, assigning a glyphic sign to each. These he used in turn in notation which had no dependent relation to the Latin alphabet and which functioned as a self-sufficient system. One of the more daring and remarkable propositions for reform came from the same John Wilkins who had invented the 'real character.' He proposed a form of 'visible language' which schematically mimicked the organs of speech in small glyphs. His analysis of articulation was published in a full visual chart which shows the sources of the glyphic forms he proposed for a notation system. While Wilkins's proposal was no more successful than that of his predecessors, the proposal for such a 'visible speech' would be another recurrent theme in later centuries.

Shorthand systems had not been much improved since the invention of Tironian notes. Though medieval manuscripts were filled with abbreviated messages, commentaries and notes, these were largely idiosyncratic inventions of an individual scribe. The transformation of shorthand into a systematic method of transcribing speech had the impetus of a varied clientele. On the one hand, shorthand had the appearance of a cryptographic method, which lent it a certain mystique and use value; on the other hand, because shorthand was in most cases an abbreviation of spoken language, it could be based on an analysis of orthographic peculiarities similar to those which motivated spelling reform. Later there were forms of shorthand which attempted to notate articulatory processes, mapping the activity pronunciation, but these proved to be too complicated to become popular, and the concept of an abbreviated orthography remained the most popular basis for shorthand systems.

Timothy Bright's *Characterie* (1588) is considered the first systematic shorthand method of the English Renaissance, and is was reputedly put into service in the court of Elizabeth I. A published proposal for shorthand writing appeared in 1628 with John Willis's *Art of Stenographie: Teaching the Way of Compendious Writing*. Willis had been the author of a treatise on the art of memory, and his shorthand extends mnemonic operations to writing. Basically Willis suggested a series of contractions in which the skeletal forms of words are made to serve for later recall of full speech. By eliminating the vowels, Willis felt he had arrived at an efficient means of speeding up the recording process, but the method was still far too slow to function as a real shorthand. Samuel Botley's *Maximo in Minimo* or *Mr. Jeremiah Rich's pens dexterity* (1674), had certain charming features: he used visual means to condense meaning: thus a script majuscule 'A' indicated an angel, while one tipped to the side indicated a fallen angel. A series of lowercase 'b's' was supposed to indicate brotherly kindness, while an arrow looped into a circle with a sharp inward turning point was to stand for 'the devil goeth about.' The limitations of such a system – that it would require a different visual sign for every word or concept – are as clear as are its sources of inspiration – the myth of the visual directness of Chinese characters and Egyptian hiero-

glyphs. Ultimately it would be the demands for recording in the areas of business and finance which provided the strongest support for a fully developed shorthand system, but that, also, would not happen for several centuries. In the interim, shorthand systems remained limited in form and in influence.

Occult Sciences and Mysticism

Mystical, occult and intellectual traditions were blended in the early Renaissance, but the writers whose conviction that divine mysteries were behind all knowledge perpetuated in a distinct metaphysical tradition. With Meric Casaubon's realization, published in 1615, that the Hermetic texts had been the product of the early Christian era, the basis for one major element of Renaissance mysticism was discredited as ancient (and thus irrefutable) wisdom. But the distinction between rational and mystical approaches to knowledge was more a matter of individual disposition than historical development, and inquiries into the value of the alphabet framed in terms of occult practices remained a flourishing intellectual practice into the 17th century. The combined strains of Hermetic, Neo-Pythagorean, Neo-Platonic and kabbalistic traditions blended in their own peculiar hybrids of thought. The activities of the Christian kabbalists was treated in the previous chapter, but the kabbalistic strain of mystical thought which engaged with the letters of the alphabet influenced writers who were not defined entirely as kabbalists. Several outstanding figures who were involved in a serious pursuit of occult knowledge in the Renaissance, Cornelius Agrippa von Nettesheim, John Dee, and Guillaume Postel, made unique contributions to alphabet history.

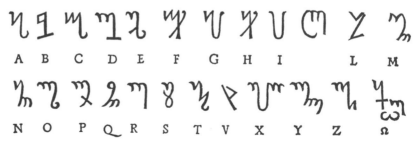

191

Alchemical alphabet from Cornelius Agrippa, *De Occulta Philosophia*, 1529

Heinrich Cornelius Agrippa von Nettesheim (1486–1535) was renowned for the exhaustive three volume work *De Occulta Philosophia* which he in fact wrote at the suggestion of Trithemius. It was published in 1529, nearly a decade after it had been written, and the same year as Geoffrey Tory's *Champfleury*. Agrippa's work was influenced by those 3rd- and 4th-century Neo-Platonic writers who had been most engaged with magical and supernatural beliefs: Iamblichus, Porphyry and Plotinus. Agrippa's thoroughness as an anthologizer was such that his work remains a major reference work on occult beliefs of the Renaissance and Middle

Ages. Agrippa considered his book to be a guide to practical magic (by contrast, for instance, to the work of the other significant occult anthologizer, Pico della Mirandola,who considered his work to be a handbook for mystical experience).

In the third volume of his work Agrippa cited several occult alphabets, all of which have been referred to and reproduced repeatedly by later historians. The first of these was a by now familiar form, a Celestial Alphabet, the second was the alphabet of Malachim (or 'royal' alphabet, from the Hebrew for the word king), the third was an alphabet known as 'Crossing the River' and finally there was an alphabet reputed to be of great antiquity, the Theban alphabet. This was supposedly recorded by one Petrus Apponus from the renegade pope Honorius, but in fact appears in later compendia of alchemical alphabets. Agrippa's Celestial Alphabet reappeared in the *Oedipus Aegyptiacus* of Athanasius Kircher, more than a hundred years later, where it was identified as an alphabet which had been transcribed from the angels, the same attribution which Agrippa granted to his *Scriptura Malachim*. The alphabet with the intriguing title 'Crossing the River' is similarly identified in Kircher, but also without explanation. While the visual forms of the Celestial alphabet bear some vague visual relation to the letters of Hebrew, the forms of the other three are visually peculiar. Agrippa presented them with Hebrew names, stating that they had all been revealed to the Jews in antiquity. In addition, Agrippa invoked the kabbalistic tradition presenting the letters in a grid of three lines. These he associated with the three classes assigned to the Hebrew letters: those belonging to the angels, to the heavens, and to the mundane world in descending order.

Guillaume Postel (1510–1581) made several contributions to alphabet history, including a literal description of the origins of the celestial alphabet in the map of the heavens. Postel was a visionary whose dreams of a world united under a single government and religion had led him into conflict with the entrenched forces of ruling monarchs, and he was saved from serious retribution only by his reputation as a visionary and scholar. Postel was well-versed in Hebrew and Arabic, and his concept of a celestial writing displays influences of both a kabbalistic sensibility and an older astrological tradition from the ancient Near East. The positions of the stars in the heavens were, he believed, not merely the source for the shapes of the original Hebrew letters, but were the eternal letters themselves in their cosmogenic form. The connection of the points of light visible in the night sky created a celestial writing which, Postel suggested, could be read. This notion combines the kabbalistic concept of the letters as eternal and essential with the more general notion of the world as 'book' of divine revelation which permeates Christian mysticism thoughout the Renaissance. Postel's celestial alphabet was, of course, not unique, but his articulation of it inserted the idea into mainstream French thought, and the idea was taken up by Jacques Gaffarel, the kabbalistic librarian of Cardinal Richelieu.

chim uel Melachim, hoc eſt angelorum ſiue regalem:& eſt ālia quā uocant
tranſitus fluuii,& horum omnium characteres & figuræ tales ſunt.

Scriptura Cœleſtis

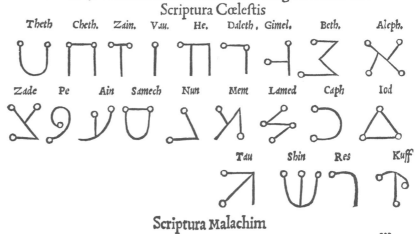

Scriptura Malachim

z iii

Angel alphabet; from Cornelius Agrippa, *De Occulta Philosophia*, 1529

CCLXXIIII. DE OCCVLTA PHILOSOPHIA.

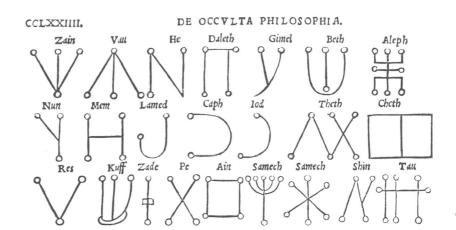

193

Alphabet of Kings; from Cornelius Agrippa, *De Occulta Philosophia*, 1529

Scriptura tranſitus fluuii.

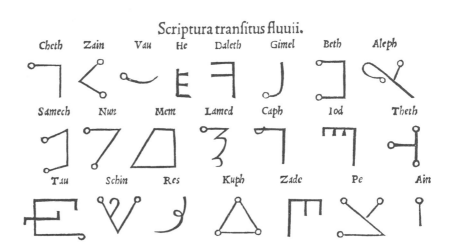

Alphabet of Crossing the River; from Cornelius Agrippa, *De Occulta Philosophia*, 1529

Postel was also the author of a theory supporting the proposition that the original settlers of Europe had been the Gallic people. He stated that it was Janus (or Nachus), the father of Japhet, who had brought the Phoenician characters to the West.[12] He suggested that these letters were later ruined by the Greeks, and that an Arcadian woman, Carmenta, had actually discovered the Latin letter forms. Postel held Cadmus responsible for 'butchering' the Phoenician characters so that they appeared to have been a Greek modification, thus losing all trace of their Gallic origins. Postel's themes, with their anti-classical and anti-Latin bias, were revived in the 18th-century theories linking the alphabet to natural origins.

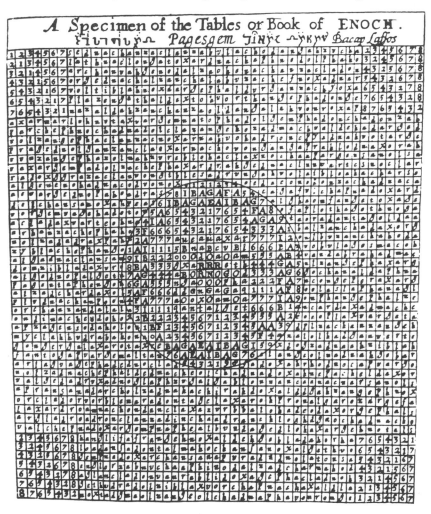

John Dee's Enochian table 1586

John Dee (1527–1608) originally achieved renown for his expertise in mathematics, and in the 1540s he lectured extensively on the principles of geometry – including Pythagorean symbolism. Again it is important to recall how blurred the boundaries of disciplines were in this period which later became distinct: Johannes Kepler's original formulation of the solar system was based on a model of five perfect Pythagorean forms. Dee

blended Neo-Platonist and kabbalistic ideas into his scholarly inquiries and was disposed to an occult interpretation of natural phenomena, serving at the end of his life as astrologer to James I of England. In 1581, he became involved in a series of experiments involving a device known as a scrying glass. He was assisted by Edward Kelly who functioned as a medium and read the shifting patterns of light and markings in the visionary glass, transforming his impressions into a stream of described images. Dee became convinced that these were direct communications from angels and he became intent on learning the angelic language, believing that it was the original language spoken before Babel.

In 1586, as part of these communications Dee felt that he had received a version of *Enoch his Book*, subtitled *48 Claves Angelicae (Angelic Keys)*. The Book of Enoch, one of the books of the Apocrypha,[13] was believed to contain the oldest accounts of creation. According to legend, Enoch had a vision in which the angel Metatron (the archangel of the Presence of God) said 'come and behold the letters by which Heaven and Earth were created, the letters by which were created rivers and seas, the letters by which were created the trees and herbs.'[14] This alphabet of creation was supposedly revealed in turn to Moses by Metatron, and the legend as told in Enoch continued with an account of original emerald tablets, engraved with sacred laws, which Moses destroyed in anger over the orgiastic rites of his people. The ten commandments, by contrast, were merely mundane laws necessary for controlling their behavior and written in ordinary Hebrew.

Dee's version of the alphabet was received by him letter by letter, and in reverse order, since its power was so great that it was supposedly destructive merely in transmission. The Enochian letters were also grouped into 'calls' or 'keys' and Dee later embedded these in a set of five squares or tablets, each associated with one of the primal elements (fire, air, earth, water) and a fifth element, aethyr. In a manner typical of occult practice, Dee made endless links through number symbolism, so that the four elements were linked to four castles of the alphabet, in turn linked to the four winds of Celtic legends, the four archangels (Michael, Raphael, Gabriel and Uriel) and so on. This Enochian invention seems to have been Dee's own contribution to alphabet history, since the book is referred to elsewhere as recording an original language, but never with any images or illustrations.

The prevailing and persistent theme of the world as the Book of Nature can be found in a wide range of sources in this period. For instance, in a work proposing a criticism of academic learning for its lack of spiritual content John Webster in his *Academiarum Examen* (1654) seriously discussed the possibility of restoring the Original Tongue. The aim of all learning, Webster asserted, should be to see the Godhead 'of which all the causes and effects of nature are characters or hieroglyphics of his power so legible that those who will not read them and by them him are without excuse.' The language of nature was the very 'protoplast of

195

Jacob Boehme, frontispiece from
Complete Theosophical Works,
Amsterdam, 1682

Adam,' since he was made in the original image of God's word. The curious collapse of Old Testament concepts and Christian belief in the Logos are typical of the synthetic tendencies of mystical Renaissance thought. In his further discussion Webster revealed his Neo-Platonist orientation in his description of the divine source of all being as a generative force. Describing the angelical or paradisical language he stated that it was 'brought to light by peripheral expansion and evolution of the serviceable word.' Going on he elaborated: 'The world is the great book, every creature a character living and speaking symbols, not dead letters.' Webster subscribed to the concept of Adamic language or naming, in which it was assumed that Adam had known this original language of Nature, and that the names he had given to the creatures and creations had corresponded precisely to their form and identity. While similar in its belief that there could be a right relation between name and thing, word and referent, which characterized the philosophical language of Wilkins, Webster and the mystics are differentiated by their belief in the power of revelation and transcendent approach to God, rather than the power of rational thought to apprehend divine order through scientific inquiry. While Wilkins was moving toward a rational belief in mental activity as the basis of human thought, communication, and representation, the mystics of the Renaissance functioned with the conviction that the Divine Essence could appear to the human mind through mediative exercise and devotional practice. Webster is only one of the many writers of the period to use this metaphor of the Book of Nature and the term *letters* as a term interchangeable with symbol, hieroglyph or emblem. Jacob Boehme was perhaps the best known and most prolific among these, his monumental *Mysterium Magnum* tracing out a detailed history of the process by which the tongues of human speech had become differentiated in the course of the diffusion of the descendants of Noah. This history would serve as the basis of many 18th-century historians' work, but as it appears in Boehme it has little in it specific to the alphabet.

Another German mystic involved in the theoretical investigation of the alphabet was Franciscus Mercurius (Baron) Van Helmont (1618–1695), who published a treatise titled *Alphabeti Vere* (1667). In this small text, Van Helmont, largely through means of a series of engraved plates, showed the precise correspondence between Hebrew letters, Chaldean originals and the articulatory organs of the mouth. In his work he proposed that the divine origin of the alphabet was thus demonstrated through these evident correlations and that the 'holiest script of the Hebrews' was based on 'resemblance to the motions of the human tongue.' For Helmont, these correspondences made Hebrew the most 'natural' kind of writing, by which he meant both the earliest and most original and also the most truthful form of the letters. If 'speech could be described in painting,' he asserted, that would best be achieved 'by the various motions and formations of the tongue itself.' Helmont was a mystic, not a linguist or phoneticist, and for him these conclusions had the

value of divine revelation by which he accorded the Hebrew letters and Chaldean alphabet (attributed to Abraham) great antiquity and sanctity.

The last great Renaissance figure to use mysticism as the basis of his scientific pursuits was Robert Fludd, the English medical and alchemical researcher. His major work was the unfinished but multi-volume *Utriusque cosmi … historia* or *The Technical Physical and Metaphysical History of the Macrocosm and Microcosm*, which was published between 1617 and 1621. Fludd firmly believed that alchemy held the key to understanding the structure of nature, and like Kircher his slightly later contemporary, caused beautifully detailed images of the schematic form of this knowledge to be drawn on copperplates engraved to accompany his text. The visual structure of these works provides an insight into the devices and conceptual mechanisms by which Fludd related various spheres of knowledge, and his use of kabbalistic imagery necessarily led him to make use of the alphabet as one of his cosmological ordering devices. The image titled *The Downward Spiral of Creation* is a clear diagram of Christian kabbalistic thought, with each domain of the universe demarcated to define its identity as a position in the whole, and associated with a letter from Alpha at the highest sphere to Tau at the center, the Earth and Humanity.

Baron Van Helmont, *Alphabeti Vere Naturalis Hebraici*, 1667

Fludd's enormous reputation and influence were compromised to some extent even in his own lifetime by his public apologies of Rosicrucianism. Published in 1616 and shortly thereafter, these were tracts written in defense of an organization which may not even have existed at the time.

The earliest published documents linked to the secret brotherhood appeared about this time, but they are generally considered specious invocations of a metaphorical rather than actual organization. Fludd's earnest belief in the existence of the order, to which he aspired no doubt on account of the difficulty in finding a receptive audience for his blend of alchemical and scientific agendas, led to his being ridiculed, though this did not interfere with either royal patronage or the publication of his major work. The Rosicrucians, when they actually came into being as a group in the early 18th century, remained committed to the perpetuation of kabbalistic and Hermetic doctrine in combination with a Christian religious conviction and thus were a major avenue for the transmission of the occult tradition into the 19th century, where it would again become a popular phenomenon.

VIII

THE SOCIAL CONTRACT, PRIMITIVISM, AND NATIONALISM: THE ALPHABET IN THE 18TH CENTURY

The spirit of rationalism which characterized the late, high Renaissance and manifested itself in the elaborate taxonomic structures of philosophical languages became more fully developed in the 18th century, moving away from a description of divine order and into debates between the scientific and theological bases for knowledge. In keeping with the general intellectual tenor of the period, theories of language and meaning production, particularly with respect to writing as a form of representation, became more closely bound to inquiries into the historical basis of society and the distinguishing characteristics of so-called civilized culture. The myths which had made the hieroglyphic the very essence of a symbolic form in the Renaissance began to crumble with the work of linguistically rather than mystically inclined scholars such as Nicolas Fréret and Abbé Barthélemy. Chinese characters and the purported antiquity of Chinese civilization maintained their mystique, with scholars struggling to reconcile the biblical account of a single creation with the existence of exotic cultures and language.

The terms *natural* and *primitive*, which appeared with regularity in the published inquiries into the origins of language, took on a new value in 18th-century European parlance. Writing was considered one of the distinguishing signs of civilization and the alphabet was accorded an active and significant role in maintaining the hierarchy of social orders. The analysis of the alphabet as a symbol engaged with debates about the production of linguistic meaning in which the concept of natural was idealized as original and pure, but coded in human terms. The term primitive was bound up with two ideas: the original condition of humankind and thus the original language, and with the characterization of this condition: either as crude, supposedly preceding the development of institutions which advanced humanity through reason, or as pure, innocent and unspoiled. Many debates on the origins of language had at their heart an assertion of the fundamental rightness of the social contract. Language was the very means to form the bonds which linked human beings in a rational and rulebound social order – and it was also the sign par excellence of the ways social relationships, political power, and economic exchange were governed by that order. The 18th-century debates on language were distinguished from those of the Renaissance by their diminished (often to the point of dismissal) emphasis on the role of God or a Divine Being as the source of writing or speech, and instead on the implications of this development for a sense of social history and human identity. Influenced by John Locke's *Essay on Human Understanding*, 18th-century philosophers

199

of language emphasized the concept of its arbitrary and social basis for language.

The social forces at work to motivate these conceptual changes included an increased contact with cultures beyond the limits of Western Europe, particularly in those areas where colonization had followed the paths made by the explorations of the previous centuries. Settlements under colonial rule were grounded on a hierarchy whose legitimacy was justified by assumptions of the inherent superiority of European forms of government, science and belief. Meanwhile, within Western Europe, the rise of the nation state as an entity, its consolidation within principles of law and institutions of government along national lines, promoted concepts of identity in nationalistic terms. The theory of the origin and identity of the alphabet and language also became bound up in these emerging identities. The claims for a Celtic, Anglo-Saxon or Gaulish origin of writing gave evidence of the force of this mythic invention. Writing was assigned a privileged place as both key to and means for the production of history as well as of the uses to which such claims might be put in the context of struggles for consolidation of new territorial boundaries.

A S P E C I M E N
By J O H N B A S K E R V I L L E
Of B I R M I N G H A M LETTER-FOUNDER and PRINTER.

A

Double Pica Roman.

TANDEM aliquando, Quirites! L. Catilinam furentem audacia, fcelus anhelantem, peftem patriæ nefarie molientem, vobis atque huic urbi ferrum flammamque minitantem, ex urbe
A B C D E F G H I J K L M N O P.

Double Pica Italic.

TANDEM aliquando, Quirites! L. Catili.am furentem audacia, fcelus anhelantem, peftem patriae nefarie molientem, vobis atque huic urbi ferrum flammamque minitantem, ex urbe vel ejecimus, vel emifimus, vel ipfum egredientem
A B C D E F G H I J K L M N O P.

A

B

C

D

E

F

Great Primer Roman.

TANDEM aliquando, Quirites! L. Catilinam furentem audacia, fcelus anhelantem peftem patriæ nefariè molientem, vobis atque huic urbi ferrum flammamque minitantem, ex urbe vel ejecimus, vel emifimus, vel ipfum egredientem verbis profecuti fumus. abiit, exceffit, evafit, erupit. nulla jam pernicies à
A B C D E F G H I J K L M N O P Q R S T U V.

Great Primer Italic.

TANDEM aliquando, Quirites! L. Catilinam furentem audacia, fcelus anhelantem, peftem patriae nefarie molientem, vobis atque huic urbi ferrum flammamque minitantem, ex urbe vel ejecimus, vel emifimus, vel ipfum egredientem verbis profecuti fumus. abiit, exceffit, evafit, erupit. nulla jam pernicies à monftro illo,
A B C D E F G H I J K L M N O P Q R S T U V W.

B

C

D

E

F

200 John Baskerville's printing types,
1789 sample sheet, Paris

Theories of language changed in the 18th century, shifting their focus from taxonomic articulation of logical and linguistic categories to the study of linguistic systems. Grammar, which had had a secure place in the study of classical languages, became a foreground player in the study of vernacular languages. Though the study of grammar brought little to bear on the study of the alphabet, the shift away from elements and parts, words and letters, to sentences and relationships had a progressive and forward looking aspect to it with which the discussions of the primitive language seem oddly out of synch. But the compilations of scraps and snippets of information on the origins of language from classical and biblical sources often served as preface to works on grammar – or to the other major new linguistic industry of the 18th century, the dictionary. Many major grammatical texts, such as the much referred to *Hermes* by James Harris, published in 1751, included these several aspects of

language study side by side without evident conflict. Nor was there any to the 18th-century mind in which the ongoing interest in the historical development of writing was still largely nourished from textual sources, though the study of ancient sites and monuments was putting an increased pressure on received tradition to accommodate the material evidence of a vastly different chronology – that suggested by philological and archaeological investigations.

Giambattista Bodoni's modern
type, Parma, 1771

Typographic Inventions and Decorative Devices

201

At the opening of the 18th century printing, was an industry with two hundred and fifty years' established tradition; the specialization of the trade had become such that printers were no longer required to possess every skill in the trade. Punchcutting, type-casting, marketing and distribution of types had become the province of dealers and foundries selling their wares to a market of printers who in turn supplied the service of print production to their clients. The specimen sheet as a printed form proliferated in the 18th century as a means for foundries to advertise their stock to printers, and there was a significant increase in typographic styles – both the number of faces and the range of available sizes. The extravagantly elaborate forms of display faces would be a product of the 19th century when the industrial revolution created new markets for advertising and commercial printing. Though there was an increase in decorative titling types in the 18th century, the period was distinguished in printing history by the invention of the so-called modern type faces.

ODE I.

AD VENEREM.

Intermissa, Venus, diu
Rursus bella moves. Parce, precor, precor!
Non sum qualis eram bonæ
Sub regno Cinaræ. Desine, dulcium
Mater sæva Cupidinum,
Circa lustra decem flectere mollibus
Iam durum imperiis. Abi

Closeup of Bodoni's modern type in the 18th century edition of Horace, Parma

Modern type faces were differentiated from the oldstyle roman and blackletter faces by an increased contrast between their thick and thin strokes and an overall greater delicacy of form. This was made possible in part by improvements in paper production since the newer, more regular surfaces could accommodate a more sensitive impression. The types of the English printer John Baskerville showed the effects of these changes while preserving many of the design features of earlier faces. Baskerville's designs were sometimes referred to as vernacular faces, and their subtle forms are considered by typographic historians to have a 'sparkling' appearance on the page.[1] But the most distinctive modern types were a radical departure from earlier roman faces and were designed without regard for earlier models of either calligraphed or inscriptional forms. These faces were made in accordance with strictly mathematical programs of proportions and form. There were several versions of such types developed through the course of the 18th century, particularly in France in the work of the Didot and Fournier families. But perhaps the best known examples in current use are those which were invented just at the turn of the 19th century by Giambattista Bodoni in Parma, Italy.[2] However, of all the various proposals for type constructed in accord with rational principles none more completely embodies features of the early 18th century associated with the French Enlightenment than the designs for the Royal Type of Louis XIV.

The project was actually begun in the 1660s, as part of the initial attempts to link the newly established Academie des Sciences with the technical professions in order to forge modern innovations in industry.[3] The Imprimerie Royale had been established in France in the 1640s, and the new project was supervised not by printers, but by a committee of representatives of the Academie. The so-called *Romains du Roi* were to be

Designs by committee of the Academie des Sciences for the *Romains du Roi*; copperplate engraving by Louis Simmoneau from 1702

TYPES
GRAVÉS
PAR GRANDJEAN ET ALEXANDRE.
1693. (2)

ROMAIN.		ITALIQUE.	
A	a	*A*	*a*
B	b	*B*	*b*
C	c	*C*	*c*
D	d	*D*	*d*
E	e	*E*	*e*
F	f	*F*	*f*
G	g	*G*	*g*
H	h	*H*	*h*
I	i	*I*	*i*
J	j	*J*	*j*
K	k	*K*	*k*
L	l	*L*	*l*
M	m	*M*	*m*
N	n	*N*	*n*
O	o	*O*	*o*
P	p	*P*	*p*
Q	q	*Q*	*q*
R	r	*R*	*r*
S	s ſ	*S*	*s ſ*
T	t	*T*	*t*
U	u	*U*	*u*
V	v	*V*	*v*
X	x	*X*	*x*
Y	y	*Y*	*y*
Z	z	*Z*	*z*

Granjean's cutting of *Romains du Roi*, 1693

Simon Fournier, titlepage of 1742 *Modèle des Charactères*.

full sets of both roman and italic faces, upper and lower case and the title was used to distinguish them from the beautiful *Greques du Roi* produced earlier. These designs – which were never cut as faces in their original form – differed significantly from the constructed faces of such type designers as Dürer and Tory by the fact that they were not modified by an experienced printer's eye but were produced in strict accord with programmatic mathematical formulae. The copper engravings which were to be the basis of these types were produced in large part by Louis Simmoneau from designs by Jacques Jaugeon, Père Sebastien Truchet and G.F. des Billettes at the end of the 1690s. One striking peculiarity of the face was that its italic forms were in fact merely sloped roman letters, and in this sense resembled the transformations effected in early digital mutation of letter forms more than they resembled older models of calligraphic or inscribed alphabets. These designs remained unpublished until 1965, though they were adapted by Philippe Granjean for his cutting of the eighty-two fonts known as the *Romains du Roi*, a massive undertaking only completed by Granjean's pupils in 1745.[4]

Granjean's adaptations modified the originals, taking into account the variations required for legibility at different point sizes and for softening the otherwise relentlessly 'perfect' designs. These designs came in for serious criticism, even in the mid-18th century. The highly esteemed printer Simon-Pierre Fournier, for instance, disparaged the original designs, though he attributed the defects of design to the absence of a sufficiently well-qualified engraver to achieve the work. In fact, the designs in the original copper plates were well-realized on their own terms, though ill-suited to the aesthetic requirements of printing. Fournier, like Granjean, realized that the effect of these types on the page, had they been produced in accord with the original designs, would have been one of deadening stability. Fournier possibly lacked the historical perspective to realize that these letter forms, by their very harmony and regularity, embodied both the intellectual principles held in high esteem as a theoretical ideal and also the worldview of the monarch by whom they had been commissioned. The compass and the square, used to divide the spaces from which the letter forms emerged, were appropriate tools for designing type which was to lay claim to universality, transcendence and immutability in the same manner as Louis XIV's unshakable egocentrism shaped his claims to absolute monarchy. The extremely formal characteristics of these letter forms – which were sharply criticised by later designers – were precisely those which made them so indicative of the political symbolism of their aesthetic form. While the Royal types remained the exclusive property of the Imprimerie Royale, the ultra-rational aesthetic which had inspired their design was shared by the so-called modern faces of Fournier and the Didot family, whose widely imitated work set the tone for much of Western European printing in the 18th century. Fournier's designs were published in 1742, in the *Modèle des Charactères*. These faces were characterized by thin, unbracketed serifs, extreme variation of thick and thin strokes and a

strong vertical emphasis – in other words, by a distinctly rational seeming formalism.

The 18th century saw a dramatically increased availability of printing types to serve the needs of the expansion of Western European culture in its contacts with foreign languages and scripts. Motivated by colonial, religious and, later, anthropological concerns, type designers cut many new 'exotic' faces to accommodate the demand for publications in non-European languages. A specimen book such as the *ABC Buchdruckerkunst* of Christian Friedrich Gessner, produced in Leipzig in 1743, provides significant evidence of this trend: typefaces for more than four dozen languages – among them Aetheopic, Armenian, Brahmin, Syriac, Saracen, Malabarischen and Chinese – were all made available for sale. Gessner's were particularly rich holdings in this realm, but not unique. The display in Diderot and D'Alembert's *Encyclopédie* seems very modest by contrast, with its mere dozen or so alphabets corresponding largely to languages of the Near and Middle East, and these all presented in copper engravings, rather than as type fonts. The reason for this may have been pedagogical, since their presentation emphasized comparative grammatography rather than utilitarian applications. By the time of its 1799 publication Edmund Fry's *Pantographia* contained images of several hundred alphabets in an uncritical blend of mythic and actual examples.

Plate of 'Ancient Oriental Alphabets' from Diderot and D'Alembert's *Encyclopédie*

George Bickham, *The Universal Penman*, 1743

More significant than the statistical enumeration of these facts of production is the effect on European attitudes towards language. The boom in universal languages of the late 17th century found its echo in the 18th as well, also motivated in part by the desire to transcend the difficulties of cross-cultural communication. But more overwhelming was the

interrelation between historical and cultural perspectives as scholars of language struggled to determine links between cultural identity and linguistic form, as well as to understand the chronological development which had resulted in such widespread proliferation and diversification. The tale of Babel remained a major touchstone for these researches in the 18th century, and the variety of languages was explained in relation to that point of biblical reference. But the diversity of narratives into which this single reference fitted was considerable, making use of alphabetic writing as one of the key elements linking national identity and historical priority.

A scanty Fortune clips the Wings of Fame,
And checks the Progress of a rising Name.

18

206

Two examples from George Bickham, *The Universal Penman*, 1743

With glittering Beams & native Glory bright,
Virtue, nor Darkness dreads, nor covets Light;
But from her settled Orb looks calmly down,
On Life or Death, a Prison or a Crown.

The tradition of penmanship developed in the Renaissance continued in the 18th century, though many historians of calligraphy consider this to have been a decadent period characterized by excesses of decoration, flourishing, and pictorial conceits. These are manifest in display pieces and in the artful copper engravings of such skilful designers as Mauro Poggi, T.A. Pingeling, Gaetano Giare and others.[5] Themes of travel and

architecture entered into these elaborately engraved designs, adding to the mythological, religious and mundane themes of the earlier centuries, while the proliferation of natural flora and fauna accurately observed and presented reflected the 18th-century reexamination of the physical world. One landmark publication in this area was George Bickham's *Universal Penman*, a work which helped popularize new calligraphic styles as well as promoting a clear, legible hand. Other practical manuals for the teaching of penmanship as a useful and necessary tool had appeared in the 18th century, but in the 19th, as the needs of industry and commerce required increasing numbers of skilled clerks and secretarial workers, these publications became the basis of standardized training and curricula.

Richard Ware, *The Young Clerk's Assistant*, London, 1733, title page and chart of 'square' hands

207

Decorative devices and elaborate initials were also created to serve the printing trades in the form of wood or metal initial letters designed for use with cast metal type. Once again, themes from the Renaissance persisted, such as that of playful naked *putti* or floral patterns, while newer themes made their appearance as well. Again, an increased attention to naturalistic detail in the depiction of plants and animals was evident, and the use of exotic seeming creatures and foreign views were all popular material for new designs reflecting an interest in cultures beyond the borders of Western Europe.

Copperplate engraved initials, by Mauro Poggi (late 18th century) and T. A. Pingeling (1780)

Letter M from Johann David Steingruber, *Architetonisches Alphabeth*, 1773

Decorative initial with theme of exotic travel, possibly by Jan van Vianen

Natural Language and Letters

In the 18th century the term 'natural' came to be associated with the idea of self-evident or irrefutable fact. The idea of a natural language was one grounded in the logic of physiology, in keeping with the era's fondness for granting privileged status to empirically observable phenomena. One extension of this sensibility was in the schemes used to account for the shapes of alphabetic letters in terms of a link between their visual shape to the organs of articulation. The most notable 17th-century precedent for this interpretation was the work of Van Helmont, whose assertions had forged a link between the movements of the tongue, lips and mouth and forms of the Hebrew alphabet. But Helmont's aim had been to demonstrate the divine origin of Hebrew, while 18th-century writers conceived of Divine invention in a more oblique manner, if they considered it at all. In addition, these writers all concerned themselves with the form of the Roman alphabet. Thus their desire to ground the visual shapes of letters in the organs of articulation included both a peculiarly ahistorical ignorance of the development of the alphabet and a faith in the human body as an original source for natural forms.

The idea of a physiologically based notation system has some credibility as a guide for pronunciation: the mapping of the organs and relative positions of tongue and so forth in a shorthand code was one of the bases on which the eventual development of the International Phonetic Alphabet was developed. But the attempts to see the alphabet in terms of physiology was motivated by a desire to read the letters as a set of motivated signs, grounded in some original source, rather than as an arbitrary set of visual elements. These proposals were also testimony to the

increased sophistication of phonetic analysis, since the categories of labials, dentals, palatals, fricatives and plosives provided a suggestive framework within which to propose a visual interpretation. Another theme was the increasing recognition that the correspondences between the letters of the alphabet and the sounds of contemporary French, English or other spoken language were highly inadequate. In the introduction to his 1758 publication, *An Introduction to Language, Literary and Philosophical, Especially to the English, Latin, Greek and Hebrew*, Anselm Bayly, the English philologist, bemoaned this fact, stating that ideally 'each letter should correspond to a sound.' That it did not was proof of its imperfection – arising either from the deterioration of the original, pure form of language, or from the as yet not perfected condition of human knowledge. In the debates over the natural versus social character of language, Bayly took the side of culture: children learned language only with difficulty, he pointed out, and though he believed strongly that the original language had contained more perfect connections between words and their meanings, he still considered it to have been a human invention grounded in lessons from the great Instructor and Creator.

Interpretations in which the alphabet was considered to have been based on physiology divided into descriptive systems – those which asserted that they were discovering the true origin of the letter forms or their meaning – and prescriptive systems – which attempted to design a universal notation system based on the mechanisms of pronunciation. The Englishman, Charles Davy, and French scholar, Abbé J. Marie Moussaud, were both authors of descriptive systems, while Charles de Brosses wrote one of the most famous of all physiological alphabet texts, including a proposal for a universal writing.

Davy's 1772 *Conjectural Observations on the Origin and Progress of Alphabetic Writing* ascribed the origin of writing to human invention, rather than divine gift. Davy emphasized that it was the principles of phonetic representation, rather than the specific activity of letters, which were the remarkable achievement in alphabetic writing, so that it was the concept of representing sound, rather than the means by which this was achieved, which he felt was to be most admired. Davy's analysis of letter forms was limited to diagrams of the lips, teeth, tongue. He considered that the alphabetic sequence had been determined by the patterns of the mouth in pronunciation: 'aleph' closed the lips, 'beta' opened them and put the tongue in position to pronounce the 'gimel,' as its final 'l' in turn readied the mouth for the 'daleth' and so forth. But the letters he schematized in his illustrative diagrams were Roman letters, majuscules, and the internal contradictions of this method were never mentioned – the improbability that letters whose forms were developed in monumental inscriptions had derived from the organs of speech. In addition, his understanding of the physiology of speech was quite limited: he relied on the obvious features of the mouth (teeth, tongue, lips), rather than extending to the palate, glottis and larynx as Wilkins had a century earlier.

ALPHABETIC WRITING. 87

O-mega exhibited the hollow of the mouth in profile, with the lips thruſt forward as in ſpeaking :

Beta was a delineation of the lips in profile, in the natural ſituation of the head.

Mu exhibited them turned upwards.

Pi was their inverted profile.

And *Phi* was a drawing of the lips as they appear in front, which was erected for the ſake of taking up leſs room.

Zeta and *Nu* may be conſidered both as palatines and linguals.

Zeta (the ſound of which ſeems to be compounded of the ſounds of δ and σ *) is pronounced by raiſing the tip of the tongue

Charles Davy's tiny diagrams,
Conjectural Observations,
London, 1772

210

Davy invoked historical themes which were quite typical of the 18th century, particularly in his attempt to reconcile his insights with contradicting biblical and classical texts. For instance, Davy argued against the

possibility of an antediluvian origin for the alphabet on the simple grounds that there was no evidence of writing before the Flood. He favored the theory of its invention in the Sinai, particularly its use to inscribe the Decalogue of Moses. This was a fairly standard position for his time, though there were other scholars who continued to argue for Adam's role in the invention of letters as well as language. Davy's discussion linked the invention of the alphabet to the prohibition against graven images, thus distinguishing it from the first writing, hieroglyphic. Because they pictured the elements they represented, hieroglyphics were unacceptable to the Jews, he felt, since they were under the strictures of Moses's new Laws. Finally, Davy echoed the sentiments of Jean-Jacques Rousseau's famous formulation that language had been invented to communicate the human passions and emotions, and he added that the uses to which writing had been applied had moved in rapid succession to business, to memory, to specifying the conditions of the covenant, to determining the conveyance of property. In summary Davy considered the alphabet to be an invention which communicated humanness by the social purposes to which it was put, and to be pictorial, but abstractly so, because it represented sound through depicting the mechanisms of pronunciation.

Moussaud, like Davy, analyzed the visual form of the Roman letters in terms of articulatory organs. His work, *L'Alphabet Raisonné ou Explication des Lettres*, was based on the principle that letters either represented the organs of speech or they represented the movement of air produced by those organs. The several hundred pages of his two-volume work were devoted to exhaustively detailing these patterns, though the graphic evidence he presented was limited to a few schematic designs. Unlike Davy, Moussaud defended his choice of the Roman alphabet, making clear that his was a deliberate selection, and stated that the perfection of the forms of the letters made it obvious that these could not be a degraded or deteriorated form of the early alphabet. He felt that it was highly improbable that the scratchings, awkward glyphs and 'barbarous' images of the Sinai or Phoenicia could have been the pure originals of letters which were superior aesthetically. Having established the primacy of the majuscules of the Roman alphabet on aesthetic grounds, he then proceeded to a direct analysis of the symbolism of the letters: 'A' was the simplest, representing mouth and tongue; 'E' the sign of existence, the very breath of life, was the image of the nose from below, two nostrils and the diaphragm separating them; 'I' was not an organ, but the shape of the sound, fast clean and sharp, like an arrow, and the dot on the lower case 'i' was a stranger, a remnant of an older notation system; 'O' was the most full sound, the shape of a globe; and the two parallel lines of the 'U' were the guiding canal of the voice. Moussaud divided letters into the passive consonants and the active vowels, the tranquil voices of reflection and the dynamic language of the passions. In so doing he was able to discuss language as the interweaving of two strains – one natural and independent of institutions, immediate and expressive which consisted of the vowels, and the

211

other conventional, understood only through training, which was that contained in the consonants. This ingenious solution to the apparent contradiction between the expressive materiality of language and the clearly social nature of its forms, meaning and conventions was Moussaud's unique contribution to alphabet theory.

CARACTERES PARTICULIERS,

répandus et plusieurs fois répétés dans le cours de l'Ouvrage.

VOYELLES.

Moussaud: chart of letter values, from *L'Alphabet Raisonnée*, 1803

Moussaud: chart of letter values; the 'A' and 'B' and 'V;' the 'D', from *L'Alphabet Raisonnée,* 1803

Charles De Brosses's *Traité de la Formation Mechanique des Langues* became the best known of the articulatory interpretations of alphabet forms. His assertion, quite simply, was that all languages shared this physiologically based sound symbolism and were of a necessity determined by nature itself. De Brosses's treatise contained a search for value, not merely the original of a letter form, but the essence of meaning, which he felt resided in an onomatopoeic reading of sound symbolism. He had very little to say about the visual forms of the alphabet, but from the first pages of his two-volume work, he was promoting the analysis of spoken language.

The first example he offered was a contrast of the pronunciation of the French words for soft (*doux*) and rough (*rude*). In the association of the gentle sound of the word *doux* and the harsher sound of the word *rude* the kernel of his entire treatise was contained. De Brosses believed that the physical quality of the words was evidence of their kernel meaning, and it followed from this that all language was onomatopoeic in its original form, much of which, he felt, could be recovered with careful examination of existing elements. But his major contribution was a proposal for a writing system grounded in physiology, one adaptable to any and all languages, and more or less apparent to the eye. He designed this writing system in strict accord with phonetic analysis, his marks designating lips, nose, tongue, teeth as the basis of what he termed an 'organic alphabet.' Though never adopted, his scheme provided inspiration for later inventors of phonographic notation systems. The drawbacks to De Brosses's scheme were that though it might have been pronounceable to the initiated, as a notation system it would have jettisoned the rich philological history of language apparent in traditional writing which in part conveyed meaning by the visual forms of morphemes, prefixes and suffixes, rather than merely by their sound.

The unifying feature of these proposals was their profound belief that a close relation between written form and physiology would result in a more perfect alphabet – whether it could merely be demonstrated as historical fact or whether it had to be reinvented. The assumption that empirical, observable natural forms, such as those of the mouth, were in themselves inherently perfect, was the basis of this attitude. The body carried no association of carnal impurity in such systems, but was a natural fact, and therefore, could be the basis of a neutral or even positive image. The social order was not in conflict with this natural image, but a logical – or even, as in the language of Moussaud, *reasonable* – extension of its character.

The distinction between these and earlier physiologically based interpretations resided chiefly in the absence of a mystical or transcendent belief in divine sources for alphabetic form. There is none of Helmont's leap of faith in these texts and theological conviction has been subsumed into a cool logic and rational analysis.

213

Planche II *Tom. I. p. 180.*
Les articulations ou inflexions des six
organes de la trombe Vocale.

214

Charles De Brosses's schematic
diagrams for his organic alpha-
bet, *Traité de la Formation
Mechanique des Lettres* (Paris,
1765)

Planche IV *Tom. I. p. 181.*

Les six lettres ou consonnes du nouvel alphabet organique.

LEVRE.	GORGE.	DENT.	NEZ
P.	c.	D.	s.
B.	Gh.	Th.	st.
M.	K. Qu.	T.	ts.
F.	cl.	Dgh.	scr.
V.	cr.	Dj.	sc.
Bz.	Cs.	Dz.	sp.
Bl.	Cz.	Dr.	spr.
Pr.	Ct.	Tr.	spl.
Ps.	Gl.	PALAIS.	str.
Pt.	Gr.	J.	scl.
Fl.	Cn	Z.	sr.
Fr.		ch.	sm.
Vr.		LANGUE.	sf.
		L.	sl.
		N.	sn.
		R.	
		gN.	
		gL.	

Charles De Brosses's schematic diagrams for his organic alphabet, *Traité de la Formation Mechanique des Lettres* (Paris, 1765)

215

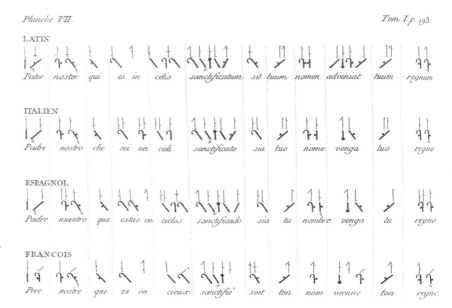

Charles De Brosses' schematic diagrams for his organic alphabet, *Traité de la Formation Mechanique des Lettres* (Paris, 1765)

216

Primitive Origins and the Social Contract

18th-century accounts of the origins and development of writing evidenced an increasing concern with a coherent and consistent narrative history within which to present their arguments. This involved both a necessary comparison of the condition of modern culture with that of the past, and also, a more elaborately detailed chronology than had previously been customary. Again the underlying subtext of these works was the guiding question of whether human society had deteriorated or improved on its original state. Contact with people and cultures in Africa and the Americas had raised doubts about the nature of so-called primitive existence, and the image of Edenic innocence was both supported by the observation of indigenous people living in harmony with their natural environment and contradicted by their apparent difference from the preconceived image of Adam and Eve as nude but conventional Western Europeans. The role of writing in these various discussions was as clear evidence of cultural superiority, but assessing the condition of writing in the early stages of human history became a crucial point on which to determine the course of progress or lack thereof.

The figures whose work gave definitive form to discussions of the development of writing in the 18th century included William Warburton, Court de Gebelin, and Thomas Astle, all of whom remained frequently cited sources throughout the next century. Each believed that writing was a human invention which was bound up in the terms of the social contract between individuals and government. The influence of Enlightenment writers on these historians was evident, and the author who established a

founding link between social theory and alphabet history was Lord Monboddo. In *The Origin and Progress of Language* (1772) Monboddo insisted that not only writing but language *depended* on the existence of the state since without a basis for regulation human relations would not have been able to evolve into rational form and exchange. By contrast, Court de Gebelin felt that language was more properly to be considered the *instrument* of the state and its facilitating medium, seeing in the activity of writing an effective technology for realizing the aims of a rational and scientific government. Thomas Astle, along with William Massey, James Herries, James Williams, and a host of other lesser known figures concurred on the point that language was 'the first and most admirable of human inventions' which had been 'enlarged as human affairs and circumstances rendered necessary' and that if there were any divine intervention in the invention it was only in the sense that all human activity was inspired by divine models or Ideas. Writing, even more than language, was evidence of the human character of social systems and the tool of law, reason, science and emotions.

The idea of divine invention did not lack for supporters, however. Daniel Defoe writing in 1726 and an anonymous French author responsible for the *Dissertation Historique sur l'Invention des Lettres* published in 1772 demonstrated the tenacity of the notion of writing as a direct gift from God. Defoe maintained that it was an indisputable historical fact that the first alphabetic characters had been written by God on tablets of stone, and to support his arguments gave detailed chronological accounts of events leading up to the moment at which the original letters had been inscribed in the year 2515 of biblical history. Defoe's essay was subtitled *An Inquiry into the Antiquity and Origin of Letters proving that the two Tables written by the Finger of God on Mount Sinai was the first Writing in the World and that all other Alphabets derive from Hebrew.* Defoe absolutely dismissed hieroglyphic writing, stating that it could not have had any relation whatsoever to the forms or principles of the alphabet. He also dismissed the possibility of an antediluvian writing, the biblical authority for the Mosaic Tablets bearing such strong weight in his arguments, but the author of the *Dissertation* was convinced that the first writing had been on two columns of brick and stone, known as the columns of Seth, which had existed before the Deluge. Like Defoe, this author relied exclusively on textual sources, but was less interested in reconciling them to a single narrative than in enumerating their various contributions to the history of writing. This practice of giving equal weight to mythical, biblical and historical sources continued until the force of archaeological evidence contradicted the traditional accounts, but attempts to accommodate a divine origin for writing within a historical framework would persist well beyond the 18th century.

William Warburton's major contribution to the study of the history of writing was in the area of hieroglyphics; to Warburton goes credit for finally demystifying the Egyptian writing system and placing it within a

217

linguistic context, well in advance of the decipherment by Thomas Young and Jean François Champollion. While Warburton did not and could not supply the meaning of hieroglyphic characters, he recognized that they had served a wide range of mundane and practical purposes in their original function and had only become a more arcane and secret system in their later use. Now accepted as the standard historical account, Warburton's proclamations on this point were revolutionary in an 18th-century context in which the emblematic and enigmatic character of the hieroglyph was still taken for granted and the term itself practically equivalent to esotericism. But Warburton's work had other implications, and the multi-volume *Divine Legation of Moses*, published in rapidly succeeding editions well into the 19th century, was a work which participated in the politics of contemporary life as much as in historical discussion. On the one hand, the work was an encyclopedic collection of most of what was contemporary knowledge about the ancient world.[6] Warburton maintained that while Adam and Eve had lived in a condition of natural religion, one in which humans realized by virtue of their 'Reason and Freedom of Will' that they were moral agents accountable for their conduct to their Maker. While Warburton maintained, in keeping with Locke, that human reason was universal, he argued the Deist belief in nature as the only source of knowledge about God, and in favor of supernatural revelation. Such a Divine Revelation had been made only to the Jews, and it was through Moses that knowledge had been passed down, though it was through Christ that certain aspects of this Revelation were later intensified and restored. Warburton argued passionately for the mutual benefit derived from relations between the state and religion, and that the contract which united them was of the same variety as that which united the state and its people. Warburton's thesis was that religion had lost its hold on the mind of the people who now, he complained, cared only for what they termed civil liberty and denounced the value of the Christian faith. Religion had served a social function, as laws had served a spiritual function, in taming the more selfish instincts of humankind, but all this was to be lost if the institutionalized structure of state religion were eroded. Warburton's work was intended as propaganda to bring the wayward back in line with organized religion and obedience to the Crown.

Warburton's work, first published in the 1740s, supported the idea that certain early cultures of humankind were originally primitive, barbarous, uncivilized and that the earliest forms of writing, hieroglyphics, were evidence of this. Alphabetic writing represented an advance on this condition, and the increasing degree of abstraction possible in writing as it moved from the literal representation of things to the suggestive representation of concepts was evidence of increasing social sophistication in his eyes. Warburton took up the earlier classifications of hieroglyphics within the descriptive semiotic analysis of Clement of Alexandria. He made use of the terms *curiological*, *tropical* and *allegorical*, but linked them to an evolutionary hierarchy bolstered by the notion of progress.

William Warburton's diagrams showing evolution of letters from hieroglyphics, based on the Count de Caylus's diagrams (*The Divine Legation of Moses*, London, 1765)

219

Warburton saw no reason to assign a divine origin to the alphabet, stressing its social rather than religious function, and further insisted that had the letters been invented by God and given as a gift, that this fact would have been so momentous that it would have been explicitly commented upon by Moses, not merely implied in the story of the Tablets. Letters, Warburton said, had been in common use before they appeared in the Commandments. The alphabet had been imported from Egypt by Moses and then transformed, and here Warburton also interpreted the second commandment as an interdiction against the use of hieroglyphic writing or other pictorial depictions. Warburton, in spite of his tendency

to slight the Jews and disparage the continual credit granted to the Hebrew language as original, was an astute theorist of culture. The thrust of his analysis was to examine the function of religion and in particular the social uses of the mythic concept of a Divine Revelation. The desire to receive a 'revealed Will for the rule of their actions,' he said, was of paramount importance in rendering religious law effective as a means of social control. It is this argument which he turned upon the purported divine origin of letters, undermining its credibility by asserting that there would have been no better 'sanction to recommend their use' than this fact, or 'security against return to the idolatrous practice of hieroglyphic writing to which this people [the Jews], so fond of Egyptian manners, were violently inclined.'

COMPARISON OF MASSEY, HUGO and HELMONT's VALUES FOR THE LETTERS OF THE HEBREW ALPHABET

	Massey -- 1763	Hugo -- 1738	Helmont -- 1657
alef	chief, prince, first sound, ox	princeps	chief
beth	house	house	house
gimel	a camel	camel	camel
daleth	a gate		door
he	(the sound)	(from the sound)	this or that
vau	hook	a hook	hook
zayin	weapon, club	weapon, a club	weapon or spear
heth	quadreped	(from the sound) or quadreped	wild beast
teth	cover or wrapper	(from the sound)	wrapper or womb
yod	a hand	hand	hand
koph	the palm, or to bend	palm (hand or tree)	cavity or hollow
lamed	a goad or spit	goad	teaching
mem	a blot	stain or blemish	mother, increase
nun	a fish (or sound)	fish	everlasting
sameleh	a base	base	support, bedpost
ayin	a fountain, or eye	eye	eye
pe	mouth or face	mouth or face	mouth
tsede	hunting pole, fish hook	spear or fish hook	hook
qoph	circle or monkey	circle or monkey	circle
re	the head	head	head
shin	a tooth	teeth	teeth
tau	a sign or boundary	final sign	final sign

Based on William Massey *The Origin and Progress of Letters: an Essay in Two Parts,* 1763, (often citing either Bellarmine, Joseph Scaliger or Angelus Caninius), Hermanus Hugo, *De Prima Scribendi Origine,* 1738, and Baron von Helmont, *Alphabetum Naturae,* 1657.

William Massey: values assigned to the letters contrasted with those assigned by Hermanus Hugo and Baron Van Helmont

If on the one hand Warburton was intent upon distinguishing the abstract chararacter of alphabetic writing from its mimetic hieroglyphic precedent, then other writers of the period were equally intent upon filling the void of meaning with accounts of the pictorial origin and value of the

letters. Such accounts arose in every period, through the systematic description of the letters of the alphabet in relation to presumed pictorial sources according to either their names (the aleph = the ox variety) or their appearances – which often included improbable examples from the physiological models described above to sets of tools, plants and animals. One of the first thorough accounts of pictorial value was recorded by William Massey in 1763 in *The Origin and Progress of Letters*. It is evident Massey had researched earlier sources thoroughly and conscientiously supported his assertions by citing other authorities. The work of both Hermanus Hugo (*De Prima Scribendi Origine*, first published in 1617) and Van Helmont haunted Massey's text. This is significant not only because of the way in which the traditional interpretations of the letters was passed on through this succession of writers but because the idea of an interpretation of the letters as meaningful in themselves became accepted through this tradition. While such values were not translated into a symbolic interpretation of words on the basis of the letters from which they were composed, the social significance of the early alphabet came to be defined in part according to the correspondences of letters and objects in these analyses.

By the 19th century the assignment of a pictorial origin would be justified by these interpretations, but in the 18th century the meanings were assigned more exclusively through linguistic links. For instance, some of Massey's values were: aleph = prince, chief and the first sound which children uttered;[7] beth = a house, though Massey stated unequivocally that he saw absolutely no visual resemblance; gimel = a camel, because the word was the same; daleth = a gate, and so forth. The most telling letters were in fact those whose names did not have a descriptive value: thus 'he' was considered a name derived entirely from the sound of the letter, 'mem' described a 'blot,' while 'samech' was 'a thing drawn into itself.' The range of values assigned to these more ambiguously named letters was quite broad; Massey tended to contrive more literal solutions for the enigmatic names while Hugo and Helmont had been content with abstractions.

Gebelin also proposed values for the individual letters but his scheme contained a far more elaborate subtext: Gebelin saw the letters as symbols of the necessary and sufficient elements for a primitive way of life, that of the nomadic Semitic tribes. First published in the early 1770s, Gebelin's *Le Monde Primitif* was rapidly accepted as the standard account of the early history of humankind. Gebelin was one of the most prominent scholars of ancient Near Eastern language and culture of his day, and considered, therefore, an outstanding authority on the early epoch of human activity. The function of writing in society, Gebelin stated, was to preserve knowledge, science, and invention through a stable means of externalizing thought. Gebelin believed that all human beings and cultures had the same source and that the proof of this resided in written forms where the similarities between Chinese characters, Hebrew letters and Egyptian hieroglyphic forms could be demonstrated.

221

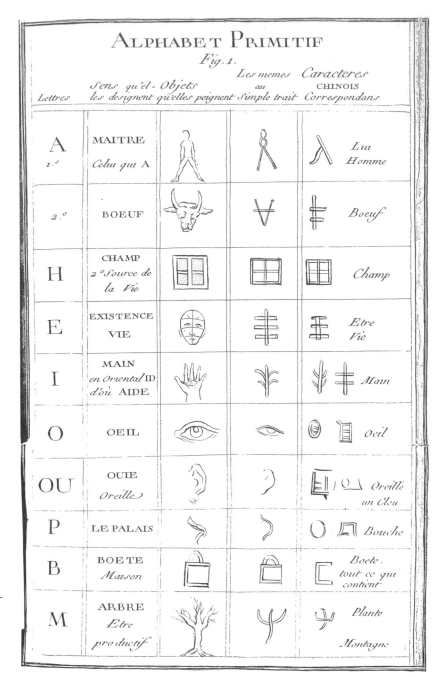

Court de Gebelin's visual correlations of alphabetic characters, hieroglyphics and Chinese characters (*Histoire Naturelle de la Parole*, Paris edition of 1816)

222

Gebelin determined that if writing had been a natural invention, that is, one which followed from the human condition as mewing from a cat or barking from a dog, then all early writing would have been similar. The existence of hieroglyphic writing, so different from that of alphabetic, was on the one hand testimony to the artificial or cultural character of writing, though on the other hand, Gebelin added, the observation that these forms of writing were different was in fact an error. Hieroglyphics had

| | ALPHABET PRIMITIF | | | |
| | | *Fig. 11.* | | |
Lettres	Sens qu'elles désignent	Objets qu'elles peignent	Les mêmes au Simple trait	Caractères Chinois correspondans
N	Etre Produit Né Fruit			Attaché l'un à l'autre Nœud &c
G	Gorge Cou Canal			Passage
C	Creux de la Main Cave . K			
Q	Couperet Tout ce qui Coupe			Tout ce qui sert à Couper
S	Scie Dents			Mortier à broier à briser
T 1.ʳ	Toit, Abri			Toit Couvert
T 2.ᵈ	Parfait Grand			Perfection Dix
D	Entreé Porte			Porte Maison
R	Nez Pointe			Angle Aigu
L	1° Aile 2° Bras			Aile

Court de Gebelin's visual correlations of alphabetic characters, hieroglyphics and Chinese characters (*Histoire Naturelle de la Parole*, Paris edition of 1816)

223

been the first, the earliest writing, and had like all human inventions, been based on imitation. Using the popular notion of hieroglyphic writing, Gebelin considered it a form of pictorial denotation which ranged from literal to more abstract. By the logic of his own circular reasoning, he further asserted that since all writing was similar, alphabetic writing must also be a form of painting, and thus should be interpreted as an

assemblage of hieroglyphic characters. Gebelin thus projected images onto the schematic forms of the alphabet. Very few of Gebelin's assigned values corresponded with those of either Massey or other historians (only in the value he assigned 'daleth' and a secondary value for 'aleph') but his alphabetic glyphs were all thematically related to the agricultural life of the ancient Near East. Gebelin elaborated his theory of pictorial origins by making an additional – but incongruous – link between the objects the letters resembled at their invention with the organ which produced their sound. In some cases, as with 'B' or 'P' he claimed that this latter was revealed in the pictorial value, while in other cases it was unclear on what grounds he supported this part of his argument.

The definition which Gebelin gave to the term *primitive* was revealing: he considered that the only form of human culture which was truly civilized was that embodied in the structure of rural, agrarian society. Not only were hunters and gatherers excluded from consideration as civil people, but the concept of civilization was linked to writing through the control of property. Gebelin went so far as to say that there was absolutely no need for writing among people who did not possess property, since the function of written language was to keep accounts, provide documentary evidence of ownership or transfer, and to maintain records of such exchanges. Thus it was pointless to consider the 'savages' (by which he meant non-European indigenous populations of the African and American continents) as children of nature – it was in fact only farmers who justly deserved that designation.

Gebelin concluded his study of the origins of language and writing by tracing the development of the alphabet from the Near East to Greece, displaying his acquaintance with the various transformations of the letters and the changes from twenty-two letters of the Hebrew alphabet to the seventeen letters of the alphabet of Cadmus and so forth, but again the fact that the letter forms which formed the center of his investigation were the Roman majuscules of Imperial inscriptions was a point which went completely unmentioned. The force of tradition was so strong in Gebelin's mind that he saw visual links in the forms of the letters, interchanging the Aleph for the Alpha and the majuscule 'A' without any hesitation. They were all the same letter, he argued, and thus shared the same original value. Writing had been a civilizing force, as far as he was concerned, but could only occur in cultures disposed to become civilized. Gebelin's distinctions loaded the term primitive with a romantic association, linking the image of an Arcadian early condition for agricultural society with a notion of natural superiority which in turn translated into social superiority: so though the *primitive* was a condition of innocence it was not to be confused with the state of the *savage*, and though it had been original, it had not been universal.

Though Astle's work was published in 1784, he was in many ways the precursor to 19th-century scholarship, rather than a participant in the speculative practices of his contemporaries. The distinguishing elements

224

Frontispiece from Gebelin's *Le Monde Primitif*, with Mercury, led by Love, about to grant writing to humankind.

of Astle's monumental work, *On the Origin and Progress of Writing, as well Hieroglyphic as Elementary*, were his accurate account of the diffusion of writing from the source of its invention in the Near East, the assertion that letters were arbitrary forms, and the conviction that the alphabet had developed gradually through a process of transformative adaptation. In other words, Astle was on the verge of an evolutionary narrative rather than a creationist one, and his use of classical and biblical sources was seriously tempered by his synthesis of archaeological evidence. Not surprisingly, it was Astle's work which became the touchstone for such 19th-century scholars as the perpetually venerable Isaac Taylor.

Astle's conviction that the letters were arbitrary was coupled with an increased emphasis on the surrogate character of writing: speech was the 'substance, and writing the shadow which follows it.' This attitude, in which writing loses its enigmatic power as a visual form as its relation to linguistic systems is demonstrated, enjoyed an upswing of popularity as the languages linked to cuneiform, hieroglyphics and other ancient scripts were systematically reconstructed by the decipherments of the 19th century. Astle had no patience for the mythic conceptions which had dominated the field of his research, and he expressed sharp criticism of those scholars who, pressed by 'the difficulty of accounting for the invention of the art of exhibiting to the sight the various conceptions of the mind, which have no corporeal forms, by a small number of elementary characters or letters', fell into the easy solution of supposing them to be 'of divine original.'[8] He understood that the significance of alphabetic writing was its dependence on the analysis of spoken sounds and its independence from mimetic representation. Though he felt that the letters were in some way derived from hieroglyphics, he was also fully convinced that letters did not 'derive their powers from their forms' and that, as a consequence, these forms 'depended entirely on the will and fancy of those who made them.' Astle responsibly cited Warburton, Monboddo, Gebelin and others, and with remarkable clarity, rejected the portions of their theses which did not support his own. His work was not entirely without its mythical traces – he provided a family tree for Thoth, and linked him to the ancient Greeks and to the Phoenicians, but he also provided the first diagram mapping the relation of alphabetic writing systems to each other, a diagram which was both replete and surprisingly accurate.

225

Nationalism and the Descendants of Noah

One conspicuous genre of 18th-century alphabet symbolism was the analysis of the alphabet in terms of the geographical distribution of the sons of Noah throughout the globe and the use of these histories as the basis of myths of national identity. Linked to the emerging concepts of the nation as a fundamental entity, and the stresses of European politics, these theories inevitably bore within them claims of the authors to have

discovered (and be descended from) the original people and the one true language. Most prevalent were theories asserting the priority of one or another of the Celtic, Gaulish, or Anglo-Saxon groups in the settlement of Europe. These texts revealed strong partisan sentiments, supporting the right of the Irish to remain independent of British rule, a conflicted area in 18th-century politics, or of the Anglo-Saxons to be defined as distinct from their Norman conquerors, and the English language as a form whose original purity had been violated. On the continent such a theory had been proposed by Guillaume Postel as early as the 16th century when he put forth the claim that the Celts had been the original settlers of France. Postel's nationalistic mythology was part of a widespread movement in French literature which was conceived as a reaction to the claims of Classicism and the legacy of Greek and Roman culture as it was being reinvented in the Renaissance.[9] The 18th-century writers who took up this theme made little reference to Postel, however, often making use of highly original analyses of both the letters and language in the form of new, unorthodox etymologies.

Rowland Jones's 'T' diagram showing origin of prepositions, (*Hieroglyfic*, London, 1763)

Of the authors who used the letters of the alphabet as evidence of early human history, Rowland Jones was one of the most prolific and original. He wrote four books which explored his premises: that the original Europeans were Celts, that all the letters of the alphabet were based on the combination of two elements, the I and the O, and that the Celtic origin of the English language could be discerned through an etymological investigation which made use of the symbolism concealed in letters and words. In *Hieroglyfic or A Grammatical Introduction to An Universal Hieroglyfic Language* (1763) and *The Origin of Language* (1764) Jones expounded the fundamental principles which he explored further in *The Io Triads* and *The Circles of Gomer*.

Jones's stated motivation was to restore the original language and thus recover what he called 'primitive knowledge.' By this he meant the condition of humankind before the confusion of tongues at Babel. Themes of

racial purity rather than the innocence of humankind were evident in the work of Jones, Nelme, Vallancey and other writers concerned with the origins of language in terms of national identity: none of them attempted to recover the language of Adam, for instance, or of Abraham, but instead focused on the diffusion and differentiation of languages among the sons of Noah. As far as Jones was concerned, the original pre-Babel language had been that of the a people he identified as the Cumbri, equivalent to the Galli-Celtic group. Since all living human beings were necessarily descended from Noah, all others having perished in the deluge, the activities of the sons of Noah took on considerable value in Jones's work. It was God, not Noah, who had determined the distribution of the earth to Japhet, Shem and Ham, and it was thus by divine intention that the sons of Japhet, Gomer and Magog, had settled the lands of Europe, while the Shemites (or Semites) had remained in the East and the Hamites had migrated into Africa. Jones focused on Gomer, the oldest son of Japhet, as the primary settler and original Celt. He further asserted that it was on account of Japhet's virtuous character, superior in all respects to that of his brothers, that he had been the only one of Noah's descendants permitted to retain the unspoiled, original language.

1. The ſtate of n.an previous to the formation of Eve and his eſſential modes. 2. His compound ſtate or the noneſſential modes and diviſion into parts and actions. 3. Emblems of concupiſcible appetites, innate parental traces, energies and paſſions acquired by the fall. 4. The ſtate of man and woman after the fall, as enchanted and confined to place or matter. 5. The Serpent, an emblem of ſpeech. 6. A theta inſtead of the Coptic kei, an emblem of man's primitive ſtate, &c. 7. Birds; but the round u is made uſe for the Coptic e. 8. Beaſts and Bulls. 9. Fiſhes. 10. Twigs and trees. But more of this hereafter.

And as all letters are thus deriveable from the parts of man, reſembling all other things, Adam might be very well inſtructed in their uſe in paradiſe;—And the diviſions of time appear to have been made from the days of the creation. See the former treatiſe.

Jones's page of 'sacred hiero-glyphs,' which he stated could not be adequately represented using printing types. (*Hieroglyfic*, London, 1763)

Jones's efforts to recover this language in the existing forms of English made extensive use of the analysis of the letter forms, which he considered the elemental radices of the tongue, claims grounded in little more than Jones's own projections onto the visual forms. The letter forms, he said,

227

were the smallest elements of writing and had the same effect upon the sight as vibrations had upon the ear. Adam had been instructed in their use, and these original forms had been in existence until Babel, but they were still in possession of the Celts by way of Gomer – whom Jones equated with Hermes and Mercury and 'other druids.' In analysing the letter forms, Jones derived a simple and incomplete cosmology of which the letters 'o' and 'l' were the primary elements. 'O' was an indefinite circle, signifying the universe while 'l' was an indefinite line signifying 'man in his state of innocence.' The 'o' and 'l' together or 'ol' was equivalent to 'all' of the human and cosmic universe. Jones saw in the sequence of the vowels or voices (which, oddly, he enumerated as the Greek vowels) a series of sexual symbols of male and female posteriors, member, clitoris, and so forth which he characterized as 'the impulse and springs of generation.' The number of letters in Jones's system was small, and he associated their basic symbolism with a part of speech he termed 'particles,' by which was meant a radical or fundamental element or simple, articulate sound. The 'T,' 'M,' 'N,' and 'L' were associated with images of a man's body upright, with arms or wings, thighs, in various postures, but there is no apparent system to his discussion – for instance, he indicated that 'R' was the image of animals and their parts – but he had no values for any letters beyond these few nor any indication of how these symbols had come into being.

In addition to particles, Jones's grammar included nouns, pronouns, and prepositions. These latter were all contained within the 'o' which was the universal expression for the circle of motion and extension and the 'i' he simply presented without comment. The 'T' was an 'i' with a transverse line and capable of bearing all directional prepositions in its glyphic form or combinations, as Jones indicated in a small diagram. Jones ended his *Hieroglyfic* with a table of 'sketches of creation,' or versions of the 'sacred hieroglyphs,' made up out of printing types. These he claimed were 'drawn from sacred characters made use of by Priests and Druids to preserve original, ancient and secret knowledge.'

Each of Jones's books contained a version of this cosmology, and the links he suggested between his claims for an original Celtic language and the analysis of letters or words were supported mainly by his assertions rather than by sustained argument, let alone convincing evidence. In *The Origin of Language* he elaborated a reduced creation myth in geographic terms: 'a' and 'e' recorded the division of the earth into land and water and so forth. He then articulated detailed discussions of a little more than a dozen letters which lent themselves to his position, occasionally interjecting etymological interpretations. The radical 'ar' for instance he claimed was equivalent to the Celtic word for earth and the basis of the word 'Ararat' which, in the language of Noah, signified 'returned upon earth.'

The same methodology employed by Jones to demonstrate the Celtic origin of language was used by L.D. Nelme to prove its English-Saxon

origin. Nelme stated that his aims in making this demonstration were to return to a pure language which would enable the spread of the Gospel. Like Jones, Nelme saw the 'o' and 'l' as the 'ol' or 'all' of English-Saxon radicals, the radix of all bodies and letters from which could be derived ten more radical symbols. To these symbols values were assigned which Nelme termed uniform and unchangeable, values which he claimed 'never failed' in the interpretive process known as 'decomposition.' Nelme's biblical history was essentially the same as that of Jones: he claimed Japhet as the original settler of Europe and the British Isles, his language was the only one not confused at Babel, and the 'poisoning' of the English-Saxon tongue had occurred through the invasion of the Normans with their Latin based language.

Nelme's diagram of the chart of radicals, from which all other letters could be made: from *An Essay towards an Investigation...*, 1772

Distribution of the Earth among the sons of Noah (from Nelme)

229

Nelme contributed certain unique propositions, however, such as the analysis of the Chaldaic aleph as a map of migrations from the central circle of Eden. Chaldea was the name given to the land of Abraham, and the Chaldaic characters with their forms composed of whole lines and whole circles described the rivers, ways, and roads by which migrations had taken place before the deluge. In the circle of the earth Nelme charted the divisions of territory in the usual distribution among the sons of Noah, this case merely identified as different cultural groups: the Celts, or Chosen Ones, the Scythians or Shot-Out-Ones, and the Pelagians who took the name Etrurians.

The Chaldean *aleph* as a map or chart of the movement of people out from the Garden of Eden (from Nelme)

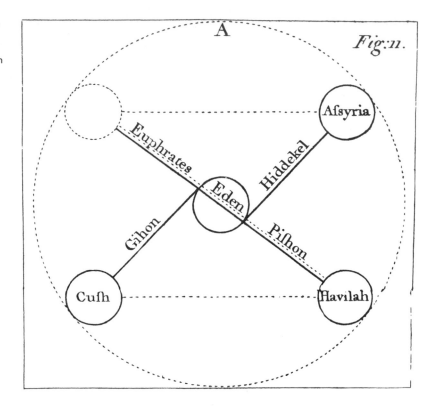

Nelme's image of the Ogham alphabet as a combination of his radicals (from Nelme)

Inscription on ancient Etruscan vase, showing primitive alphabet of Celts (from Nelme)

Celestial, Hebrew and Radical alphabet showing correlations (from Nelme)

Signs	Values for the Radicals
I	symbol of altitude, a rod or staff in natural state, sceptre, river, branch or tree
O	circle, symbol of horizon, rod or staff bent around, boundary of sight
⌒	dislocated orb, serpent hissing, radical ideas of similitude
∧	dislocated line, mountain, Ararat, chevron
b	line to circle, cut from the West, as a fixed place, East, possessed by sons of Shem, most glorious part of the world
c	chasm of circle, left after (b) was cut off, West as inheritance of Japhet
d	West of circle, lath, central part, Ham deemed unworthy
n	unity, negation, possession of Ham
u	first part of the division, fourth end of lath, possession of Cush, deformity, limitation
E	height and utility, egg, eye, island
⌒	union of (I) to (C) to (E) to (M) = increase, compound as in (ma) or (man)
r	the last radical, priority, gives life and spirit to the whole system, in Saxon Rod-icals res = thing

Nelme's List of Radicals and their Values

Nelme also had his chart of radicals and his analysis of their combinations. The 'I' was the rod, or staff in a natural state, the 'O' the rod or staff bent around to form the horizon or boundary of sight, a figure whose use he said had been prohibited among the Jews by the second commandment and as to be considered a sign of the Gentiles. Many of the other radicals were glyphs depicting geographical divisions or distribution, and from these combinations an entire lexicon of English-Saxon was derived, which he elaborated in the dictionary following his introductory text. Nelme also linked the Ogham tree alphabet known from Welsh inscriptions to the basic forms of the English-Saxon 'Ol,' though the full development of discussion of Ogham was made by another author, Charles Vallancey.

Vallancey, in his *Prospectus of a Dictionary of the Language of the Aire Coti or Ancient Irish*, claimed that the Irish had lost their ancient alphabet, which had consisted of 18 letters (or 16, depending on whether certain repetitive symbols were counted independently), all of which had been named for trees. The Ogham alphabet, which he claimed had been invented by Thoth at the time that the Israelites came into Egypt, retained some of these letters, their names and their forms. The resemblance between these letters and those of the Hebrews was apparent, Vallancey felt, and he stressed this connection by emphasizing the many tree metaphors associated with writing in the Old Testament: the 'branchy' vine, the three vineyards of the learned, the blossom of a branch signifying a letter, the thorn as a symbol of offence, and the image of orderly pruning as a symbol for the composition of verses. Having thus connected the image of writing and the symbolism of trees, Vallancey cited the recently found manuscript published by Joseph Hammer Purgstall in which an early medieval Arabic scholar had included a version of the Ogham tree alphabet.[10] The only explanation for this, Vallancey felt, was that there had been early contact and a common source for Ogham, Arabic, and Hebrew – a point he further demonstrated through pointing out the similarity of Hebrew letters and Irish tree names in an artful piece of philological contortionism.

The Iriſh Ogham or Tree Alphabet lately diſcovered in an Arabian Manuscript in Egypt.

מ	ל	כ	י	ט	ח	ז	ו	ה	ד	ג	ב	א	Chald:
													Arab:
													Egypt:
													Tree

ת	ש	ר	ק	צ	פ	ע	ס	נ				Chald:
												Arab:
												Egypt:
												Tree

	Chald:
	Arab:
	Egypt:
	Tree

| | Iriſh Ogham |

Charles Vallancey's chart showing the tree alphabet from Joseph Hammer Purgstall's newly published manuscript, and correspondences with Chaldean [Hebrew], Arabic and Egyptian, 1802

232

Vallancey's work linked the existing language of Ireland with ancient Celtic, ancient Persian, and also with 'Hindoostani, Arabic and Chaldean.' Vallancey thought that there was both linguistic and cultural evidence of these links, and that traditions, rituals, religious beliefs and the figures of deities or mythic figures were all shared by these disparate groups. It is perhaps useful to note that the concept of a single source for European language and culture had been given a boost among scholars and linguists at this time. It had become apparent that Sanskrit contained the oldest shared forms of Indo-European grammatical structures, and that it was closer to an 'original' language than the classical Greek and Latin, or even Hebrew. The excitement caused by this realization had resolved some of the frustrations which had met linguists attempting to reconcile linguistic change and diversity with biblical history or mythic tales of an original, primeval language. The distortions of the linguistic

concepts in popular form, however, lacked the philological soundness of this research and borrowed instead the casual comparative methodology employed by Vallancey and Gebelin.

Vallancey's genealogies were not always clear. He proposed that the Welsh were Gomerians, the Irish were earlier settlers of the region than the Welsh; old Irish was Punic, ancient Irish had been known as Bearla, which was the same as Pheni, i.e. Phoenician, and the Phoenicians were direct descendants of Japhet, also known as Indo-Scythians and so forth in a proliferation of rather muddled identities. Vallancey extended the reach of his linguistic connections into Asia, demonstrating that there were many verbal and cultural links with the people of India, particularly with respect to the practice of erecting *linga* stones as phallic symbols in religious enclosures. The Gaelic language, he went on, was the same as that spoken near Tibet, and as there was indisputable proof to the proposition that people who shared a common linguistic base were of the same stock, these geographically dispersed people nonetheless comprised elements of the same nation. This collapse of cultural identity with national identity was one of the most revealing of Vallancey's tenets, with its obvious attempt to legitimize claims to territorial sovereignty and provide grounds for resisting rule imposed from outside – namely, that of the Crown of England on the island of Ireland.

Jones, Nelme, Vallancey, had in common that they were defending the heritage of a group of people whose cultural identity they based on ancient history: the very antiquity of these claims was supposed to provide a legitimate basis for resisting incorporation into the still new United Kingdom of England, Scotland, and Wales. Their work also gave evidence of the tensions of religious identity; their continual dismissal of classical authorities as historians and also of Latin or Greek sources for English, Celtic or Saxon, made clear that there were strict lines drawn between members of the Latin Catholic church and that of the Anglicans. There were also strains of another persistent European theme, anti-Semitism, in the works of these writers, who dismissed the Hebrew origins of alphabetic writing on various grounds, making sure that their original Celtic or Saxon alphabets were not confused with the Chaldean alphabet of Abraham. In *The Remains of Japhet*, for instance, a work by James Parsons which shared many of Jones's ideas (that Gomer was the patriarch of Celts, Magog of the Scythians, that the sons of Ham were Phoenicians, Egyptians and Ethiopians, and that Adam had original writing and that after the Deluge there had been centuries without 'the use of letters'), Parsons made it absolutely clear that there was to be no confusion between Celtic sources for writing and Hebrew alphabets. He stated that such assertions in Greek and Latin writers could not be supported since the classical authors had no knowledge of the writing of antiquity – only the Irish did, through the Holy Writ. The Irish were Pelasgians and Homer, a Celt, had used the Pelasgi language, after which the Greeks mutilated the ancient tongue. This ancient language was Pelasgi-Celtic,

233

not Hebrew, and Parsons stated unequivocally that the Hebrew letters could not have been the originals because 'the forms of every letter are of a different air and complexion not at all reconcilable to any of the other tables of European letters.'

HEBREW LETTERS	CELTIC LETTERS
Aleph = some tree	Ailm = fir, plane, or oak
Beth = thorn	Beith = birch
Gimel = tree in moist ground	Gort = ivy tree
Daleth = a vine	Duir = oak
He = pomegranate tree	Eadhan = ivy tree, five-fingered leaf
Vau = palm tree	Ur = heath
Heth = small tree	Huath = white thorn
Iod = ivy	Idho = yew tree
Koph = bull rush, old vine	Coll = hazel tree
Lamed = twig, small branch	Luis = luis
Mem (no value)	Muin = vine
Nun = coriander	Nion = ash
Ain (no value)	Oan = broom or furze
Ts (no value)	————————
Sin (no value)	Sail = willow
Tav (no value)	Tine = fig tree

Vallancey's values for the Celtic Letters (Charles Vallancey, *An Essay on the Antiquity of the Irish language*, 1802)

Another writer determined the dispel any connection between the alphabet and culture of the Greeks and the Hebrew alphabet of the Jews was Philip Allwood. Allwood's version of the lineage of the Helladians, or people who settled Hellas, was that they had originated on the plain of Shinar, migrated into Egypt (where their language and customs became slightly modified through contact with the Mizraim), and thence into Greece. Allwood called these people Ammonian, and linked them to the Cuthite shepherds who had migrated into ancient Egypt to an area near Thebes. These were the people who had possessed the first language of humankind, a primitive, expressive language. The figure of Palamedes, who figured in classical accounts as either inventor or importer of the 16 letters of the Phoenician alphabet adapted to the Greek language, was described by Allwood as 'P'Al'Am-Hades,' a figure who combined the mythic identity of Ulysses elements of biblical tales of Ham. His elevation to the status of a deity in ancient accounts was proof of the value placed upon writing 'whose discovery was considered the highest effort of the human intellect.'

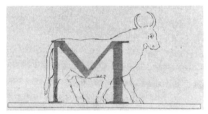

Philip Allwood's drawings of the derivation of letters: 'A,' 'pi' 'M' and 'omega' (*Literary Antiquities of Greece*, London, 1799)

Allwood's account of the dispersal of the Cuthites, Pelasgi, descendants and Shem, Ham and Japhet, was unique mainly for its insistence on a link between the people and culture of ancient Egypt and that of the Greeks. His description never completely clarified the details of geography in the way that Nelme's or Jones's had, and he included such baffling and apparently contradictory analyses as the decomposition of the term Olympia into 'Al Ompi A' meaning 'Om-Pi' or the Oracle of Ham – though Ham was traditionally the son of Noah cast into disregard, and exiled in legend to the farther reaches of the African continent. Like Parsons, Allwood disparaged the contribution of the Jews, claiming that they had been limited in their diffusion and disdained among the people with whom they had come in contact. The sources of the forms of the alphabet, therefore, were to be found among traditions of the ancient Egyptians: the initial *aleph*, for instance, recorded the form of a simple device used to gauge the height of the flood waters of the Nile on a yearly basis, the *pi* was derived from the portals of a temple, the 'M' from the shape of the cow holy to Isis and essential to agricultural life, and the *omega* was a pure hieroglyphic image of a serpent curled around the globe. It is not clear what advantage Allwood sought to gain from this particular construction of the history of Greek culture and identity, since the distinction he seemed intent on making was between the Semitic people and the Greeks; but it did allow for the Greek culture to be grounded in what he called a 'fable' of 'perfect innocence' and to be connected with the Egyptian tradition, still revered in the late 18th century as the source of ancient wisdom.

The Occult Traditions

236

Interest in the occult use or properties of letters was far from absent in the 18th century. Kabbalistic activities continued and in the Christian community became bound up in the development of secret societies such as the Freemasons and Rosicrucians. The iconography of these cult groups made elaborate use of Hebrew lettering and demonstrated the same respect for the authority of the holy scriptures as for Christian teachings. Both the Masons and the Rosicrucians made free and rather unsystematic use of what they considered ancient wisdom – borrowing from Hermetic, kabbalistic, alchemical, Egyptian and other traditions without hesitation. As so-called secret societies, these groups had restricted membership, determined through professional or social affiliations (or both), they defined their aims in terms of a mixture of Christian faith and an intellectual inquiry for profound 'wisdom' associated with ancient occult traditions. They saw themselves as a spiritual brotherhood determined to better the condition of humankind through knowledge of divine revelation. These sects contributed little new information on the history of the alphabet, mainly distorting earlier traditions to suit their need for

ritual signs and arcane symbols in their cult practices, initiation ceremonies and publications.

As the distinctions between empirical science and alchemy had already displaced the occult tradition from its claims to supreme authority, so the increasing understanding of ancient cultures intensified the distinction between the scholarly 'orientalists' and the masonic cultists' version of esoteric knowledge. Nonetheless, the boundaries were not so distinctly drawn that a well-respected scholar, such as Gebelin, could not participate in the Freemasons and still retain the highest respect among his contemporaries. In fact, an incident involving Gebelin and the Italian occultist Giuseppe Balsamo, Count Cagliostro, demonstrates that the conflicts acted out were less frequently to differentiate scholarly from esoteric practices than they were to preserve credibility and power in the wider sphere.[11]

When Cagliostro arrived in Paris in the early 1780s he created a sensation. His reputation for possessing powers derived from knowledge of Egyptian antiquity brought him tremendous success. His popularity penetrated as far as the royal Court, as he gained the special attention of a lady-in-waiting to Marie Antoinette. He established a 'temple' in Paris under the name Hathir-Schatha, Prince of Sages, and entertained his select circle (which included women 'by the special permission of Isis') with fantastic tales of enchanted, magical lands.

Cagliostro's magic alphabet (P. Christian, *Histoire de la Magie*, Paris, 1872)

Rosicrucian cross with Cagliostro's alphabet on it (P. Christian, *Histoire de la Magie*, Paris, 1872)

Fearful of the considerable influence wielded by this foreign seer, the aristocratic French Freemasons raised a protest against Cagliostro's claims to authority. An interrogation was scheduled in which the esteemed Gebelin was to be given an opportunity to unmask Cagliostro for a charlatan. In the course of the public interview, Cagliostro not only demonstrated his intimate understanding of the Egyptian traditions which distinguished his occult practice, but engaged in a series of divinations involving a magic alphabet in which he foretold the death of Louis XVI, Marie Antoinette, and the rise and fall of Napoleon Bonaparte, giving dates, names, and details of the manner and place of their triumphs and defeats. The company were so impressed by Cagliostro's demonstration, which took place in May 1785, that they conceded the superiority of Egyptian masonry to that of the French order. This concession did little to save Cagliostro from a series of misadventures with the French authorities, his banishment, and eventual undoing at the hands of Church officials in Rome four years later.

The Masons' involvement in the events of the French Revolution may have added retrospective detail to this account, but whatever the truth of this tale, it points up the seriousness with which divinatory practices, esoteric knowledge and symbolic interpretation were regarded within elite circles of European power. John Locke may have defined new directions in philosophy and language studies with his discussion of the arbitrary nature of linguistic signs and their dependence upon social context and training, but the desire to see in the letters of the alphabet a set of arcane glyphs potent with symbolic value had remained a mainstay of intellectual thought in the 18th century, alongside the interpretations of the letters as natural images or as the encoded record of human history.

IX

THE ALPHABET IN THE 19TH CENTURY: ADVERTISING, VISIBLE SPEECH, AND NARRATIVES OF HISTORY

Arguably the single event most significant for the history of writing in the 19th century occurred at its very beginning: the decipherment of Egyptian hieroglyphics in the years immediately following the discovery of the Rosetta Stone in 1799. Though credit for this work is generally granted to Jean-François Champollion, his success was not by any means the result of mere individual effort. The decipherment was based on decades of developments within the scholarly community concerned with a study then known as 'oriental languages' and the contributions of Thomas Young and Silvestre de Sacy were particularly important to the project. Their decipherment of hieroglyphics put the myth of the enigmatic visual image to rest once and for all within the scholarly community, though the popular image of the hieroglyph remained associated with the qualities of mystery and esotericism.

But the significance of Champollion's much acclaimed achievement for historians of writing lay in the fact that the visual features of hieroglyphics, so long considered the essential key to their meaning, were now subordinated to their role as surrogates for sound values and words. This realization, that even that most intriguingly visual of all writing systems, hieroglyphics, conveyed meaning by representing the sounds of a spoken language had a profound impact on the status of the visual characteristics of other written languages. If hieroglyphics did not produce meaning by direct appeal to the eye, then the far less glamorous forms of writing, such as cuneiform or Cretan scripts, were that much less likely to be granted importance as visible images. The faith that the meaning of ancient writing could be understood simply through visual means was greatly diminished as a result of these developments. In general, the philologists and linguists of the 19th century concentrated their research on structures internal to individual languages or language groups, analyzing their grammatical structure and their development over time.

Curiously, however, the 19th century was also the period which witnessed the fullscale adoption of the theory of pictorial origins of the alphabetic forms – either linked to hieroglyphic precedents or to the objects associated with the letternames. This theory dominated narratives used to explain the history of the alphabet and its integral relation to the ancient Semitic culture in which it had originated. The increase in archaeological activity by European teams in the Near East, Middle East and areas of Crete, Greece and Asia Minor provided massive amounts of new material for constructing the chronology of ancient history, a situation which continued in the 20th century as well. Improved methods of dating

Mould for hand-casting of hot metal type: Charles Thomas Jacobi, *Printing* (London: George Bell and sons, 1908)

Typecasting machine: Charles Thomas Jacobi, *Printing* (London, George Bell and sons, 1908)

240

materials from excavations offered evidence which challenged the specifics of biblical chronologies, if not their cast of characters or events. If the 18th-century debates on origins and development had posed theology and science as equal contenders for authority, then the 19th-century investigations of writing continued this debate in terms of creationist and evolutionary models. Increasing evidence of the gradual evolution and transformation of writing systems, in particular the alphabet, had to be either reconciled with accounts in the Scriptures or else established on entirely new intellectual and conceptual grounds. The very idea that there might be a manner of narrating history without recourse to scriptural authority was a radical departure from even the sophisticated insights of 18th-century historians aware of the social and cultural function of alphabetic writing. Many 19th-century historians of the alphabet chose a middle path, choosing to retain some traces of biblical imagery in a vague chronology of the historical development of letter forms, simply overlooking the contradictions inherent in putting archaeological evidence next to scriptural authority.

The mechanization of printing processes in the 19th century involved the invention of high speed presses and mechanical devices to automate every aspect of type setting, casting and distribution. The effect of these changes was a dramatic increase in both the rate at which materials could be printed and the amount of material which appeared in print. The first invention essential to this change was an innovation in paper making: in 1806 Henri Fourdrinier designed a machine capable of producing a continuous roll of paper, which could move through a mechanized press at a speed way beyond that of individual sheets. While the rate of 250 sheets an hour had been considered fast production on a hand-fed press, the use of roll paper in combination with steam driven printing presses (first used in 1814 in the offices of *The Times* in London) pushed that number into the thousands. By the mid-20th century, newspaper web presses using letterpress methods were capable of producing 70,000 copies of a 96-page eight-column newspaper in an hours time on machines which differed only slightly in design from those in use a century earlier.[1]

But while the rate of printing was dependent on innovations in paper production technology and power driven presses, it remained limited by the rate at which metal type could be cast, set and redistributed for recomposition. The methods of cutting metal punches, making matrices, and casting type in hand-molds which was in place into the mid-19th century were in almost all particulars the same as those used in the shop of Johann Gutenberg. Composition was done letter by letter, casting as well, and distribution of type back into the cases followed this same model. In addition, since type was fragile it wore out or broke frequently and thus a means of readily available replacement was sought. Finally, handset forms could not be accommodated to high-speed presses. These, it became evident, would rely on cylinders passed over a continuous roll of paper, rather than the flat, locked up forms produced by traditional typesetting.

The problems faced were thus to find a means of rapid casting, rapid setting, and a substitute for the flat forms of traditional type.

The first improvements came in the area of casting, with power used to force the hot molten lead into the moulds, replacing the ancient method of using a hard shake of the wrist to throw the metal into the matrix. David Bruce, responsible for this innovation, devised a continuous casting machine. By 1834 he could produce a row of the same letter through mechanized processes. But while this casting machine produced a quantity of type for replacement purposes, it did nothing to speed up the processes of setting and distribution which were still done by hand, letter by letter. These problems were resolved only after invention of the typewriter in the 1860s and early 1870s, which provided the first means of keyboarding a rapid sequence of letters. By linking the keyboard mechanism to a casting machine, two means of fabricating composed type were devised: Otto Merganthaler's Linotype machine and Tolbert Lanston's Monotype machine. Merganthaler's machine, in production and use by the 1880s, cast one line of type after another using brass matrices.[2] These were automatically redistributed into storage magazines after each line was set, making possible continuous production of cast type which was already composed. Distribution was no longer an issue – the slugs of metal were simply melted down when the job had been printed, and then recast. Lanston's machine, also in production by the late 1880s, cast one letter at a time, but had certain aesthetic advantages over linotype.

Though linotype and monotype were capable of fulfilling the casting and composing needs of printers, in part by turning the printshop back into a foundry, they could not provide a solution to the more fundamental problem: the need for a supply of steel punches. All of these casting devices relied upon brass matrices which were themselves produced with the use of steel punches – the handcarved metal instruments on which the form of the letters was carved as the first stage of the design and casting process. These punches were also fragile, and frequently had to be replaced. Their production remained the province of highly skilled craftspeople and the hand process could not keep up with the demand. Linn Boyd Benton's invention of the pantographic punch cutting machine in 1884 thus provided the last piece of technology necessary for rapid production of high quality type. Benton's machine was also applicable to production of wood type, generally used for larger display sizes and elaborate, decorative work.

Another invention which contributed to highspeed production was the stereotype, a means of duplicating whole pages of set type so that they could be curved onto the cylinder of a high speed press. Stereotyping, first experimented with by Lord Earl Stanhope around 1799, was developed in the 1840s and perfected some years later as a casting method.[3] Originally using papier maché, and later a resinous wax material, stereotyping was a mould casting process. The soft material was poured onto a standing form of type, let harden, and then used as the matrix for casting a flexible metal

241

sheet of an entire page. These flexible sheets could be wrapped around the cylinders of what was termed a 'perfecting press,' one which printed both front and back of a roll of paper simultaneously. Stereotypes, and the related electrotypes, were also used to make duplicates of forms which could be shipped to geographically dispersed plants for printing. This was a method especially popular with advertisers, who preferred not to have their designs either recast or reset for each publication.

The impact of these combined inventions was a rapid escalation in the quantity of materials in print. But these mechanical innovations had an effect upon the design of letter forms as well. Linotype faces had to be recut to adapt to the fit of the brass matrices used to cast type in lines. Letters had to fill out the full width of the matrix in order to align with each other properly. Such designs at first lacked some of the subtlety associated with that of type set by hand, but gradually linotype faces acquired their own aesthetic sophistication. The use of the pantographic cutter to replicate the steel punches at the basis of type production made for more regular results than those achieved through traditional handcutting. Here again the technological means of production came to be an aspect of the aesthetics of letter forms, an integral feature of their identity, reflecting and embodying the mechanization characteristic of the period.

Typography: Advertising, Display and Nostalgia

The major force influencing 19th-century typographic design was the impact of industrialization. Mechanization of the printing trade resulted in the substantially increased volume of work produced by high speed printing presses and industrially made paper, both often of lower quality than any employed in printing up until that time. Not only were huge numbers of books and journals printed, but increased amounts of publicity and commercial printing appeared alongside the more traditional religious, literary and journalistic forms. In response to the needs of the burgeoning business of advertising, tremendous numbers of new type faces were designed whose capacity to engage the eye of the ever-more saturated reader was amplified through decorative means. Large sized type, engraved in wood by mechanical processes, was used to produce huge posters which papered the walls, kiosks and other surfaces of the modern urban environment while the techniques of display advertising made their impact in the pages of most journals and newspapers.

In an additional boost to aesthetic invention, the flexibility of lithographic reproduction, used in mass production cylinder presses by mid-century, freed professional lettering and calligraphy artists from the restraints imposed by metal type. The imagination of designers expanded by quantum leaps in ever more dazzling displays of visual ingenuity and invention. In metal type as well the shaded, expanded, condensed, bejewelled and decorated forms of display types offered by the average job shop

Advertising showing use of
varied display faces

Advertising showing use of
varied display faces

Type specimen sheet showing
display faces

outstripped the modest offerings available in the past, permitting the most mundane of advertising circulars to be typeset with gaudy abandon.

Visual language overflowed the limits of intimate space, from the page of the book to the poster placard, and the engagement of public space and public readership through the seductive dynamics of display typography played a significant role in transforming the experience of language from that of a literary, legal or business transaction to one of overblown commercial persuasion succeeding through tactics of rhetorical inflation. In visual terms the results were an almost limitless proliferation of fantastically decorated faces. Typographic specimen sheets from the 19th century combined the richness of these new offerings with an eclectic vernacular vocabulary the end result of which were sheets which resonate across the space of more than a century with particular poetic and cultural suggestivity.

Improvements in printing technology made specific contributions to the historiography of writing through the publication of elaborate black-and-white or color reproductions of examples of unfamiliar scripts for both scholar and amateur. The works of Henry Shaw, with their detailed redrawing of manuscript lettering from the Middle Ages, were produced in the mid-19th century, as were the magnificent volumes of Joseph Balthazar Silvestre. His 1841 *Paleographie Universelle* was unrivalled for its exquisite facsimiles of ancient and foreign papyri, cuneiform tablets, illuminated manuscripts or calligraphed documents from Egypt, India, the East and the Americas. Silvestre's work, produced with the collaboration of Champollion-Figeac, brother of the Egyptologist, was a testament to both the possibilities which printing offered to the scholar and to the existence of an audience for deluxe editions of significant scale concerned with the history of writing.

At the end of the 19th century another direction was defined in the domain of fine arts printing – which ultimately had an effect upon commercial design work as well. This was the revival of interest in older forms of letter and page design. Most marked in the work of designer and printer William Morris, these nostalgic reinventions of the tradition of the illuminated manuscript or Renaissance printing, with its complicated artisanal decorative borders, black letter type, and elaborate initial letters, became the distinctive style of the Arts and Crafts movements in England, Europe and the United States. This fine art imitation of older forms and the fantastic range of new display types used in advertising had in common a keen attention to the visual aspects of letter design and a conviction that the stylistic choices had some impact on meaning production. Not coincidentally, theories of synaesthesia – the interrelation of the senses in the varieties of aesthetic experience – developed in late 19th-century Symbolist art, literature and music. There were many writers and artists of the period who wrote of the 'color' of vowels, the 'power' of letters or their symbolic value. Texts by Victor Hugo and Arthur Rimbaud are among the most well-known instances of such artistic exploration, but the

243

work of Paul Claudel and others also reflected this interest into the early 20th century.[4]

Page from William Morris's, *The Earthly Paradise*, 1888, showing 19th century printed version of manuscript book

Hugo, for instance, tried to create a 'hieroglyphic' reading of the letters of the alphabet.[5] He saw in the letter 'Y' a tree, the branching of two rivers, two roads; and also saw in the 'Y' the head of a donkey or cow (though surprisingly he did not see a steer or ox with horns); the 'Y' was also a glass on its feet and a supplicant with arms raised to the heavens. 'A' was an arch, the peak of a roof; 'D' was the back; 'B' was one D on another, thus, a humpback; 'C' was a crescent, croissant, and the moon; 'E' was the foundation, the right foot, the entire basis of architecture; 'F' was a gallows, a gibbet and a fork; 'G' was a horn; 'H' the facade of a building with two towers; 'J' the cornucopia or horn of plenty; 'K' the angle of reflection equal to the angle of incidence; 'L' the leg and foot; 'M' a mountain, or a campsite with tents side by side; 'N' was the door barred with the diagonal stroke; 'O' was the sun; 'P' was a porter carrying a load; 'Q' was the rump of an animal with a tail; 'R' was the porter leaning on his

staff; 'S' was a snake; 'T' was a hammer; 'U' was an urn; 'V' a vase; 'X' crossed swords; and 'Z' was God, though no visual image was invoked to explain this. Hugo's hieroglyphic alphabet had no systematic logic, nor did it expand into a code for interpreting words as combinations of these elements. It was purely a subjective exercise, a projection of images through a process of personal association, onto the graphic forms. Schematic in the extreme, the letters of the alphabet lent themselves to any number of such projections.

The Symbolist poet Stéphane Mallarmé, proposed an equally idiosyncratic and imaginative reading of the letters in his text titled *Les Mots Anglais*, a metaphysical study of the powers of English words. Mallarmé, writing in the last decades of the 19th century, was best known to later generations for his typographically complex work, *Un Coup de Dés* (*A Throw of the Dice*), but to his contemporaries the fuller dimensions of his work on music, language, and his dramatic texts were all influential and familiar. Mallarmé's interpretations of the alphabetic letters had in common with Hugo's that they derived from no source but his own imagination and yet purported to provide an insight into the symbolic value of the letters and their significant function within words. Many of his values have apparent origins in the form of the letters he was analyzing: the 'W' instills a sense of oscillation in the double wave of the letter; the 'F' communicated a sense of flying, a projectile striking space, transposed by rhetoric into the record of this sensation in the very word for flight; 'J' expressed a quick, direct action; 'K' was the image of knottiness or joining, knitting together. Through a combination of associations, Mallarmé blended the iconographic value he perceived in the letter with English words in which it was the first letter. Mallarmé believed that the letters were the 'bones and tendons' of language, and that his interpretive practice had recovered original, Anglo-Saxon roots which were the substrata of the ordinary life of words. In point of fact, Mallarmé had made an assessment very typical of the late 19th-century Symbolist sensibility, rather than a scholarly discovery of etymological radicals, and was synthesizing the visual characteristics of the letter in its graphic form with associations invoked by the specific English vocabulary he had selected.[6]

245

Penmanship and Business

The virtuoso display of calligraphic skills which had become characteristics of artful penmen in the 18th century had little application to the daily activities to which penmanship was put as a basic tool for the clerks, business people and secretarial staff of the 19th-century world of commercial life. George Bickham's *Universal Penman* was already more of a practical manual and less of an extravagant showpiece than that of some of his contemporaries – for whom cultivating the tastes of an upper-class clientele more concerned with decorative devices than simple legibility was

Proper writing posture for hand and pen

Good and bad postures for writing

Measured analysis of letters

All from Platt R. Spencer, *New Compendium of Spencerian Penmanship*

paramount. But one has only to compare the plates in that work with the manuals of one of the principle writing masters of the 19th century, Platt R. Spencer, to see the changes in mainstream attitudes towards penmanship.

Spencer was interested above all in what he termed 'practical writing.' This was the development of skills useful to anyone entering the world of business, education, law, journalism or other arena of activity dependent upon literacy. Spencer first developed his methods of teaching handwriting at the age of 15, in Kingsville, Ohio. But it wasn't until 1852 that he set up an institutional basis from which to implement his pedagogic program, the first Spencerian Commercial College. A few years later he established the 'Spencerian Log Seminary' housed in a log cabin near his home in Pittsburg, which served as a summer school for writing, while other branches of the 'International Chain' of Spencerian institutions proliferated, accompanied by a corresponding increase in publications disseminating his method. Beginning in 1848 he produced a tremendously successful series of manuals on Spencerian or 'Semi-Angular Penmanship.' With their elaborate instructions on the correct posture, gestures and materials for writing, as well as their systematic development of skills in forming and spacing letters, these were a major fixture in business colleges and curricula throughout the latter half of the century.

For Spencer, as for other teachers of handwriting, the disciplining of the hand in the development of good habits for writing was tantamount to a course in moral righteousness, and the rhetoric which wove through his manuals made clear that slovenliness of handwriting was no less a sin than any other major fault of character. But the benefits he promised from his method were more rooted in the material world. The introduction to his *New Compendium of Spencerian Penmanship*, published posthumously by his children in 1887, listed among the motives for learning penmanship that it led to 'promotion and advancement' in the world of business from the very first well-penned letter to the establishment of a place within the business hierarchy. Spencer hinted that 'a legible, rapid, elegant handwriting' would net a worker greater recompense within a pay scale and lead to other 'pecuniary advantages' by providing a competitive edge. Good penmanship was no longer the singular privilege of the wealthy, but the necessary tool for office workers at every level of the business world. Spencer was not alone in promoting a course in practical penmanship, the names and numbers of his rivals were many, including one George Eastman of Rochester, who asserted that it was he who was the inventor of Spencer's 'semi-angular hand.' Penmanship was not merely an aid to business, but was big business itself, with the numbers of students enrolled in Spencerian programs alone numbered at more than 12,000 a year in the 1860s[7] – a figure which does not reflect the total number of school children involved in learning script forms of penmanship through various methods.

Decorative calligraphy continued to find its practitioners as well, and the beautifully achieved flourishes of handdrawn lettering, produced for

Three images from George
Becker, *Ornamental
Penmanship*, 1854

publication from copperplate engravings, provided models for the highly dextrous. An example of such publications was the product of another commercial penman and pedagogue, George Becker, who gave his title as Professor of Drawing, Writing, and Bookkeeping in the Girard College in Philadelphia. Titled *Ornamental Penmanship. A Series of Analytical and Finished Alphabets* (1854), Becker's book provided both specific examples of highly flourished and decorated hands, and some basic principles on which they could be constructed. While his drawings had much in common with the elaborate forms of both display faces of metal type and the ornate forms of lettering used in lithography, they had the additional delicacy of the copperplate medium to emphasize the flickering contrast of light and heavy strokes.

Spencer and Becker conceived of letter forms very differently, a fact which is evident in their different emphases in letter production. Spencer stated repeatedly and unequivocally that the most important aspect of good penmanship was the disciplining of motor activity. The skills which he used to train students in his method thus treated the letters as complex forms built out of a series of repetitive movements, each of which must be mastered as an act of muscular control. The expressive potential of an individual's movements became the conceptual premise for another field which came to maturity in the 19th century, graphology: by the century's end the exhaustive detailing of characteristics associated with any and every possible drawn version of a letter form had become the basis of a vast number of publications used in fields as diverse as business, psychology and parlor game entertainment. Becker, on the other hand, in his 'analytical' approach to decorative letters, broke them down into component graphic parts as if in imitation of the Renaissance constructed alphabets. He treated the letters as purely graphic elements, images on a surface whose creation was an effect of design decisions determining shapes, borders and patterns. Thus as handwriting became increasingly linked to the cult of individual personality, the proliferation of graphic styles in printing types provided increasing possibilities for the social production of meaning in relation to style through associations of elegance, authority, popularity, humor or dependable solidity.

247

Phonography, Phonetics, and Pedagogy

While good handwriting was a standard business skill, elegant, well-formed writing could not serve all the needs of the commercial world with its myriad of rapid transactions and proliferating activities. The demand for swift, accurate methods of recording spoken language developed in the realm of journalism and law, as well as in the corporate meeting room and sales manager's office. Various methods of shorthand writing had been created since antiquity, as has been mentioned before, but in the 19th century these became regularized, while they intersected with areas of

History of shorthand in chart form by William Upham

1	John Willis, 1602	
2	Edmond Willis, 1618	
3	Witt, 1630	
4	Henry Dix, 1633	
5	Mawd, 1635	
6	Thomas Shelton, 1641	
7	Thomas Shelton, 1650	
8	Theophilus Metcalf, 1645	
9	Jeremiah Rich, 1669	
10	John Farthing, 1654	
11	Job Everardt, 1658	
12	Noah Bridges, 1659	
13	William Mason, 1672	
14	William Mason, 1682	
15	William Mason, 1707	
16	Elisha Coles, 1674	
17	William Hopkins, 1674	
18	Lawrence Steel, 1678	
19	Abraham Nichols, 1692	
20	Francis Tanner, 1712	
21	Philip Gibbs, 1736	
22	Aulay Macaulay, 1747	
23	Peter Annet, 1750	
24	Thomas Gurney, 1753	
25	Henry Taplin, 1760	
26	Thomas Stackhouse, 1760	
27	David Lyle, 1762	
28	Alphabet of Reason, 1736	
29	Mark Antony Meilan, 1764	
30	John Byrom, 1767	
31	Holdsworth and Wm. Aldridge, 1768	
32	R. Graves and S. Ashton, 1775	
33	Wm. Williamson, 1775	
34	Thomas Hervey, 1779	
35	W.J. Blanchard, 1779	
36	W. J. Blanchard, 1786	
37	John Mitchell, 1782	
38	Michael Nash, 1783	
39	Samuel Taylor, 1786	
40	William Graham, 1787	
41	William Mavor, 1789	
42	Thomas Rees, 1795	
43	John Crome, 1801	
44	Richard Roe, 1802	
45	Archisden, 1632	
46	Ralph Fogg (Salem), 1636	
47	(Printed at Boston), 1809	
48	Thomas Towndrow, 1837	

interest to linguists and teachers. The history of spelling reform, phonographic shorthand, phonetic analysis, and the development of an alphabet suitable for both non-Western and Western languages were all interrelated in the 1800s, with solutions in one realm often offering possibilities in another.

A shorthand system can be a system for representing words in shortened form as a single sign, known as a *lexical* or *alphabetic* approach, in which case it is specific to a particular language. Or it can be a system for representing the sounds of speech, a *phonographic* approach, in which case it has the potential to be applicable to a wide range of languages, dialects, and speech situations. Most of the classical systems of shorthand notation, such as that reputedly developed by Cicero's slave Tiro, were alphabetic in nature. Known as *notae*, these systems were in use up through the 9th or 10th centuries in Europe, but then largely disappeared from use. One 19th-century historian of shorthand stated that the habit of abbreviation and use of *notae* in manuscripts had become so widespread as to obscure meaning and prompt the publication of official edicts prohibiting this practice.[8] Alphabetic shorthand systems reappeared in the court of Elizabeth I of England, of which the most famous published version was authored by Timothy Bright. These systems made use of glyphic marks for frequently used words, relying on notational designs to mark vowels or record the skeletal form of speech by writing only the consonants in shorthand code for the rest of the record. But they were cumbersome, because they required extensive memorization of these forms and were both inefficient and frequently inaccurate. In the 18th century a move toward a phonographic system was made by John Byrom in his *Universal English Short Hand*. Byrom grouped his glyphic 'letters' by the affinity of the sounds of the words they represented, while the later works of a Mr Richardson in London and then a M. Blane of Paris both took up musical metaphors – Blane quite literally by using staffed notepaper. None of these systems ever achieved widespread use, and the most popular shorthand system of the late 18th century was that of Samuel Taylor. Published in 1786 it was the system in which Isaac Pitman was instructed as a young man. Brief and more simple than most lexical shorthands, the system still had shortcomings in terms of its legibility, and Pitman proposed his own Phonography as an improved method in the 1830s.

Pitman's system was both simple, complete, and logical, based on a correlation between the sounds of speech and conventional spelling transformed into a set of rapidly produced shorthand marks. The system thus had far fewer marks than a conventional lexical system containing an extensive vocabulary of individual glyphs. Essentially, Phonography was an abbreviated, rapidly written alphabet, with certain contractions. Pitman's understanding of phonetics, however, was still primitive at this point. He divided his marks into 'consonants' and 'vowels' – categories familiar to the wide public which adopted his system but inadequate for advanced work in linguistics. The success of Pitman's shorthand can be

249

The engraved plates of Pitman's *Stenographic Soundhand*, 1837

accounted for by the fact that it was based on such familiar conceptual categories. The system was also relatively easy to learn because it was based on fewer characters than any previous system. The basic elements were a set of marks for consonants (a straight line in one of four directions, a quarter circle in one of eight positions) and marks for vowels which could be eliminated in a rapid skeleton notation for texts which were to be immediately transcribed into longhand.

Isaac Pitman's 'Penny Plate' containing all fundamentals of his phonographic shorthand, 1840

Pitman's system, like Spencer's in his arena, was a tremendous commercial success. Pitman sold many copies and many editions of his works. The first of these, titled *Stenographic Sound-Hand* (1837), was printed in an edition of 3000 copies whose production was closely supervised at every stage from the printing to binding by Pitman himself.[9] Within a few years, having made improvements on his system and renamed it Phonography, Pitman opened the 'First Phonographic Institute,' in Bath. By the time of the publications in 1839 and 1840 of the single sheet 'Penny Plate' versions of his 'new and natural system of shorthand,' his system was well-worked out. Pitman established a journal and a series of manuals designed to instruct a student in the gradual acquisition of a system which

must have looked rather daunting to the recipients of the microscopically minute engraving on the Penny Plate version of the system.

Pitman's shorthand had the great advantage that it was adaptable with only slight modifications to most European tongues, and could even be extended to accommodate other languages. For example, this flexibility was demonstrated in a tiny publication which used Pitman's system to write Esperanto. Pitman's Phonography was based on a fixed, logical set of relations between sounds and characters, which had no visual relation to alphabetic forms. But Pitman's interests in both the phonetic character of English, and in the difficulties which arose from trying to teach school children to read and write a language whose orthography was so idiosyncratically irregular, led him to extend his efforts beyond the realm of shorthand and into the domain of pedagogy. Using some of the profits he realized from the sale of his shorthand manuals, he helped finance a campaign for spelling reform in English. At this juncture he began collaborating with the linguist Alexander Ellis whose own work had grown out of the need to develop a phonetic notation system accurate enough for technical linguistic analysis.

6 — TABLE OF CONSONANTS.

Letter	Character	Name	As in	
P	\	po	Rapo	Pomo
B	\	bo	Rabo	Boto
T	\|	to	Bato	Tono
D	\|	do	Ledo	Domo
Č	/	čo	Sučo	Čeno
Ġ	/	ġo	Kaġo	Ġeno
K	—	ko	Kuko	Kafo
G	—	go	Pago	Gařo
F	\	fo	Bufo	Foko
V	\	vo	Lavo	Vilo
C	(co	Paco	Colo
S)	so	Kiso	Salo
Z)	zo	Nazo	Zono
Ŝ)	šo	Fišo	Šalo
J)	jo	Ažo	Juro
M	⌢	mo	Limo	Mano
N	⌣	no	Pano	Napo
L	(up	lo	Kilo	Loko
R	(up / down	ro	Maro	Rado
J	(up	jo	Fojo	Jugo
Ŭ	... u short			
H	ʔ up / down	ho	Mirho	Hoko
Ĥ	ʃ down	ho	Eĥo	Ĥoro

(Left margin labels, rotated: Explodentoj · Kontinuantoj · Aspirantaj Koalescentaj Likvidaj Nazaloj)

7 — TABLE OF SINGLE AND DOUBLE CONSONANTS.

		L HOOK		R HOOK		N HOOK		F & V HOOK	
P	\	pl	\	pr	\	pn	\	pf	\
B	\	bl	\	br	\	bn	\	bf	\
T	\|	tl	ʃ	tr	ʃ	tn	⅃	tf	⅃
D	\|	dl	ʃ	dr	ʃ	dn	⅃	df	⅃
Č	/	l	/	čr	/	čn	/	čf	/
Ġ	/	...		ġr	/	ġn	/	ġf	/
K	—	kl	⌐	kr	⌐	kn	—	kf	—
G	—	gl	⌐	gr	⌐	gn	—	gf	—
F	\	fl	⌒	fr	⌒	fn	⌒	...	
V	\	vl	⌒	vr	⌒	vn	⌣	...	
C	(...		cr)	cn	(...	
S)		sn)	...	
Z)	...		zr)	zn)	...	
Ŝ)	šl ⌣ up down		šr ⌣		šn ⌣		...	
J)			jr ⌣		jn ⌣		jf ⌣	
M	⌢	ml	⌢	mr	⌢	mn	⌢	...	
N	⌣	nl	⌣	nr	⌣	nn	⌣	...	
L	(...		...		ln	(...	
R	⌐ up / down		rn	/	rf	/
J	⌣		jn	/	jf	/
Ŭ	...								
H	ʔ		hn	⌐	hf	⌐
Ĥ	ʃ	

251

Pitman's system adapted for Esperanto, around 1840 (George Ledger, London, 1890)

In addition to receiving an impetus from advocates of spelling reform, the production of new phonetic notation systems had been in part stimulated by missionaries, politicians and those involved in extensive contact with non-European linguistic groups. The interests of these various groups overlapped in their recognized need for a notation system which, like Phonography, would be based on a clear relation between sound and graphic sign, but based on more sophisticated phonetic insights. The advocates of spelling reform realized that in order to be practical, their proposals must almost of necessity be based upon the existing contents of the printer's case – or at the very least be able to be accommodated with very little modification of these means by the use of diacritical marks or a

handful of additional characters. But the disadvantages of relying on the conventional alphabet were manifold, since, in fact, it was this mismatch between an essentially Latin writing system and the heterogenous English language which had caused the very difficulties spelling reformers were intent on resolving. Published proposals for spelling reform in English can also be traced to the era of Elizabeth I, in the work of John Hart and subsequent authors such as Alexander Gill and Charles Butler, who struggled with the difficulty of making a simple correspondence of one sound to one sign. Again, the ambitions of phoneticists escalated beyond those of spelling reformers because of their increased contact with foreign languages containing sounds unknown in English. One 18th-century proposal, by an American named Dr William Thornton, aimed to create a mark for every sound the human voice could possibly produce, even those tones, clicks and other features never employed for producing of linguistic meaning in European languages.

THE PHONETIC ALPHABET.

The phonetic letters in the first column are pronounced like the italic letters in the words that follow. The last column contains the names of the letters.

CONSONANTS.

Mutes.

P	p	*rope*	pi
B	b	*robe*	bi
T	t	*fate*	ti
D	d	*fade*	di
C	ç	*etch*	çe
J	j	*edge*	je
K	k	*leek*	ke
G	g·	*league*	ge

Continuants.

F	f	*safe*	ef
V	v	*save*	vi
Ƕ	ɟ	*wreath*	iɟ
Ꮸ	ꝺ	*wreathe*	ꝺi
S	s	*hiss*	es
Z	z	*his*	zi
Σ	ʃ	*vicious*	iʃ
Ɀ	ʒ	*vision*	ʒi

Nasals.

M	m	*seem*	em
N	n	*seen*	en
Ʋ	ŋ	*sing*	iŋ

Liquids.

L	l	*fall*	el
R	r	*rare*	ar

Coalescents.

W	w	*wet*	we
Y	y	*yet*	ye

Aspirate.

H	h	*hay*	eç

VOWELS.

Guttural.

A	a	*am*	at
ᴁ	a	*alms*	a
E	e	*ell*	et
Ɛ	ɛ	*ale*	ɛ
I	i	*ill*	it
Ƚ	i	*eel*	i

Labial.

O	o	*on*	ot
Ꙩ	ꙩ	*all*	ꙩ
ꭥ	ꭥ	*up*	ꭥt
Ơ	ơ	*ope*	ơ
U	u	*full*	ut
Ш	ɯ	*food*	ɯ

DIPHTHONGS: Ɨi̯, Ʊy̨, OU ou, OI oi.
as heard in by, new, now, boy.

A ¼lb. parcel of Tracts explanatory of Phonetic Shorthand and Phonetic Printing, may be had from I. Pitman, Phonetic Institute, Bath; post-paid, 6d.

Pitman's Phonetic alphabet with types cast according to his specifications

252

VOWELS.

Short hand.	Long hand.	Type	Example of its sound.	Name.
N.1	ℰ ɩ	Ɩ i	feet	i
	𝒥 ɩ	I i	fit	it
2	ℰ ɛ	Ɛ ɛ	mate	ɛ
	ℰ e	E e	met	et
2½	𝒜𝓍	Æ æ	mare	æ
3	𝒜 a	A a	psalm	a
	𝒶 a	ᴀ a	Sam	at
4	𝒪 o'	Θ ɵ	caught	ɵ
	𝒪 o	O o	cot	ot
5	𝒰 u	U u	cur*	u
	𝒲 y	ᴜ u	curry	ut
6	𝒪 o'	O o	bone	o
7	𝒰 u	ɯ ɯ	fool	ɯ
	𝒰 u	ᴜ u	full	ut

COMPOUND VOWELS.

	Long hand.	Type	Example of its sound.	Name.
	ʃ ɟ	Ᵽi	high	i
	𝒪 ó	Φ ð	hoy	ð
	𝒯 ɤ	ᵹ ɤ	how	ɤ
	𝒰 ʯy	Ψ y	hew	y

COALESCENTS.

	Long hand.	Type	Example of its sound.	Name.
ᴜ	𝒴 y	Y y	yea	yɛ
c	𝒲 w	W w	way	wɛ

BREATHING.

	Long hand.	Type	Example of its sound.	Name.
((.)	ℋ h	H h	hay	hɛ

CONSONANTS.

Short hand.	Long hand.	Type.	Example of its sound.	Name.
\	𝒫 p	P p	pay	pɩ
\	ℬ b	B b	bay	bɩ
\|	𝒯 t	T t	toe	tɩ
\|	𝒟 d	D d	doe	dɩ
/	ℰ ɋ	Ɇ ɋ	chew	ɋɛ
/	𝒥 j	J j	jew	jɛ
—	ℰ c	C c	call	cɛ
—	𝒢 y	G g	gall	gɛ
ᴗ	𝒯 f	F f	few	ef
ᴗ	𝒱 v	V v	view	vɛ
(𝒻 ɟ	T t	thigh	ɩt
(ℏ ð'	Ꟈ ꟈ	thy	ðɩ
)	𝒮 ɹ	S s	seal	es
)	𝒵 ɀ	Z z	zeal	zɛ
)	ℱ ɟ	Σ ʃ	mesh	iʃ
)	𝒵 ɀ	Ƶ ʒ	measure	ʒɩ
(ℒ ℓ	L l	lay	el
\	ℛ ɹ	R r	ray	rɛ
⌢	ℳ m	M m	sum	am
⌣	𝒩 n	N n	sun	en
⌣	𝒴 ɲ	Ꞑ ŋ	sung	iŋ

253

Weary of half-way measures, Pitman and Ellis worked together to design a system they dubbed Fonotypy. First issued in 1844, the system was modified considerably in its graphic form (as well as in the nuances of sound/sign relations) in succeeding editions. The Phonotypic [sic] alphabet was the typographic equivalent of the Phonographic shorthand characters, and consisted of a full set of typographic letters designed, carved,

Phonographic and Phonotypic alphabets (models for handwriting and types), 1840s

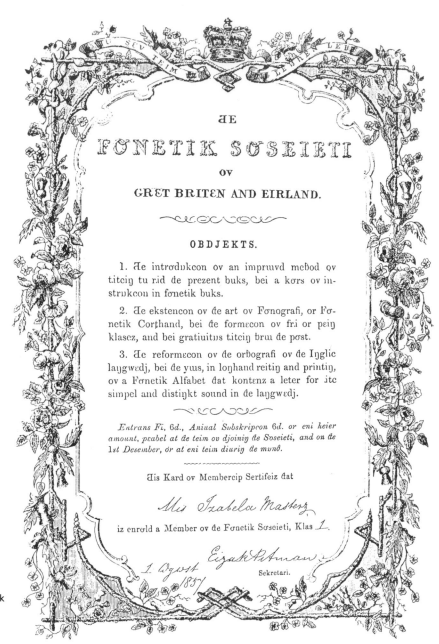

Membership card of the 'Fonetik
Soseieti' of Pitman, 1850s

punched and cast. Though Pitman promised in 1846 that he would make
no more changes to the system, thus permitting it to be adopted in publi-
cations intended for teaching purposes, he continued to refine the system
until he had had seventy-two versions of the alphabet designed, many of
them cut at his own expense. Ellis became disgusted with this continual
modification, seeing in it the downfall of the system since the endless
mutations made the very standardization for which it aimed impossible. In
spite of this, Fonotypy was adopted in succeeding decades by missionaries

in China, India and Africa, as well being used to record the language of the Micmac tribes in Nova Scotia, all testimonial to its usefulness in the field.

Pitman promoted his work through the establishment of a 'Fonetik Soseieti', publication of the *Phonographic Journal* and then the *Fonetik Nuz*. But the success of Fonotypy remained modest by contrast to the adaptation of his shorthand. Pitman's system was in part incorporated into the International Phonetic Alphabet, along with elements of Ellis's Glossic, developed in the 1870s, and the Romic characters of the renowned phoneticist Henry Sweet (whose character inspired Shaw's fictional Henry Higgins). Founded in 1886, the International Phonetic Association had as its major aim the development, promotion and standardization of an internationally useful phonetic alphabet. Here again the history of similar proposals could be traced in fine detail, but the themes which weave through this history include the desire for a universal language system which would transcend linguistic boundaries. The IPA had no such ambitions, but such systems as Joseph Maimieux's *Pasigraphie* (1797) or Ferdinand Schutz's *Simplification de l'Etude des Langues* (1855) conflated the concept of universal notation with universal language – as had Bishop John Wilkins a century before that. The Universal Language movement gained considerable momentum as well in the course of the 19th and early 20th centuries, but as these proposals have little to do with alphabet history and more do to with lexical systems (and the political temper of the times) they will not be dealt with here.

Front page of a journal of an American spelling reform society inspired by Pitman's work and using his Phonographic and Phonotypic models; 1849

ÐƐ FONETIC NUZ.

CONDUCTED BF ÐƐ PROPRIETUR, ALECSANDER J. ELIS, B.A.

NR 1.]	SATÉRDA, 6 JANUERI, 1849.	PRIS 4½d. STAMPT. Per Cwerter in adváns, 4s. 6d.

(FACTS FOR SPELLERS OF THE OLD SCHOOL.

READER! Do you ask why we propose to change the English orthography? We reply :

1. IT IS A FACT, that no one can tell the sound of an English word from its spelling.

Proof.—To *read* the book he has *read* ; to *present* a *present* , the *slough* of a snake found in a *slough* ; *lead* me to the *lead* mine : *refuse* the *refuse*, &c., &c. ; the words in italics are pronounced differently, that is, are different spoken words, according to their meaning alone ; and there are 201 words of this kind in our language, which are pronounced in 406 different ways :—2. The same combination of letters has very different significations in different words : compare *hear, heard, heart, here, where ; hoe, shoe ; now, know ; lover, clover ; lumber, plumber ; laughter, slaughter ; doe, does* (v.), *doeth ; eyed, keyed, conveyed, journeyed* ; and so on, in an infinite number of cases.—3. There is a very large number of words concerning the pronunciation of which even orthoepists are not agreed : as, *knowledge*, (uol-ledge, no-ledge) ; *leisure*, (lee-zhur, lezh-ur) ; *inimical, inimical*, and so on.—4. No one can be sure of the pronunciation of any word he has not previously been taught : let the reader try the unusual words, *batman, beaufin, rowlock, bourgeoise* (type) ; and the names of places and persons, *Beaulieu, ---hislock, Hochelaga*, and so on. Turn the page and read :—
Davnian, biffin, rullec, buryoice, Bowli, Aftech, Hoshalagah.

2. IT IS A FACT, that no one can tell the spelling of an English word from its sound.

Proof.—1. There are 405 spoken words, spelled in 857 ways , but the variations of the spelling never depend on the sound, and cannot be learned from it.—2. There are upwards of 1509 words, about the spelling of which authors are not agreed.—3. The style of spelling cannot even be predicted from a knowledge of etymology : compare *fancy phantom, concede succeed, island bay, husband house, rhyme, ghost, city, flys flies, buryess bourgeoise burgher*, &c., &c.—4. No sound in the language is uniformly represented by the same sign.—

(THE ENGLISH PHONETIC ALPHABET.

The letter written,	prntd	is always sounded as		The letter written,	prntd	is always sounded as	
Ɛ ɛ	Ɛ ɛ	*ee* in *eel*		P p	P p	p	in *pole*
A a	A a	*a* .. *ale*		B b	B b	b	.. *bowl*
A q	A q	*a* .. *alms*		T t	T t	t	.. *toe*
Θ ɵ	Θ ɵ	*a* .. *all*		D d	D d	d	.. *doe*
O o	O o	*o* .. *ope*		Ϲ ϲ	Ϲ ϲ	*ch*	.. *cheer*
W w	W w	*oo* .. *food*		J j	J j	*j*	.. *jeer*
I i	I i	*i* .. *ill*		C c	C c	*c*	.. *came*
E e	E e	*e* .. *ell*		G g	G g	*g*	.. *game*
A a	A a	*a* .. *am*		F f	F f	*f*	.. *fear*
O o	O o	*o* .. *olive*		V v	V v	*v*	.. *veer*
U u	U u	*u* .. *up*		Ͱ t	Ͱ t	*th*	.. *thigh*
U u	U u	*oo* .. *foot*		Ð ð	Ð ð	*th*	.. *thy*
Ɉ ɉ	Ɉ ɉ	*i* .. *isle*		S s	S s	*s*	.. *seal*
Θ θ	Θ θ	*oi* .. *oil*		Z z	Z z	*z*	.. *zeal*
Ȣ ȣ	Ȣ ȣ	*ow* .. *owl*		Ʃ ʃ	Ʃ ʃ	*c*	.. *vicious*
U u	U u	*u* .. *mule*		Ʒ ʒ	Ʒ ʒ	*s*	.. *vision*
				R r	R r	*r*	.. *rare*
Y y	Y y	*y* .. *yea*		L l	L l	*l*	.. *lull*
W w	W w	*w* .. *way*		M m	M m	*m*	.. *mum*
				N n	N n	*n*	.. *nun*
H h	H h	*h* .. *hay*		Ŋ ŋ	Ŋ ŋ	*ng*	.. *sing*

The sign (') is prefixed to *l, m, n*, to show that they form syllables by themselves ; thus, *lit'l, spaz'm, op'n* = little, spasm, open. The parentheses {} indicate that the inclosed words are not spelled phonetically.}

Adifunal leterz for foren sundz hwiç diu not ocúr in inglif.

Ðe leter rit'n,	prntd	iz olwaz ssnded az		Ðe leter rit'n,	printd,	iz olwaz ssnded az
Ä ä	¨A ä	freng {e}		Hl hl	·Hl hl	welf {ll}
A a	·A a	freng {a}		Hr hr	·Hr hr	welf {rh}
Ü ü	¨U u	freng {eu}		Ḻ ḻ	Ḻ ḻ	italyan {gl}
Ö ö	¨O ö	freng {eu}		Ṇ ṇ	Ṇ ṇ	italyan {gn}
Ë ë	¨E e	freng {e}				
A a	·A a	fr. fort {a}		K k	K k	jerman {ch}
Ò ò	·O ò	fr. fort {o}		Q q	Q q	duç {g}
U u	·U u	fr. fort {u}		Ɔ ɔ	Ɔ ɔ	árabic {ain}
Ó ó	·O ó	fr. fort {eu}				polif {rz}

Ðe strongli pronúnst árabic leters qr indicated in rjtiŋ, bj subscrjbiŋ, and in prinț bj preficiŋ, a dot; dus, *Mu hámmed* 2.Ife (Mehemet Ali). For furðer particulerz, and similarlz for intermediet ssndz, se ðe *Esenfalz* or *Fonetics*, bj Alecsander Jon Elis, B.A.

Ðoz ignorant ov foren languwejez qr advjzd tu pronúns

ä, d, é, ü, o, ù, ;, k, q, ɔʒ,
qs, q, u, a, o, g, y, c, g, z, z.

respectivli, tu omit ›, tu disregárd ðe mare or strong leterz, until ða can lern ðe tru ssndz. In freng ò, ù ma be pronúnst az aw, u, und ò, a az w, ı ; iu jerman ò, ö ma be spoc'n lje s, r, und s, u lje c, ı.
Ðe sjn (') iz plast over ðe vsel in ðe acsénted silab'l, or at its cloz. Hwen it is not printed, ðe wurds must be red az if it stud
1) on ðe lqst silub'l *but sinn* ov ol wurds endiŋ in *ie* or *ies*, und ov ol wurdz haviŋ un *f*, a z, or a y bfōr dar lqst vsel, und ov ol wurdz haviŋ un *c*, a, q, o, o, w, f, or ʒ in ðar lqst silub'l but wun ;
2) on ðe lqst silub'l *but tú* ov ol uðer wurds.

Wurdz holli printed in capitals, und freng wurdz, (hwiç hav no régulerli acsénted silab'lz,) form ðe onli eccepfun tu ðe abův rulz.

TABLE X

Initial Teaching Alphabet by Rote

No.	Character	Name[2]	Example	No.	Character	Name[2]	Example
I.	æ	ain	æbl	23.	y	yay	yellœ
2.	b	bee	but	24.	z	zed or	zœ
3.	c	kee	cat			zee	
	d			25.	ꙅ	zess	aꙅ
4.	ḓ	did	ḓog	26.	wh	whee	whie
5.	ᴇᴇ	een	ᴇᴇ(h	27.	ꜿh	chay	ꜿhurꜿh
6.	f	ef	fun	28.	ꞇh	ith	ꞇhin
7.	g	gay	gæt	29.	ꞇh	thee	ꞇhen
8.	h	hay	hay	30.	ʃh	ish	ʃhip
9.	ie	ide	ies	31.	ʒ	zhee	meʒuer
10.	j	jay	jam	32.	ꬻ	ing	siꬻ
11.	k	kay	kiꬻ	33.	ꞃ	er	heꞃ
12.	l	el	lip	34.	ɑ	ahd	faꞃheꞃ
13.	m	em	man		a	ask	
14.	n	en	not	35.	a	at	at
15.	œ	ode	œpen	36.	au	aud	autum
16.	p	pee	pæ	37.	e	et	egg
	q			38.	i	it	it
17.	r	ray	rat	39.	o	og	on
18.	s	ess	sit	40.	u	ug	up
19.	t	tee	top	41.	ꙍ	oot	bꙍk
20.	ue	une	ueꙅ	42.	ꙍ	ood	mꙍn
21.	v	vee	vois	43.	ou	oun	out
22.	w	way	wet	44.	oi	oin	oil
	x						

Initial teaching alphabet designed in the mid-20th century by Sir James Pitman, grandson of Sir Isaac Pitman, (Sir James Pitman, *Alphabets and Reading*, London, 1969)

256

Pencil movements when forming initial teaching alphabet characters

CONSONANTS.

VOWELS.

Alexander Bell's diagrams of the organs of speech and their relation to the letters of his *Visible Speech*, 1867

Pitman's pedagogic goals were perhaps best realized by his own grandson, Sir James Pitman, whose ITA, or Initial Teaching Alphabet, was first published in the middle of the 20th century. Used as a tool for teaching young readers the intricacies of English pronunciation in a systematic and logical notation system, it had been adapted for the first years of primary teaching in a number of successful experiments. But the needs of professional linguists and phoneticists was better served by the development of the IPA.

Before Ellis and Pitman parted ways over their disagreements on the final form of Fonotypy, Ellis had already proposed his own phonetic alphabet, which he termed 'The Alphabet of Nature.' Published in 1845, his book surveyed the existing phonetic notation systems and proposed that his contribution would notate the 'mechanical conditions requisite for the production of sensations termed spoken sounds.' This was a vastly different project than that of Pitman, who wished merely to notate the acoustic effects, i.e., audible sounds, rather than notate the means of their production. Feeling that the production of this alphabet was outside the scope of his skills at the time, Ellis proposed a 'Transition Alphabet' presented in a chart which listed labials, palatals and gutturals classed according to whether they were explosive, sibilant, trilled, nasal or otherwise modified and indicated their notation with the use of adapted and augmented conventional letters. His next compromise solution was the Phonotypic alphabet he developed with Pitman, about which he had many reservations, not the least of which was that it did not embody any physiological information.

Of the many other stages along the way to the development of the International Phonetic Alphabet, such as the contributions made by Richard Lepsius's 'Standard Alphabet,' (made of diacritical marks appended to the conventional letters), none was more innovative or original than that of Alexander Melville Bell. Bell's *Visible Speech*, published in 1867, retained no remnants of the traditional alphabet. Instead it used an entirely new symbology, a set of schematic signs based on the organs of articulation. Though based on the same kind of analysis which had inspired both Van Helmont and Wilkins, Bell's system was linked to a sophisticated phonetic analysis of human language. Similar kinds of sounds were indicated with similar symbols, differently oriented to indicate their place in the mouth. Though not immediately and obviously readable, this system could be readily learned and provided, again, a flexibility adaptable to the study of foreign languages. The advantage of Bell's types and system over that of Pitman derived largely from his more developed understanding of the articulatory basis of phonetics.

When Henry Sweet, considered the foremost English phonetician of his day, began to search for suitable notation systems with which to implement his own phonetic work, he vacillated on the usefulness of Bell's types. He had already rejected Pitman's phonographic system with such disdain that he nicknamed it the 'Pitfall system,' maintaining that it was

grossly inaccurate as a means of recording the phonetic structure of language. Sweet ultimately adopted Bell's system in his editions of the late 1880s, the *Primer of Phonetics* and *The History of English Sounds*. Sweet also made use of his own system, Romic, since it was a simpler adaptation of conventional letters and less foreign to the eye.

COMPLETE TABLE OF RADICAL SYMBOLS.

The fundamental principle of Visible Speech is, that all Relations of Sound are symbolized by Relations of Form. Each organ and each mode of organic action concerned in the production or modification of sound, has its appropriate Symbol; and all Sounds of the same nature produced at different parts of the mouth, are represented by a Single Symbol turned in a direction corresponding to the organic position.

The following are all the Radical Symbols :—

1	O	The Throat open. [Aspirate.]
2*	O	" " contracted. [Whisper.]
3	X	" " closed. [Glottal Catch.]
4*	I	" " sounding. [Voice.] } The Stems of all
5*	I	" " " and the lips 'rounded.' } Vowels.
6*	C	Part of the Mouth contracted. } The Stems of all Consonants.
7*	Ɛ	" " " divided. }
8*	(The Nasal Valve open. [Soft Palate.]
9*	·	Vowel Definer. } Joined to 4 and 5.
10*	n	Wide Vowel Definer. }
11*	\|	Shutter. Joined to 6.
12*	ᵒₐ	Mixer. Joined to 6 and 7.
13	}	Consonant Definer.
14	Y	Force Director.
15	>	Breath Director.
16	c	Tongue Director.
17	·	Stopper.
18	I	Divider.
19	}	Vibrator.
20	I	Holder, or Long.
21	ᶜ	Abrupt.
22	ᵓ	Hiatus.
23	o	Link.
24	'	Accent.
25	}	
26	´	} Modulators.
27	`	
28	ᶜ	

* Of these Symbols the Ten marked * make up all the Vowel and Consonant Letters, as shown in the next Table.

COMPLETE TABLE OF LETTERS,—WITH THEIR NAMES.

	Consonants.							Vowels.						
	Organic Name.	Mixed.	Divided.	Mixed Divided.	Shut.	Nasal.			Back.	Back Wide.	Mixed.	Mixed Wide.	Front.	Front Wide.
Aspirate,	O							High,	1	1	I	I	ɪ	ɪ
Throat,	O				X			Mid,	J	J	ɪ	ɪ	ɛ	ɛ
Throat Voice,	θ							Low,	J	J	I	I	ɛ	ɛ
Back,	C	G	Ɛ	Ɛ	ᴄ	G		High Round,	ɪ	ɪ	ɪ	ɪ	f	f
Back Voice,	Ɛ	Ɛ	Ɛ	Ɛ	ᴇ	ᴇ		Mid Round,	ɪ	ɪ	ɪ	ɪ	ɛ	ɛ
Front,	ᴏ	ᴔ	ᴕ	ᴕ	ᴒ	ᴒ		Low Round,	ɪ	ɪ	ɪ	ɪ	ɪ	ɪ
Front Voice,	ᴔ	ᴔ	ᴕ	ᴕ	ᴒ	ᴒ								
Point,	ᴜ	ᴝ	ᴝ	ᴝ	ᴅ	ᴅ								
Point Voice,	ᴝ	ᴝ	ᴝ	ᴝ	ᴅ	ᴅ								
Lip,	ᴐ	ᴣ	ᴣ	ᴣ	ᴆ	ᴆ								
Lip Voice,	ᴔ	ᴔ	ᴣ	ᴣ	ᴆ	ᴆ								

Glides.

									Round.		
	Breath.	Voice.	Round.	Throat.	Back.	Front.	Point.	Lip.	Back.	Front.	Lip.
	<	I	ɪ	Ɂ	ᴧ	Y	ᴝ	ᴣ	ᴧ	ᴝ	ᴣ

Modifiers and Tones.

(Nasal.	}	Trilled.	◁	Suction Stopped.	ᶜ	Abrupt.	— Level Tone.
(Nasal Mixed.	‖	Divided.	▷	Emission Stopped.	ᵓ	Hiatus.	/ Rising Tone.
}	Inner.	c	Inverted. [To Back.]	o	Link.	⟋	Whistle.	\ Falling Tone.
}	Outer.	ᴐ	Protruded. [To Lip.]	'	Accent.	⟋	Voiced Whistle.	v Compound Rise.
Λ	Close.	·	Stopped.	ᵢ	Emphasis.	ᶜ	High Key.	Λ Compound Fall.
V	Open.	<	Suction.	I	Holder.	J	Low Key.	

The 'letters' of Bell's system and their correspondence with spoken sounds, *Visible speech*, 1867

The International Phonetic Alphabet was the result of the contributions from Pitman, Ellis and Sweet combined with the efforts of French phonetician Paul Passy. The guidelines for the alphabet were straightforward: that each letter should indicate a distinct sound, any sound found in several languages should use the same letter to represent it, as much as possible the letters of the IPA should consist of letters from the Latin alphabet, and new letters should suggest sound by their resemblance to older letters. Finally, the system should be easy to acquire and use, and this was the primary reason for rejecting an organic alphabet grounded in the physiology of articulation such as that of Bell. The IPA made an early administrative decision to remain independent of the Simplified Spelling Society, recognizing that their aims and consequently their methods were necessarily different. As Otto Jespersen, another prominent phoneticist who contributed to the development of the IPA, pointed out, a notation system which had sufficient precision to be useful for linguists was far too difficult and specialized to be of value to young readers.

Phonological diagrams by
Andrew Comstock, *A Treatise on
Phonology*, Philadelphia, 1846

THE INTERNATIONAL PHONETIC ALPHABET

The International Phonetic Alphabet, early 20th century

		Bi-labial	Labio-dental	Dental and Alveolar	Retroflex	Palato-alveolar	Alveolo-palatal	Palatal	Velar	Uvular	Pharyngal	Glottal
CONSONANTS	Plosive . . .	p b		t d	ʈ ɖ			c ɟ	k g	q ɢ		ʔ
	Nasal . . .	m	ɱ	n	ɳ			ɲ	ŋ	ɴ		
	Lateral Fricative . .			ɬ ɮ								
	Lateral Non-fricative .			l	ɭ			ʎ				
	Rolled . . .			r						ʀ		
	Flapped . . .			ɾ	ɽ					ʀ		
	Fricative . .	ɸ β	f v	θ ð s z ɹ	ʂ ʐ	ʃ ʒ	ɕ ʑ	ç j	x ɣ	χ ʁ	ħ ʕ	h ɦ
	Frictionless Continuants and Semi-vowels	w ɥ	ʋ	ɹ				j (ɥ)	(w)	ʁ		
VOWELS								Front Central Back				
	Close	(y ʉ u)						i y ɨ ʉ ɯ u				
	Half-close . . .	(ø o)						e ø ɤ o				
	Half-open . . .	(œ ɔ)						ɛ œ ɜ ʌ ɔ				
	Open	(ɒ)						æ a ɑ ɒ				

Alphabets designed for children showing familiar animals, brave soldiers and longing women, from Henri-Désiré Porret, *Illustrations Typographiques*, Paris, 1834-42

Ultimately, the phoneticists, spelling reformers and practitioners of shorthand had little use for any investigation of the alphabet which went beyond the practical applications or mechanical notation. Nonetheless, there were individuals whose work crossed the lines between subjective interpretation and an interest in phonetics into the realm of sound symbolism. One such figure was Charles Kraitsir. *The Significance of the Alphabet*, Kraitsir's major contribution to the study of letters, was published in Boston in 1846. Kraitsir was essentially a phoneticist, and concerned with the analysis of the sounds of language, but his introductory remarks expressed the conviction that 'the laws which regulate the combinations of sounds into words' were the basis of a 'refined and expressive natural language.' With this statement Kraitsir reintroduced a familiar theme, that of the original natural language which he felt should be the object of philology.

The basis of Kraitsir's symbolism was simple: the categories of vocal sounds (labials, liquids, gutturals and lingual dentals) were each associated with distinct qualities. Vowels were not included, because they were not produced, he stated, by the articulating organs, though they could be 'produced by the wind in trees, on the Aeolic harp, by all musical instrument, by animals; the cat produces all the vowels as they are pronounced on the continent of Europe and Asia....' He proceeded, in his own unsystematic manner, to characterize the 'sounds' of the consonants. The liquid consonants 'L' 'M' 'N' 'R' expressed the 'flowing material of nature, element, aliment, almus.' The 'M' expressed meeting, and this was the basis of the value of all words in which it appeared: 'middle, means, measure, amity, multitude, might, mystery.' 'N' was a root letter for 'in' and for what 'pertains to the nose, in almost all languages.' 'M' was identified with 'me' and 'mama' both cited by Kraitsir as instances of selfish love which were indicated by the closing of the lips and cutting off of the breath of life in pronunciation of the letter. 'R' was the symbol of rough and 'original' movement, associated with the phenomenon of activity. The labials named the lips, and everything that the lips signified, while the gutterals and dentals were similarly characterized by association. Kraitsir's method was a common one in the history of sound symbolism – echoes of Plato's *Cratylus* resonate through his pages – and the only remarkable aspect of

his work was that it prefaced a serious text on phonetics rather than being couched in poetic, philosophical, or mystical terms.

One final area in which the alphabet and pedagogy overlapped in the 19th century was in the area of rhyming alphabets. The emphasis on children's engagement with the letters was stressed in these works, designed to familiarize the young with the sounds and shape of letters through ingenious rhymes and visual designs. These ranged through every possible theme from the encyclopedic drawing of flora and fauna to historical figures, humorous tales, familiar events of daily life exemplifying the vices and virtues of the naughty and the dutiful and so forth. These were widely published in the form of nursery books, in journals intended for family readership or for an exclusively juvenile audience. Though these rhyming alphabets had little to do with historical investigations into the symbolism or development of the alphabet, they did broaden the range of materials through which children could be familiarized with those letters which, in spite of all the efforts by reformers, remained the basis of European writing, printing and publishing.

C was a CANDY MAN, and sold lots of sweets,

E was an ELF, who danced with a FAIRY,

D was a DRUNKARD, and slept in the street.

F was a FOX, both cunning and wary.

261

Rhyming alphabets of the 19th century containing moral tales, banalities, history and Biblical stories, from *The Mother's Picture Alphabet*, London, 1887; *Little Pet's Picture Alphabet*, New York, 1850s or 60s; and *The Illuminated Scriptural Alphabet*, Philadelphia, n.d.

ADAM, from the dust did God create,
To dwell in Eden's bowers, in blissful state;
But Sin—a serpent we should ever shun,—
Poisoned a life so happily begun.

A. Adam the first man, full plainly we vie;

Praying to God, as good men ought to do.

BENJAMIN'S cup was found, it is true,
In the mouth of his sack, and the gold with it, too;
But poor little Ben, though in very great grief,
Had this joy to sustain him—he wasn't a thief.

B. Was young Benjamin, happy and free,

Till the cup was discovered, as thus we may see.

CAIN was a man of wild passions, 'tis said;
Abel was gentle as the lambs that he led:
They were brothers; but Cain very envious grew
Of his dear gentle brother, whom he wickedly slew.

C. Is for Cain, who his brother did kill,
Who bore him the kindest of brotherly will.

Narratives of History

Debates about whether the alphabet had been a human invention under divine inspiration or simply a divine gift continued in the early years of the 19th century, though primary place would soon be taken by questions of how the letters had – or had not – derived from Egyptian hieroglyphic precedents. Two advocates for the human invention were Andrew Carmichael and Fortia d'Urban. They shared with the majority of their contemporaries a profound belief in the existence of a Divine Creator, but argued that it was through the gifts granted to humans by the benevolence of this Creator that writing, among other inventions, had come into being. This attitude was characteristic of much work on the alphabet in the 19th century, in which the existence of God went unquestioned, but was reduced to a background assumption. Meanwhile the major foreground issues of the day fell into two areas: one the familiar question of how to reconcile archaeology and scripture and the other the conflict over single versus multiple inventions of writing, an issue complicated by the evident disparities between hieroglyphic and alphabetic writing, a conflict sometimes triangulated through consideration of the Chinese characters.

Andrew Carmichael introduced his discussion of the origins of the alphabet, prosaically titled *An Essay on the Invention of Alphabetic Writing* (1815), by stating that the difficulty of accounting for the invention of writing naturally led to a belief in divine invention. Citing the work of various authorities whose credibility he refused to question (such as the obscure 'Hartly on Man'), he nicely sidestepped the conflict by pointing out that in the largest sense the achievements 'attained by the mind of man' were the result of 'those laws by which Providence visibly governs the world.' Having resolved a potentially tricky bit of theological logic, Carmichael put forth the points of his own argument. The alphabet, he stated, had been invented out of the strong necessity to have a record of the harmonious flow of sounds produced in poetry. Poetry could not be represented by hieroglyphics or Chinese characters since they merely pictured objects, not spoken verse or language. Apparently unaware of the developments which had occurred in Egyptological studies, Carmichael based his entire discussion on the conviction that the alphabet was the only form of writing which represented speech. Carmichael extended his analysis by studying passages of complex rhyme in the work of Virgil. By basing his arguments on such solid foundation, Carmichael could assert that it was through the visual experience of seeing patterns in the *notation* of simple sounds that Virgil was able to compose his verse with such supreme success. His extended study of sound patterns in Virgil's work concluded with a reiteration of his opening statements, that he considered it 'unphilosophic, inconsiderate and puerile' to 'disentangle every perplexity by resorting to miraculous interposition' when it was clear that the achievements under discussion could be readily attributed to the gifts with which 'the Creator in his munificence has endowed mankind.'[10]

Though in keeping with the 18th-century notion that writing had been invented to serve the human passions first and foremost, Carmichael's assessment was original, without extensive precedent in its dependence on a poetic text as a means of demonstrating the human origin of the alphabet. This work anticipates some of the arguments put forth by 20th-century classicists in defense of the superiority of the Greek alphabet over its Semitic sources, and in that regard has an interest beyond the merely idiosyncratic character of its discussion. Fortia d'Urban, by contrast, argued in his 1832 publication that the forces of necessity which led to the alphabet's invention arose from the practical needs of humankind, rather than from the urgencies of their emotional life. Fortia d'Urban's basic positions were fairly standard: that writing had been invented by the Hebrews, that it was older than Moses, and that it had been spread by Cadmus into Greece. At the center of his text was the question of whether or not there had been writing in Greece at the time of Homer, an inquiry which, again, would continue to haunt the work of classicists up into the late 20th century.[11] Whatever the moment of its invention, however, writing served one major purpose as far as he was concerned, and that was to preserve the record and memory of certain facts and to make them known to absent people. In Fortia d'Urban's conception, writing had the basic function of producing history. It was this link, between the creation of narratives about the history of writing and the realization that it was writing itself that created history, which was perhaps the most distinct characteristic of 19th-century theories about the alphabet.

On the other side of the argument on divine versus human invention, was one of the authors whose work was to have influence in the continuation of mystical traditions into the 20th century, Fabre d'Olivet. He was the author of the monumental *The Hebraic Tongue Restored and the True Meaning of the Hebrew Words Re-Established and Proved by their Radical Analysis*, first published in 1817. D'Olivet's work was concerned with the root values of the letters and syllables of the earliest form of the Hebrew language. The divine spirit was omnipresent in D'Olivet's work, not merely as the source of writing, but as the very essence of alphabetic forms. The influence of kabbalistic thought can be felt in this work but it is more properly a treatise of Jewish mysticism, conspicuously lacking any reference to the sephirot, the tree of knowledge, or the traditional kabbalistic texts. D'Olivet's express motivation was to return 'the Hebrew tongue to its constitutive principles' and thereby restore the generative force of its forms.[12]

263

D'Olivet began by tracing the history of the Jews, their betrayal of Moses through idolatry, the dispersion of the ten tribes, and the loss of their original language. Court de Gebelin was the authority to whom he referred most frequently, citing his theories on the two forms of grammar – the universal grammar which embodied the general spirit of humanity and the particular grammars which were proper to a specific people and reflective of their civilization, its knowledge and its prejudices. This

conviction, that the forms of a language embodied the spirit of a people in a cultural code, then led him to adapt Gebelin's analysis of the Hebrew letters and expand upon them in an exegesis which linked culture and language, the alphabet and the spiritual life of the Jews. From his discussion of the individual letters he proceeded to an elaborate investigation of the roots of the Hebraic language in an exhaustive study stretching to several hundred pages treating the meanings of the 'radical vocabulary.'

D'Olivet's transformation of Gebelin's system involved reducing the number of letters to sixteen 'primordial characters' which he then analyzed in connection with what he termed 'their hieroglyphic principle.' These reiterated the values of Gebelin had assigned linking the letters with parts of the body. The letters had acquired these values from their inventors, he further explained, 'only because they already contained the idea' because of the suffused presence of divine wisdom. But the letters evolved beyond this simple symbolic association, and became what D'Olivet termed *nouns*, after which they took on the value and identity of *signs*. D'Olivet believed that a force of a *sign* in a language deteriorated over time as languages became blended, mixed or interrelated. Hebrew, however, had 'shot from the dried trunk of the primitive tongue,' and thus preserved almost all the forms and actions of the signs.

NAME	VALUE
aleph	power, stability, unity
beth	virility, paternity, action
gimel	ideas from corporeal organs or their action
daleth	sign of nature, divisible, abundance in division
he	life, abstract idea of being
vau	knot which unites, or point separating nothingness and being
zayin	demonstrative sign, link which unites things
heth	elementary existence, equilibrium, effort, labor
teth	resistance and protection
iod	potential manifestation, spiritual duration, eternity
kaph	a mould which receives and makes forms
lamed	expansive movement, power derived from elevation
mem	maternal, female sign, exterior and passive action
nun	produced or reflected being, corporeal existence
samech	circumscription, circular movement with limit
ayin	material meaning, as vocal sound it is bent, perverse, bad
pe	speech, and that which is related
tsade	scission, solution, goal, termination
qoph	agglomerating or repressive form, giving the means of forms
resh	all movement, good or bad, original sign of renewal
shin	relative duration and movement
tau	sign of reciprocity, all that is mutual and reciprocal

Fabre D'Olivet's system of values for the letters of the Hebrew alphabet, 1812–13

D'Olivet's concept of a primitive tongue containing kernels of meaning which were themselves a life force from which all culture and knowledge was generated, and which could be recovered in the roots of language, was a developed cosmological model of the alphabet founded on faith as much as on philological research. Having established his set of alphabetic signs, D'Olivet freely constructed interpretations for the syllabic roots of the Hebrew language. From the meaning of 'A' as 'universal man, mankind, the ruling of the earth' 'AB' became the 'root whence come all ideas of productive cause, efficient will, determining movement, generative force,' most particularly 'paternity;' 'ATH' was a root which developed 'the relations of things to themselves' and so on in a sequence in which concepts built upon each other as well as on the root signs.

Such a theory depended upon the belief that Hebrew was the primitive, original language, and that the letters of the Hebrew alphabet bore within them at least a trace of the forms which had been revealed to Adam or Moses in mythic fashion. The archaeological evidence was rapidly undermining the scientific basis for this belief through the course of the 19th century. With each succeeding decade, the image of the historical past was being reformulated. The crucial turning point was the 1874 posthumous publication of Emmanuel de Rougé's work on the hieroglyphic origins of the alphabet, but the sensibility within which his work was received had been building since earlier in the century, though often through peculiarly idiosyncratic theories, such as that of Charles Wall.[13]

The *Orthography of the Jews*, published in 1835, put forth Wall's thesis that the Hebrew alphabet had had pictorial origins. He believed that this could be demonstrated from a close reading of the Pentateuch. The language Moses had used in these books was highly figurative, so much so that the only explanation for the remarkable character of the writing resided in its connection to hieroglyphic 'picture writing.' This highly original proposition was in turn supported by a flash of insight into the distinctions between alphabetic and hieroglyphic writing. Wall realized that there was a major difference between using an image, however schematic, to represent some thing and the representation of a sound with an arbitrary mark. The transition 'from the idea to the letter' was not simple matter of passing from idea to the sound by which it was expressed but 'from an idea to something with which it is utterly unconnected.' Wall further puzzled over the quandary that alphabets, in their contemporary, 19th-century state, did not even have a sound value – only syllables and phonemes did – which widened the gap between hieroglyphics and letters.[14] Wall did not resolve any of the questions he raised, but he had intuitively grasped a connection between Hebrew and hieroglyphics, though on a basis which was as unsound as it was original.

The problem of establishing that there had been a transition from Egyptian precedents to the early alphabet continued to be an obstacle to conceptualizing the two as related; but on the other hand if this could not be resolved there remained the difficulty of accounting for two or more

(Chinese characters being the third system frequently cited) independently created writing systems which would appear to be contrary to every scrap of biblical evidence supporting the theory of the monogenesis of human culture and history. James Brodie's *The Alphabet Explained*, published in 1840, began with a discussion of the relations between the sound values of hieroglyphics and Hebrew letters. In this regard he was on solid linguistic ground, at least, basing his inquiry on principles which would eventually assist De Rougé in his analysis of the links between the two writing systems. Brodie reached no conclusions, finally suggesting simply that the alphabet had either been an independent creation or it had been an adaptation of hieroglyphics, but his major objection to reaching a clear conclusion was that there was no visual evidence on which to trace the transformation of hieroglyphic forms to alphabetic letters, certainly a judicious position.

Brodie was a cautious scholar, unwilling to make leaps of faith without sufficient evidence. Increasingly, 'evidence' meant empirical materials or artifacts of the sort supplied by expeditions whose methodology and techniques granted them an air of scientific authority lacking in mere textual reference and literary tradition. But not all scholars of the period were equally circumspect. George Smith, in his 1842 *A Dissertation on the very early origin of Alphabetic Characters, Literature and Science*, proposed some startlingly original ways 'to harmonize the early records of sacred and profane history.' Smith objected to the hieroglyphic theory of the origin of the alphabet on the basis that it contradicted Scripture. This single point was so powerful (and not just for Smith), that he created an account by which the Greek letters were carried by Thoth/Hermes to Egypt where they became hieroglyphics. Smith cited and often refuted Diodorus, Cicero, Sanchoniatho, Josephus, Berosus, Pliny and a host of other often contradictory authors up to and including William Warburton and the unnamed author of a recent work on 'Antiquities of Egypt' to support the details of his history. With all these conflicting histories to sort out, Smith fell back on the version which most completely corresponded to traditional interpretations of the Old Testament: that it was the descendants of Shem who, 'after the confusion of tongues' were allowed to retain not only the 'principle on which the alphabet was constructed but its proper use as an alphabet.' The descendants of Ham, the 'unhappy sons of Misraim', were so far removed from the use of letters that when Thoth arrived among them he found them making 'sounds like brute animals.' In fact, Smith attributed any conditions in which humans appeared primitive or barbarous to a decline simply on the basis of the belief that God would not have made humans imperfect. And as for the alphabet used among the descendants of Shem, it was the original one, in place well before the Deluge. Used by Seth as well as Noah, it was even known to Adam, as Smith states, on the authority of the Dr Parsons whose *Remains of Japhet* had contributed to 18th-century theories of alphabet history.

Smith's final conclusion was that the alphabet had been perfect in its original form and communicated directly from God. It was through the efforts of Thoth to restore learning 'after the Flood' that the less perfect, more barbarous and primitive hieroglyphic writing had appeared. Hieroglyphs represented a deteriorated condition for writing rather than its original state. Smith was typical of his contemporaries in his scrupulous attention to the scholarship which preceded his, but his citations were limited to the work of those theologically inclined authors whose sources were textual rather than to writers in the emerging field of ancient languages. He would, however, have found little support there for the version of this history he was proposing.

Of the authors whose work was considered significant by their contemporaries, Charles Forster stands out for his combination of archaeological and biblical approaches to the study of the development of the alphabet and the interpretation of other early writing systems, notably cuneiform. Forster's work faded more quickly than that of earlier, more clear headed writers such as Thomas Astle. Forster's work was given credibility because he actually visited a number of important sites in the Ancient Near East and based his observations on evidence he collected himself, such as his examination of the famous Behistan monument. One area in which he expended considerable effort was the Sinai, and *The One Primeval Language traced Experimentally through Ancient Inscriptions in Alphabetic Characters of Lost Power From the Four Continents including the Voice of Israel from the Rocks of Sinai and the vestiges of Patriarchal Tradition from the Monuments of Egypt, Etruria and S. Arabia*, published in 1852, was based on this experience.

Charles Forster's view of the Wadi Mokatteb in which he found the Sinai inscriptions (*The One Primeval Language*, 1852)

267

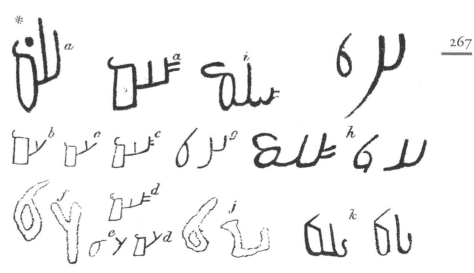

Glyphs from various authors, assembled by Charles Forster, to show the origins of a letter in one inscription and its possible derivation (*The One Primeval Language*, 1852)

[a] Beer, 110, 111. [b] Gray, 153. [c] 165. [d] 88, 89. [e] Niebuhr, Tab. xlix.
[f] Wilson, No. i. [g] Beer, 88, 89. Gray, 88, 89: the second examples are *ámir*, but the initial monograms marked *a* are evidently identical.

The book had a great deal of validity, but, like most of Forster's work, was on rather shaky scholarly ground. Forster had a tendency to rely on imagination where evidence was lacking, and to convince himself of relations among languages, cultures and scripts largely on the basis of visual similarities among forms. It is an axiom of the discipline that this is not a solid basis on which to make connections, and even in the 19th century this caveat was sufficiently well-known that Forster pushed his interpretation of the inscriptions he found in the Sinai region through an analysis of the 'powers' or sound values associated with the visual forms. It was in fact this extra step which moved his scholarship toward the mainstream from which Emmanuel De Rougé's work emerged, using similar bases for comparison of Egyptian hieroglyphics and early alphabetic forms.

EGYPTIAN			PHOENICIAN			GREEK								LATIN		
		HIEROGLYPHIC	HIERATIC				CADMEAN Right to left	Left to right	LOCAL FORMS	EASTERN	WESTERN	LOCAL FORMS		PELASGIAN	LATIN	
a	eagle.			aleph		alpha	A	A		A A	A A			A	A A A	a
b	crane.			beth		beta		B	C Paros, Siphnos, Thasos, etc.	B B	B B			B	B B	b
g	bowl.			gimel		gamma		Γ	L Corinth, < C Corinth, C Megara, etc.	Γ A	Γ Γ	< C Chalcis, Phocis, Locris, Arcadia, Elis, etc.		< C	< C	c
d	hand.			daleth		delta				D	Δ D D			Δ D D	D	d
h	plan of house?			he		epsilon			B Corinth, etc. E	E E	E E			E	E II	e
f, v	cerastes.			waw		digamma		F		[F]	F F			F	F I'	f
t (tch, z)	duck.			zayin		zeta	I	I		I	I			I	[G a new letter formed from C.]	g
χ (kh)	sieve.			cheth		eta	B	B		B H(hē)	B H(h)			B	H	h
th	tongs; loop.			teth		theta	⊗	⊗		⊗ ⊙	⊗ ⊙			⊗		
i	leaves.			yod		iota			Crete, Thera, Melos, Corinth, etc.	I	I			I	I	i
k	throne.			kaph		kappa		K		K	K			K	K	k
l	lioness.			lamed		lambda	Λ	Λ	V Attica. Γ Argos.	Λ Λ	Λ Λ	L Chalcis, Boeotia, etc.		L	L L	l
m	owl.			mem		mu	M	M		M M	M M			M	M	m
n	water.			nun		nu	N	N		N N	N N			N	N	n
s	door-bolt.			samekh		xi			H Later Argos. [Attica. Naxos, Siph-nos, Thasos, etc.)	I	[see below]					
ā	weapon.			ayin		omikron	O	O	Ω Paros, O Siphnos, etc. O, C Melos.	O	O			O	O	o
p	door.			pe		pi		Γ		Γ Π	Γ Π			Γ	Γ P	P
t (ts)	snake.			tsade		san (ss)	M	M	T Halicarnassus, Teos, Mesembria.					M		
q	knee ?			qoph		koppa	Q	Q		[Q]	Q			Q	Q	q
r	mouth.			resh		rho		P		P R R	P R R			P R	R R	r
š (sh)	field.			shin		sigma			Crete, Thera, Melos, Argos, Corinth, etc. M			M Phocis, etc.			S S	s
t (tu)	arm with cake in hand.			tau		tau	T	T		T	T			T	T	t
				ADDED LETTERS:		upsilon				V Y	V Y			V	V	u, v
						xi				[see above]	X +			X	X	x
						phi				Φ Φ	Φ Φ			Φ		

One authoritative and standard version of the derivation of Hebrew from Egyptian characters as it had come to be accepted: E. Maunde Thompson, *Handbook of Greek and Latin Paleography*, London, 1893

Forster stressed that the huge number of inscriptions which he had seen in the 'howling wilderness of the Sinai' were in an improbable site for any kind of human activity, and that they therefore could not be account-ed for without recourse to the biblical account of the wanderings of the Jews in that region for forty years. According to Forster, specific incidents recorded in the Bible about this period in Jewish history were also record-ed in the inscriptions he had located. In particular, he cited the stories of two miracles, one at the beginning of the forty years of wanderings, the other at the end: the stories of the rocks of Meribah and Meribah Kadesh. In both instances water had appeared from the stones to save the Israelites, and Forster interpreted written inscriptions he had found as original accounts of these events. Forster went further, stating that all of the Sinai inscriptions contained details of the daily life and events of years spent by the Jews in the wilderness. The form of these inscriptions was a schematic hybrid, between hieroglyphs and letter forms, according to Forster. This was confirmation of their origin since it was 'only reasonable to suppose that the characters employed in them would bear a close affini-ty to the written language of Egypt,' the land from which the Jews had been sent into exile.

While such assertions may have served for truth in Forster's eyes, the linguistic basis for his interpretations of the scripts was never supported, though he claimed to have grounded them in scholarly comparisons. His belief that there was a single origin for the alphabet, a single primeval lan-guage, led to his constructing an elaborate chart in which he asserted transformations and relations among nearly fifty scripts including the cuneiform from Behistan, Enchorial forms from Nimroud, Celtiberian, Abyssinian, Tartar Siberian, Egyptian Hieroglyphic and the alphabet from Monuments of Central America. Again, because the concept of a single original language was the only theory of writing which reconciled with scripture, it persisted in the face of contradictory evidence.

Many of Forster's views were shared by Henry Noel Humphreys, who cited Forster's work in support of his own in *The Origin and Progress of the Art of Writing* (1853). Humphreys, however, believed that the first alphabet of the Hebrews had been Samaritan. This had been abandoned after captivity in Babylon and then adopted and modified when Abraham was in Chaldea. Both major changes in alphabet theory were afoot by this period in the work of the oft-mentioned De Rougé, and continued in the work of François Lenormant and then Isaac Taylor in the 1860s and 1870s.[15] By the time of Taylor's publication of the two volume *The Alphabet*, mainstream historians had determined that the links between Egyptian hieroglyphics and the alphabet were more than mere specula-tion, though the influence of cuneiform syllabaries was only vaguely taken into account. Taylor's work remains monumental, his detailed discussion of the relations of alphabets and their development still largely reliable, straightforward and clear. He was not always correct in every particular, but his overall grasp of the scope of the history of alphabetic scripts and

269

their diffusion and differentiation were a remarkable achievement and remain undiminished in spite of the contributions of other scholars to the field. In spite of the soundness of Taylor's and other scholars' work, many of their contemporaries continued either unaware or uninfluenced by it in their own idiosyncratic writing. A year after De Rougé's work was published, Daniel Smith produced a tome in which he traced the letters of the alphabet to their origins in basic triangular forms and a year after publication of Taylor's *The Alphabet*, George Wood had such a poor grasp of the historical work available to him that he could only suggest general principles for the origins of the letters and none of the specifics detailed extensively in the work of other authorities.

Wood's work, published in 1883, with the telltale title *A Popular Treatise on the History of the Origin and Development of Written Language*, hardly bears investigation. Suffice to say he accepted the idea of the Egyptian hieroglyphics as the basis of the alphabetic letters, but in coming up with visual images which he believed to have been the basis of this transformation he simply allowed his imagination free rein. With no regard whatsoever for cultural or linguistic differences, he proposed that the origin of the 'A' had been an axe, of the 'B' a bow, of the 'C' a crescent, the 'E' an eel, the 'S' a serpent and the 'T' a tree of the variety best known outside the Tigris and Euphrates valley.

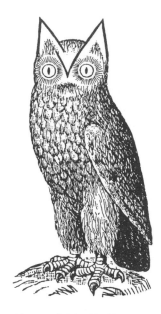

Above and right: The hieroglyphic principle as the basis of letter derivation, according to Wood (George Wood, *A Popular Treatise*, Hartford, Connecticut, 1883)

Axe. Bow. Crescent.

Eel. Serpent. Tree.

The rebus principle of writing, according to Wood

Daniel Smith, on the other hand, though he cited all the proper authorities, even the prominent German linguist Professor Bopp (a first for alphabet historians), stuck resolutely to the conviction that the original sources for letter forms were combinations of triangles. His work, *Cuneorum Clavis, The Primitive Alphabet and the Ancient Ones of the Earth* (1875), shared with that of Charles Forster a desire to connect the cuneiform inscriptions with the original alphabet. He based his conviction

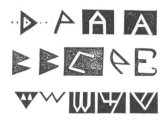

Derivation of letters 'A,' 'B,' and 'W' from triangles (Daniel Smith, *Cuneorum Clavis, or The ancient ones of the Earth*, London, 1875)

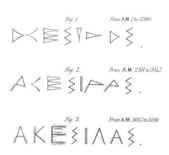

Smith's version of the evolution of Greek alphabet from Cuneiform originals, giving dates of the process (Daniel Smith, *Cuneorum Clavis, or The ancient ones of the Earth*, London, 1875)

Smith's full chart of the evolution of the alphabet, showing some values for letter names; note that *He, Cheth*, and *Yod*, typically, lack iconic value (Daniel Smith, *Cuneorum Clavis, or The ancient ones of the Earth*, London, 1875)

on visual experience. Having seen records brought to light by excavations at Nineveh he had been struck by the similarities between the simple forms of monumental Greek inscriptions and cuneiform. He also clung to the belief that all the early nations had had the same language and alphabet: the fact that Abraham had fled from Ur of the Chaldeans into Canaan and thence to Egypt was proof that there had been no language barrier to this movement. Smith's work was published posthumously with extensive notes by an editor, H.W. Hemsworth. Hemsworth's running commentary provided some useful perspective. For instance, as Smith finished his account of the ease of communication among biblical people and kingdoms, the editor interjected that if the work had come to him earlier, during Smith's lifetime, he would have asked him to expunge the biblical materials because they were 'unscientific.' This was a unique instance in print of the perceived contradiction between the traditions of text-based scholarship and that of archaeologically-based scholarship, which was generally resolved by authors simply adhering to one or the other of the positions and ignoring conflicting evidence.

Smith's claim that the entire primitive alphabet had been made of triangles, however, met with no such objections from his editor, who considered it a quite remarkable bit of scholarship. Smith asserted that triangles were the basis of all cosmology and chemistry, that they were the most fundamental elemental forms. Through an artful combination of abstract and pictorial diagrams, Smith demonstrated that the letters were simultaneously based on combinations of these triangles and on the visual image from which the letter had derived its name in the by then well known A=aleph scheme of values.

271

PLATE VII.

	Primitive.	Cadmean.	Etruscan.	Pelasgic.	Bardic.	Ancient Hebrew.	Samaritan.	Phoenician.	Palmyrene.	Modern Hebrew.	Roman.	VII.
Awleph, an ox or leader.		A	A		Λ	X X					A	
Beth, house or tent.		B		B		9	E	9			B	
Gimel, camel.		<	>		1	7	1		J	G	
Dawleth, tent door.				>	9,4	4	4,9			D	
He.			...Epsilon....								E	
Vau, hook pin.	V	F	V	V		X	7	7.7	7		F or V	
Zain, armour.		Z	3	7				Z	
Cheth.		B		E						CH	
Yod.						Z					I	
Kaph and koph.		K		K		4	7	H			K or Q	
Lamed, or ox goad.				V		L	2				L	
Mem, water.				W				41			M	
Nun, fish.						4					N	
Samech, prop.					Z	Y					S	
Ain, eye.										O	
Tsade, fish-hooks.									TS	
Resh, head.						9.4		9,4			R	
Shin, tooth.							47			SH	
Tauv, cross.		+			T	X.+		4.+			T	

There are two themes through which these historical narratives may be summarized. Firstly, the concept of the primitive which was used in the work of Gebelin, Warburton and others a century earlier to focus discussion on the inherent character of human nature and society was used in the discussions of George Smith, Charles Forster, and their contemporaries in contrasting models of development: creationist and evolutionary. Considerations of the original condition of humankind were not pressed into the service of reflections upon the nature of the state, social contract, or potential for civilization among different human groups in this latter work. Instead, the arguments which proceed from identifying the early stages of alphabet formation served to distinguish between those who believed in its early, original perfection– either as a divine revelation or as a human invention under divine inspiration, both assimilable into the same creationist mythology – and those who believed in slow development, organic mutation, transformation, in short, a description based on evolutionary theory. Organic metaphors, tree diagrams, and other figurative representations of this model found their way into alphabet literature at the same period in which alphabetology was becoming legitimized through the scientific methods. By making use of archaeology, linguistics, decipherment and ancient historical study, historians of the alphabet participated in the general intellectual tenor of the late 19th-century infatuation with the authority of empiricism and materialism.

Letter*	Value	GEBELIN	Value of Chinese Character	CHASE Hebrew	Chinese
A	master	man		aleph = prince	—
	ox	ox			
B	box, house	any container		beth = house, place, box	receptacle, enclosure
G	neck, throat	passage		gimel = camel	top, head, neck
D	door, entry	door to a house		daleth = door	door, hatchet, knife, cleaver
H	field: source of life	field		he = hollow	niche, support, ladle
(v)				vau = hook	hand, claw, hooked
(z)				zayin = armour	work, art, bow, shield
E	life, existence	being, life		heth = (doubtful)	table, sun
(t)				teth = (unknown)	archetypes representing the sun
I	hand	hand		yodh = hand	put aside, reject
C	hollow of the hand	—		kaph = hollow hand	hollow, branching, grasping
L	wing, arm	wing		lamedh = instruct	man, head, or covering
M	tree, productivity	plant, mountain		mem = water	channel, water
N	product, fruit	knot		nun = fish, smoke	air, vapor, long journey
(s)				samech = prop	prop, support
O	eye	eye		ayin = eye	eye
OU	ear	ear			
P	palate	mouth		pe = mouth	inclosure, mouth
(ts)				tsadhi = locust	a locust, shrill, cutting sound
Q	scythe	cutting tool		koph = ear	ear or orifice
R	pointed nose	sharp angle		resh = head	a mound, the middle
S	saw, teeth	mortar		shin = tooth	(unclear origin)
T	roof, shelter	cover, shelter		tau = (meaning doubtful)	cutting or piercing
T	perfect	perfection			

Chart comparing Court de Gebelin and Pliny Chase's systems for deriving the alphabet from Chinese characters

The second theme which arises in summarizing the work of these 19th-century authors is their contributions to the development and acceptance of a pictorial basis for the letters. The relationship between the words which give the letters their Hebrew names and the forms of the letters became consolidated in this period, stabilizing into a code in which there were both fixed and mutable terms. In other words, the idea that the 'A' had derived from the image of the ox-head linked to the word 'aleph' fitted so easily into a logic of pictorial derivation that it was rarely questioned, but certain letters whose names were less figuratively specific, such as 'H' and 'he' continued to acquire values which varied from author to author. Archaeological evidence of early forms of the letters produced only schematic models. The pictorial hieroglyphs linked by sound to certain early alphabetic forms, such as those which De Rougé used to demonstrate his theory of their relations, are almost never the same as those used in the standard mythologized A=aleph form. The mnemonic device of acrophony, the use of a word beginning with the letter as its name, was so suggestive that the projected pictorial values came to be seen as a factual basis for the origin of the letters. The contents of these schemes varied, in some cases, as with Fabre d'Olivet's adaptation of Gebelin, they were based on a cosmology of the human anatomy and not necessarily pushed toward a visual correlation; in other cases, such as that of Smith or Taylor, the iconography embodied the artifacts of a nomadic desert culture, with its tents, camels, rods and staffs. The desire to see in the schematic forms of the letters original images from which they were derived is no different from seeing the images of mythological characters in the configurations of the stars which form the constellations, and the sequence of events by which names, images, and schematic forms came into being was roughly equivalent. The names had a genuine history, but the images on which they were supposedly derived were not supported by any visual evidence.

Not every historian of the alphabet whose work was published in the 19th century wrote in compliance with mainstream sensibilities. The search for the original inventors of the alphabet extended beyond the limits of Hebrews, Phoenicians and Egyptians. Some of these proposals hinged on debates about the relative antiquity of Chinese, Indian, Egyptian or other cultures. One was the modest contribution by Charles Schoebel, whose 1882 *Memoire* attempted to weave insights into the relative perfection of Sanskrit grammar into a theory of the Indian, specifically Dravidian, origin of the alphabet. In other cases, such as the work of Godfrey Higgins, older speculations about national identity emerged.

Godfrey Higgins published two extensive works on the Druidic origins of the alphabet, *The Celtic Druids*, in 1829, and *Anaclypsis* a few years later. Higgins's arguments that the Druids of the British Isles were the ancient Celtic nation were very close to those of Charles Vallancey, whom he acknowledged among his sources.[16] Citing Greek authorities who asserted the early existence of two alphabets, the Pelasgian and the Ionian (or Western and Eastern Greek alphabets according to more conventional

273

historians), Higgins asserted that these had had a common source. This was in fact true, though not in the manner Higgins suggested. This common source was, predictably, that alphabet in place before the Deluge. Consisting of seventeen letters, including the always mysterious *digamma*, this was the alphabet of the Druids which the Greeks had adopted and transformed, and then, through their own careless disregard for ancient traditions, forgotten where it came from. Aside from disparaging the Greeks, which Higgins did throughout, he assiduously promoted the superiority of the Irish people and their letters. Higgins contended that various figures from antiquity – Hermes, the Cumaean sybil, and Virgil among them – were in fact Celts, born among the Druids, and schooled in their language. The letters of the ancient Irish language were given the names of trees and the oldest of these alphabets was the Ogham alphabet known by the names of its first three letters, 'beth-luis-nion.' He took the leaf metaphor literally, claiming that the prophecies of the sybils had been noted on tree leaves, thus proving their relation to the Druids. This circular logic supported extensive claims in Higgins's texts, and he ultimately concluded that the inspiration for the Egyptian hieroglyphics had come from the ancient Irish alphabet.

274

Godfrey Higgins, Tree alphabet, names and forms (*The Celtic Druids*, London, 1829)

1	2	3	4	5	6	7		8		9
	B	Boibel		B	Beith		A		A	
	L	Loth		L	Luis		E		E	
	F	Foran		N	Nuin		F		I	
	S	Salia		F	Fearan		H		K	
	N	Neaigadon		S	Suil		J		L	
	D	Daibhoith		D	Duir		K		M	
	T	Teilmon		T	Tinne		L		N	
	C	Casi		C	Coll		M		P	
	M	Moiria		M	Muin		N		R	
	G	Gath		G	Gort		P		S	
	P			P	Poth		R		T	
	R	Ruibe		R	Ruis		S		U	
	A	Acab		A	Ailim		T			
	O	Ose		O	On					
	U	Ura		U	Ux	Fig. 12.				
	E	Esu		E	Eactha					
	J	Jaichim		J	Jodha					

Higgins work, however, had its precedents, and was clearly within a nationalistic tradition. Another position which waxed and waned in popularity in texts on the origins of writing was the claim of China and Chinese characters to great antiquity. Pliny Earle Chase, in *Remarks on the Asiatic Origin of the Alphabet* (1863), took up the theme proposed in the earlier work of Gebelin, Joseph Webb, and M. de Guignes, who had suggested links between hieroglyphic symbols and Chinese characters.

Chase did not only see a connection, he granted priority to the Chinese, thus contradicting centuries' earlier theories which had asserted that China had been settled a colony of Egypt. Chase had been struck by the etymological coincidences among forms of Chinese and English, even extending to the similarity of letter forms. He firmly believed that by studying the Chinese radicals an original alphabet might be discovered. He noted the similarity between the letters 'O' and 'U' and the shape of the mouth in pronouncing them which he in turn associated with the Chinese forms which represented the mouth, eye, or the idea of 'revolving.' On such slim evidence he built his case, finishing his work with a comparison of Phoenician 'ancient letters' and their Chinese archetypes.

There was not a scrap of historical evidence to support Chase's propositions, but he was not alone in asserting either the great antiquity of Chinese writing or in seeing connections with hieroglyphics based on a perceived conceptual similarity. Chinese characters have been dated into the second millennium BC, making them more or less contemporary with certain cuneiform, hieroglyphic and early alphabetic forms, but evidence for much older writing is as scarce as evidence for early contact with the Egyptians or the use of hieroglyphics as a source for Chinese writing. The cult of Chinoiserie and the projection of exoticism and mystery onto the Chinese culture no doubt had a part in fueling Chase's imagination, and by bestowing a remote and ancient history on Chinese writing he forestalled objections with a cloud of obscurity.

In another scheme which linked Chinese characters, hieroglyphics and the letters of the alphabet, Moreau de Dammartin had proposed a shared astrological basis for all of these writing forms. Stating that he wished to demonstrate a 'common source in astronomy for all forms of writing,' Dammartin set out an elegant if farfetched scheme in his 1839 publication, *Origine de la forme des Caractères Alphabetiques de toutes les Nations...* Starting from the calculation that there were thirty-six constellations in addition to the zodiac, and that twenty-two of these were in the northern hemisphere – where writing had originated – Dammartin linked the fundamental twenty-two letters of the alphabet with an equal number of basic characters and hieroglyphics. Aleph was the first letter because Taurus, the bull, had been the zodiacal sign in ascendency during the period in which writing was invented, about 4,400 years earlier (around 2500 BC), thus casting a strong influence on the entire system. Letter by letter Dammartin explored the similarities between constellations which had been the basis of the alphabetic form and the Chinese characters. Ultimately he linked these twenty-two figures to the elements in the Kabbalah, including the symbolism of Tarot, the greater Arcana and numerical values as well.

The idea of the constellations as the basis of letter forms found at least one other advocate in the 19th century, Lethierry-Barrois. His proposal was modest by contrast to that of Dammartin, limited to the observation that there were links established by the Hebrews themselves between the

Moreau de Dammartin's cosmological derivation of all writing from astrological sources (*Origine de la Forme des Caractères*, Paris, 1839) (By courtesy of the New York Public Library)

signs of the zodiac and the letters of the Hebrew alphabet. While most of the support for such associations points to the kabbalistic traditions which are much later in date than the invention of writing, Lethierry-Barrois's cosmological relations and equivalences served more as the basis of a spiritual text than as an explanation of alphabet origins.

However, the sort of conflation of Tarot, astrology, numerology and kabbalistic symbolism which was evident in both his work and that of Dammartin led to the increasingly widespread popularization of occult practices. The activities of Eliaphas Levi (Adolphe Constant), Adolphe Desbarolles, and Gerard Encausse and others were only the highly visible sign of a rather large movement which was spreading fascination with concepts of magnetism, hypnotism, spirit writing, and occult diversions through the lecture circuit, small societies, and private parlors. The occult esotericism of secret societies had become the basis of entertainment, distraction, spiritual quests and charlatanism among all classes, reaching a wider audience than ever before. Mystery and mysticism continued to haunt texts on the alphabet with immodest and unprovable propositions about the cosmological and universal nature of its symbolic forms. The work of Emile Soldi, published in 1900, was of this nature. *La Langue Sacrée*, part of an extended series of works on the spiritual origins of human thought and cult practices, employed a curious blend of archaeological material and single-minded occult sensibility.

Soldi's language was steeped in evolutionary metaphors and the technical jargon of expeditions, excavations and anthropological relativism. He stated that writing went through three stages of evolution, from divine signs or *cosmoglyphie*, to phonetic writing in which cosmic ideograms became syllabic signs (no doubt paralleling the emergence of amphibians from the primal sea and their adaptation to life on dry land), and thence perfected itself in the form of the alphabet. Unidirectional, monogenetic, and reductive, Soldi's theory was bolstered in his text by a plethora of examples in which he could trace the universal use of signs from one culture to another. This commonality established the cosmological significance of the form: it was a self-evident fact of the universe which had become apparent to humankind and thus incorporated in symbolism worldwide. Soldi protested against reference to the terms 'Japhetite, Semite and Chamite' on the basis that they were anti-scientific, but he happily subscribed to the concept of a single primeval language, namely Egypto-Sumerian, from which all language and writing had sprung. To prove his point, Soldi traced the origins of the letter 'S' through images of a 'dorsal spine,' a stele, a tree, a tomb, a support and column, a sceptre and so forth in a series of mutations which moved between Egyptian, Babylonian and biblical sources. This discussion of the 'S' wove together an elaborate system of linguistic values linking an ancient Sumerian root, *Sam*, with another root, *Tat*, so that iconographic and graphic elements became loaded with lexical value finally residing in the Hebrew *Samek*. The primordial unity of all human tongues was once again the conceptual

framework with which all the various strains of thought and evidence must be made to conform. Soldi's work demonstrated the chameleon quality of mystical writers as well as that of scholars, since he found it useful to adopt the terminology of his authoritative contemporaries in the elaboration of his own idiosyncratic scheme to recover the original 'Cosmoglyphs.'[17]

The alphabet fostered imaginative speculation in the realm of occult or cosmological writers long after its historical origins were being traced to scratched surfaces in the Sinai peninsula. But there were also writers who found the practicality, efficiency and functional character of the alphabet equally worthy of high praise – and equally mysterious. Luther Marsh, a writer whose sole contribution to the historiography of alphabet symbolism seems to be a short talk presented for the New York Historical Society in November, 1885, praised both the democratic character of the alphabet – 'it was given to all' – and its inexhaustible power. 'How trivial these symbols look and the simplest things we show to childhood. But a sleeping force lies within them which revolutionizes the world.' The power of the alphabet resided in its capacity to pull thoughts 'floating in ether, intangible spiritual substances' into a form which could be kept forever. Was it a divine invention? Marsh refused to concede that human invention was incapable of so supreme an achievement, but he hedged his response, stating that 'if some old Cadmus of a trilobite, or a toadstool, a radiate, a beetle or a mollusk, had invented the alphabet aeons before the Phoenicians arose', then at least a human being might know to which of the wild creatures it would be appropriate to 'lift a hat, with filial respect...' when walking through the fields. Marsh's humor was tempered with profound theological convictions. The highest task of writing was for him to 'glory in the Sacred Word.' But the most miraculous feature of the letters in his eyes was the fact that these few symbols, with their infinite combinations, would never be exhausted, that knowledge of all aspects of human endeavor could 'find their home, their record, their perpetuation in and only in these few symbols of the ALPHABET.' But even if the actual monuments in which the alphabet was used disappeared, if the documents of people anxious to 'float down the stream of time some relic of their doings,' crumbled into dust, still their existence and history would remain 'in the grasp of the Alphabet.' Nicely articulating the crucial stimulus to fascination with the history of the alphabet, Marsh stressed that the alphabet itself was the repository of history, not only its instrument or means.

X

20TH CENTURY: ECLECTICISM, TECHNOLOGY AND THE IDIOSYNCRATIC IMAGINATION

Archaeological and linguistic discoveries which provided major turning points in conceptualizing the history and development of the alphabet occurred in the late 19th and early 20th centuries in the work of Mark Lidzabarksi, Flinders Petrie, Godfrey Driver, and many other researchers.[1] There are many points still open to debate concerning the dates and sites of the origin of the alphabet in the geographical region stretching along the Mediterranean coast from the Sinai peninsula to the southern edge of Asia Minor and its transmission into Crete, areas of Greece, and the Italian peninsula.[2] But the general outlines of that history are accepted within the community of scholars whose work focuses on this research. The alphabet is assumed to have formed in the synthesis of contacts between Egyptian writing systems and cuneiform syllabaries around the middle of the second millennium BC; it became stabilized within a few hundred years and diffused throughout the Mediterranean region, especially westward and northward, into the regions of present day Greece and Italy, certainly by the 8th century BC. Among Greek speaking peoples, the alphabet became modified, acquiring a more complete system of vowel notation. But the visual forms of the contemporary alphabet used on these pages were derived from gradual transformations by stonemasons, scribes, and typographers in the subsequent two thousand years.

While this early history of the alphabet has become systematically codified – and even its areas of controversy given familiar outlines – within the disciplines of archaeology, Semitic and Classical studies, the discussions of the symbolic value of the alphabet which are less firmly grounded in the conventions of this scholarly tradition have continued to proliferate. The 20th century therefore has had its full share of independently conceived theories on the value and meaning of the alphabet, some carrying on traditions of mysticism, religion or ideological beliefs which have frequently granted significance to the letters as a system of fundamental elements or keys to knowledge, history, or revelation. Some of these positions refused to acknowledge archaeological or linguistic evidence, while others made free use of such information as the basis of speculative analysis. The writers whose work appeared most idiosyncratic were often those with the fewest links to any particular established tradition or community and whose imagination, rather than research, provided the larger portion of motivation for their work. What is incontrovertibly true, however, is that the fascination which the letters provide for speculation was undiminished in the 20th century, demonstrating the powers of the human mind to

project an unlimited number of varied interpretations onto the schematic forms of the alphabet.

Finally, it was in the 20th century that Franz Dornseiff published his densely unique contribution to alphabet historiography, *Das Alphabet in Mystik und Magie*. First drafted as a master's thesis in 1916, Dornseiff's text was published in its full form in Leipzig in 1922. His was the first attempt to chart the several traditions within which the alphabet had been interpreted as a symbolic, rather than merely linguistic, form. Until the present publication, it was almost the only text which had examined the place of the alphabet within Gnosticism, Pythagoreanism, the Kabbalah and so forth in order to trace a history of ideas across the field of disciplines in which the alphabet has been granted symbolic value.[3]

Electronic media and typographic form

While there were many stylistic innovations in typography and design throughout the early 20th century, none of these involved a radical reconceptualization of letter forms in either theoretical or practical terms until the development of photographic and, even more particularly, electronic methods of production entered into play. Until the middle of the 20th century, commercial printers continued to rely primarily on conventional methods of composing type, either through linotype and monotype high-speed casting of metal, or, for specialized production, engraved plates, rotogravure, or lithographed reproductions. Photography had become an integral instrument of the printing trade, but it was not used extensively in the actual composition of type until after mid-century.

Prototypes for photographic type composition machines had been developed experimentally as early as the late 19th century. The first photo-typesetter used for production was that of A.E. Bawtree, based on a model patented in England in 1856.[4] In 1919 and 1922 respectively, PhotoLine and PhotoLinotype machines were introduced by the Dulton and Robertson Companies consisting of cameras with film or glass matrices. But the first phototypesetting machine which was actually marketed was shown in a 1950 printing exposition in Chicago. This Intertype Fotosetter made use of negative images of the letters on film which generate type through successive exposures of one letter after another on a photosensitive paper or film. By the end of the 1950s such machines began to find their place within the printing industry, though widespread use awaited improvements linking electronic innovations in word processing to phototypesetting production.

While putting photographic methods at the service of the typesetting industry brought both new problems (distortion, unevenness of color owing to chemical baths, clumsy procedures for making corrections) and new solutions (infinite supply, speed of composition, and ready access) to the printer, the new technology did not cause a radical reconceptualization

We know not when, and we cannot c
there dawned upon some mind the f:
which people uttered are expressed l
Hence, what better plan than to sel
from the big and confused mass of
and all their kin, a certain number c
to denote, unvaryingly, certain sou
That was the birth of the alphabet, one o
and most momentous triumphs of the hu

**We know not when, and we canno
there dawned upon some mind th
which people uttered are expresse
Hence, what better plan than to se
from the big and confused mass o
and all their kin, a certain number of si
to denote, unvaryingly, certain sounds?
That was the birth of the alphabet, one o
and most momentous triumphs of the hu
We know not when, and we cannc
there dawned upon some mind th
which people uttered are expre
Hence, what better plan than tc
from the big and confused mas
and all their kin, a certain num**

Univers, optical font designed by
Adrian Frutiger

of letters. The variety in type forms made possible through photography included useful ranges in size, scale, and even slanting or distorting of letters. But these were frequently based on a single negative image and the variations were produced through optical means. The limits of such transformations were those imposed by the mechanical manipulation of the negative with photographic techniques, such as the use of an anamorphic lens. The letters were still very much visual forms. Much work went into the designs of such innovative typographers as Adrian Frutiger and Herman Zapf in adapting conventional letters to the peculiarities of the photographic process, but the problems they faced were the same problems of adapting designs to small and large point sizes, harmony between italic and roman letters in a single face, and aesthetic solutions to problems of legibility which had been the concern of type designers since the 15th century – and calligraphers for centuries before that.

ITC Galliard CC

ABCDEFGHIJKLMNOP
QRSTUVWXYZ&*ABCDEFGH
IJKLMNOPQRSTUVWXYZ*
ABCDEFGHIJKLMNOPQRS
TUVWXY&Z
abcdefghijklmnopqrst
uvwxyz
abcdefghijklmnopqrst
uvwxyz

281

Galliard, optical font designed
by Matthew Carter

A substantial conceptual change occurred with the introduction of digital designs treating letters as information rather than as visual images. The nature of the alphabetic forms came under investigation in the combined efforts of mathematicians and designers. One such team consisted of Donald Knuth and typographers Charles Bigelow and Kris Holmes (though Knuth had input from a number of other designers, such as Zapf and Matthew Carter and Richard Southall in the course of producing his TEX and METAFONT designs). The questions raised went to the very heart of philosophical speculation on the identity of letters – was the alphabet a set of discrete elements, each with an essential identity which could be coded into a mathematical equation? Or was it a set of marks which gained their identity through differentiation from each other, composed of a number of elemental parts (strokes, bowls, cross-bars) in combinations which must remain visually distinct from each other but had no essential form? The answers to these questions had implications for the storage of letters, programs for design, and methods of constructing devices for optical character recognition.

282

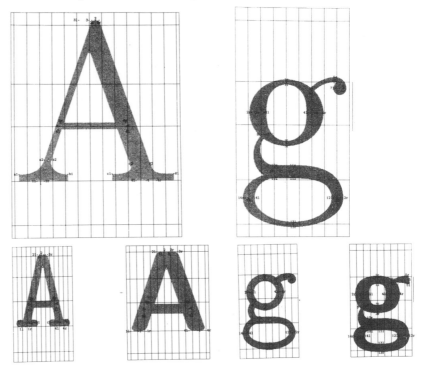

Computer fonts: Donald Knuth's diagrams, *Computer Modern Typefaces*, Menlo Park, CA, 1981

Ultimately the flexibility of the electronic medium is such that letters have been designed using all of these various parameters: they can be considered simply stroke patterns in which case the only variable is the thickness of the lines making up their stick-figure forms, as patterns of pixels (which have no identity beyond the values assigned to each point in the image, as in the analogy of yarn making up a tapestry), or as polygons whose outlines are configured by a set of points which define the curves and

lines which make up the complex positive and negative shapes of letter forms (such points can be manipulated the way nails used to stretch an elastic thread may be moved to reconfigure a formed pattern). The contrast between the attitudes of teachers of penmanship with their emphasis on the strokes formed by muscular movements and that of designers making patterned surfaces out of modular elements has been extended in the 20th-century electronic vocabulary to include designs which imitate pen movements (called ductal letters) and designs which mutate letter forms through the illusory dimensions of electronic space in accord only with the logic of electronic data processing.

Stroke font, pixel font, polygon parametric font diagrams

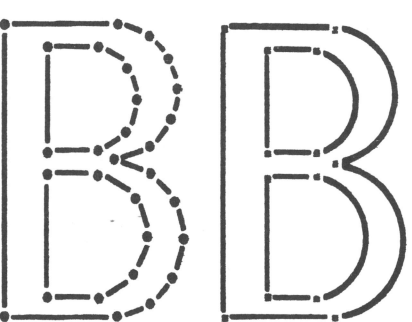

The first B uses straight lines; the second combines straight lines and arcs

283

The most recent design innovations in electronic type design involve the production of what are termed multiple-master fonts. In these fonts a range of letter forms may be generated which cover the full spectrum between serif and sans-serif versions of a single design. The letters are generated from a number of inter-related parameters which modify the design

in each of its versions, rather than working from a single base design. The end result is a letter form which is more adaptable to the electronic environment than those adopted from optical or photographic models. The possibilities for producing innovative and original forms of letters has never been greater, or accessible to more individuals, since the computer combines the freedom of calligraphic drawing with the reproductive capabilities of photography and the generative power of electronic data processing.

Adobe's multiple master font, 1992

284

Manipulated letter form to show electronic capabilities

Avant-Garde Typography

Experiments in the use, design, and manipulation of letterforms proliferated among artists active in the many avant-garde groups of the early 20th century. In paintings, posters, handbills, small magazines and independently produced books, artists broke with the standard forms of typographic design and liberated letter forms as visual elements through radical design strategies.

Among Cubist artists, the invention of collage techniques which appropriated material from popular media are dated to Pablo Picasso's 1912 *Still Life with Chair Caning*, a work which integrated mass produced paper and hand painted lettering imitating the title of a daily journal into the painted canvas. In the years immediately following, Picasso and his studio mate, Georges Braques, produced dozens of collage works making use of printed materials, some of which retained their verbal legibility and many of which simply became the basis of more abstract designs.[5] At the same time Futurist artists in Russia and Italy, as well as others experimenting in Germany and the United States, picked up on these techniques and made use of them for their own stylistic innovations. The result was the production of works of visual art whose incorporation of verbal elements – whether hand painted or collaged – helped to call attention to the two-dimensional surface of the picture plane, contributing to the destruction of the illusory quality of pictorial space which had been a feature of Western painting since the Renaissance.[6]

Poster by Ilia Zdanovich, Soirée du Coeur á Barbe, Paris, 1923

Among writers, the call for experimentation was in part a continuation of the work of late 19th century Symbolist poets, especially Stéphane Mallarmé, whose own typographically radical work, *A Throw of the Dice*, first appeared in print according to its original designs in 1914. But a more immediate impetus came from the Italian Futurist poet, Filippo Marinetti, whose manifesto of 1909 called for inventions in every artform. Marinetti wanted to make a distinct break with the nostalgic works linked to the past and invent modern works for the future. In typographic terms, this called for jettisoning the highly decorative pages of Victorian design, with their predominantly floral and organic motifs, in favor of a mathematically precise and streamlined mode. Marinetti's own publications such as the 1914 *Zang Tumb Tuuum* and 1919 *Words in Liberty* made use of multiple fonts, sizes, and scattered the words on the page in a visual imitation of onomatopoeic devices. Marinetti had a wide influence, not only among Italian artists, but throughout Western Europe and Russia.

Among the Russian poets, Velimir Khlebnikov, Aleksander Kruchenyk, and Vladimir Mayakovsky were some of the first to be seriously involved in experimenting with the visual presentation of text on the page. Khlebnikov and Kruchenyk, in their 1912 essays, 'The Letter as Such' and 'The Word as Such' laid out an extensive theoretical agenda for taking the visual, material form of language into account in poetic practice. Their work verged on the mystical, with Khlebnikov in particular claiming

285

Tristan Tzara 'Bulletin' *Dada*

insight into the significant value of the letter forms. But other Russian writers, particularly those involved in creating what they called a 'transmental' language, *zaum*, were motivated by an investigation of linguistic structure. Ilia Zdanevich, for instance, made use of typographic manipulations to isolate units of both visual and sound value in a suggestive punning play of verbal presentation. Zdanevich's most accomplished piece in this realm, a work titled *Ledentu as Beacon*, appeared in 1923, the same year as the better known and equally visually striking *For the Voice*. This latter work was designed by the Russian Constructivist typographer, Lazar El Lissitzky, from a text by Mayakovsky, and demonstrated many of the characteristics which became typical of Soviet design: use of diagonals, striking black and red contrasts, changes of scale, and a hard, geometric basis for the layout of the pages.

The Dada artists whose activities were first initiated in Zurich in the midst of the First World War also made use of typographic innovations to give the19th-century advertising (mixed faces, sizes, and the use of small graphic elements such as pointing hands, arrows and so forth), they established a visible profile through publication of many ephemeral works. Handbills and posters were particularly useful as a means of promoting their activities, and the graphic techniques used in the striking designs of these pieces became incorporated into the pages of *Dada*, one of the major publications of the loosely associated group. *Dada* style was borrowed, modified, and diffused among many avant-garde artists in Europe throughout the late 1910s and into the 1920s. Several of the important artists associated with these practices later became involved in teaching at the Bauhaus, or in other institutions where their work laid the foundation for the mainstream traditions of 20th-century graphic design. One effect of the avant-garde artists was to incorporate elements of self-conscious experiment, formerly more limited to advertising work, into the design of the editorial pages of literary and journalistic publications. More fundamentally, their work called attention to the visual representation of language as an element in the production of verbal meaning.[7]

New Narratives of History

As mentioned above, the mainstream narrative of the origin and development of the alphabet became standardized in the 20th-century in the archaeological and linguistic disciplines which focused their study on the early civilizations of the ancient Middle and Near East.[8] One area of tension in this narrative remained. This was a reformulation of the old conflict between those who believed in a single point of origin for the alphabet (though few scholars continued to support a monogenetic source for *all* forms of writing) and a more diffuse process of creation. This latter position was most strongly supported by the work of Flinders Petrie in the early decades of the 20th century. His discovery of the widespread use of

schematic signs from a shared signary around the edges of the Mediterranean argued against any clear pictorial precedent in hieroglyphic prototypes and against a single geographic location for the development of the alphabet. Other scholars, such as Godfrey Driver, Ignace Gelb and David Diringer, and later, Joseph Naveh continued to work out the details of a model which in essence built on the premises supplied by Emmanuel de Rougé and Isaac Taylor. This was essentially that the alphabet had been developed in a more localized region in which Semitic-speaking people were exposed to both cuneiform syllabaries and hieroglyphic signs which provided the conceptual and practical tools on which to develop an alphabetic system. Support for Petrie's position did not gain momentum in the course of the century, though at the same, arguments for a single particular point of origin for the alphabet (namely the Sinai peninsula) which had provided so satisfying a solution to scholars still hoping to reconcile archaeological knowledge and biblical traditions were also qualified. As stated above, a region, the eastern coast of the Mediterranean, and a general chronological period, the first half of the second millennium BC, are now considered the time and place of the development of the Semitic alphabet from which all other extant alphabetic systems derived.

Outside of this mainstream, alternative narratives of alphabet history continued to be put forth, often by scholars with partisan interests. Some of the most popular areas for such activity were not in the history of the alphabet proper but in the study of those offshoots of the alphabet associated with esoteric traditions, such as Runic scripts. But alternative narratives of alphabet origin, development, or symbolic value arose along as wide a spectrum of thought in the 20th century as in any other.

The work of L.A. Waddell was produced in support of the ideological stance revealed in its title, *The Aryan Origin of the Alphabet*. Published in 1927, Waddell's text had a single major agenda: to prove that the alphabet had been invented by the Sumero-Phoenicians, and that they were in no way connected with the Semitic people in that region, to whom they were, according to Waddell, vastly superior. Waddell's text is a work of facile distortion, readily reorganizing historical facts to suit his political stance, and the interpretation of the individual letters he brought forth to support his argument was highly idiosyncratic. According to Waddell, Thoth was actually Thor, the first Sumero-Gothic king. This point was easily proved in his opinion by the similarity of names, a logical strategy which led him to further assert that King Ar-Thur was in fact also the same individual. With this solid historical ground established, Waddell stated that the first form of Sumerian writing brought to the British Isles around 400 BC had been the Runes which retained many of the features of their Sumerian parentage. Waddell believed that the greatest and most useful inventions of the human mind had been Aryan. The two most important among these, he asserted, paraphrasing the French philosopher Mirabeau, were writing and money: 'the common language of intelligence and the other the common language of self-interest.' To support his blatantly anti-

Semitic thesis, Waddell assigned values to the letters which demonstrated his complete disregard for linguistic scholarship on the relations of writing, phonetics and speech. His symbolism was derived from a gratuitous reading of the signs as elements of what he termed the Sumerian language.

Chart showing the Sumero-Gothic origin of the alphabet, (L.A. Waddell, *The Aryan Origin of the Alphabet*, 1927)

The Sumerian script was the oldest form of writing in the Mesopotamian region and its invention has been dated as early as 3100 BC.[9] A form of cuneiform, it had been one of the scripts deciphered through the efforts of Georg Grotefend and Henry Rawlinson, 19th-

a =	wavelet, aquatic sign, associated with Asa, meaning Lord, One
b =	mass in division, to bisect
c =	late, redundant letter
d =	delta, from Egyptian hieroglyph for hill
e =	water canals, thus, to word for water in French *eau;* also, eye
f =	serpents and fate
g =	lever, balance and the word to give
h =	from Hammurabi law code, associated with verb *to cut*
i =	wooden bar
k =	earth, a parent sign, diagram of coat with collar, sleeves, skirt
l =	balance (Sumerian "t")
m =	from pre-dynastic Egyptian sign for mountain
n =	cancelled out
o =	sun, moon, a well, a hole, opening or the verb *to call out*
p =	early form of shepherd's crook, staff or scepter of a leader
q =	earliest form of object called a "cue" in English
r =	diagram of the foot, Sumerian verb *to run*
s =	fish or god of the waters
t =	to tear, an arrowhead or dart
w =	pair of ears, thus, *to hear*
x =	a letter surrounded by much confusion
y =	Semitic addition to the alphabet standing for Yehovah
z =	battle axe, a jewel or a stone

Waddell's Aryan values for the letters of the alphabet (L. A. Waddell, *The Aryan Origin of the Alphabet*, 1927)

289

century German and English scholars. Mainstream historians considered the Sumerians 'a people of unknown ethnic and linguistic affiliation,' and by the end of the third millennium BC their language had disappeared, their script taken over by the linguistically Semitic Akkadians.[10] Waddell, however, invented his own history of the script and the people to whom he ascribed its development. He blended Runes, Akkadian symbols, and Sumerian symbols in his cosmology without regard for the chronological and cultural discrepancies in his system. Describing the relation between the signs for 'T' and 'Th' he stated that in its Runic form the 'D' sound was transformed through 'the lengthening of its stem where by the name of the first Gothic King *Dar* or Dur, became 'Thor.' This compound letter survived in Britain, Waddell continued, and could be found on coins 'of the

Pre-Roman Ancient Briton king Addedomaros, the Aedd-mawr of the Welsh.' He readily contradicted the work of authorities like Isaac Taylor – his discussion of the 'W' for instance begins by stating that Taylor mistakenly believed it to be a late sign, while in fact it was an Assyrian/Sumerian sign for two ears, pronounced 'Wa' in which form it had come to be the basis of the English word 'hear.'

RUNES	NAMES	VALUES ASSIGNED BY GUIDO LIST
ᚠ	fa, feh, feo	fire- generation, fire-borer, property, livestock, to grow, wander, destroy; the primordial word; arising, being
ᚢ	ur	eternity, primal fire primal light, primal generation, aurachs, resurrection
ᚦ	thorr, thurs	thunder, thunderbolt, lightning flash, a threatening sign but also thorn of life (phallus)
ᚨ	os, as, ask, ast	mouth, arising, ash, ashes, the power of speech, spiritual power working through speech, bursting fetters
ᚱ	rit, reith, rath	red, wheel, right, the solar-wheel, the primal fire, God itself, exalted introspective awareness of the Aryans
ᚲ	ka, kuan, ka	world tree, Aryan tribal tree, feminine principle (kaun) the All in a purely sexual sense; blood, highest possession
ᚺ	hagal	to enclose, the All-hedge, hail, to destroy; introspective consciousness, to bear qualities of God within
ᚾ	nuath, noth	need, compulsion of fate, organic causality of all phenomena; constraint of clearly recognized way
ᛁ	is, ire, iron	iron, doubtless consciousness of personal power, all of life obedient to the compelling will
ᛅ	ar, sun, ar-yans	nobles, the sun and light to destroy spiritual and physical darkness, doubt, uncertainty, primal fire, God
ᛋ	sol, sal, sul, si	sun, sal-vation, victory, column, school, the conquering energy of the creative spirit
ᛏ	tyr, tar, turn	to turn, conceal, cap of concealment, to generate, reborn phoenix spirit of young sun-god
ᛒ	bar, beor	birth, the eternal life in which human life is one day, pre-destination in the greatest sense
ᛚ	laf, lagu, logr	primal-law, defeat, life, downfall, intuitive knowledge of all organic essence, laws of nature ,Aryan sacred teachings
ᛘ	man, mon	moon, to mother, to increase, empty or dead, sanctified sign of propagation of human race; "ma" as mothering
ᛦ	yr, eur	iris, bow, rain-bow, yew-wood bow, error, anger, inverted man rune; mutability of the moon (feminine essence)
ᛇ	eh	law, horse, court, marriage, the concept of lasting love on the basis of marriage, two bound by the primal law of life
ⵣ ᚷ	fyrfos or ge	fyrfos or hooked cross or the gea, geo, earth, given of life; the first a sign of nuptually bound dieties, dyad of spiritual/physical power; second a primal root for life

Values assigned to the Runes by Guido List, *The Secret of the Runes*, 1908

Waddell's interpretations fall apart at the very first interrogation by genuine scholarship, but the work of Guido von List (the aristocratic middle term was his own addition to his given name) with respect to the meaning of Runic forms was less vulnerable on this point. List's work had in common with Waddell's a desire to legitimize the ethnic origin and mythos of the German people through the symbolism of a script form. List died in 1919, and his major publication, *The Secret of the Runes*, was published in 1908 in the context of Pan-Germanic enthusiasm for folkloric mysticism and revelations about the roots of German culture. List's work differed from Waddell's in its lack of explicit anti-Semitic statements: his search for the 'primal language of the Aryo-Germanic people and their mystery,' provided material later used by members of the National Socialist party and their leaders, but in the absence of evidence, it is difficult to know the extent to which their practices would have been sanctioned by List. Runes, however, supplied a cult symbolism for the Nazi party, and the associations forged in that period were in part drawn directly from the texts of Guido List.[11]

List believed that the Runes were 'word symbols of a prehistoric age' and that in their symbolism might be traced the 'occult aspects of origins of social and racial order.' The theme of a 'lost knowledge' recoverable in the interpretation of a script was a familiar one in alphabet symbolism and a potent force motivating mystico-magical revelation. List divided the Runes into two classes, those which represented letters and were 'holy signs' or 'magical characters' and the 'hieroglyphs,' which were not script symbols. His interpretation of his latter term provides an example of the pseudo-etymology by which he 'recovered' the Aryan roots of language. He traced the work to its purported original 'hiroglif' which he divided into root words: 'ir,' 'og,' and 'lif;' these in turn he associated with three primal-words 'ar,' 'ag,' and 'laf.' These roots had multiple layers of meaning each associated with one of three stages of being: arising, being, and passing away. So that 'ir/og/lif' contained a cycle of values: 'beginning/to see/concealed life' and then 'in a circle/increase/to live' and finally 'error/to separate/conclude.' His cosmology had been influenced by Eastern philosophy – he elaborated on the task of the ego to become a non-ego, for instance – and his interpretation of the eighteen script-symbols he counted as the original Runes often had the quality of epigrammatic spiritual instruction: 'The fourteenth rune says: First learn to steer, then dare the sea-journey.' The sources available to List were texts on German mythology and more overtly fictionalized versions of the German antiquities, but the spirit of his work betrayed a substantial dose of influence from the two figures who exerted so powerful a force on German culture in the late 19th century: Richard Wagner and Friedrich Nietzsche.[12] Runes have continued to attract speculative interpretations into the present, no doubt because their actual history remained obscure well into the late 20th century and because of their association with pagan practices in Scandinavia and the British Isles.[13]

291

Not all 20th-century investigations of the primal origins of scripts were associated with supporters of an Aryan agenda. The work of Robert Graves, such as *The White Goddess* first published in 1948, contained an investigation of the origins of the Beth-Luis-Nion ancient Irish tree alphabet. Graves was searching for the unified origin of poetic themes, such as that of the 'white goddess' of his title. He found one form of this myth in an ancient Welsh poem that used the imagery of the trees and their names as invoked in the Beth-Luis-Nion script and the similar Boibel-Loth Ogham script. The alphabets contained slight variations on the symbolism of the tree-names for the individual letters, and Graves was interested in the origins of this symbolism. He traced the species names in these scripts to the only geographic region in which he could account for them all: the southern coast of the Black Sea. This is in fact one region through which the Runic forms may have passed in their geographical and formal transformation from Etruscan or other Italic scripts into the use among Germanic tribes. Turning his attention to the Celtic traditions in which the alphabets were more immediately embedded, he discussed the traditional imagery of trees as warriors in the ancient Welsh myth of 'The Battle of the Trees.' This was a metaphor, he explained, for the power of letters, each bearing the name of a tree native to the British Isles, and betrayed one of the sources for what Graves termed 'the historical grammar of poetic myth.' Graves's poetic investigations did not display the same racialist biases as those of List and Waddell, but shared the single-minded search for unifying myths and traditions which could be guaranteed through symbolic interpretation of an alphabet script.

Graves drew extensively on the work of Robert O'Flaherty, whose book *Ogygia* provided source material on Druidism, including the symbolism of the alphabet. Graves perceived a magic calendrical system in the trees associated with the thirteen consonant sounds of the tree-alphabet: the Birch, Rowan, Ash, Alder, Willow and so forth each associated with one of the months of the lunar calendar. Birch, the tree linked to the first letter, B or Beth, thus gave its name to the first month of the year, from 24 December to 20 January.[14] In his extended interpretation of the symbolic value of each of these trees, Graves made use of Classical sources as well as myths from the British Isles. Birch was a 'self-propagating tree' whose branches had been used for 'flogging delinquents – formerly lunatics – with the object of expelling evil spirits.' Birch switches were also used for 'driving out the spirit of the old year' while the lictors accompanying Roman consuls carried birch rods during the installation ceremony. Graves did not synthesize these various meanings, simply listed them to a cumulative effect for each of the letters in the Irish tree alphabet.

The Hebrew alphabet, with its own symbolic traditions, was also the object of speculative interpretations of the kind which had attached to Runes, Ogham and ancient Irish. René Palaysi's work *L'Alphabet: Code mystique du langage et de la philosophie des Ancêtres*, published in 1945, was written with full cognizance of developments in archaeology as well

as the various debates among Semiticists and Classicists but then developed its own independent arguments. He began his work by citing the discoveries made by French archaeologist Paul Montet, specifically the Ahiram tomb inscription (around 1923), and its contributions to the theory of the invention of the alphabet. But rather than conclude as Montet had that it pointed to a Phoenician origin, Palaysi brought the force of tradition and other historical evidence to support his argument for a Hebrew invention. Palaysi's interpretations of the individual letters, however, were created from within a subjective mystical tradition, rather than an archaeological one. He began with the statement that it was generally maintained that the alphabet was an arbitrary series of letters in an order fixed by convention. According to Palaysi, however, the letters were a more profound cosmological system whose sequence was significant and whose meanings were governed by hidden laws of sound associations.

Palaysi created a 'grammar' of elemental units which was not conceptually different from that of other sound symbolists – whether of the Celtic, Aryan or Saxon variety. Like many of those authors, Palaysi proceeded from the peculiarly shortsighted proposition that the symbolic values based on the original Hebrew alphabet could be found in the associations suggested by words in the French language. Thus he granted 'A' the value of an ox, because it was a domestic animal essential for existence, but claimed the letter had the philosophical value associated with 'abstraction,' 'acte,' and 'attention.' Similarly 'B' was associated with 'besoin' (need) 'but' (goal) 'bête' (beast) 'balme' (balm) and 'bâti' (built); 'C' was linked to the French words for conscquence and knowledge (along with the letters 'G,' 'K,' and 'Q'); 'D' with determinism, direction and distance; 'E' with space, hearing, evolutionism; 'F' with figure, finality, foundation and form; 'H' with harmonize, humanity and history; 'I'/'J' with idea, image and judgment; 'L' with language, law and light; 'M' with modality, measure and movement; 'N' with birth, nervousness and number; 'O' with observation, operation, order; 'P' with particularity, perception, perfection; 'R' with rapport, research, reflexion; 'S' with science, sagacity and sensation; 'T' with tenacity, transformation and travail; 'U'/'V'/'W' with unity, value and truth. 'X' was not a letter, Palaysi said, but a Phoenician invention, while 'Y' was the combination of 'V' and 'I' and thus the sum of verity and intelligence; and 'Z' was the crowning of 'I' with intelligence, though he did not make clear what the reason for this last assessment might be.

Palaysi spelled out an extensive etymology using this letter symbolism, which he felt could be used as a key to the meaning of words. As is frequently the case in such idiosyncratic interpretations, Palaysi moved freely between Latin words, Hebrew roots, French terms and the associations he had put onto his letter symbols. For instance, he interpreted the word 'dog' according to its Latin spelling CANIS, but in accord with a vocabulary of French words as in 'C= qui connait' (who knows) 'A=qui est attentif' (who is attentive) 'N=qui reproduit' (who reproduces), 'I=qui est

Fig. 7 Cretan.

Fig. 8 Hittite.

Fig. 9 Proto-Elamite

Fig. 10 Hieroglyph: bull, nose, breath, front, front of anything.

Fig. 11 Sinaitic.

I II III IV
Fig. 12 Cretan.

can be seen.

Fig. 244 *he* Fig. 245 *khet* Fig. 246 *he*
Hebrew square. Canaite-Phoenician.

I II III IV V
Fig. 247
I Cretan. II South Semitic A. III Phoenician A. IV Ugarit A. V North Semitic A.

man raising his hands.

Fig. 34 Egyptian Fig. 189

I II
III
Fig. 291 Cretan.

Fig. 292 Cyprus. Fig. 293 Easter Island.

Fig. 294 Chinese. Fig. 295 Old Hebrew *jod*.

Fig. 63 Indus valley script.

I II III IV V VI
Fig. 64 Crete.

Fig. 65 North American Indian. Fig. 66 Eskimo

Fig. 67 Ewe (West Africa): I, me.

294

Signs and designs behind the origins of letters according to Alfred Kallir (*Sign and Design, the Psychogenetic Origins of the Alphabet*, London, 1961)

intelligent' (is intelligent), and 'S=qui est savant' (is knowing). Palaysi's system was exhaustive and self-contained: he had supplied both the associations on which it was based and the interpretations to which these associations might lead. Palaysi's work was not really a narrative of the history of the alphabet, but a symbolic interpretation grounded in certain historical associations, but it served as the basis for the work of Alfred Kallir in his version of the development of the alphabet.

Alfred Kallir's method had something in common with 19th-century scholar Soldi de Beaulieu who borrowed from every conceivable archaeological source regardless of chronological or geographical obstacles, and traced a single, synthetic narrative of alphabet development and symbolism across this corpus of documents. Though his interpretive framework was Kallir's own, he made reference to the work of Fabre d'Olivet, as well as that of Palaysi, in creating his study, *Sign and Design: the Psychogenetic Sources of the Alphabet*.[15] Published in 1961, Kallir's book proceeded from the basic premise that the alphabet was a system of 'primordial signs from the collective unconscious' in which the 'creation of individual man as well as of the human species' was encoded in a sequence which was a 'magic chain of procreative symbols destined to safeguard the survival of the race.' Though Kallir used the term 'race' his discussion had none of the racial biases of Waddell's or List's work, and he seems to have meant the human species by the term, rather than one particular branch.

Kallir's system drew on visual artifacts from diverse sources and time periods: proto-Elamite, Assyrian, Sinaitic, Cretan and hieroglyphic in which he found common iconography. He used two principles, for which he coined neologisms: *symballic*: meaning the 'persistent concurrence' of acoustic and visual features of a letter sign, and *acrocratic*: meaning the schematic or sometimes partial representation to which a letter had often been reduced from an original drawing. Kallir firmly believed in the pictorial origin of alphabetic forms, however schematic, and in the iconography of these images he perceived a procreative narrative which also gave value to the sequence of the letters.

Kallir's narrative was explicitly psycho-sexual. He began his discussion with the 'A,' interpreting the image of the ox as an image of virility; the 'horns' in this glyph were an image of the male member, with all the powers associated with phallic penetration, piercing, ploughing. He cited Freud's discussion of the furrowed field and rapidly linked it to the hieroglyphic image of the plough as a sign used to indicate 'love.' The list of Semitic words beginning with *aleph* which he selected as proof were all associated with paternity and virility: father, creator, progenitor, firm, lord, male, and so forth, while in Arabic the vocabulary he chose was even more explicitly sexual, with its images of pricking and fecundation. A sign Kallir indicated had been used as a determinative in Egyptian hieroglyphics to indicate 'A' he associated with the word 'to beget' as well as with the male member. In the Runic system, he went on, the first three letters were associated with horned animals as were the Devenagri symbols for the

dipthongs *ai, ao, au*. Words beginning with these dipthongs had procreative associations with predominantly masculine imagery. Kallir proceeded to elaborate examples from Greek, Semitic, and children's first efforts at language in the full scope of his argument linking the *alpha* with the phallus, and any lateral extension in graphemic form with the erect and procreative male member.

He followed his examination of the symbolism of the '*a'/aleph/alpha* in its many linguistic variations with a similarly detailed investigation of the symbolism of 'B'. This was the image of the feminine, the vessel of womanhood, ready to receive the procreative force of the *aleph*, in the womb symbolized by the 'C.' The cross stoke in the 'G' which followed indicated the act of penetration of the feminine cavity by the male member, while the swelling curve of the 'D' was the growing womb. 'E' was the image of the birth process, with the 'F' as its completion and the 'H' as the icon of rejoicing, with arms raised to heaven. These first eight letters formed a microcosmic circle, followed by two others, composed of the letters 'I' through 'N' and then 'O' through 'Z', each with their own elaborate symbolic value.

Kallir believed that the psyche was 'timeless and eternal,' and that the use of the alphabet in daily, pedestrian business guaranteed the circulation of the basic information about human procreative cycles through the psyche. His beliefs gave human metaphoric form to cosmological theories about the alphabet which had generally been framed in more abstract spiritual terms. Robert Hoffstein's book *The English Alphabet* (1973) returned to this level of abstraction in its imagery, and was close in spirit to the work of Fabre d'Olivet and other writers for whom the alphabet was the embodiment of the story of Creation. Hoffstein was not a kabbalist, nor was he concerned only with Jewish or Hebrew symbolism. His approach to the alphabet was to see in it the symbology of the Word and to interpret the letters as the seed, the light, the foundation, and spirit of humanity suffused with divine inspiration.

One aspect of mainstream interpretations of the development of the alphabet which acquired a new dimension in the 20th century was the reading of the supposedly pictorial images from which the schematic forms of the alphabet had originated. The names of the letters had been established in antiquity as a mnemonic device, according to the acrophonic principle whereby a word beginning with that letter was used as its name. The pictorial imagery suggested by these words often led to the confused belief that the forms of the letters had originated in more replete pictorial forms – a supposition for which there is no archaeological evidence. The classic version of this confusion frequently arose from the habit of showing the named image and the associated letter in publications – such as the versions produced by Sir John Evans (father of the expert on pictographic scripts from Crete, Arthur Evans) and A.C. Moorhouse, in his more storybook version. Their attempts to make their own schematic drawings match the early Semitic letter was revealing –

both in their contortions and the differences between the two solutions they presented.

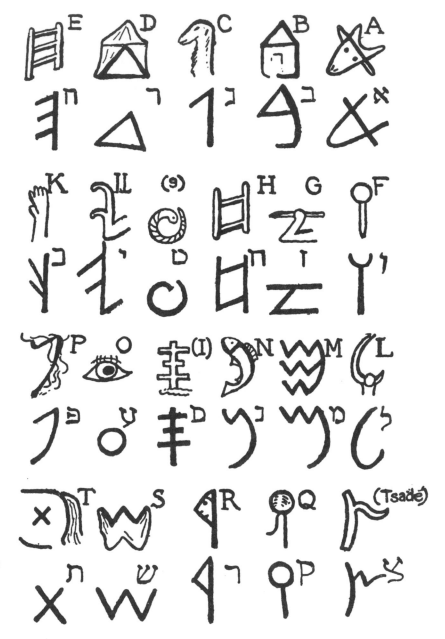

Depiction of words associated with the names of the letters which suggests a pictorial origin for the alphabet, by Sir John Evans (Sir Arthur Evans, *Scripta Minoa*, Oxford, 1909)

Several writers who considered themselves historians (rather than spiritualists or metaphysicians) believed that the letters had had a pictorial derivation. Among these was Joseph Bouuaert, whose *Petite Histoire de l'Alphabet* was published in 1949. Bouuaert, like many other alphabet historians, had an idea of the logic of development he felt the letters must have taken in their graphic evolution. Unlike many of his contemporaries, he was not convinced that the alphabet had been derived from Egyptian

Depiction of the letters
suggesting pictorial origin,
(A. C. Moorhouse, *Development
of the Semitic Alphabet*, 1953)

prototypes, but instead, he saw in the letters an independent graphic creation which had gradually become simplified. Bouuaert felt that the letters had originally been more pictorial, but had come to be increasingly schematic, so that an original image could be identified in the remnants of traditional forms. Thus the 'A' for Bouuaert was without question the simplified form of the ox, with only its horns and head outline still remaining, an image which permitted associations to be made with an iconographic original.

Picture-value	Hieroglyphic (1500- B.C.)	Hieratic (1500- B.C.)	Sinaitic 345	Old Hebrew	Phoenician	Biblical Square-script	Old Semitic Letter-names
Cow's head							'Aleph
House							Beth
Camel			346				Gimel
Door		(P)					Daleth
Jubilation							Hē
Rosette							Waw
Weapon			350				Zayin
Lotus-flower							Ḥeth
Coiled snake			351 (b)				Ṭēth
God Seth			346				Yodh
Plant (Coat of Arms of U. Egypt)			349				Kaph
Horizon							Lamedh
Water							Mēm
Water-serpent			346				Nūn
Fish			346				Sāmekh
Eye							Ayin
Mouth			349				Pē
Face			350				Ṣādē
Animal's belly							Koph
Head			346				Rēsh
Wood			346				Shin
Life			346				Tāw

Chart showing 'original'
hieroglyphic forms of letters
(Samuel B. Mercer, *The
Development of Our Alphabet*)

297

Perhaps the more interesting versions of such pictorial interpretations, however, are those which read the alphabet as a cultural code, as a set of symbols representing the most essential and important elements of the life of Semitic peoples as envisioned by 20th-century historians. One of these was the work of Hubert Skinner, published in 1905. *The Story of Letters and Figures* was a more sophisticated work than its title would suggest, and it was not aimed entirely at schoolchildren, but at synthesizing an interpretation of the alphabet as a cultural system. Skinner believed in the universal character of humanity, in needs, desires, and ideas which tran-

scended the limitations of history. Thus he proposed interpretations of the letters which often wove together the elements of what he imagined was Phoenician life with the lives of English-speaking people of the early 20th century.

Skinner began by stating that it was 'natural' that the 'A' should both represent the ox and be the first letter, since the ox was 'the earliest friend of man among brute creation.' From ancient times, he asserted, the ox and cow had been the companion of civilized people, helping them to subdue the wilderness, providing milk and sustenance, assistance in cultivation, all facts which were as true in the present, he stressed, as they had been in the days of barbarism. Skinner's rhetoric was steeped in the beliefs that agrarian life, cultivation of the earth, and civilization were intimately connected, and that the images of the letters would necessarily reveal this because the alphabet was also an instrument of civilization. In this regard, he echoed the 18th-century writers who considered farming the basis of human culture, the most natural and civil of social conditions. Skinner's text moved through each of the letters in turn, identifying their iconography and interpreting its place in the social order as a whole. 'B' was not merely a house, but carried the idea of a home and Skinner commented that: 'There is no race of people in the world to whom the idea of home is dearer that it is to the English-speaking nations...' In its iconography the Hebrew *Beth* conformed to a flat-roofed dwelling, open to the air, whose imagery he saw repeated in the word 'booth.' Skinner had more difficulty connecting the image of the camel with 20th-century Chicago, in which he was writing, so he discussed the *Gimel* without making such a link, and passed to the *Daleth*, the triangular opening to a tent, so readily perceived in this role in the English word 'Door.'

He went on: 'As the alphabet maker had now pictured a house and a door, he turned his mind naturally to a window and a fence.' These letters, and the sounds they made, were so close ('E' and 'H') that Skinner grouped them together, and moved on to discuss the 'F' which was a dagger hanging on a nail between 'the window and the fence' of the previous two letters. Next in sequence in the Hebrew alphabet (whose sequence Skinner was in principle following) was *zayin*, representing the handle of a dagger and part of its blade. It was just such a Phoenician knife which Judith might have used in rescuing her people from Holofernes, Skinner added, making use of biblical imagery to anchor his discussion in ancient but familiar history. Skinner's approach was distinguished by his insistence on understanding the alphabet in relation to narrative – both that of its sequence letter by letter, and of its relation to this imagined Phoenician past vividly evoked through biblical references and the means by which he connected these to the lived experience of his contemporaries. While such an approach may be understood when it occurred in the work of a person not integrally involved with either archaeological investigation or the study of ancient languages, it is less comprehensible in the work of M. Dunand, a French scholar who was both.

	BOUUAERT -- 1949		SKINNER -- 1905		DUNAND -- 1945
ᚨ	aleph =	ox, then, head with horns	A =	ox head, cow	alef = ox
℈	beth =	door, supports of roof	B =	the house, home	beth = house
า	gimel =	neck of camel	C =	camel, favorite animal	gimel = camel
Δ	daleth =	door, bottom stroke is ground	D =	delta, as in geography	daleth = door
∄	he =	man on knees, arms raised in joy	E =	window or fence	he = (tree branch, maybe)
Y	vau =	from nail to small flame	F =	nail and dagger	waw = hooks
⊥	zayin =	sword in its sheath	I =	handle, part of blade	zayin = branch, balance
Π	heth =	flower, calix			kheth = wall
⊕	teth =	hand, fingers extended			teth = roll
℥	yod =	hand	J =	the hand	yod = arm, hand
ꟁ	koph =	folded hand, thumb extended	K =	--	kaph = hand
Ꮭ	lamedh =	cross, cane, then shepherd's crook	L =	whip and fist	lamed = needle, rod
ꟽ	mem =	water (but not Egyptian zig-zag)	M =	the sea	mem = water
ꟻ	nun =	serpent	N =	fish	nun = fish
₮	sameleh =	fish in many forms	X =	the rock	samek = support, hold up
ꝋ	ayin =	eye evolved past recognition	O =	eye	ayin = eye
𝟽	pe =	mouth, open mouth	P =	mouth	pe = mouth
ꞈ	tsede =	side of man in profile	Ts =	scythe	tsade = a nose, hook
ꝙ	qoph =	stomach with esophagus attached	Q =	back of head with neck	qof = monkey
ꞁ	res =	head			resh = head
W	sin =	tooth	W =	support, sickle, saw	shin = tooth
✝	tau =	cross, a mark for a mark	T =	the mark	tau = a sign

Values assigned to the alphabet by Bouuaert, 1949, Skinner, 1905 and Dunand, 1945

Dunand's book, *Byblia Grammata*, published in 1945, was written to communicate developments in Phoenician studies. He began by stating that scholars such as François Lenormant, Wilhelm Gesenius and Hans Bauer had repeatedly pointed out that the letter names were not linked to the origins of the alphabet and that the mnemonic device of their names had often been mistakenly taken for a 'historical cause or source root.' However, he continued, Lenormant had indicated that the Phoenicians themselves had been aware that they had lost the original sources and traditions of the letters and thus resorted to a kind of 'hieroglyphicization' in order to transform the letters back into forms closer to an original image. This convoluted logic lent Dunand the justification he felt he needed to interpret the Phoenician letters systematically. *Alef* was the ox, *Beth* a house with a double sloped roof, a structure 'well-documented in Phoenicia in the early Bronze age.' As Dunand's reading proceeded, he fell into the usual pattern, allowing the letters whose meaning was fixed in their name, such as the *Gimel* = camel to stand, their relation to ancient Near Eastern life self-evident, while other letter names received elaborate explanation. *Waw*, for example, he described as the supports by which the beams of the Tabernacle were suspended, an interpretation not widely repeated elsewhere, while there were other signs, such as *He*, which could not be read as images for the reason that he found not a single Hebrew or Phoenician word which began with this sound.

The prevailing feature of the interpretations of Skinner and Dunand, was their clear motivation to see meaning in the letters rather than allowing that they were functional forms identified by name for the sake of convenience and clarity. By casting the interpretation of names into either a theory of the pictorial origins of the letters or a symbolic reading of their acrophonic names, the alphabet became more than a linguistic system, it became a repository of historical knowledge. This was not so different from the desire to see the alphabet as a code of spiritual or cosmological knowledge; it was simply given substance according to a different set of themes, more secular, and less abstract than those of the metaphysicians. It is this continual desire to see meaning that is perhaps the strongest feature of human imagination in its relation to the alphabet. The continual projection of images onto schematic forms is not sufficient, the images produced must necessarily fit into some system. That the forms themselves had some genuine history went unquestioned in nearly every case, but it was the special contribution of Hans Bauer, author of *Der Ursprung des Alphabets* (1937), to demonstrate in an experiment with schoolchildren how readily such forms could be invented. Bauer very simply asked a group of children to invent a script, one which had no relation to the alphabet with which they were familiar. In about three minutes they had completed their tasks – and of the two dozen symbols they each created, seven were identifiable as elements of the old Phoenician alphabet! The realization that there was a link between the physiological capacity of human beings to produce marks and the possibilities for creating simple graphic symbols which would define what marks would be made in any human writing system was something which was not unique to Bauer, though his experiment provided a dramatic demonstration of a situation explored by physical and social anthropologists, such as André Leroi-Gourhan or Claude Lévi-Strauss. Such work is fascinating both for its exploration of the human potential for mark-making and for its insights into the cultural function of writing, but it has little to do with the alphabet *per se*.

Specific research into the relations between the alphabet, cultural development and physiology has however been done in the 20th century, mainly under the impetus of work by the cultural theorist Derrick Kerckhove. *The Alphabet and the Brain* (1988), contained the results of a conference staged to combine the physiological analysis of right/left brain functions with cultural theories of the 'lateralization of the alphabet.' Eric Havelock's assertion that the actual structure of the Greek alphabet, rather than literacy itself, had brought about changes in cognitive processes was used as a foundation for Kerckhove's work. Havelock, it will be recalled, stated that the simplicity of alphabetic writing (by which he meant the Greek alphabetic system with its vocalic notation) permitted the human mind freedom from the difficult task of decipherment, allowing development of speculative and abstract thought. Kerckhove had begun his research by examining the development of Greek drama in 5th-

and 6th-century BC Athens, believing there was a correlation between the invention of the alphabet and the organization of dramatic form.

Kerckhove's assembly of neurophysiologists, biologists and historians of culture and literacy attempted to chart the ways that different writing systems affected (and were affected by) cognitive processes. He went so far as to state that processes of genetic transformation were brought about through the changes in cognition – themselves wrought by alterations in writing systems. Kerckhove linked both the direction of writing and the notational structure of writing to brain processing. He distinguished in particular between *feature detection* (essential for scripts which were more complex visually or depended upon extra-notational information) and *sequence detection* which formed the basis for reading an alphabet with full vowel notation, where it happened that the 'preference' was from left to right. Kerckhove posited the existence of causal relations between cultural and biological phenomena, stating that the form of the alphabet in classical Greece would have effected so striking a cognitive change that it would have had an impact on the conditions of gene selection in turn, affecting the physiological conditions of cognition.

Though stating that he wished to avoid a Eurocentric bias, Kerckhove's work contained many of the same problems which had put Havelock into a controversial position. For instance: Kerckhove asserted that the Greek alphabet, because it notated vowels, was a full record of speech, and thus did not require memory of the speech context for its reading. While this observation may have applied with accuracy to the brief period in which there was a relatively accurate correlation between written and spoken systems (it is assumed that the Greek alphabet did serve its speakers with great accuracy) a similar observation would be far from sustainable in analyses of contemporary alphabetic systems used for modern European languages, especially English. Assertions supporting this cognitive development, grounded in an assumption about the effect of a replete notation system on the function of the brain and a corresponding cultural and genetic change were very difficult to sustain. While it is true, as Kerckhove and his team pointed out, that ninety-five per cent of alphabets with vocalic notation use a script written left to right and while the alphabets without such notation (Hebrew and Arabic, for instance) are written right to left, it seems very difficult to locate a cause for this which does not simply describe the historical development of conventions – unless one proposes a profoundly biased set of assumptions about cultural difference. Kerckhove also presented the findings of researchers examining the relations between cognition and the character based scripts such as Japanese and Chinese, but the results were embedded in the same difficult quandary of trying to separate historical conventions from presumedly essential properties of a language and establishing links of any kind with physiological operations of information processing in the brain. Perhaps the most disturbing feature of Kerckhove's work, especially given its recent date, is its continuation of the belief that Greek culture produced a degree of abstract, sophis-

301

ticated thought which was supposedly never achieved within communities of Arabic, Hebrew, Chinese or other language users who did not make the Greek alphabet the basis of their writing.

Unique Interpretations of the Alphabet

While most 20th-century interpretations of the alphabet fall into one of the many traditions established in the long history of symbolic analysis of its forms, there are a number of authors whose work proposed a theory of the origin or significance of the alphabet which was without extensive precedent. One such proposition was put forth by J. Deloly in *L'Eau et Les Secrets du Langage*, published in 1962. Deloly believed that all language had arisen from onomatopoeic inspiration, in particular, the imitation of water signs. So universal was the symbolism of water sounds, and so pervasive in the human psyche, that Deloly charted correspondences between the signs which represented particular sounds in languages as diverse as Chinese, French and ancient Hebrew. The single letter in which this imagery was most apparent was *Mem*, the hydronymic letter, as Deloly called it. Letters did not exist at the beginning of language, but they were linked to sense of words through their qualities as graphic signs. The sense of all words came from the living water in which the origins of all linear forms, patterns, shapes – vertical, horizontal, sinuous and so forth – could be detected. The very first writing, Deloly suggested, had been the engraving of river waters on the face of the earth, by which processes a river made a character which blended the sound of its movement with the image inscribed in its path. The only point of historical or linguistic scholarship evident in Deloly's work was the association of the hieroglyphic sign for the sound mem with the hieroglyphic sign resembling waves, a double zig-zag line. The rest of his discussion was an independent invention grounded on this one sign extended to an interpretation of the entire alphabet.

Howard Peacey's *The Meaning of the Alphabet* (1949), was a more conventional reading of sound symbolism. Peacey repeated much of the spirit, if not the precise details, of the kind of analysis proposed by writers as diverse as Plato and Charles de Brosses by asserting that the manner in which the letters make use of the breath is the source of their symbolic value. Peacey proposed that there were 'rational meanings or values naturally inherent in the spoken letters of the alphabet and their corresponding signs.' These he stated were produced by the structure of speech, which he compared to the structure of a piano as the inherent means of producing different musical values as sound. Not letters, but letter *sounds* were therefore 'natural signs' on this account. Peacey analyzed these first by dividing the consonants (as signs of motion) from the vowels (actions of the essential forms). The most elemental signs were those easiest to pronounce, such as *Ma*, which he proposed was almost universally the first

spoken sound. The alphabet, 'read in its proper order is a natural symbol of Creation.' This Creation was described abstractly, in categories identified as the Beginning of Form, Determination, Specification, Detail and so forth. Ultimately, however, Peacey denied that these could be detected in or even linked to the visual forms of the letters, which he believed had been created in the manner suggested by Flinders Petrie, as a shared signary locally condensed into an alphabetic system.

The work of D. Duvillé, *L'Aethiopia Orientale ou Atlantie* (1936) was one of the many 20th-century texts which seriously took up the idea of the lost continent of Atlantis and linked it to the invention of the alphabet. Theories of Atlantis can be traced to the writings of Plato, who is generally given credit for the first full account of the mythic lost continent. But the modern version of the Atlantis myth received its strongest advocate in Ignatius Donnelly, whose *Atlantis: The Antediluvian World* was first published in 1882. The myth met with particular favor among German writers, and a whole generation of Atlantis stories grew up in the early decades of the 20th century which took Donnelly's text as their point of departure. This was not surprising, since Donnelly had carefully combed the history of literature for references to and discussions of the lost continent, its history and culture. The Atlantis myth served as a new version of the idea of an original people, single language, and single source of alphabetic writing, and had the advantage over earlier biblical accounts that its verity depended on evidence which could not be easily recovered.

Donnelly had suggested that the alphabet had been invented on Atlantis, since by his account the continent had been the original site of all human culture. Through detailed discussion, Donnelly argued that the alphabet of the Phoenicians, Egyptians and even the Maya must have had a common source. This was the antediluvian alphabet, and memory of this script was preserved in Hebrew scriptures, where it was referred to as the writing of 'the Ad-ami, the people of Ad, or Adlantis.' This original Eden had been the antediluvian world, and from it all human beings had descended, bearing with them the ancient memory of their past in the letters of the alphabet.

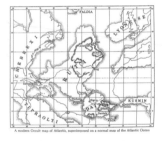

Map of Atlantis, source of original language and writing (Ignatius Donelly, *Atlantis, the Antediluvian World*, 1882)

Donnelly did not elaborate the details of the alphabet as a symbolic form, but Duvillé did. His Atlantis, however, was the ancient Aethiopia in which a mother tongue common to all had been spoken on the now submerged continent. The Atlanteans had had a highly developed, superior culture with extensive colonies, and according to Duvillé, these antediluvians had been the 'red race,' identified by the term *phoinos*, which he interpreted to mean red. In Genesis, he went on, only the three post-diluvian 'races' were described: the 'black' Hamites, the 'white' Japhites, and the 'yellow' Shemites. Cadmus, the *phoini*cian, had been one of the original Atlanteans, and the Cadmean alphabet was obviously the original antediluvian script. This script was described in terms of twenty-two hieroglyphic forms, however, rather than alphabetic ones. In the final passages of his work, Duvillé suggested that there was an analogy between

303

the dynamic organs of the larynx and those of the genitalia, and that vocal language had a sexual parallel through these correspondences, though he did not develop this discussion in detail.

Another interpretation of the original language which borrowed from the Atlantis myth was put forth by G.F. Ennis in a 1923 publication, *The Fabric of Thought*. Ennis's theory was relatively simple, but also, relatively peculiar. He suggested that in the nonsense syllables of a single nursery rhyme were preserved the sounds and symbols of an original human language. This rhyme, full of racist bias, he gave as: 'Ena Dena Dina Do/Catch a Nigger by the Toe/If he hollers let him go/ Ina Mena Mina Mo.' Through elaborate charts arranging the letters in rows, squares, and columns, Ennis demonstrated that the nonsense syllables spelled out a primal code, each letter of which was the name of a god or king and filled with profound significance. As the English version of the rhyme was so close to the original language it proved that England was very close – geographically and spiritually – to the old Atlantis. Language, Ennis concluded, had originally been European, not Asian or Middle Eastern. Like Donnelly, Ennis provided a chart diagramming the structure of the original Atlantis, one which had its geographical details encoded into the numerical value and structure of the alphabet. Children and rustics, he concluded, were the true guardians of culture, and thus the continual repetition of this rhyme in the mouths of schoolchildren perpetuated the 'wonder of the code and the glory of life and death.'

Map of Atlantis showing parallels between elements of a nonsense rhyme and structure of original continent (G. F. Ennis, *The Fabric of Thought*, London, 1923)

Unique, too, is the work of Francis Haab, *La Divination de l'Alphabet Latin*, published in 1948. Haab believed that the letters of the alphabet were ideograms which symbolized the fundamental divinities of Greek mythology, but, oddly enough, the gods and goddesses invoked in his text had both Latin and Greek names. Greek mythology was a fundamental truth, based on rationality, poetry, religious intuition and ethics, and all its tales were one elaborate system of revelations. The Latin alphabet, however, not the Greek, was the most pure of ancient alphabets. Haab's presentation took two forms, a schematic representation of the lineage and relations among mythological divinities, and a letter by letter investigation of the values of the alphabet. The one figure which appeared repeatedly in the schematic diagram was that 'I' representing Jupiter, who was both 'the first hero,' 'the one,' and 'man.' Above Jupiter was God, who gave rise both to humankind and to the Spirit. Each of the gods and goddesses took their place in this pantheon according to Haab's interpretation of their genealogical origin.

APOLLO
BACCHVS
CERES
DIANA
VESTA
FORTVNA
GE *(Gaia ou Rhéa)*
HERA-IVNO
IVPPITER *(Dieu Manifesté ou " Fils ")*
J *(l'homme)*
HERA-KLES
LATONA
MERCVRIVS
NEPTVNVS
PLVTO
PALLAS
QVPIDO
MARS
SATVRNVS
THEMIS
U *(la femme)*
VENVS
VVLCANVS
X *(Dieu Absolu ou " Père ")*
HYMEN
Z *(la Foudre ou " Esprit ")*

Chart of names of gods and goddesses, and diagram showing relations among them as signified in the alphabet (Francis Haab, *Divination de l'Alphabet Latin*, 1948)

305

There were instances in which the name of a god or goddess did not contain the letter by which it was symbolized, and Haab proposed that in these cases the letters served as a hieroglyph embodying the character of the deity in graphic form. Haab believed that the Latin alphabet had been

invented directly from the Greek with modifications to compensate for the fact that that system had been inadequate for the needs of the Hellenic religion. The Latin alphabet, on the other hand, presented a perfected graphic vision, serving as exterior signs by which the spirit might be introduced to divine revelations. The letters must of necessity be as pure as possible, and not instances of type badly corrupted by decorative excesses. As a consequence, Haab chose a sans serif face, one composed only of a minimum bare lines which more closely resembled the early monumental Greek letters than any other alphabet invented before the sans serif faces designed in the first half of the 20th century. Only by returning to these ideal letters could the live voices of the truth be heard in their roots, a truth which revealed the genius of the Greeks and their great character. The table of relations demonstrated both the relations of the gods to each other and to humankind, and then back to the inexpressible absolute, the flowing Creativity which was the constant manifestation of the three primary principles of the Absolute, the Creator and the Spirit. Haab emphasized that daily use of the alphabetic letters permitted continual contact and conversation with the gods.

Universalizing principles continued to be a major source of inspiration for idiosyncratic historians of writing. The work of Hugh Moran, *The Alphabet and the Ancient Calendar*, 1953, asserted that astrology had been the central organizing principle for the invention of the alphabet. He rejected the theory of Egyptian origins, and stated that the astrological symbols of the lunar zodiac which had first originated with the Babylonians formed the basis of all writing systems – Chinese characters and Akkadian cuneiform as well as various alphabets. Moran's work repeated much of the thesis of Moreau de Dammartin, and like that 19th-century writer, he charted the graphic relation of signs in various systems to prove his point. The idiosyncracy of work like that of Moran or Haab resides not so much in the specifics of their inventions, but in their absence of relation to any tradition of scholarship in the area of linguistics, archaeology or ancient history. It should be apparent by now, however, that even an acquaintance with those traditions is not in itself guarantee of validity and the determination of the original graphic forms of the alphabet remains sufficiently unclear that it may be they were created with the same leap of human imagination which has characterized the theories motivating these individual interpretations – or the innovative spontaneity of the schoolchildren in Bauer's experiment.

The Alphabet in the Age of Electronic Media

Marshall McLuhan, the philosopher of media, suggested in *The Gutenberg Galaxy*, that the rise of audio-visual media (to which might now be added virtual media), would bring about the elimination of print. McLuhan saw positive possibilities in this change – the potential for an

'open society' in which a network of connections would bypass the centralized control which he felt was a feature of print technology. McLuhan's 1960s optimism has yet to be borne out by positive social change through the use of electronic media to create a more democratic society – issues of access and information control have as much potential for abuse by centralized power structures as did print media. But McLuhan's fascination with technology has become a common preoccupation in late 20th-century attitudes towards writing, alphabets and media. It is apparent that the elimination of print will not necessarily lead to the elimination of the alphabet or written language, but rather a change in its forms, its means of transmission and material supports. Certainly the look of alphabetic writing has already been significantly affected by electronic media, though it remains to be seen how the stylistic treatment of alphabetic signs will evolve over time under the influence of new technology.

Jérome Peignot in *De L'Ecriture à la Typographie* (1967), stated that there were only haphazard signs at the base of the alphabet, and that the art of writing had evolved from nothing in order to model a void, thus becoming associated in the minds of humankind with the concept of the passage of God onto the Earth. But once they existed, he went on, citing the work of typographer Eric Gill, letters became things in themselves, not in any sense the mere picture of things, even had they had originally been so. It is this existence, of the letters as things, which has been the subject of this study – since it is as fully developed but arbitrary signs that the alphabet functions so efficiently, in spite of its problems, limitations, and defects, as the basis for communicating ideas and information across the full spectrum of human activity.

Peignot reflected on McLuhan's suggestion that the advent of electronic media contained the threat of an analphabetic chaos, but he countered this with the conviction that writing, alphabetic or other, had a seductive power. Writing was a means of concretizing thought into physical form so that it could live independently of the instant of its creation. He felt that human gestures were essential to the life of type and the alphabet – and vice versa – and that the experience of books was one which would endure beyond electronic invention because of the pleasure – visual, tactile, intellectual and emotional – which books provided.

307

While it daily becomes more problematic to believe that books as we have known them will endure, or that future generations will take more pleasure from the physicality of writing than from the immaterial electronic trace, it is also evident that electronic media offer tremendous possibilities for preservation of older forms. Many of the sources referred to in this book were literally crumbling as they were read, and may not exist for future generations of scholars unless they are recorded electronically, preferably in some sophisticated surrogate capable of recreating the visual excitement of the forms of the originals. The immateriality of the electronic medium also puts into new perspective the status of documents susceptible to change, erasure, duplication without a trace – all so radically

different from texts produced on parchment, paper and stone whose history resides in their material as well as in the substance of their linguistic expression.

Electronic media also offer possibilities for design experimentation which do not have to conform to the linear constraints which were developed from the habit of typographic printing. The next decades may witness the reinvention of calligraphic imagination in electronic form and correspondingly innovative methods of reading and processing language visually. In spite of outcries to the contrary, there is no evidence that literacy will disappear with the proliferation of electronic media. What seems certain is that modes of literacy will be transformed in the next century. It is impossible to predict the effect all this will have on the writing system which has for millennia served as the object and instrument of so much historical knowledge, spiritual investigation and imaginative speculation – the alphabet.

NOTES

I The Alphabet in context

1 Annemarie Schimmel, *Calligraphy and Islamic Culture* (New York: New York University Press, 1984) is a good starting point for study of this tradition.

II Origins and Historians

1 Herodotus, trans. A.D. Godley, Loeb Classical Library (Cambridge, Mass.: Harvard University Press, 1957), vol. 3, p. 63.
2 Full discussion of this point is in Chapter III.
3 Robert K. Logan, *The Alphabet Effect* (New York: William Morrow & Co.) pp. 85-87.
4 Maurice Pope, *The Story of Decipherment* (London: Thames and Hudson, 1973).
5 Erik Iversen, *The Myth of Egypt and its Hieroglyphics*. (Copenhagen, 1961)
6 Pope, *Decipherment*.
7 Isaac Taylor, *The Alphabet* (London: Edward Arnold, 1899)
8 P. Kyle McCarter, *The Antiquity of the Greek Alphabet* (Missoula, MO: Scholars Press for Harvard Semitic Monographs, 1975).
9 John Healey, *The Early Alphabet* (London: British Museum Publications, 1990) and David Diringer, *The Alphabet* (New York: Funk and Wagnalls, 1948) provide the sources for this brief summary.
10 Wayne Senner, ed., *The Origins of Writing* (Lincoln and London: University of Nebraska Press, 1989).
11 Information in the following sections synthesizes research recorded in Diringer, *Alphabet*, Senner, *The Origins*, and Healey, *Early Alphabet*; other sources as noted or in the bibliography of major sources.
12 Martin Bernal, *The Cadmean Letters* (Winona Lake: Eisenbrauns, 1990).
13 For instance, Ron Stroud in Senner, ed., *The Origins* 'Writing in Ancient Greece.'

III Classical History, Philosophy and Divination

1 Powell, Barry, *Homer and the Origin of the Greek Alphabet* (Cambridge: Cambridge University Press, 1991).
2 In fact this letter is called 'o' or 'ou' in the early stages of adaptation; the name 'omicron' is attached later. See Powell, *Homer*, p. 43.
3 The reader is referred to Powell, Martin Bernal, *The Cadmean Letters* (Winona Lake: Eisenbrauns, 1990), David Diringer, *The Alphabet* (New York: Funk and Wagnalls, 1948), and Ignace Gelb, *A Study of Writing* (Chicago: Chicago University Press 1944) for fuller discussion.
4 Bernal, M., *The Cadmean Letters* and *Black Athena* (New Brunswick: Rutgers University Press, 1987).
5 Duville, D., *L'Aethiopia Orientale ou Atlantie* (Paris: 1936). p. 212.
6 Sophocles, E.A., *The History of the Greek Alphabet* (Cambridge: 1848).
7 Hall, Manly Palmer, *An Encyclopedic Outline of Masonic, Hermetic, Qabbalistic and Rosicrucian Symbolical Philosophy* (San Francisco: 1928).
8 Budge, E.A. Wallis, *Egyptian Magic* (London: 1901).
9 Pennick, Nigel, *Secret Lore of Runes and other Ancient Alphabets* (London: 1991).
10 Powell, *Homer*, p. 233-6.
11 Powell, *Homer*, p. 199.
12 Pennick, *Runes*, p. 43
13 Sophocles, E.A., *Greek Alphabet*, p. 11.
14 Kotansky, Roy, 'Incantations and Prayers for Salvation on Inscribed Greek Amulets,' in Christopher Faraone and Dirk Obbink, eds., *Magika Hiera*. (Oxford and New York: 1991), p. 107-137.
15 All citations in this section are from Plato, *Cratylus*, in *The Dialogues of Plato* (B. Jowett, trans.) (Oxford: 1953).
16 Obviously, the original words are Greek, and the translator (Jowett) found English equivalents or substitutions to suggest similar concepts.
17 Plato, *Thaetetus* (B. Jowett, trans.) (Oxford: 1958).
18 Dionysius of Halicarnassus, *On Literary Composition* (Rhys Roberts trans.) (London: 1910).
19 Philip, J.A., *Pythagoras and Early Pythagoreanism* (Toronto: 1966).
20 Seligmann, Kurt, *Magic, Supernatural and Religion* (New York: 1948).
21 Pennick, *Runes*, p.60-63.
22 Pennick, *Runes*, p.63-64.
23 Plutarch, *Essay on the Letter 'E' at Delphi*, in *Moralia* (Frank C. Babbitt, trans.), (London: 1969).
24 These characterizations are directly from Plutarch.
25 Parke, H.W., *Greek Oracles* (London: 1967).
26 Strubbe, J.H.M., 'Cursed be he that moves my bones,' in Faraone/Obbink, eds., p. 33-59.
27 Strubbe, p. 34.
28 Kotansky, in Faraone/Obbink, eds., p.108.
29 Faraone, C., 'The Agonistic Context of Early Greek Binding Spells,' in Faraone/Obbink eds., p. 3-32.
30 Faraone, p. 13.
31 Betz, p. 94.
32 Winkler, John J., 'The Constraints of Eros,' in Faraone/Obbink, eds., p. 225. (p. 214-243).
33 Kotansky, p. 109.
34 Kotansky, p. 114-5.
35 Betz, Hans Dieter, *The Greek Magical Papyri* (Chicago: 1986). See p. 3.
36 Halliday, W. R., *Greek Divination* (Chicago: 1967).
37 Luck, George, *Arcana Mundi* (Baltimore: 1985), p. 19.
38 Flint, V., *The Rise of Magic in Early Medieval Europe* (Princeton: 1991), p. 218.

IV Gnosticism, Hermeticism, Neo-Platonism and Neo-Pythagoreanism: The Alphabet in the Hellenistic and Early Christian Eras

1 Stanley Morison, *The Politics of Script* (Oxford: Clarendon Press, 1972).
2 Morison, p. 19.
3 Morison, p. 58.
4 Jacques Derrida, *Of Grammatology* (Baltimore, MD: Johns Hopkins University Press, 1976).
5 Hans Jonas, *The Gnostic Religion* (Boston: Beacon Press, 1958).
6 A. Dupont-Sommer, *La Doctrine Gnostique de la Lettre 'Waw' d'Apres une lamelle Araméenne* (Paris: Paul Geuthner, 1946).
7 Jonas *op. cit.*
8 Maryse Waegeman, *Amulet and Alphabet* (Amsterdam: J.C. Gieben, Publishers, 1987).
9 Jean Canteins, *Phonemes and Archetypes* (Paris: G.P.Maisonneuve et Larose, 1972).
10 Canteins *op. cit.*
11 E. A. Wallis Budge, *Egyptian Magic* (London: Kegan, Paul, Trench, Trubner & Co., 1901).
12 Plotinus lived between approximately 204 AD and 270 AD.
13 Canteins, p. 54, citing Nicomachus, *Manual of Harmony and Fragments*.
14 Ibid.
15 Dupont-Sommer *op. cit.*

16 St Jerome, *Lettres*, T.II (Paris: Société d'Edition 'Les Belles Lettres,' 1951). My translations.

17 Adolphe Hebbelynck, *Les Mystères des Lettres Grèques d'Apres un Manuscrit Copte-Arabe*, (Paris: Ernest Leroux, 1902).

18 Hebbelynck, p.14.

19 See Maurice Pope, *The Story of Decipherment* (London: Thames and Hudson).

V Calligraphy, Alchemy and Ars Combinatoria in the Medieval Period

1 Donald M. Anderson, *Calligraphy* (New York: Holt, Rinehart and Winston, 1969).

2 Marc Drogin, *Medieval Calligraphy* (Montclair, NJ: Allanheld, Osmun and Co., 1980) p. 8.

3 Anderson *op. cit.*

4 Anderson, p. 73.

5 Nicolete Gray, *A History of Lettering* (Boston: David R. Godine, 1986) p. 43.

6 Gray, p. 52.

7 Gray p. 67.

8 Drogin, p. 12.

9 Drogin, p. 17-20.

10 The dating of this manuscript is generally considered to be no earlier than the 4th century, but has been dated as late as the 7th.

11 Jonathan Alexander, *The Decorated Letter* (New York: George Braziller, 1978).

12 Anderson, p. 61.

13 Alexander is the major source here and throughout this section.

14 Alison Harding, *Ornamental Alphabets and Initials* (London: Thames and Hudson 1983), p. 19.

14 This is also the era in which the publication of folios of examples of writing were fostered by collaborations of printers and historians – such as in the fabulous Balthazar Silvestre folio produced by the Didot Frères brothers in Paris, or the laborious work of Henry Shaw or William R. Tymms in England.

15 The scholarship on this point is sharply divided into those who claim Runes never had any magical associations and those who assert that they did.

16 René Derolez, *Runica manuscripta* (Brugge, 1954); also see Chapter VII.

17 Ralph W. Elliott, *Runes, An Introduction* (New York: The Philosophical Library, 1959), p. 45-61.

18 *Theologiae Patriae*

19 Taylor, F. Sherwood, *The Alchemists, Founders of Modern Chemistry* (New York: Henry Schuman, 1949) p. 53-55.

20 Newbold, Bacon, p. 25

21 Joseph Martin Feely, *Roger Bacon's Cypher* (Rochester, NY: 1943).

22 The Hegira, date at which Mohammed fled Mecca, is 622 AD, taken as year 1 of the Moslem calendar.

23 Michael Howard, *The Runes and other Magical Alphabets* (Wellingborough and Northamptonshire: Thorsons Publishers Ltd., 1978).

24 Joseph Hammer Purgstall, *Ancient Alphabets and Hieroglyphic Characters Explained with an account of the Egyptian Priests, their classes, initiation and sacrifices* (London: W. Bulmer, 1806). (The colophon states that the text was based on a copy made in 1166 of the Hejira (approximately 1788) from an earlier copy 413 (1035) of the original.

25 Martin Gardner, *Logic Machines and Diagrams* (Chicago: University of Chicago Press, 1982), p. 4.

26 Paolo Rossi, cited by Anthony Bonner, *Selected Works of Raymond Llull* (Princeton: Princeton University Press, 1985), p.70.

27 Llull had composed earlier works on the Principles of Law, Justice and Theology as well.

28 Bonner, p. 310

VI Kabbalah

1 Jewish scholars avoid the use of AD, and use the form CE, for Common Era, when not using the Jewish calendar.

2 Gershem Scholem, *The Kabbalah* (New York: Quadrangle, The New York Times Book Co., 1974) is the major source used for this history.

3 These divisions are from Aryeh Kaplan, *Sefer Yetzirah* (York Beach, Maine: Samuel Weiser, 1991).

4 Scholem, *Kabbalah*, p.316, citing Jacob b. Jacob ha-Kohen, a medieval Spanish kabbalist.

5 Harold Bloom, *Kabbalah and Criticism* (Seabury, NY: Seabury Press, 1975).

6 Joseph Leon Blau, *Christian Interpretation of the Cabala in the Renaissance* (New York: Columbia University Press, 1944) is the most authoritative source, in spite of the date of publication, for information on this aspect of the Kabbalah.

7 Perle Epstein, *Kabbalah, The Way of the Jewish Mystic* (Garden City, NY: Doubleday & Co., Inc., 1978).

8 The longest version is barely twice that, or about 2600 words.

9 Sources for this section include Aryeh Kaplan, Perle Epstein, Johann Reuchlin and Carlo Suares.

10 Carlo Suares, p. 3.7

11 Johann Reuchlin, *De arte cabbalistica* (New York: Abaris Books, 1983) translated by Martin and Sarah Goodman; p. 315.

12 Perle Epstein, p. 87.

13 The number is arrived at by pairing each letter with the other, without repetition, double letters, or combinations of the same pair: Aleph Beth was considered equivalent to Beth Aleph.

14 Cited in Nigel Pennick, *The Secret Lore of Runes and Other Ancient Alphabets* (London: Rider, 1991), p. 24.

15 Cited in Pennick, p.22.

16 From Reuchlin, p. 299.

17 Rabbi Yitzchak Ginsburgh, *The Alef-Bait* (Northvale, New Jersey: Jason Aronson Ltd., 1991) p. 3.

18 Ben Shahn, *The Alphabet of Creation, An Ancient Legend from the Zohar* (New York: Pantheon Books, 1954).

19 Moshe Idel, "The Golem in Jewish Magic and Mysticism," in *GOLEM!*, ed. by Emily Bilski.

20 Chayim Bloch, *The Golem* (1925)

VII Rationalizing the Alphabet: Construction, Real Character and Philosophical Languages in the Renaissance

1 Marc Drogin, *Medieval Calligraphy* (Montclair, NJ: Allanheld & Schram, 1980).

2 Geoffrey Tory, *Champfleury*, 1529.

3 Donald Anderson, *Calligraphy: The Art of Written Forms* (New York: Holt, Rinehart and Winston, 1969).

4 Nicolete Grey, *A History of Lettering* (Boston: David R. Godine, 1986) p. 139.

5 Lois Potter, *Secret Rites and Secret Writing* (Cambridge: Cambridge University Press, 1989) provides a limited case study on English Royalist literature in the mid-17th century.

6 Wayne Schumaker, *Renaissance Curiosa* (Binghampton, NY: Center for Medieval and Early Renaissance Studies, 1982) p. 112.

7 Schumaker, p. 112.

8 Potter, *Secret Rites and Secret Writing*.

9 John Locke's *An Essay on Human Understanding* was first published in 1689.

10 Barbara Shapiro, *John Wilkins, An Intellectual Biography* (Berkeley and Los Angeles: University of California Press, 1969).

11 Schumaker, p. 146.

12 Janus/Nachus must be Noah, since he is designated the father of Japhet.

13 The Apocrypha is an addendum to the Old Testament, it consists of 14 books, not accepted as scripture by the Jews, who only take the 39 books of the original Old Testament as sacred; Catholics, however, accepted the Apocrypha and the New Testament, as well as the Old; Protestants also rejected the Apocrypha as scripture. (Rabbi Weiss)

14 Michael Howard, *The Runes and Other Magical Alphabets* (Wellingborough and Northamptonshire: Thorsons Publishers Ltd., 1978) p. 10.

VIII The Social Contract, Primitivism and Nationalism: The Alphabet in the 18th Century

1 Daniel B. Updike, *Printing Types* (Cambridge: Harvard University Press, 1937).

2 Nicolete Gray, *A History of Lettering*, (Boston: David R. Godine, 1986).

3 André Jammes, *La Reforme de la Typographie* Royale (Paris: Librairie Paul Jammes, 1961).

4 Updike, *Printing Types* (Cambridge: Harvard University Press, 1937). Granjean died in 1714.

5 Alison Harding, *Ornamental Alphabets and Initials* (London: Thames and Hudson, 1983).

6 Robert M. Ryley, *William Warburton*, (Boston: Twayne Publishers, 1984).

7 One of Massey's sources was the scholar Joseph Scaliger.

8 Thomas Astle, *The Origin and Progress of Writing* (London: 1784) p. 1.

9 Claude-Gilbert Dubois, *Celtes et Gaulois au XVIe Siècle* (Paris: Librairie Philosophique J.Vrin, 1972).

10 See the section in the Medieval chapter.

11 Paul Christian, *Histoire de la Magie* (Paris: 1892) is the source of this story.

IX The Nineteenth Century: Advertising, Visible Speech and Narratives of History

1 J. Ben Lieberman, *Types of Typefaces* (New York: Sterling Publishing Co., 1967) p. 52.

2 Thomas Dreier, *The Power of Print – and Men* (Brooklyn, NY: Merganthaler Linotype Company, 1936).

3 *From Xylographs to Lead Molds* (Cincinnati: The Rapid Electrotype Co., 1921).

4 Gerard Genette, *Mimologiques* (Paris: Aux Editions du Seuil, 1976).

5 Genette, p.336.

6 Stéphane Mallarmé, 'Les Mots Anglais,' *Oeuvres Completes* (Paris: Gallimard, 1956).

7 Warren P. Spencer, *Origin and History of the Art of Writing* (New York: Ivison, Phinney, Blakeman and Co., 1869), p. 36.

8 William P. Upham, *A Brief History of the Art of Stenography* (Salem, Mass.: Essex Institute, 1871).

9 Alfred Baker, *The Life of Sir Isaac Pitman* (London: Sir Isaac Pitman and Sons, Ltd., 1908).

10 Andrew Carmichael, *An Essay on the Invention of Alphabetic Writing* (Dublin: 1815).

11 See sections in Chapter II and Chapter III treating these debates.

12 Alfred Kallir was one 20th-century author influenced by this work; see Chapter X.

13 See Chapter II.

14 Charles Wall, *The Orthography of the Jews* (London: Whittaker and Co., 1835).

15 See Chapter II.

16 See Chapter VIII.

17 Emile Soldi-Colbert de Beaulieu, *La Langue Sacrée*, (Paris: Ernest Leroux, 1900).

X Twentieth Century: Eclecticism, Technology and the Idiosyncratic Imagination

1 See Chapter II for complete discussion.

2 It should be clear by now that my discussions throughout this book have been focused on the branch of the alphabet which developed in the West, and have not attended to the developments, history, culture or symbolic interpretations of any of the Arabic, Cyrillic, Devenagari or many other alphabets in use in the Middle East, Asia and Africa.

3 Gerard Genette and André Massin's works made their own more recent contributions in this area, though Genette's focus is on sound symbolism and poetics and Massin's work was largely pictorial reproduction not historical discussion. Other contributions to this field of study exist, but generally with a narrow focus, such as Madeleine David's work on the 16th to 18th centuries or Jonathan Goldberg's work on Renaissance handwriting.

4 James Hutchinson, *Letters* (New York: Van Nostrand Reinhold, 1983).

5 Patricia Leighton, *Re-Ordering the Universe* (Princeton: Princeton University Press, 1989).

6 William Seitz, *The Art of Assemblage* (New York: Museum of Modern Art, 1961), Marjorie Perloff, *The Futurist Moment* (Chicago: University of Chicago Press, 1986).

7 Herbert Spencer, *Pioneers of Modern Typography* (London: Lund Humphries, 1969) and The Liberated Page (London: Lund Humphries, 1987) and my own, *The Visible Word* (Chicago: University of Chicago Press, 1994).

8 See Chapter II for the discussion of this archaeological and linguistic historiography.

9 Ignace Gelb, *A Study of Writing* (Chicago: University of Chicago Press, 1952), p. 60-61.

10 Gelb, *Writing*.

11 Guido List, *The Secret of the Runes* ed. by Stephen Flowers (Rochester, Vermont: Destiny Books, 1988).

12 Flowers' commentary in List, p. 26-31.

13 See Nigel Pennick, *The Secret Lore of Runes and Other Ancient Alphabets* (London: Rider, 1991) for a recent exposition on the topic by a believer.

14 Robert Graves, *The White Goddess* (London and New York 1948).

15 See Chapter IX for discussion of Fabre d'Olivet and Soldi.

BIBLIOGRAPHY

(In Chapters VI, VII and VIII, historic texts published in the 16th-18th centuries have been distinguished by asterisks)

II Origins and Historians

Albright, W.F., 'The Early Alphabetic Inscriptions from Sinai and Their Decipherment,' *Bulletin of the American Schools of Oriental Research*, No.110, April 1948, p.6-22.

Berger, Philippe, *Etude sur l'origine de l' écriture* (Paris: L'Imprimerie Nationale, 1892)

Bernal, Martin, *The Cadmean Letters* (Winona Lake: Eisenbrauns, 1990)

Bouuaert, Joseph, *L'histoire de l'alphabet* (Brussels: 1949)

Carpenter, Rhys, "The Antiquity of the Greek Alphabet," *American Journal of Archaeology*, 37:8-29; 1933.

Cohen, Marcel, *La Grande Invention de l'Ecriture et son evolution* (Paris: Klincksieck, 1958)

Cross, Frank Moore, "The Development of the Alphabet," in Senner, ed., *The Origins of Writing*

Diringer, David, *The Alphabet* (New York: Funk and Wagnalls, 1948; revised edition 1968).

Driver, Geoffrey, *Semitic Writings* (Oxford: Oxford University Press, 1948; revised 1976).

Fevrier, James, *L'Histoire de l'Ecriture* (Paris: 1948)

Fry, Edmund, *Pantographia* (London: Cooper and Wilson, 1799)

Gardiner, Alan, 'The Egyptian Origin of the Semitic Alphabet,' *Journal of Egyptian Archaeology*, 3:1-16.

Gelb, Ignace, *A Study of Writing* (Chicago: Chicago University Press, 1944).

Gesenius, Wilhelm, *Scripturae Linguaeque Phoeniciae Monumenta* (Lipsiae, 1837)

Healey, John, *The Early Alphabet* (London: British Museum Publications, 1990)

Jensen, Hans, *Geschichte der Schrift* (Hanover, 1925) and Sign, Symbol and Script (New York: Putnams, 1969)

Lidzbarski, Mark, *Handbuch der nordsemitischen Epigraphik* (Weimar: Felber, 1898)

Logan, Robert K., *The Alphabet Effect* (New York: William Morrow & Co., 1986)

McCarter, P. Kyle, *The Antiquity of the Greek Alphabet* (Menston: Scholars Press for Harvard Semitic Monographs, 1975)

Mercer, Samuel B., *The Origin of Writing and Our Alphabet* (London: Luzac and Co., 1959)

Naveh, Joseph, *The Early History of the Alphabet* (Leiden: E.J.Brill, 1982)

Petrie, W.M. Flinders, *The Formation of the Alphabet* (London: 1912)

Pope, Maurice, *The Story of Decipherment* (London: Thames and Hudson, 1975)

Rougé, Emmanuel de, *Memoire sur L'origine Egypt: de l'Alphabet Phénician* (Paris: Imprimerie Nationale) 1874

Senner, Wayne, *The Origins of Writing* (Missoula MO and London: University of Nebraska Press, 1989)

Taylor, Isaac, *The Alphabet* (London: Edward Arnold, 1899)

Trager, George, 'Writing and Writing Systems,' *Current Trends in Linguistics*, vol.12, (The Hague: Mouton, 1974)

Ullman, Bernard L., *Ancient Writing and Its Influence* (Toronto, Buffalo, New York: University of Toronto Press, 1980)

III Classical History, Philosophy and Divination

Bernal, Martin, *Black Athena* (New Brunswick: Rutgers University Press, 1987; and London: Free Association Books, 1987)

Betz, Hans Dieter, *The Greek Magical Papyri* (Chicago: University of Chicago Press, 1986)

Budge, E.A. Wallis, *Egyptian Magic* (London: 1901)

Chaignet, Anthelme E., *Pythagore et la philosophie Pythagoricienne* (Paris: Didier et Cie., 1873)

Chatelain, Emile, *Introduction à la lecture des Notes Tironiennes* (Paris: 1900)

Dionysius of Halicarnassus, *On Literary Composition*, Rhys Roberts trans. (London: MacMillan and Co., 1910)

Dornseiff, Franz, *Das Alphabet in Magie und Mystik*, (Leipzig and Berlin: B.G. Teubner, 1916)

Dupreil, Eugene, *La Legende Socratique et les Sources de Platon* (Bruxelles: Editions Robert Sand, 1922)

Duvillé, D., *L'Aethiopia Orientale ou Atlantie* (Paris: Société Française d' editions litteraires et techniques, 1936)

Faraone, Christopher and Dirk Obbink, eds., *Magika Hiera* (Oxford and New York: Oxford University Press, 1991)

Flint, V., *The Rise of Magic in Early Medieval Europe* (Princeton: 1991)

Gaudin, Claude, *Platon et l'alphabet* (Paris: Presses Universitaires de France, 1970)

Genette, Gerard, *Mimiologiques* (Paris: Editions du Seuil, 1976)

Hall, Manly Palmer, *An Encyclopedic Outline of Masonic, Hermetic, Qabbalistic and Rosicrucian Symbolical Philosophy* (San Francisco: 1928)

Halliday, W. R., *Greek Divination* (Chicago: Argonaut, Inc., Publishers, 1967)

Havelock, Eric and Jackson Hershbell, *Communication Arts in the Ancient World* (New York: Hastings House, Pub., 1978)

Havelock, Eric, *The Literate Revolution in Greece and its Cultural Consequences* (Princeton: Princeton University Press, 1982)

Luck, George, *Arcana Mundi* (Baltimore: Johns Hopkins University Press, 1985)

Parke, H.W., *Greek Oracles* (London: Basil Blackwell, 1967)

Pennick, Nigel, *Secret Lore of Runes and other Ancient Alphabets* (London: Rider Books, 1991)

Philip, J.A., *Pythagoras and Early Pythagoreanism* (Toronto: University of Toronto Press, 1966).

Plato, *Cratylus*, in *The Dialogues of Plato*, B.Jowett, trans. Oxford: Clarendon Press, 1953)

Plato, *Thaetetus*, B. Jowett, trans. (Oxford: Clarendon Press, 1958)

Plutarch, *Essay on the Letter 'E' at Delphi*, in *Moralia*, Frank C. Babbitt, trans. (London: 1969)

Powell, Barry, *Homer and the Origin of the Greek Alphabet* (Cambridge: Cambridge University Press, 1991)

Seligmann, Kurt, *Magic, Supernatural and Religion* (New York: Pantheon Books, 1948)

Sophocles, E.A., *The History of the Greek Alphabet* (Cambridge: George Nichols and Boston: B.B. Mussey and Co., 1848)

IV Gnosticism, Hermeticism, Neo-Platonism and Neo-Pythagoreanism: The Alphabet in the Hellenistic and Early Christian Eras

Canteins, Jean, *Phonemes et Archetypes* (Paris: G.P. Maisonneuve et Larose, 1972)

Dupont-Sommer, A., *La Doctrine Gnostique de la letter 'Waw' d'aprés une lamelle Araméenne* (Paris: Paul Geuthner, 1946)

Festugière, A.-J., *La Revelation d'Hermes Trismegiste*, I–IV (Paris: 1949-54)

Flint, Valerie, *The Rise of Magic in Early Medieval Europe* (Princeton: Princeton University Press, 1991)

Fowden, Garth, *The Egyptian Hermes* (Cambridge: Cambridge University Press, 1986)

Galtier, Emile, *Sur Les Mystères des Lettres Greques* (Cairo: Bulletin de l'Institute Français d'Archaeologie Orientale, Vol.2, 1902)

Jerome, Saint, *Lettres* (Paris: Société d'Editions 'Les Belles Lettres', 1951)

Jonas, Hans, *The Gnostic Religion* (Boston: Beacon Press, 1958)

Morison, Stanley, *The Politics of Script* (Oxford: The Clarendon Press, 1972)

Thorndike, Lynn, *The History of Magic and Experimental Science* (New York: Macmillan, 1923)

Waegeman, Maryse, *Amulet and Alphabet* (Amsterdam: J.C. Gieben, Pub., 1987)

Wallis, R.T., *Neo-Platonism* (London: Duckworth & Co., 1972)

V Calligraphy, Alchemy and Ars Combinatoria **in the Medieval Period**

Alexander, Jonathan, *The Decorated Letter* (New York: George Braziller, 1978)

Anderson, Donald, *Calligraphy* (New York: Holt, Rinehart and Winston, 1969)

Berthelot, M.P.E., *Les Origines d'Alchemie* (Paris: G. Steinhal, 1885)

Bonner, Anthony, *The Selected Works of Ramon Llull* (Princeton: Princeton University Press, 1985)

Debes, Dietmar, *Das Figurenalphabet* (Munich: Berlag Documentation, 1968)

Drogin, Marc, *Medieval Calligraphy* (Montclair, NJ: Allanheld, Osmun and Co., 1980)

Elliott, Ralph, *Runes, An Introduction* (New York: Philosophical Library 1959)

Gardner, Martin, *Logic Machines and Diagrams* (Chicago: University of Chicago, 1982)

Gray, Nicolete, *A History of Lettering* (Boston: David R. Godine, 1986, first published in London, Phaidon, 1986)

Hammer (Purgstall), Joseph, *Ancient Alphabets and Hieroglyphic Characters Explained* (London: W. Bulmer, 1806)

Harding, Alison, *Ornamental Alphabets and Initials* (London: Thames and Hudson, 1983)

Howard, Michael, *The Runes and Other Magical Alphabets* (Wellingborough and Northamptonshire: Thorsons Publishers Ltd., 1978)

Newbold, William Romaine, *The Cipher of Roger Bacon* (Philadelphia: University of Pennsylvania Press, 1928)

Read, John, *Prelude to Chemistry* (London: G. Bell and Sons, Ltd., 1936)

Shaw, Henry, *Alphabets and Numerals of the Middle Ages* (London: Studio Editions reprint 1988)

Taylor, F. Sherwood, *The Alchemists* (New York: Henry Schuman, 1949)

Taylor, Isaac, *The Alphabet* (London: Edward Arnold, 1899)

Thompson, C.J.S, *The Lure and Romance of Alchemy* (London, Bombay and Sidney: George G. Harrap & Co., Ltd., 1932)

Tymms, William R., *The Art of Illuminating* (London: 1860)

Yates, Frances, *Lull and Bruno: Collected Essays*, Vol.I. (London: Routledge and Kegan Paul, 1982)

VI Kabbalah

Agrippa, Cornelius, *De Philosophia Occulta* (Paris: Dorbon Aine, 1967)

Bartolozzi, Julius, *Bibliotheca magna rabbinica* (1675)

Bilski, Emily, *GOLEM! Danger, Deliverance and Art* (New York: The Jewish Museum, 1988)

Blau, Joseph Leon, *The Christian Interpretation of the Cabala in the Renaissance* (New York: Columbia University Press, 1944)

Bloch, Chayim, *The Golem* (1925)

Bloom, Harold, *Kabbalah and Criticism* (Seabury, NY: Seabury Press, 1975)

*Boehme, Jakob, *Libri Apoligetici* (1730)

*Cordovero, Moses, *Pardes Rimmonim* (1678)

Encausse, Dr. Gerard (Papus), *La Cabbale* (Paris: 1891)

Epstein, Perle, *Kabbalah* (New York: Doubleday and Co., 1978)

Franck, Adolph, *The Kabbalah; or the Religious Philosophy of the Hebrews* (New York: I. Sossnitz, 1926)

Ginsburgh, Rabbi Yitzhak, *The Alef-Bait* (Northvale, NJ: Jason Aronson Inc., 1991)

Glazerson, Matityahu, *Letters of Fire* (Jerusalem and New York: Feldheim Press, 1991)

Kaplan, Aryeh, *Sefir Yetzirah* (York Beach, Maine: Samuel Weiser, Inc., 1990)

Karpe, S., *Etude sur les origines et la nature de Zohar* (Paris: Felix Alcan,1901)

*Khunrath, Heinrich, *Amphiteatrum Sapientiae* (Leipzig, 1602)

Luria, Rabbi Isaac, *Ten Luminous Emanations* (Jerusalem and New York: Research centre of the Kabbalah) ed. by Philip S. Berg; 2 vols.

Mathers, S.L. MacGregor, *The Kabbalah Unveiled* (New York: Theosophical Publishing Co., 1907) (English version of Knorr Von Rosenroth's 1677 *Kabbalah Denudata*)

*Michelspacher, Steffan, *Cabala* (1616)

Pennick, Nigel, *The Secret Lore of Runes and other Ancient Alphabets* (London and Sydney: Rider, 1991)

Reuchlin, Johann, *On the Art of the Kabbalah* (*De Arte Cabalistica*) Martin and Sarah Goodman, trans. (New York: Abaris Books, 1983)

Rosenroth, Knorr von, *Kabbalah Denudata* (1678)

Scholem, Gershom, *Major Trends in Jewish Mysticism* (New York: Schocken, 1961)

Scholem, Gershom, *Jewish Gnosticism, Merkabah Mysticism, and Talmudic Tradition* (New York: Jewish Theological Seminary Press, 1965)

Scholem, Gershom, *Origins of the Kabbalah* (Princeton: Princeton University Press and the Jewish Publication Society, 1987)

Scholem, Gershom, *Kabbalah* (New York: New York Times Book Co., Quadrangle, 1974)

Seligmann, Kurt, *Magic, Supernaturalism and Religion* (New York: Pantheon Books, 1948)

Serouya, Henri, *La Kabbale* (Paris: Bernard Grasset, 1947)

Shahn, Ben, *The Alphabet of Creation* (New York: Pantheon Books, 1954)

Suares, Carlo, *The Sefir Yetzirah* (London: Shambala, 1976)

Waite, Arthur E., *The Holy Kabbalah: a study of the Secret Tradition in Israel* (New York: 1929)

Zohar, H. Sperling and M. Simon, trans. (London: Soncinco Press, 1933) Vols.1-5.

VII Rationalizing the Alphabet: Construction, Real Character and Philosophical Languages in the Renaissance

Anderson, Donald, Calligraphy: *The Art of Written Forms* (New York: Holt, Rinehart, Winston: 1969)

*Arrighi, Ludovico degli: *La operina da imparare di scrivere* (Rome, 1522)

*Baildon, John, *A Book Containing Divers Sortes of Hands* (1570)

*Becher, Johannes, *Pro Notitia Linguarum Universali* (1661)

*Beck, Cave, *The Universal Character* (Ipswich: Thomas Maxey for William Weekly, 1657)

*Botley, Samuel, *Maximo in Minimo* (London: 1674)

*Bright, Timothy, *Characterie* (1588)

*Bullokar, William, *Short Introduction on Guiding* (1580)

Coates, Guy, *The Roman Alphabet of Albrecht Dürer* (London: College of Printing, 1969)

*Dalgarno, George, *Ars Signorum* (London: 1661) and *Didascalocophus* (Oxford: 1680)

David, Madeline, *Le Debat sur les Ecritures*

et l'hieroglyphe aux XVIIe et XVIIIe siè-
cles (Paris: 1965)

*Dee, John, *Enoch his Book* (1586)

Descartes, René, *Correspondances*, Vol.1.
(Paris: Leopold Cerf, 1897)

Fairbank, Alfred, *The Book of Scripts*
(Harmondsworth: Penguin, 1968)

*Fludd, Robert, *Utriusque Cosmi...* (1617-
21)

*Gething, R, *Calligraphotechnica* (1619)

Godwin, Jocelyn, *Athanasius Kircher*
(London: Thames and Hudson 1979)

*Hart, John, *A Method or Comfortable
Beginning* (1569)

*Helmont, Franciscus Mercurius (Baron
van), *Alphabeti vere naturalis hebraici
brevissima delineatio* (1667)

Huffman, William H., *Robert Fludd and the
End of the Renaissance* (London and
New York: Routledge, 1988)

*Kircher, Athanasius, *Oedipus Aegyptiacus*
(Rome: 1652)

*Kircher, Athanasius, *Polygraphia Nova et
Universalis* (Rome: 1663)

Knowlson, James, *Universal Language
Schemes in England and France 1600-
1800* (Toronto and Buffalo: University of
Toronto Press, 1975)

*Lodowich, Francis, *A Common Writing*
(1647)

Mackenzie, Norman, ed., *Secret Societies*
(New York, Chicago, San Francisco:
Holt, Rinehart and Winston, 1967)

Mersenne, Marin, *Une Harmonie Universelle*
(Paris: 1636; reprinted by Editions du
Centre National de la Recherche
Scientifique, Paris, 1963)

Osley, A.S., *Scribes and Sources* (Boston:
David R. Godine, 1980)

*Palatino, Giovambattista, *Libro Nuovo*
(1540)

*Porta, Giovanni, *De Noto Furtivo* (1563)

Potter, Lois, *Secret Rites and Secret Writing*
(Cambridge: Cambridge University
Press, 1989)

*Robertson, Robert, *On Pronunciation*
(1617)

Salmon, Vivian, *The Works of Francis
Lodwick* (London: Longman Press,
1972)

Schumaker, Wayne, *Renaissance Curiosa*
(Binghampton, NY: Center for Medieval
and Early Renaissance Studies, 1982)

Shapiro, Barbara, *John Wilkins: An
Intellectual Biography* (Berkeley and Los
Angeles: University of California Press,
1969)

*Top, Alexander, *The Olive Leaf* (Menston,
England: Scolar Press Ltd., 1971 reprint
of 1603 edition)

*Tory, Geoffrey, *Champfleury* (1529)

Trithemius, Johannes, *In Praise of Sribes*
(Collegeville, MN; Monastic Manuscript
and Microfilm Library, St. John's Abbey
and University, 1976)

*Trithemius, Johannes, *Steganographia*

(Nuremberg: 1721)

*Webster, John, *Academiarum Examen*
(London: 1654)

*Wilkins, John, *An Essay Towards A Real
Character and Philosophical Language*
(London: Royal Society, 1668)

Wilkins, John, *Mercury: or the Swift and
Secret Messenger*, introduction by
Brigitte Asbach-Schnitker (Amsterdam
and Philadelphia: John Benjamins
Publishing Co., 1984)

*Willis, John, *Art of Stenographie* (1628)

VIII The Social Contract, Primitivism and Nationalism: The Alphabet in the 18th Century

*Allwood, Philip, *Literary Antiquities of
Greece* (London: J. Davis, 1799)

*Astle, Thomas, *The Origin and Progress of
Writing* (London: T. Payne and Son, B.
White, et al., 1784)

*Bayly, Anselm, *An Introduction to
Languages, Literary and Philosophical,
Especially to the English, Latin, Greek
and Hebrew* (London: 1758)

Christian, Paul, *Histoire de la Magie* (Paris:
1892)

Cohen, Murray, *Sensible Words: Linguistic
practice in England 1640–1785*
(Baltimore and London: Johns Hopkins
Press, 1977)

Court de Gebelin, *Le Monde Primitif* (Paris:
Plancher, Eymery, Delaunay, 1816)

David, Madeleine, *Le Debat Sur Les
Ecritures* (Paris: Bibliothèque Générale
de l'Ecole Practique des Hautes Etudes,
1965)

*Davy, Charles, *Conjectural Observations
on the Origin and Progress of Alphabetic
Writing* (London: T. Wright, 1772)

*De Brosses, Charles, *Traité de la Formation
Mechanique des Langues et des Principes
Physiques d'Etymologie* (Paris: 1765)

*Defoe, Daniel, *An Essay upon Literature or
An Enquiry into the Antiquity and
Original of Letters proving that the Two
Tables Written by the Finger of God in
Mount Sinai was the First Writing in the
World and that All Other Alphabets
Derive From Hebrew* (London: 1726)

*Dissertation Historique sur L'Invention des
Lettres ou Caracteres de L'Ecriture*
(Paris: Chez Desnos, 1771)

Gray, Nicolete, *A History of Lettering*
(Boston: David R. Godine, 1986)

*Herries, John, *Elements of Speech*
(London: 1773)

Jammes, André, *La Reforme de la
Typographie Royale* (Paris: Librarie
Paul Jammes, 1961)

*Jones, Roland, *Hieroglyfic or Grammatical
Introduction to An Universal
Hieroglyphic Language* (London: John
Hughes, 1763)

*Jones, Roland, *The Origin of Language*
(London: 1764)

MacKenzie, Norman, *Secret Societies* (New
York, Chicago and San Francisco: Holt
Rinehart and Winston, 1967)

*Moussaud, J. Marie, *L'Alphabet Raisonné
ou Explication de la Figure des Lettres*
(Paris: De L'Imprimerie de Crapelet,
1803)

*Nelme, L.D., *An Essay Towards an
Investigation of the Origin and Elements
of Language and Letters* (London: 1772)

*Parsons, James, *Remains of Japhet*
(London, 1767)

Updike, Daniel B., Printing Types
(Cambridge: Harvard University Press,
1937)

*Vallancey, Charles, *Prospectus of a
Dictionary of the Language of the Aire
Coti or Ancient Irish compared with the
language of the Cuti or Ancient Persians
with the Hindoostaneem, the Arabic,
and Chaldean* (1802, Graisberry and
Campbell)

*Warburton, William, *The Divine Legation
of Moses* (London: 1765)

*Williams, John, *Thoughts on the Origin of
Languages* (London: 1783)

*Wilson, Thomas, *The Many Advantages of
a Good Language to Any Nation*
(London: 1724)

IX The Nineteenth Century: Advertising, Visible Speech and Narratives of History

Albright, R.W., 'The International Phonetic
Alphabet – Its Background and
Development,' *International Journal of
American Linguistics*, Vol. 24, No.1,
January 1958, Indiana University

Baker, Alfred, *The Life of Sir Isaac Pitman*
(London: Sir Isaac Pitman and Sons,
Ltd., 1908)

Bell, Alexander Melville, *Visible Speech*
(London: Simpkin, Marshall & Co.,
1867)

Brodie, James, *The Alphabet Explained or
the Science of Articulate Sounds
described, illustrated, and viewed in con-
nection with the Origin and History of
Nations to which is added an inquiry
into the origin and progress of alphabeti-
cal writing* (Edinburgh: John Johnstone,
1840)

Carmichael, Andrew, *An Essay on the
Invention of Alphabetic Writing*
(Dublin: 1815)

Chase, Pliny Earle, *Remarks on the Asiatic
Origin of the Alphabet* (American
Philosophical Society, 1863)

Dammartin, Moreau de, *Origine de la forme
des Caractères Alphabetiques de toutes
les Nations, des clefs chinoises, des
hieroglyphs Egyptians etc.* (Paris: 1839)

D'Olivet, Fabre, *The Hebraic Tongue Restored* (1817)

Ellis, Alexander, *The Alphabet of Nature* (London: S. Bagster and Sons, 1845)

Forster, Charles, *The One Primeval Language Traced Experimentally through Ancient Inscriptions in Alphabetic Characters of Lost Powers From the Four Continents including the Voice of Israel from the Rocks of Sinai and the vestiges of Patriarchal Tradition from the Monuments of Egypt, Etruria and S.Arabia* (London: Richard Bentley, 1852)

Fortia d'Urban, M. le Marquis de, *Essai Sur l'Origine de l'Ecriture* (Paris: H. Fournier Le Jeune, 1832)

Genette, Gerard, *Mimologiques* (Paris: Aux Editions du Seuil, 1976)

Higgins, Godfrey, *The Celtic Druids* (London: R. Hunter, 1829) and Anaclypsis (London)

Humphreys, Henry Noel, *The Origin and Progress of the Art of Writing* (London: Ingram Cooke and Co., 1853)

Kraitsir, Charles, *The Significance of the Alphabet* (Boston: E.P. Peabody, 1846)

Lethierry-Barrois, Ad., *Hebrew Primitif* (Paris: A. Franck, 1867)

Marsh, Luther, *The Alphabet, the Vehicle of History* (New York: New York Historical Society, 1885)

Pitman, Sir James, *Alphabets and Reading* (London: Pitman Publishing Co., 1969)

Schoebel, Charles, *Memoir* (London: 1882)

Silvestre, J. Balthazar, *Paleographie Universelle* (Paris: Firmin Didot Frères, 1841)

Smith, Daniel, *Cuneorum Clavis: The Primitive Alphabet and Language of the Ancient Ones of the Earth by means of which can be read the cuneiform inscriptions, inscriptions on the stone tablets, obelisks, cylinders, and other remains discovered in Assyria* (London: Chiswick Press, 1875)

Smith, George, *A dissertation on the very early origins of Alphabetic Characters, Literature and Science* (London: Simpkin and Marshall, 1842)

Soldi-Colbert de Beaulieu, Emile, *La Langue Sacrée* (Paris: Ernest Leroux, 1900)

Spencer, Warren P., *Origin and History of the Art of Writing* (New York: Ivison, Phinney, Blakeman and Co., 1869)

Upham, William P., *A Brief History of the Art of Stenography* (Salem, Mass.: Essex Institute, 1871)

Wall, Charles, *The Orthography of the Jews* (London: Whittaker and Co., 1835)

Wood, George Ingersoll, *A Popular Treatise on the History of the Origin and Development of Written Language, especially of its alphabetic signs* (Hartford, Connecticut: Press of the Case, Lockwood and Brainard Co., 1883)

X Twentieth Century: Eclecticism, Technology and the Idiosyncratic Imagination

Bauer, Hans, *Der Ursprung des Alphabets* (Leipzig: Hinriches Verlag, 1937)

Bouuaert, Joseph, *Petite Histoire de L'Alphabet* (Bruxelles: Office de Publicité, 1949)

De Kerckhove, Derrick and Charles J. Lumsden, eds., *The Alphabet and the Brain* (Berlin, Heidelberg, New York: Springer-Verlag, 1988)

Deloly, J., *L'Eau et les Secrètes du Langage* (Paris: Editions du Scorpion, 1962)

Donnelly, Ignatius, *Atlantis: The Antediluvian World* (New York: Harper Brothers, 1882)

Dornseiff, Franz, *Das Alphabet in Mystik und Magie* (Leipzig: B.G. Teubner, 1922)

Dunand, M., *Byblia Grammata* (Beyrouth: 1945)

Duvillé, D., *L'Aethiopie Orientale ou Atlantie* (Paris: Société Française d'Editions Litteraires et Techniques, 1936)

Ennis, G.F., *The Fabric of Thought* (London: Effingham Wilson, 1923)

Gelb, I.J., *A Study of Writing* (Chicago and London: University of Chicago Press, 1952)

Graves, Robert, *The White Goddess* (New York: Farrar, Straus & Giroux, 1948)

Haab, Francis, *Divination de L'Alphabet Latin* (1948)

Hoffstein, Robert M., *The English Alphabet* (New York: Kaedmon Publishing Co., 1973)

Hutchinson, James, *Letters* (New York and London: Van Nostrand Reinhold, 1983)

Kallir, Alfred, *Sign and Design: The Psychogenetic Sources of the Alphabet* (London: James Clarke and Co., 1961)

Knuth, Donald, *Computers and Typesetting* (Menlo Park, California: Addison Wesley Publishing Co., 1986)

List, Guido, *The Secret of the Runes* (1908)

McLuhan, Marshall, *The Gutenberg Galaxy* (Toronto: University of Toronto Press, 1962)

Moran, Hugh A., *The Alphabet and the Ancient Calendar* (Palo Alto, California: Pacific Books, 1953)

Palaysi, René, *L'Alphabet code mystique du langage et de la philosophie des Ancetres* (Paris: A. Nizet et M. Bastard, 1945)

Peacey, Howard, *The Meaning of the Alphabet* (Los Angeles: Murray and Gee, Inc., 1949)

Peignot, Jerome, *De l'Ecriture à la Typographie* (Paris: Gallimard, 1967)

Skinner, Hubert, *The Story of Letters and Figures* (Chicago: Orville Brewer Publishing Co., 1905)

Waddell, L.A., *The Aryan Origin of the Alphabet* (London: Luzac and Co., 1927)

315

INDEX